Junctures

in Women's Leadership

⟨ The Arts ⟩

JUNCTURES

Case Studies in Women's Leadership
Mary K. Trigg, Series Editor

The books in this series explore decisions women leaders make in a variety of fields. Using the case study method, the editors and authors of each volume focus on strategies employed by the women profiled as they face important leadership challenges in business, various social movements, the arts, the health industry, and other sectors. The goal of the series is to broaden our conceptions of what constitutes successful leadership in these changing times.

Junctures in Women's Leadership: Social Movements, edited by Mary K. Trigg and Alison R. Bernstein

Junctures in Women's Leadership: Business, edited by Lisa Hetfield and Dana M. Britton

Junctures in Women's Leadership: The Arts, by Judith K. Brodsky and Ferris Olin

Junctures
in Women's Leadership

⟨ The Arts ⟩

Judith K. Brodsky and Ferris Olin

RUTGERS UNIVERSITY PRESS
NEW BRUNSWICK, CAMDEN, AND NEWARK, NEW JERSEY, AND LONDON

Library of Congress Cataloging-in-Publication Data

Names: Brodsky, Judith K., author. | Olin, Ferris, author.
Title: Junctures in women's leadership : the arts / Judith K. Brodsky,
Ferris Olin.
Description: New Brunswick : Rutgers University Press, 2018. | Series: Junc-
tures: case studies in women's leadership | Includes bibliographical references
and index.
Identifiers: LCCN 2017058965 | ISBN 9780813588278 (hardback) | ISBN
9780813576251 (paperback) | ISBN 9780813576268 (epub) |
ISBN 9780813576275 (web pdf)
Subjects: LCSH: Leadership in women. | Women executives in the arts. |
Women in art. | BISAC: ART / History / Contemporary (1945–). | SOCIAL
SCIENCE / Women's Studies. | BUSINESS & ECONOMICS / Leadership. |
Non-Profit Organizations | PERFORMING ARTS / Business Aspects. | SOCIAL
SCIENCE / Feminism & Feminist Theory. | ART / Individual Artists, arts pro-
fessionals, women entrepreneurs in the arts / Essays.
Classification: LCC HQ1236.B746 2018 | DDC 704.9/424—dc23 LC record avail-
able at https://lccn.loc.gov/2017058965

A British Cataloging-in-Publication record for this book is available from the
British Library.

∞ The paper used in this publication meets the requirements of the Ameri-
can National Standard for Information Sciences—Permanence of Paper for
Printed Library Materials, ANSI Z39.48-1992.

www.rutgersuniversitypress.org

Manufactured in the United States of America

Contents

Foreword to the Series
Junctures: Case Studies in Women's Leadership Series

Throughout history, women have always been leaders in their societies and communities. Whether the leadership role was up-front such as hereditary queens and clan mothers, as elected officials, or as business executives and founders of organizations, women have participated at the highest levels of decision-making. Yet, up through most of the twentieth century, we seldom associated the word *leader* with women. I might even argue that the noun *leader* is one of the most masculinized words in the English language. When we thought of leaders, our minds seldom conjured up a woman.

Fortunately, there has been a recent shift in our thinking, our images, and our imaginations. In the United States, credit may go to those women in the public eye like Gloria Steinem, Oprah Winfrey, Cecile Richards, and even Eleanor Roosevelt, who have blazed new trails in politics, media, and statecraft. Now leadership is beginning to look more gender neutral. That said, it is important to remember that, in many parts of the world, women leaders, including prominent feminists, have risen to power more rapidly than seems to be the case here. I think of Gro Bundtland in Norway, Helen Clarke in New Zealand, Michelle Bachelet in Chile, and others. These leaders certainly raise new and interesting questions about linking feminism with powerful political leadership. We in the United States also have Sheryl Sandberg to thank for using the word *feminist* in the same sentence as *leadership*.

Despite progress in the past few decades, women have not reached any kind of rough parity with men in terms of positional leadership—that is, the form of leadership that is appointed or elected and recognized as powerful and influential in coeducational public life. Women continue to be dramatically underrepresented in all major domains of leadership from politics to Fortune 500 companies, to labor unions, to academic administration, and even in fields where they are the majority, like in health care professions, teaching, or the arts. Scholars like Deborah Rhode and Nannerl O. Keohane note that at the rate the United States is going, there will not be a convergence toward parity for an additional three centuries. Given the need for outstanding leadership at all levels and sectors of society, and given the huge waste of talent that exists when so many capable women are not encouraged to move into senior leadership positions, we cannot afford to wait for parity even three decades, let alone three centuries!

If we wish to accelerate the process of gender parity in producing leaders in the twenty-first century, what steps might we take, and what role can academia play in helping to increase the pool and percentage of women leaders? Historically, women's colleges, according to pioneering research by Elizabeth Tidball and others, graduated disproportionate numbers of women leaders up through the 1970s. More recently, business schools, which were largely male bastions, have educated a share of women leaders.

Today, in interdisciplinary fields such as women's and gender studies, examining the concept of leadership and teaching women students to be more effective leaders in a given profession or context is highly contested. For example, *Ms.* magazine noted in 2011, "Only a handful of the more than 650 women's studies programs at colleges and universities provide practical and theoretical knowledge necessary for the next generation to make a significant impact on their communities and world" as leaders. Many feminists and women scholars have negative associations with traditional ideas of leadership, arguing that the concept is elitist, individualistic, and hierarchical and justifies putting work ahead of family and parenting. Moreover, traditional leadership studies often have

failed to take account of structural and contextual frameworks of unequal power and privilege, especially around gender and race. And yet approaching the study of leadership with a gender-sensitive lens is crucial if we are to make more progress toward a fairer and more just distribution of power and opportunity for women and men alike.

Which brings us to the genesis of this series, Junctures: Case Studies in Women's Leadership. The volumes in the series are designed to provide insights into the decision-making process undertaken by women leaders, both well-known and deserving to be better known. The case studies run the gamut from current affairs to past history. The Rutgers Institute for Women's Leadership (IWL) consortium, a group of nine separate units at the university, including Douglass Residential College, the Department of Women's and Gender Studies, and the Center for American Women in Politics, is sponsoring this series as a way to provide new pedagogical tools for understanding leadership that has been exercised by women. Each volume will consist of a dozen or so case studies of leaders in a specific field of endeavor. The focus is not on the woman leader per se but rather on the context that surrounded her decision, the factors she considered in making the decision, and the aftermath of the decision. Also, even though the series is focused on decision-making by women leaders, it is not designed to demonstrate that all decisions were good ones or yielded the results expected.

The series does not promote the notion that there are biologically determined differences between women's and men's decision-making practices. There is no such thing as a "women's" approach to leadership. Nothing universally characterizes women's approaches to leadership as opposed to men's. Neither gender is genetically wired to be one kind of leader as opposed to another. That kind of biologically determined, reductionist thinking has no place in this series. Nor does the series suggest that women make decisions according to a single set of "women's values or issues," though there is some evidence to suggest that once women reach a critical mass of decision makers, they tend to elevate issues of family and human welfare more than men do. This evidence, collected by the Rutgers

University's Center for American Women in Politics, also suggests that women are more likely to seek compromise across rigid ideologies than are men in the same position.

Our series of case studies on women in leadership is not designed to prove that simply electing or appointing women to leadership positions will miraculously improve the standard-of-living outcomes for all people. Few of us believe that. On the other hand, it is important to examine some questions that are fundamental to understanding the values and practices of women leaders who, against the odds, have risen to shape the worlds in which we all live. The series employs the "case study" method because it provides a concrete, real-life example of a woman leader in action. We hope the case studies will prompt many questions, not the least of which is, What fresh perspectives and expanded insights do women bring to leadership decisions? And, more theoretical and controversial, is there a feminist model of leadership?

In conclusion, the IWL is delighted to bring these studies to the attention of faculty, students, and leaders across a wide range of disciplines and professional fields. We believe it will contribute to accelerating the progress of women toward a more genuinely gender-equal power structure in which both men and women share the responsibility for forging a better and more just world for generations to come.

Alison R. Bernstein
Director, Institute for Women's Leadership (IWL) Consortium
Professor of History and Women's and Gender Studies
Rutgers University / New Brunswick
April 2015

New Foreword to the Series

Junctures: Case Studies in Women's Leadership

The last time I saw Alison Bernstein was at a book launch party for the first two volumes in the Junctures: Case Studies in Women's Leadership series, in the late spring of 2016. Sadly, on June 30 of that year, Alison—director of the Institute for Women's Leadership (IWL), professor of history and women's and gender studies at Rutgers, and original editor of the Junctures series, which is sponsored by the IWL—died. The first volume, *Junctures in Women's Leadership: Social Movements*, which she and I coedited, was published one month before Alison's death. (The second volume, which focuses on women's leadership in business, was published simultaneously.) The day before she died, I was visiting the progressive, independent City Lights Bookstore in San Francisco and saw our newly published *Junctures* volume on the shelf. I texted Alison a photograph of the book because I knew it would please her. Her former colleagues at the Ford Foundation—where she served first as a program officer, later as director of the Education and Culture program, and then as vice president for Knowledge, Creativity, and Freedom and its successor program Education, Creativity, and Free Expression—described Alison as "a powerful voice for justice" and "a ferocious defender of and advocate for the rights of women and girls."[1] In its illumination of women leading change across a range of contexts, including social movements, business, the arts, higher education, public health, science, politics, and media, the Junctures series carries these feminist and egalitarian impulses

forward. It carries them forward as well in its advocacy of gender parity and its message that for women to take their full place as leaders, our expectations and stereotypes about leadership must change.

The Junctures series seeks to redress the underrepresentation of women in leadership positions and suggest a different kind of future. Although quick to denounce a "women's" approach to leadership, Alison did note that research indicates that once women reach a critical mass of decision makers, they tend to elevate issues of family and human welfare more than men do. In addition, the Junctures series suggests that when women wield power and hold decision-making positions, they transform organizations, ideas, industries, institutions, culture, and leadership itself.[2] Women's lived experiences are distinct from men's, and their lives collide with history in unique ways. Moreover, the diversity of experience among women further enriches their perspectives. This influences how they lead: for example, women broaden art and museum collections to include more work by women and by artists from diverse backgrounds. This is not insignificant. The arts volume makes a persuasive case for the necessity of women artists and arts professionals in leadership positions to advance gender parity in the arts. "Women leaders make a difference," its authors conclude.[3] Similarly, the editors of the business volume determine that "from their [women leading change in business] experiences come unique business ideas and the passion to address women's needs and interests."[4] Each volume, in its way, illustrates this.

The Junctures series aims to capture women's leadership in action and at pivotal junctures or moments of decision-making. Its goal is to broaden our conceptions of what constitutes successful leadership in these changing times. Our approach is intersectional: we consider gender, race, class, ethnicity, and physical and social location and how they influence access to, and the practice of, leadership. We wander through time and historical contexts and consider multiple ways of leading. Authors and editors of each volume conducted multiple interviews with living subjects, which makes this compendium a contribution to academic scholarship on

women's leadership. Collectively, the volumes contemplate the ways that gender conventions have influenced how some women have practiced leadership, the pain and impetus of gender and/or racial discrimination and exclusion, and the challenges some women leaders have faced as mothers and primary caretakers of home and children.

We use the format of the "case study" broadly. Each essay or case study is organized into a "Background" section, which describes the protagonist's rise to leadership and lays out a decision-making juncture or problem, and a "Resolution" section, which traces the ways the leader "resolved" the problem or juncture, as well as her legacy. Each volume considers what prepared these particular women for leadership, highlights personal strategies and qualities, and investigates the ways that family, education, mentors, personal injustice, interaction with social movements, and pivotal moments in history shaped these protagonists' approaches and contributions as leaders in varied contexts. We have sought to cast a wide net and gather examples from the United States as well as around the world (the first three volumes include case studies from Kenya, Nicaragua, South Africa [2], the United Kingdom, and Laos). Necessarily volume authors have had to make difficult decisions about whom to include and exclude. Our goal is to offer a rich abundance of diverse examples of women's leadership and the difference it makes rather than a comprehensive theory about women's leadership or even what feminist leadership might entail. We seek to prompt questions as well as provide answers.

Alison and I stated in the preface to the social movements volume that some of the qualities that fuel leadership include "courage, creativity, passion and perseverance."[5] Alison Bernstein exemplified all of these qualities. "She was wild, clear, and shameless," Ken Wilson, Alison's former colleague at the Ford Foundation, wrote of her.[6] The same could be said of many of the audacious and brave change-makers in this series. The Institute for Women's Leadership sends their stories out into the world to document and preserve them and to educate and inspire faculty, students, and leaders across a range of fields and disciplines. We hope these volumes will inform

those who aspire to leadership and apprise those who practice it. Leadership has the potential to forge gender and racial equity, to bring about innovative solutions, and to advance social justice.

Mary K. Trigg
Faculty Director of Leadership Programs and Research, Institute for Women's Leadership (IWL) Consortium
Associate Professor and Chair,
Department of Women's and Gender Studies
Rutgers University / New Brunswick
October 2017

Notes

1 Ford Foundation, "Remembering Alison Bernstein," https://www.ford foundation.org/ideas/equals-change-blog/posts/remembering-alison -bernstein/. The quotes are from Margaret Hempel.
2 Lisa Hetfield and Dana M. Britton, *Junctures in Women's Leadership: Business* (New Brunswick, N.J.: Rutgers University Press, 2016), xi.
3 See preface.
4 Hetfield and Britton, *Junctures: Business*, xiii.
5 Mary K. Trigg and Alison R. Bernstein, *Junctures in Women's Leadership: Social Movements* (New Brunswick, N.J.: Rutgers University Press, 2016), xii. This insight is drawn from Linda Gordon, "Social Movements, Leadership, and Democracy: Toward More Utopian Mistakes," *Journal of Women's History* 14, no. 2 (2002): 104.
6 Ford Foundation, "Remembering Alison Bernstein."

Preface

These case studies show how belief in the importance of the arts and a commitment to feminist principles of social justice (even if some of the women in our case studies may not have called themselves feminists) led women leaders to transform global culture by dedicating their lives and careers to abolishing the misconception that white men are the only worthy cultural creators and providing access to the arts for diverse audiences. Other women may have been leaders in various arts disciplines, but we believe the most significant ones were inspired simultaneously by their deep love for the art disciplines in which they were active participants and by their commitment to engaging in the quest for inclusivity of race, gender, and class among the creators in their fields and their audiences. They proved that women leaders make a difference.

We have presented the case studies in chronological order by birthdate to show how women leaders persevered and how their concerns shifted to reflect the global social, political, and economic changes taking place during the 125 years covered by these case studies, ranging from Bertha Honoré Palmer, who was born in 1849 and whose leadership activities occurred starting in the 1890s, to Veomanee Douangdala and Joanne Smith, both born in 1976, who became cultural entrepreneurs in the early years of the twenty-first century. Their interests and careers reflect the movements that arose during this period to protest discrimination and achieve social justice for all, particularly the American and European first

and second waves of feminism in the last half of the nineteenth century and in the 1960s, respectively.

These movements go back to the late eighteenth century. The most well-known early tract on feminism was *The Vindication of the Rights of Woman* by Mary Wollstonecraft. In the second half of the nineteenth century, the first wave of feminism arose in the United States and England focusing on voting rights; as a result, (white) women were enfranchised when a constitutional amendment was passed in 1920. The second wave of feminism, also predominantly white, arose in the early 1960s with the publication of books like Betty Friedan's *The Feminist Mystique*, Simone de Beauvoir's *The Second Sex*, and the establishment of the National Organization for Women (NOW) and other associations.

The 1970s spawned movements like the feminist art movement which began simultaneously in several locations—the East and West Coasts of the United States and Europe. Feminist artists at that time burst onto the art scene with work that contained blatantly political messages and also broke through the Modernist aesthetic with revolutionary stylistic innovations such as the inclusion of the decorative arts associated with women and women's life experiences. On the art history front, Linda Nochlin published the essay "Why Have There Been No Great Women Artists?" in 1971, pointing out that the great artists of the past were all men, since women were not considered capable of making important art. Therefore, Nochlin concluded, instead of being an objective discipline, art history was gendered and biased.[1] On the creative front, also in 1971, Miriam Schapiro and Judy Chicago formulated the Feminist Art Program at California Institute of the Arts to develop an aesthetic based on women's experience. In London, Mary Kelly included her baby's diapers in her 1976 radical exhibition *Post-partum* at London's Institute for Contemporary Art. Artists in New York mounted large-scale street protests against museums that mounted exhibitions without women artists. Women artists themselves mounted citywide art festivals such as Philadelphia Focuses on Women in the Visual Arts. Exhibitions devoted to resuscitating the history of women artists, starting with *Women Artists, 1550–1950* at the Los Angeles

County Museum of Art (LACMA), curated by Linda Nochlin and Ann Sutherland Harris, took place. Women artists founded cooperative galleries across the country, and through their research, activist organizations like the Women's Caucus for Art, which consisted of women artists, art historians, and curators who belonged to the College Art Association, cited discrimination in the employment of women in art and art history departments and museums.

Our assignment in this book was to cover women leaders in both the visual and performing arts. We have included leaders and founders of institutions, women challenging sexist and racist stereotypes through their arts practices, and diversity in geography, ethnicity, class, age, and historical context. These women leaders include eight who are Caucasian, two who are African American, and one each who are Asian, Latina, and Native American. Class diversity ranges from Bertha Honoré Palmer, who used her upperclass, wealthy social status to persuade the federal government to recognize the contributions of women for the first time, to Jaune Quick-to-See Smith, who grew up in foster homes on the impoverished Salish-Kootenai Indian Reservation.

This volume may seem heavier in case studies of leaders in the visual arts, but it was important to include institutions like museums, which are the sites where the arts and the public often intersect. As will be evident in reading these case studies, the upheaval took place in the performing as well as the visual arts. Furthermore, women emerged as leaders in the arts in other countries as well as the United States; therefore we have included women leaders from the United Kingdom, South Africa, and Laos as examples.

There are many more women we would have liked to include, such as Nancy Hanks, the founding director of the National Endowment for the Arts; Zelda Fichandler, cofounder of the Arena Stage in Washington, DC, the first racially integrated public theater company; Mary Schmidt Campbell, the founding director of the Studio Museum in Harlem; the avant-garde choreographer Pina Bausch; Lourdes Lopez, the director of the Miami City Ballet, the first Latina woman to head a major classical ballet company; the Guerrilla Girls, whose research and posters make public the discrimination against

women artists; and Marin Alsop, the conductor of the Baltimore Symphony Orchestra, the first woman to head a major American orchestra and also the first openly lesbian woman in such an important musical leadership position.

The documentation of these women is important in itself. Our own experience in conducting the research for this book and struggling to find the information confirmed the studies showing that women's accomplishments and strategies too often go unrecorded or are denigrated. Thus we are glad to help in preserving their history.

Our initial case studies detail two women caught between the traditional construct of women as wives and mothers and the "new woman" who could operate in the male sphere of business and government. Bertha Honoré Palmer (1849–1918), a Chicago socialite, at first a signifier of her husband's success, bedecked in the latest fashions and fabulous jewels, transformed herself into a strong leader who persuaded the United States Congress to fund a building dedicated to women's accomplishments in the World's Columbian Exposition in Chicago in 1893 and later became the developer of the city of Sarasota, Florida. Yet she refused to identify as a "new woman."

Louise Noun (1908–2002) was born half a century later than Bertha Palmer, but like Palmer, she was born into a white upper class social milieu with a traditional construction of women's roles. Even in Palmer's time, however, wealthy women were permitted to move into the world through philanthropy, and Noun became a philanthropic leader in the city of Des Moines, Iowa. However, unlike Palmer, Noun came into adulthood after women had received the vote (the Nineteenth Amendment in 1920) and was a founding member of the Iowa chapter of NOW. At sixty-three, she gave up her volunteer activities and devoted the rest of her life to building the first art collection in the United States of women artists. Eventually, she donated her collection to several museums, thus providing the initial opportunity for the American public to see that women could be artists.

Samella Lewis, Míriam Colón, and Jaune Quick-to-See Smith worked to bring people of color into the cultural mainstream by founding new institutions and engaging in educational activities. Lewis founded the African American Museum in Los Angeles and an

art history journal, the *International Review of African American Art*, to document the art of the African diaspora. Colón, one of the few Latina actresses to succeed in the theater and film world, founded the Puerto Rican Traveling Theater to bring live performances into the New York City barrios, whose residents could not afford to buy tickets to Broadway plays. Jaune Quick-to-See Smith organized collaboratives and exhibitions with other Native American artists and lectured ceaselessly to promote recognition of Native American art and culture in the mainstream.

Julia Miles left a prestigious position as a producer and director to found Women's Project Theater, an organization to help achieve gender parity in the theater. Bernice Steinbaum, Anne d'Harnoncourt, and Martha Wilson used their leadership to transform existing institutions—Steinbaum to transform the art market for the benefit of women and artists of color, d'Harnoncourt to open the museum to more diverse populations, and Wilson to overcome government censorship and create and preserve new art forms.

The youngest women who are our subjects reflect the globalism of the last few decades, the dissolution of both physical and cultural borders, and acceptance of other civilizations as being of equal value to white European culture: Jawole Willa Jo Zollar created a dance company based on the mix of African dance with the everyday experience of African Americans; Kim Berman, striving for the parity and sustainability of blacks in South Africa, founded Artist Proof Studio (APS) to serve black artists; and Gilane Tawadros, who emigrated with her family from Egypt to England, was the founding director of the Institute of International Visual Arts (InIVA), an innovative institution with a mission to overthrow the hegemony of white, European art by focusing globally. Under Tawadros's leadership, InIVA became a major force in eliminating racism in the international art world. Veomanee Douangdala and Joanne Smith linked the women textile artists of Laos with world markets for economic viability to preserve the Laotian weaving tradition.

The stories of these women leaders show how the arts inspire and how crucial they are to social change. When President Obama presented the National Arts Medal to Míriam Colón, he noted that

the honorees all had an "urgent inner force, some need to express the truth that they experience," which "help us understand ourselves in ways that we might not otherwise recognize." That statement describes the motivation of our subjects.[2] As Samella Lewis pointed out, "art keeps people from killing each other."[3] These case studies show very clearly that the arts communicate social justice. The arts also offer us the experience of beauty. As Lewis says, art collecting is her "nourishment."[4] In describing Philadelphia Museum of Art director Anne d'Harnoncourt, her colleague William Viola commented, "She was absolutely and completely convinced of the power of art to change lives. This was the passionate belief that motivated her at all times."[5]

There is a commitment among many in this volume to make art accessible to diverse populations, not just the elite, as Míriam Colón did in creating the Puerto Rican Traveling Theater, and to use art to communicate about one's own culture or identity. Smith encapsulates this point: "I am an American Indian and this gives me a particular kind of perspective. I am an advocate of our issues, but I am also a woman. I feel solidarity with African American, Asian, and Latino artists."[6]

We are also struck by how much the lives and careers of the women in our case studies reflect our own lives and careers, starting with common characteristics in our backgrounds. All had childhood experiences in which parents or other close family or friends believed in causes beyond themselves, treasured creativity, pushed independent thinking and action, and were aware of sexism and racism. Although they had lived in apartheid South Africa for generations, Kim Berman's family opposed the apartheid system. Louise Noun's mother, an inveterate volunteer for civic good, promoted the settlement house and suffrage movements. Her grandmother had funded a program to educate colored children (as African Americans were referred to in polite white company at that time) in the segregated South. Jawole Willa Jo Zollar's father, who was in the real estate business, tried to integrate black families into white neighborhoods. Author Judith Brodsky's father, as one of the first Jewish scholars to receive tenure in the Ivy League, brought her up to believe in opportunity for all. Ferris Olin's independent thinking

and curiosity were accepted and fostered by her parents, who never tired of her inquisitiveness.

A second shared characteristic was devotion to culture on the part of the families of the women in our case studies. Since Anne d'Harnoncourt's father was the director of the prestigious Museum of Modern Art in New York, she was obviously raised in a household and a community that valued art, but so was Jaune Quick-to-See Smith, despite growing up poverty stricken and moving from foster family to foster family. Smith's father, although an itinerant horse trader, collected art and was an accomplished draughtsman, and the people around her on the Salish-Kootenai Reservation treasured their traditional art. Bernice Steinbaum was sent to the library in the afternoon until her working mother came home. At the library, she was befriended by the artist Joseph Cornell, who she says inspired her lifetime devotion to art. Brodsky's family was poor—professors didn't make much money in her day, but she was sent to classes at the Rhode Island School of Design every Saturday morning from the time she was six. Olin's grandfather, owner of a candy store, was also a bass baritone singer who learned English while performing on Broadway and was a lifelong devotee of Saturday-afternoon Metropolitan Opera radio broadcasts.

A third characteristic is the significance of education in the lives of these women. They themselves sought education, and through their educational experiences, they gained the insights that enabled them to become leaders. It took Jaune Quick-to-See Smith twenty years to finish her degrees. Through that education, she became expert in Modernist art techniques and discovered feminist principles. Anne d'Harnoncourt became enthusiastic about art history through a course at Harvard, thus leading to her career as an art historian, curator, and museum director. Samella Lewis overcame the poverty and discrimination she suffered as an African American in the South and found her calling as an art historian by earning her PhD. Jawole Willa Jo Zollar first realized the lack of African American content in choreography while watching dance performances as an undergraduate. Míriam Colón received her first professional theater training and an eventual scholarship to study in New York through being permitted to attend classes at the University of

Puerto Rico while she was still a high school student. Ferris Olin returned to her graduate studies after a fifteen-year hiatus, and while working full-time, she began and then completed her PhD just before she turned fifty years old.

One of the themes that unites these case studies is the gender discrimination most of these women experienced at one time or another in their careers. Louise Noun's art history professor would not even place her as a volunteer in museums. He told her to return to Iowa and get married. And despite Bernice Steinbaum's successful effort to put women artists into the art market, the work of male artists still commands higher prices than the work of female artists in the art market today. When Brodsky was a graduate student, in her master of fine arts seminar class, one of the male students suddenly burst out at her, saying she didn't belong in the class; he said she was married and had another income in her household and was therefore taking away a job from men who needed it more than she did. Olin recounts how as a graduate student in art history, she continuously brought up the fact that the professor in her lecture class never discussed any women artists, but she had no luck in changing his behavior.

Another more positive aspect of the educational experiences of these women is the transformative nature of mentorship in arts leadership. Lewis was mentored as a college student in New Orleans by African American artist Elizabeth Catlett. Colón's teacher/mentor got her permission to audit a college theater class in Puerto Rico, a circumstance that led to a scholarship to study in New York. Steinbaum's fateful meeting as a child with artist Joseph Cornell led to her lifetime dedication to art.

Another theme related to their educational experience is the impact of the theorists of race, gender, and identity on their leadership. Tawadros's study of the work of sociologist Stuart Hall was crucial to her work in disrupting the white European cultural hegemony of the art world. As Hall wrote, "Difference is complex. . . . It provides an incredible site of richness, new ways of seeing and creativity."[7] Samella Lewis found a connection to scholars working in African American studies and anthropology. Brodsky and

Olin also relished the university atmosphere in which they worked. Brodsky introduced a theory seminar into the curriculum of the MFA program at Rutgers, where the students read French deconstructionists, feminist theorists, and studies of the impact of African culture on European and American Modernism. Olin created digital research tools and collected unique library research materials for scholars of feminist art history and women's leadership. Olin and Brodsky later developed online courses in the global feminist art movement for the Women's and Gender Studies Department at Rutgers.

Another common characteristic is the fact that the impetus to leadership came from altruism inspired by social movements rather than selfish motivation. Bertha Honoré Palmer led the struggle to have a woman's building at the World's Columbian Exposition of 1893 because she was inspired by the women's suffrage movement and the new social dictate for wealthy women to engage in welfare activities. Samella Lewis's own experiences of segregation and animosity as she struggled for her education (she was the first African American to receive a PhD in art history and fine art) led her to begin her activism.

The civil rights and feminist movements of the 1960s were a major inspiration for women to become leaders. Reading essays by feminist women art historians about the exclusion of women artists from the history of art led Louise Noun to assemble the first collection of work by women artists. Reminded by the civil rights movement of how poverty limits cultural exposure (and her own experience), Míriam Colón established the Puerto Rican Traveling Theater to bring live performances to the Puerto Rican barrios in New York.

The dancer and choreographer Jawole Willa Jo Zollar, incensed at the whiteness of contemporary dance, founded Urban Bush Women (UBW), the first major dance company consisting of all female African American dancers who tackle abortion, racism, sexism, and homelessness in their choreography. Jaune Quick-to-See Smith, subjected as a member of an indigenous people to widespread stereotyping and racism, was inspired by feminist art writers like Lucy

Lippard and Harmony Hammond to protest through the content in her own art and organize exhibitions to make other indigenous artists visible to the mainstream. Appalled by the underrepresentation of women working in the American theater (in the late 1970s, only 7 percent of the plays produced in the United States were written by women), Julia Miles established Women's Project Theater. Exasperated by the male chauvinist art history she was teaching, Bernice Steinbaum founded an art gallery in New York with the mission of exhibiting women artists and artists of color. Martha Wilson fought for artists who were threatened by government censorship during the United States culture wars of the late twentieth century.

Like Noun, Steinbaum, and Smith, the present authors were inspired by the feminist art movement of the 1970s. Brodsky participated in organizing Philadelphia Focuses on Women in the Visual Arts in 1973–1974, the first citywide feminist art festival. Olin, aware of the feminist movement as early as her college days at Douglass College—which, during the 1960s and 1970s, was the largest women's college in the United States and a center for the development of women's studies—administered a statewide curriculum transformation project in the humanities and social sciences for all New Jersey academic institutions, where faculty revised courses and pedagogy to incorporate the new scholarship on gender, race, ethnicity, and sexuality and later worked to put the erasure of women artists on the agenda of art librarians, art historians, and their professional associations.

Another characteristic is an ability to make use of circumstances and connections. The women in these studies took their opportunities and used them. Institutions in transition or in downward slides often bring in women leaders as a last resort, but those women, like Anne d'Harnoncourt, who became director of the Philadelphia Museum of Art at a low point in its history, rise to the challenge despite the circumstances. Michael Govan, chief executive officer and Wallis Annenberg Director, Los Angeles County Museum, described Anne d'Harnoncourt as follows: "She made it safe to be a museum director—she knew how to run a great show and how to deal with the politics around her and still do the beautiful Brancusi

or Barnett Newman exhibitions, to keep the quality high and in balance."[8] Julia Miles took advantage of her position as associate director of the prestigious American Place Theatre (APT) to use the APT as an umbrella to found Women's Project Theater. Through taking a course with artist Harmony Hammond, Jaune Quick-to-See Smith met the well-known critic Lucy Lippard; their interaction resulted in shaping the discourse around inclusivity of Native Indian culture in the American cultural mainstream. Louise Noun and Bertha Honoré Palmer did not hesitate in using their wealth and position to support revolutionary actions to promote the status of women. Veo Douangdala's family was already involved in weaving and was also a leading family in their village, thus providing her with connections to the weaving community in Laos.

Brodsky and Olin learned how to navigate the systems of a large university by serving in administrative positions. Brodsky resigned from her job as associate provost of the Rutgers Newark campus and used her experience to establish the Rutgers Center for Innovative Print and Paper (later named the Brodsky Center in her honor) with the mission to provide artists from underrepresented populations access to creating new work in print and handmade paper. Olin, returning to the Rutgers University Libraries after serving as the executive officer of the Rutgers Institute for Research on Women and the Laurie New Jersey Chair in Women's Studies, established the Margery Somers Foster Center, a resource center and digital archive on women's scholarship and leadership. Together they founded the Rutgers Institute for Women and Art, now the Rutgers Center for Women in the Arts and Humanities, the first feminist art center on a university campus.

Leadership is often defined as heading an institution, corporation, or organization. We found that definition to be too narrow, whether applied to the lives of the women in these case studies or to our own lives. Change occurs through the impact of ideas as well as overt leadership. There are multiple ways of leadership, as evidenced by these case studies, and no hard-and-fast categories. The literature on leadership has yet to describe the complex leadership exhibited by women leaders in the arts. Furthermore, the

stereotype of a leader as a tall, dominating authority figure with a deep voice is basically male and does not fit our subjects any more than ourselves. Mary Beard wrote,

> My basic premise is that our mental, cultural template for a powerful person remains resolutely male. . . . Women are still perceived as belonging without power . . . Isn't it power we need to redefine, rather than women? You can't fit into a culture that is coded as male . . . You have to change the structure. . . . It means thinking about power differently . . . It means thinking about power collaboratively, about the power of followers, not just leaders, above all thinking about power as an attribute, not as a possession . . . the ability to be effective, to make a difference in the world.[9]

Thinking about leadership and power in this way, one can understand the impact of these case studies. Zollar's choreography inserted the daily lives of African American women into high art through her dance pieces about "nappy" hair, homelessness, and racism. Smith's combination of modern artistic formal structures with an accessible iconography based on common themes among indigenous peoples was a crucial factor in the acceptance of Native Indian artists as important contributors to the American cultural mainstream. Wilson's exhibitions of artists who were considered indecent changed the discourse around censorship in the United States.

Did women in leadership positions endorse feminist principles in the way they led? Sometimes yes and sometimes no. Jaune Quick-to-See Smith fulfills what we think of as feminist leadership. Like Brodsky and Olin, she was working on behalf of the community of women artists—in this case, American Indian women artists—rather than only promoting herself. When women leaders tried to be autocratic, they sometimes ran into problems. For instance, Zollar had six principal dancers walk out on her. She recounts that she had to reconsider her style of leadership and change from a hierarchic one to a consensual team approach. Brodsky and Olin themselves moved back and forth, perhaps because they were working within the context of a male-oriented academic

institution, although at one point, the feminist artist Judy Chicago, whose work *The Dinner Party* is a major iconic art piece in the feminist art movement, asked them, "How did you make a major state university a feminist institution?"

But our expectations and stereotypes about leadership must change for women to take their full place as leaders. Bias is still inherent in our attitudes toward women as leaders, even permeating our language. Kaywin Feldman, director of the Minneapolis Institute of Art, addressed this issue in a speech at a meeting of the American Alliance of Museums:

> I've done a fair amount of interviewing to get to where I am. I heard the exact same concern every time I was not hired—and even when I was hired—"We are worried that she doesn't have gravitas."
>
> I'd like to unpack gravitas for a moment. It was one of the key Roman virtues, along with *pietas*, *dignitas*, and *virtus* (which, incidentally, comes from "vir," the Latin word for man).
>
> Gravitas signifies heft, seriousness, solemnity, and dignity. It is weighty and replete with importance. I have come to realize that it is also subconscious code for "male."
>
> In fact, the dictionary gives the following two examples of "gravitas" in a sentence:
>
> - a post for which he has the expertise and the gravitas
> - A comic actress who lacks the gravitas for dramatic roles.
>
> Funny that—the negative example of gravitas is female. The Urban dictionary defines the word as "a part of the male anatomy," going on to say for example, that the few female news anchors who are thought to possess gravitas are often assumed to be lesbians or described as shrill and therefore do not last long in their positions. Instead, American news anchorwomen are often offered "perky" as a substitute description.
>
> Please understand that my beef isn't with the word gravitas itself, it is with the cowardly discrimination that hides behind the use of the word. It's this thinking:

- Women don't have gravitas
- Leaders must have gravitas
- Women can't be leaders[10]

We do need to point out that this definition, in some respects, is European American. For instance, we take deep voices that project loudly as authoritative. On the other hand, in Laos, the homeland of Veomanee Douangdala, men as well as women are soft spoken. While speaking softly may not be a hindrance for women in Asian countries, they do suffer discrimination on other grounds.

These case studies show that women are still in transition. We have shining examples of women who have been superb leaders in the cultural world, and they have been able to provide access to the arts for disadvantaged populations and recognition for women arts professionals, but the statistics in all disciplines still show a lack of parity. In the 2013–2014 theater season on Broadway, there were no new plays by women playwrights. Four years later in 2017, there were still only two, whereas there were eight by men.[11] Even though by 2017, women made up 48 percent of museum directors, an increase of five percentage points from 2014, almost all were smaller museums, and they still only made seventy to seventy-five cents to every dollar earned by their male peers. A report states, "There are clear disparities in gender representation depending on operating budget size. Most museums with budgets of less than $15 million are run by females rather than male directors, whereas the reverse is true for museums with budgets of $15 million or more. For this second cohort of larger museums, female representation decreases as budget size increases."[12] The 2017 Pulitzer Prize for Music was awarded to the composer Du Yun, and for the first time in the history of the prize, all the finalists were women. Yet during the 2015 and 2016 musical seasons, among eighty-nine American orchestras surveyed, only 1.7 percent of the works they performed were composed by women.[13]

The year 2020 is the hundredth anniversary of women's suffrage. A group of women playwrights has organized a campaign titled 50/50 in 2020—parity for women a hundred years after women

received the privilege of the vote in the United States. It's a slogan for all of us to adopt.

Judith K. Brodsky
Distinguished Professor Emerita,
Department of Visual Arts, Rutgers University

Ferris Olin
Distinguished Professor Emerita, Rutgers University
August 2017

Notes

1 Linda Nochlin, "Why Have There Been No Great Women Artists?," first published in *ARTnews*, January 1971, 22–39, 67–71, and then in *Women, Art, and Power, and Other Essays* (New York: Harper Collins, 1988). Linda Nochlin and Ann Sutherland Harris organized the first historical exhibition of women artists, *Women Artists, 1550–1950*, which opened in 1976 at the Los Angeles County Museum of Art (LACMA) and traveled to the University Art Museum in Austin, Texas; the Carnegie Museum of Art, Pittsburgh; and the Brooklyn Museum. *Women Artists 1550–1950*, Los Angeles County Museum of Art (New York: Alfred A. Knopf, 1981).

2 Whitehouse.gov, "Remarks by the President at the National Medals of the Arts and Humanities Awards Ceremony," September 10, 2015, https://obamawhitehouse.archives.gov/the-press-office/2015/09/11/remarks-president-national-medals-arts-and-humanities-awards-ceremony.

3 Lewis in conversation with Olin, June 5–6, 1993.

4 Lewis, conversation.

5 Email from Danielle Rice to Brodsky.

6 Alejandro Anreus, *Subversions/Affirmations: Jaune Quick-to-See Smith* (Jersey City: Jersey City Museum, 1996), 111–112.

7 "Rivington Place—Celebrating Difference," InIVA.org, July 25, 2007, http://www.inIVA.org/press/2007/rivington_place_launch.

8 Michael E. Shapiro, "Museum Directors on Mentorship and Their Professional Journeys," *Museum*, March/April 2017, 34.

9 Mary Beard, "Women in Power," *London Review of Books* 39, no. 6 (March 16, 2017): 9–14, https://www.lrb.co.uk/v39/n06/mary-beard/women-in-power. Mary Beard is a British scholar and public intellectual. She is professor of classics at the University of Cambridge, a fellow of Newnham College, and Royal Academy of Arts professor of ancient literature. She is the classics editor of *The Times Literary Supplement* and often writes on feminist themes. She is the author of the 2017 book *Women and Power: A Manifesto*.

10 Kaywin Feldman, "Women's Locker Room Talk: Gender and Leadership in Museums," *Alliance Labs*, October 17, 2016, http://labs.aam-us.org/blog/womens-locker-room-talk-gender-and-leadership-in-museums/.

11 Michael Paulson, "Finally (But What Took So Long?)," *New York Times*, March 26, 2017, https://www.nytimes.com/2017/03/22/theater/lynn-nottage-paula-vogel-broadway.html?_r=0.

12 Veronica Treviño, Zannie Giraud Voss, Christine Anagnos, and Alison D. Wade, "The Ongoing Gender Gap in Art Museum Directorships," published by the American Association of Museum Directors in collaboration with the National Center for Arts Research, https://aamd.org/sites/default/files/document/AAMD%20NCAR%20Gender%20Gap%202017.pdf.

13 William Robin, "What Du Yun's Pulitzer Win Means for Women in Classical Music," *The New Yorker*, April 13, 2017, http://www.newyorker.com/culture/culture-desk/what-du-yuns-pulitzer-win-means-for-women-in-classical-music.

Bibliography

Anreus, Alejandro. *Subversions/Affirmations: Jaune Quick-to-See Smith*. Jersey City: Jersey City Museum, 1996.

Beard, Mary. *Women and Power: A Manifesto*. London: Profile, 2017.

———. "Women in Power." *London Review of Books* 39, no. 6 (March 16, 2017): 9–14. https://www.lrb.co.uk/v39/no6/mary-beard/women-in-power.

Feldman, Kaywin. "Women's Locker Room Talk: Gender and Leadership in Museums." *Alliance Labs*, October 17, 2016. http://labs.aam-us.org/blog/womens-locker-room-talk-gender-and-leadership-in-museums/.

Institute for International Visual Arts (InIVA). "Rivington Place—Celebrating Difference." InIVA.org, July 25, 2007. http://www.inIVA.org/press/2007/rivington_place_launch.

Nochlin, Linda. "Why Have There Been No Great Women Artists?" *Women, Art, and Power, and Other Essays*. New York: Harper Collins, 1988. First published in *ARTnews*, January 1971, 22–39, 67–71.

Paulson, Michael. "Finally (But What Took So Long?)." *New York Times*, March 26, 2017. https://www.nytimes.com/2017/03/22/theater/lynn-nottage-paula-vogel-broadway.html?_r=0.

Robin, William. "What Du Yun's Pulitzer Win Means for Women in Classical Music." *New Yorker*, April 13, 2017. http://www.newyorker.com/culture/culture-desk/what-du-yuns-pulitzer-win-means-for-women-in-classical-music.

Shapiro, Michael E. "Museum Directors on Mentorship and Their Professional Journeys." *Museum*, March/April 2017, 34.

Treviño, Veronica, Zannie Giraud Voss, Christine Anagnos, and Alison D. Wade. *The Ongoing Gender Gap in Art Museum Directorships*. American Association of Museum Directors in collaboration with the National Center for Arts

Research. https://aamd.org/sites/default/files/document/AAMD%20NCAR%20
Gender%20Gap%202017.pdf.

Whitehouse.gov. "Remarks by the President at the National Medals of the Arts and
Humanities Awards Ceremony." September 10, 2015. https://obamawhitehouse
.archives.gov/the-press-office/2015/09/11/remarks-president-national-medals
-arts-and-humanities-awards-ceremony.

Junctures
in Women's Leadership

⟨ The Arts ⟩

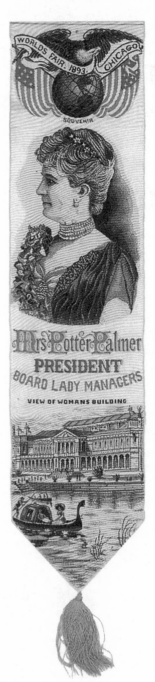

FIGURE 1 Commemorative ribbon with image of Mrs. Palmer and image of the Woman's Building, World's Columbian Exposition, Chicago, 1893.

Bertha Honoré Palmer

A "New Woman"?

Background

Bertha Honoré Palmer (1849–1918) was an unlikely "new woman."[1] Through her husband's wealth and position, she was at the top of the social class pyramid of Chicago. Her husband lavished jewels and clothes upon her. She started out by leading a life in which she was the stereotype of the ultimate feminine ideal of the white upper class, fulfilling traditional roles as wife, mother, hostess, and signifier of her husband's wealth and success. According to her son, "Before my mother became enamored with Florida, she had long been acknowledged as the fashionable queen of Chicago. Noted for her beauty, her wit, her fabulous pearls and diamonds, and the enormous Gothic Palmer castle. Of her jewels, father would say, 'There she stands with $200,000 just around her neck!'"[2] But she was always interested in politics and business.[3] With the rise of the discourse on women's rights during the second half of the nineteenth century, Palmer took advantage of the fact that philanthropy became an accepted outlet for white women of her class to go beyond the domestic sphere and exercise leadership outside the home. She initially branched out into activism on behalf of poor women, mostly immigrants. But Palmer went further. She became the driving force behind the Woman's Building at the World's Columbian Exposition of 1893. It was one of the first times that women organized a major public project by themselves in the United States. The success of the Woman's Building resulted in establishing a new image of women as capable in the arena of politics and public life in general. Much of that success had to do with the leadership of Bertha Palmer. She

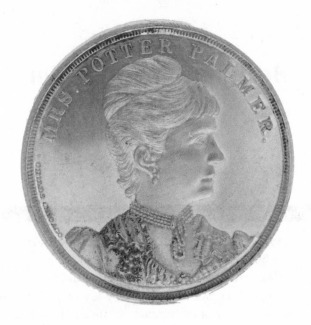

FIGURE 2 Medal struck in honor of Bertha Honoré Palmer. Reproduced by permission of Getty Images.

proved capable of managing a very complex situation, varying from mediating groups of women with differing ideologies to convincing male politicians not only to approve a pavilion celebrating women's work and accomplishments at the Chicago World's Fair of 1893 but also to provide funding for it. There is no question that her position in the forefront of Chicago's white society gave her entrée to money and power in both Chicago and Washington. She used that position to promote what she felt women deserved. Despite the fact that she would not have accepted the terminology, in exercising her power on behalf of women, she became the prototypical "new woman," unafraid to venture beyond the domestic domain into the realm of politics and business, up to that point reserved for men.

Bertha Honoré Palmer lived in an exceptional period, the last half of the nineteenth century extending into the first quarter of the twentieth century. Just to name a few key historic markers, the automobile began to replace the horse and buggy; inoculations and other modern medical practices initiated an era of better health

and longer lives; railroads crisscrossed the world; airplanes became tools for war as well as a means for faster travel; the keys to understanding physics, from the atom to the cosmos, were discovered; colonialism reached its peak; slavery was abolished in the United States after the horrifying Civil War, but Reconstruction put an end to any kind of equality for African Americans; and empires grew and collapsed. Among the most significant changes in this amazing period was the gradual emancipation of women in the United States and Western Europe. It must be said that this emancipation had mixed results. It was mostly limited to white middle-class and independent wealthy women, but nevertheless it set the stage for the fuller empowerment of women that came in the twentieth century. The principles of women's suffrage were established, thus giving women a say in their political future even though it may not have been made law until later; it became permissible, if not completely acceptable, for women to enter the economic sphere of the modern industrial world in various ways as employees, although not as executives or board members; and in some cultural fields, women began to emerge as significant figures, particularly as writers. Women artists, composers, and writers still were considered in second place as compared to their male colleagues.[4]

Bertha Honoré was born in Kentucky. The members of the family treasured their Southern values even though they moved to Chicago in the early 1850s, when the city was only a prairie town.[5] She was raised in luxury, her father being a successful businessman; Bertha Honoré was to be a "Southern belle" even though she was living in raw frontier Chicago. Her future husband, Potter Palmer, also came to live in Chicago at about the same time. They were married in 1870 when she was twenty-one. Potter Palmer was forty-four. By the time of their marriage, Potter Palmer was already wealthy, worth more than seven million dollars.[6] He had established a department store in Chicago, where he made many innovations that led to modern merchandising. Among his modernizations were a generous exchange policy, credit, and attention to customer satisfaction. It was one of the few places in the city, according to the social mores of the time, where it was all right for upper class and middle class women to be seen unaccompanied without disapprobation. He sold

the store to Marshall Field in 1865—Field is famous for creating the classic structure of the department stores of the twentieth century.[7]

Following his career as a merchant, Palmer became a real estate developer in the city. Even before the Great Chicago Fire of 1871, he was buying property. Before the fire, Lake Street, which ran along the canal, was the main thoroughfare for Chicago's businesses. Palmer began acquiring property along what eventually became State Street. He made the street continuous and attempted to persuade the city to widen the street so that it would become more impressive, but the city government refused. Before the fire, State Street had a curious pattern, turning corners around buildings constructed before it had become a continuous right of way. All those buildings were destroyed in the fire, thus providing Palmer with the opportunity to widen the street with new buildings constructed alongside the now-straight curbs; State Street replaced Lake Street as the center of Chicago's downtown.[8] Palmer had built a luxury hotel called the Palmer House, today still in existence, as a wedding gift for his wife. It burned to the ground during the Great Fire, but Palmer then promptly rebuilt it. He also opened up the lakefront for luxury housing by building the Palmer mansion on the lake. Before then, the lakeside had been considered a swampy area unfit for housing. Palmer saw its potential, which was soon realized by others who followed his lead, making Lake Shore Drive the richest neighborhood in the city.[9]

Being wealthy and living in a young city like Chicago, Bertha Honoré Palmer had flexibility that most women of her era did not. The growth of cities like Chicago, the Industrial Revolution, and the rise of bourgeois culture triggered new attitudes toward the status of women. But the concept of the "new woman" could be applied only to the women of the white middle and upper class. People of color, working-class women, and women in rural areas did not have the leisure time to become "new women." The "new women" were supposed to be educated, able to converse knowingly about political and cultural affairs, and able to ride bicycles while maintaining their traditional femininity.

Palmer set about building an art collection, one of the ways in which a white woman of her class could move beyond her assigned

stations as wife, mother, hostess, and symbol of her husband's wealth and success. She employed an art agent named Sarah Tyson Hallowell. The two traveled to Paris, where Hallowell introduced Palmer to Mary Cassatt, the American painter who lived mostly in Paris and was a member of the Impressionist circle. Cassatt herself came from a distinguished and wealthy Philadelphia family, so they possibly became such good friends because they came from the same kind of social circles. Cassatt, in turn, introduced Hallowell and Palmer to Impressionist artists such as Monet, Renoir, and Pissarro. At Cassatt's suggestion, Palmer bought her first painting, a stage scene by Degas. Palmer then went on to buy more works by Degas, as well as paintings by the other Impressionists. At one time, she owned more than ninety works by Monet. The collection she donated to the Art Institute of Chicago is often compared to the collection at the Metropolitan Museum of Art in New York given by Louisine Havemeyer, a women's suffrage activist and advocate married to the sugar baron Henry O. Havemeyer of the American Sugar Refining Company, who was also introduced to the Impressionists by Mary Cassatt. In both instances, it is these collections, formed by women, that are the basis of the excellence of the Impressionist holdings at both institutions.[10]

Parallel to the inclusion of white women in spheres outside the home, the 1870s and 1880s saw the expansion of discourse on women's rights. The movement itself was split between those who saw the most important issue as suffrage and those who concentrated on such aspects of women's empowerment as equal pay for equal work. The latter were of the opinion that the country was not yet ready for women to vote and that the right to vote would come later, when women were more firmly established as having the right to carry on their lives outside as well as inside the home. Palmer was firmly in favor of the second point of view.[11]

By becoming an active member of Chicago's women's clubs, Palmer implemented her belief in women's rights by participating in activities that would lead to social betterment for women—primarily services that would help the hordes of immigrant women from Ireland, Eastern Europe, Italy, and other parts of the world

where conditions were violent and poverty stricken. Women's clubs came into existence in the United States after the Civil War. They provided an accepted way for white middle- and upper-class women who had leisure time to participate in activities outside the home. Through the clubs, women like Palmer also had the opportunity to turn their energies toward developing leadership skills.

The missions and programming of women's clubs revealed their ambivalent nature. On the one hand, they sustained the traditional separation of male and female spheres. On the other, they provided a way for women to exert their leadership abilities and interests beyond running a household and raising children. The activities of women's clubs were twofold. They provided intellectual and cultural stimulation in the form of reading groups and speakers. They also addressed themselves to civic duties and social welfare. They encouraged literacy and founded libraries; they established schools and initiated settlement houses—buildings set aside for various activities to help immigrant women—workshops to learn English, nutrition, and skills such as the use of sewing machines for job eligibility. Palmer was an active supporter of Jane Addams, whom she came to know through their mutual membership in the Chicago women's clubs, and supported Addams in establishing Hull House, one of the first and best known of the settlement houses in the United States.[12]

Bertha Honoré Palmer's entrances into art collecting and philanthropy were acceptable ways for a rich white American woman to expand her activities beyond the domestic sphere in the second half of the nineteenth century. But a particular event caused Palmer to abandon the conventional behavior of a woman of her social standing and take on a leadership role that was much more aggressive, resulting in the Woman's Building at the World's Columbian Exposition of 1893.

In the late 1880s, excitement arose nationally over the concept of a world's fair to celebrate the quadricentennial of Columbus's voyages. After a great deal of lobbying and promises of funding so excessive as to be considered flamboyant[13] by Chicago's leading citizens, Chicago won the competition over New York. President Benjamin Harrison signed the bill on April 25, 1890, placing the

exposition in the city of Chicago.[14] The bill established two oversight boards, both all-male, but it also included an amendment setting up a "Board of Lady Managers." The suffragists are generally given credit for the passage of the amendment, which was brought to the floor of the House of Representatives by William Springer. Susan B. Anthony, one of the founders of the suffrage movement, and Myra Bradwell, an activist on behalf of women's rights and a lawyer who for many years was denied admission to the Illinois Bar by both the Illinois Supreme Court and the United States Supreme Court because she was a woman, led the effort.[15] They argued for women to be included on the two major boards, but their request ended with the establishment of a separate women's board.[16] The Board of Lady Managers was a national one, with members from various states. It had more than one hundred members, making it larger than the commission itself.

Bertha Honoré Palmer was elected president of the Board of Lady Managers. This position brought with it the potential for national leadership. Could a socialite from Chicago become that leader? Palmer faced multiple problems. The mission of the board was to decide how to ensure the acknowledgment of women in the Exposition. Despite dissension over her leadership, the board reached a decision that the best way to show the world the value of women was to have a Woman's Building, but the outlook was dire. Congress was not going to provide funding.

Resolution

At this juncture, Palmer stepped in and exerted leadership to make the Woman's Building a reality. First she had to gain control of the board. A struggle arose over the leadership right at the start. Two groups competed for control of the board, both white. One was the Chicago Women's Auxiliary, also known as the Chicago Women's Department.[17] It was created when more than two thousand women met with the mayor and other dignitaries to insist on the inclusion of women in the formation of the fair. They were an important factor in the success of the lobbying effort for the fair to take place in

Chicago. The Women's Auxiliary had a prestigious pedigree. It was composed of women (all white) who came from the highest social levels in Chicago. They were active, like Palmer, in the work to improve the conditions for poor people in the city as a moral task. One of the reasons that the Women's Auxiliary played a significant role in bringing the fair to Chicago was because the members were all married to leading business figures in Chicago—their headquarters were in the same building as the offices of the World's Fair Corporation, and the men who were lobbying for the fair to come to Chicago expected the women to raise much of the needed funds.[18] Indeed, Palmer and the other women from her social circle were crucial to the local effort to raise funds in Illinois, since through their clubs and philanthropy, they had created a network of wealthy people who could be persuaded to help with the costs of the fair.

The other faction seeking control of the board was the Queen Isabella Association, a national women's organization whose membership, unlike the socialites of the auxiliary, was middle class, comprising mostly professional women who represented a new set of working women educated to assume higher-level positions than factory jobs or their equivalent, which were more usual for women. As such, it could be said that the Isabellas truly represented the "new woman." They selected Queen Isabella as the name for the association because it was she who funded Columbus to make the voyages to the Americas, and therefore she should be honored at the fair.[19]

The struggle for power was ideological as well as classist and personal. The Women's Auxiliary and the Isabellas had divergent views on women's roles. The Isabellas, as opposed to the auxiliary women, were suffragists. They believed that the most important issue was giving women the vote rather than helping poor women; they saw the latter activity as being only an extension of the traditional woman's role as nurturer.

Mrs. Palmer wasted no time in assuming leadership of the board. She persuaded the federal government committee that had oversight over the Board of Lady Managers that such a large board was unmanageable, and it would be necessary to set up a smaller decision-making body if anything were to be accomplished.

The committee agreed, and she went ahead to establish an executive committee that she could control by selecting all the members herself. Palmer believed the bylaws gave the president that right. She appointed twenty-five women, mostly from her own Chicago social circle, and women she knew in other states—wealthy upperclass women likely to vote with her. The suffragist members of the board reacted quickly. They realized that the Chicago socialites were now in charge, and therefore the board would not make suffrage a priority.[20]

The Isabellas and their representative, Phoebe Couzins, waged a bitter fight in public to keep power in the larger group, where suffrage would have more support. Couzins brought several suits against Palmer, accusing Palmer of violating the bylaws in setting up the executive committee. The various courts sided with Palmer, who then managed to have Phoebe Couzins removed from her position as secretary of the Board of Managers. Palmer couldn't remove her from the board itself because she was a delegate. However, she gave her the responsibility for beekeeping and mines, thus sidelining her. Couzins lost the support even of many of the suffragists and faded into the background. Mrs. Palmer emerged the victor and the leader.[21]

At the same time that Palmer's authority was being assailed by Phoebe Couzins and the Isabellas, the Board of Lady Managers became embroiled in racial issues. African American women in Chicago wanted representation on the Board of Lady Managers and in the administration of the Woman's Building. "Colored women," as they were called, like their white counterparts, had been establishing their own clubs and associations. Four groups in particular were especially active in their call for representation. They presented a resolution to the board requesting that the "commission establish an office for a colored woman whose duty it shall be to collect exhibits from the colored women of America."[22] Palmer was busy on a national level, arguing for women to be included on the state commissions for the fair (she succeeded) and in addition persuading the state legislatures across the country to fund separate state women's fair commissions (she also succeeded in this effort), and so she appointed a committee to make the decision. The committee

recommended that one of the white lady managers be appointed "to represent the interest of the colored people."[23] That decision created an uproar among the colored women. They threatened to go to Washington. Palmer would have liked to meet their demands to put a woman of color on the Board of Lady Managers or at least to give women of color a role, but it was not possible given the number of members from Southern states. Palmer did her best. She hired an African American woman for the installation committee, but there was no money for a salary, so that solution fizzled out. Palmer then urged the state commissions to include women of color, and ultimately the New York Commission did appoint a woman of color to its board. She organized an exhibit about the condition of African American women nationwide in the Woman's Building library as well as a display of handmade and manufactured goods produced by women of color. The library also included books by six African American women authors, among them Frances Ellen Watkins Harper, who spoke at the fair's World's Congress of Representative Women.[24]

In the meantime, Congress had established another committee, the Board of Reference and Control, to mediate between the federal commission and the local directory (the committee of men in charge of the fair in Chicago). Even with the umbrella of the Board of Reference and Control, the overlap of responsibilities between the commission and the directory created a tense and divisive situation. By 1890, the committee of the House of Representatives, which had established the commission, was disillusioned in its effectiveness and threatened to abolish it, causing a great deal of consternation among the members of the Board of Lady Managers, since their authority came from the commission. Congress expected the local directory to raise most of the funds for the fair. Even by 1891 (the fair was scheduled to open in 1893, barely two years away), Congress had appropriated less than the $52,000 that Palmer requested for the Woman's Building for the entire administration of the fair on the assumption that the Chicago elite, along with the state commissions, would raise the rest of the funds needed to mount the fair.[25]

Judging by the overwhelming abundance of Mrs. Palmer's correspondence, much of which is accessible in archives today,[26] she made sure to insert herself as leader of the Board of Lady Managers into all the business surrounding the implementation of the fair. As such, she had a constant finger on the pulse of what was going on, and in the beginning of 1891, she learned that the House of Representatives oversight committee was threatening to abolish the commission. She immediately took action. She wrote to the women on the executive committee, urging them to come to Washington in order to lobby their individual senators and representatives to retain the Board of Lady Managers. On February 21, 1891, Mrs. Palmer herself went to Washington to lobby on behalf of the Board of Lady Managers. She wrote,

> In view of the near approach of the convening session of Congress and the possible modification of portions of the Bill which incorporated the World's Commission, it behooves each and every member of our Board to be especially vigilant concerning that section which related to the creation and duties of the Board of Lady Managers. And to that end, you are earnestly directed to communicate with the Senators and Representatives of your States immediately, with instructions to carefully guard this section at every point and prevent any change in the status of the law.[27]

Palmer planned the approach to Congress carefully. She allowed her colleagues only to meet individually with senators and representatives rather than to testify as a group.[28] But she went before both the Senate and the House appropriations committees and apparently was very convincing. She spoke about the work already accomplished by the Board of Lady Managers, and she presented a budget for 1891. It amounted to $52,000, more than the original amount awarded for the entire administration of the fair, and she was successful in securing $36,000. John Candler, the chair of the House of Representatives committee, assured Mrs. Palmer that he was "heartily in favor of women's work." Although he retained his hostility toward the commission, he could not find it in his heart

any longer to criticize the lady managers. He told Mrs. Palmer that he believed that her ladies would be "more economical and discreet" in their use of public funds than would the commissioners. Her reference to $52,000 as a "small sum" did not cause the "entranced committee chairman to bat an eye."[29]

According to a contemporary account of Palmer's visit to Washington and her victory in convincing Congress to stand behind the Board of Lady Managers, one of the compelling arguments she presented was the information that the directory had agreed to give the Board of Lady Managers $200,000 for the construction of the Woman's Building.[30] Palmer returned to Chicago triumphant in having attained not only recognition of the importance of the Board of Lady Managers but also financing for its continuation. The fact that there was a Woman's Building, conceived and implemented by women themselves, was the result of Bertha Honoré Palmer's strategic leadership.

Because the pavilion celebrated the achievements of women separately, it was the more conservative solution. On the other hand, perhaps women were better served by being singled out. Their contributions may have been lost in a situation where they were side by side with those of men. Furthermore, Palmer and her committee made the building itself a tribute to women. Although the selection of all architects was to be decided upon by the men appointed by the directory, Palmer made sure that selection of the architect for the Woman's Building remained in her hands: "Mr. Waller alarmed me last evening by saying that he understood Mr. Hunt was to build our building. Of course we will not have a man called in until the women architects have tried and failed to produce a suitable plan. . . . The announcement of the competition and the sending in of a number of good designs by competent women would attract attention to our work, and also be an advertisement for all the women who entered the competition."[31]

The architect finally hired to design the pavilion was Sophia Hayden, the first woman to receive an architectural degree from the Massachusetts Institute of Technology, and all the artists commissioned to execute murals and sculptures were women artists,

including Mary Cassatt, who painted a mural signifying women entering the world beyond the home. The image showed women in an apple orchard picking apples from the trees, thus referring to the apple of knowledge.

Palmer was responsible for keeping governance of the Woman's Building in the hands of the Board of Lady Managers, and she also played a major role in bringing all the states and forty-seven nations to participate. Her success was largely due to her network of club women in the United States and her trips to other countries, where she enlisted the participation of the governments in those countries, some of whom were resistant to show off their women on the basis that women belonged invisible in the home. Thus the exhibits ranged from scientific inventions, some patented, to traditional crafts like needlework. Despite Palmer's reluctance to endorse women's suffrage, Susan B. Anthony was invited to give the address at the opening ceremony for the Woman's Building. Palmer is said to have declared, "Even more important than the discovery of Columbus is the fact that the government has just discovered women."[32] At the exposition's dedication ceremonies, Palmer commented on women's achievements and their relationship to comparable financial worth: "Without touching upon politics, suffrage, or other irrelevant issues . . . this unique organization of women for women will devote itself to the promotion of their [women's] material interests . . . , favor women's industrial equality, and her receiving just compensation for services rendered."[33]

While Palmer is known widely, at least among feminists, for the Woman's Building, the rest of her career is equally extraordinary. President McKinley appointed her as a commissioner to the 1900 Paris Exposition, the only U.S. woman to serve on its board. Her husband died in 1902. She left Chicago and lived for eight years in London, where through her money and position, she was a member of the circle around King Edward VII. As in Chicago, her activities revealed how she was caught in the transition of the definition of female gender. She fully blended into the social rituals of English aristocratic society but at the same time showed an independence of mind, as for instance when she mounted the performance of

Oscar Wilde's *Salome*, which had been banned in England. However despite the fact that she had embraced the Impressionist group of artists when they were considered outrageous, she showed no interest in acquiring the new art of the twentieth century, such as the work of artists like Picasso, Rouault, or Klimt, all of whose creative talent she would have seen at the Paris Exposition Universelle in 1900.[34]

On Edward VII's death, she returned to the United States and began the next period in her life, which is perhaps the most remarkable. She fell in love with the West Coast of Florida and bought huge tracts of land in the area that became Sarasota, eventually owning 140,000 acres. Her biographers have found it difficult to explain her attraction to the area. Barbara Peters Smith, in her dissertation on Palmer written for a master of arts degree at the University of South Florida, speculates that Palmer missed the sense of expansion that typified Chicago after the Civil War, and this land in South Florida gave her the experience of building something—this time completely in control, without having to answer to oversight committees, as was the case in the Woman's Building project. Also, Chicago had moved on since her time there, and accustomed as she was to adulation and respect, it may have seemed too difficult to break into the new social and political scenes. Palmer was responsible for transforming the area into the resort and urban area it became. She eradicated the swamps, developed agricultural enterprises, and built a home, now destroyed. A portion of her estate remains today as the Myakka River State Park. Palmer may also have been inspired by what Henry Flagler[35] had achieved on the East Coast of Florida and wanted to duplicate it on the West Coast.[36]

The last phase of Palmer's life is very sad. She developed breast cancer and had extensive surgery, which left her disfigured. The cancer persisted, and the history of her treatment is a case study in itself of the relationship between medical practice and women during that era. Her physicians treated her with diets and sanitarium stays that were addressed more to treating emotional illness rather than cancer. Much documentation has revealed how diseases in women were treated as emotional disturbances rather than physical problems at the time. Like most people in the

early twentieth century, she did not feel free to admit she had cancer, and when she died, pneumonia was given as the cause. During the two decades between her husband's death and her own, Palmer substantially increased the family fortune by more than 100 percent.[37]

Bertha Honoré Palmer is a transitional figure in the evolution of the social construction of female gender from the nineteenth into the twentieth century. She has been written about as a woman typical of her class at that time—a body on which the wealth of her husband could be displayed, occupying a feminine sphere of a domestic if lavish life. At the same time, she is an important example of how some women during that period used their position and wealth to transform their world. Palmer had connections and used her position to influence government. She pursued them to accomplish purposes that were radical in nature in spite of the fact that she presented them from a more conservative position.

We are fortunate enough to have her own words reflecting on her life and motivations. They show how she was caught between being a "Southern Belle" and being a "new woman." She organized the Chicago Woman's Business Club, a compromise to fill the gap between women and the business world—teaching women how to cope in a male world. She participated in the social whirl but saw it as a means to conduct business and achieve her goals:

> I am not a suffragist! I simply felt that intelligent women
> could work with men to achieve their goals. I preferred diplomacy
> to balance the social and working worlds. Both my father and my
> husband had encouraged me to learn about business. I helped orga-
> nize the Chicago Woman's Business Club in 1888 to help women
> entering the work force, and served as vice-president of the Civic
> Federation to bring capital and labor together. And oh my, what a
> time I had in 1892 with Chicago's first World's Fair! We'd won the
> bid to host the World Columbian Exhibition [sic], to celebrate
> the 400th anniversary of Columbus's arrival in America, and as
> head of the Board of Lady Managers, I traveled abroad, meeting
> with many heads of state to present the works of talented women.
> Well, you can imagine, life was a whirlwind of ball gowns and grand

soirées! But I always felt that culture and society itself was a business, not a frivolity. When my dear Potter passed away in 1902, I was only fifty-three. Potter junior just twenty and Honoré a year older. I took the boys off to England, where we often dined with royalty, and they loved all that boat travel. But after a time, I was ready to come home. I was, after all, a business woman, anxious to explore new opportunities. And perhaps simplify my life a bit.[38]

Her comments on arriving in Sarasota again reveal her mixed reactions. She makes a point of how the Florida scenery made her think on the one hand of romantic European landscapes, but on the other hand, the local population reminded her of the wild west of Chicago during her youth. Business and the social whirl occur together when she talks about how she was encouraged to understand business and politics, but she ties it to meeting her husband in a truly heart-fluttering, feminine way of describing the occasion:

When I first arrived in Sarasota, I was immediately enchanted. The weather was too lovely. Here, at last was heaven! It quite reminded me of the Bay of Naples [Italy]. I was taken with the quaintness of the local communities, the fishermen, and the farmers. The hardiness of these frontiersmen reminded me of my dear late husband Potter, who was from a Quaker farming family in New York. He had come to Chicago in the 1850s when it was but a wild prairie town. My own family had arrived at about the same time from Kentucky, and I was brought up as an over-educated "Southern Belle." Business and politics were part of my life, and father had always discussed his real estate development ideas with me. I met Potter, his business associate at dinner when I was thirteen, and I expect I was a bit precocious. By the time I made my debut at twenty-one, the dashing Mr. Potter Palmer came to court me. My dear, he was the most eligible bachelor in Chicago, though older than I by twenty-three years. Still, he cut quite a figure, and his persistence eventually won me over.[39]

What was the turning point in Palmer's life? What led her to transcend the allure of beautiful clothing, jewels, and admiration

of her Chicago circle and develop skill in bringing about change? Palmer wanted to be a transformer. She wanted to lead the struggle to recognize women, and she wanted to convert the West Coast of Florida into a useful and desirable locale. Her first efforts at transformation had to be restlessness brought about by familiarity with the women's rights movement. The second effort was perhaps fueled by a desire to recreate the era of her youth and transform a whole region as Chicago had been altered during her youth. To accomplish her goals, she had no compunction in using her position and her wealth. In her efforts to empower women, though, she compromised by refusing to go the distance and endorse actions like women's suffrage that she considered too revolutionary and impossible to achieve. In her Sarasota venture, she had the opportunity to take complete control. Only illness stopped her.

Palmer's leadership style raises issues about whether women leaders have a style different from that of men. On the one hand, Palmer had a stereotypically masculine approach, taking authority without worrying about consensus and consolidating her power by eliminating her competitors. On the other hand, she used her feminine side to charm the male hierarchy, ranging from businessmen to members of Congress. Palmer also had no hesitation about using her position, her wealth, and the confidence that both of those aspects gave her. While as a prominent socialite, she had the means to dress beautifully, travel extensively, and have all her needs taken care of by an army of servants and assistants, nevertheless, her boldness and sense of her own power were extraordinary in a time when most women of her class were content (or at least appeared to be content) within the domestic sphere. One of the key ingredients in Palmer's success as a leader was her indefatigable attention to work. She was constantly on top of whatever was going on. Her attention to the detail of a project while maintaining a vision of the whole was essential to her success as an inspiring leader and an adroit manager.

Notes

1 The "new woman" was a phrase that came into use during the late nineteenth century. It was a rallying cry for women to move out of subjugation to men and

out of confinement to the domestic roles of wife and mother. Elizabeth Cady Stanton, in her 1848 address to the women's rights convention in Seneca Falls, New York, describes the characteristics of the new woman, although she does not use the term. *The Elizabeth Cady Stanton and Susan B. Anthony Papers Project*, "Address by Elizabeth Cady Stanton on Woman's Rights, September 1848," http://ecssba.rutgers.edu/docs/ecswoman1.html.

2 From *The Fabulous Bertha Palmer*, a thirty-minute film distributed by Planet Group Entertainment, in which Bertha Palmer and her son talk about her life. May 9, 2010, http://planetgroupentertainment.squarespace.com/bertha -palmer/.

3 Ishbel Ross, *Silhouette in Diamonds: The Life of Mrs. Potter Palmer* (New York: Harper, 1960), 18, 20, https://babel.hathitrust.org/cgi/pt?id=mdp .39015006573698;view=1up;seq=8.

4 For a short summary of the women's suffrage movement in the United States, see U.S. House of Representatives, "The Women's Rights Movement, 1848–1920," *History, Art, and Archives: U.S. House of Representatives*, http:// history.house.gov/Exhibitions-and-Publications/WIC/Historical-Essays/No -Lady/Womens-Rights/; and Bonnie Eisenberg and Mary Ruthsdotter, "History of the Women's Rights Movement," National Women's History Project, http://www.nwhp.org/resources/womens-rights-movement/history-of-the -womens-rights-movement/.

5 Ross, *Silhouette*, 14.

6 Margo Hobbs Thompson, "Palmer, Bertha Honoré," in *Women Building Chicago 1790–1990*, ed. Rima Lunin Schultz and Adele Hart (Bloomington: Indiana University Press, 2001), 662.

7 Robert P. Ledermann, *State Street, One Brick at a Time* (Charleston, S.C.: History Press, 2011), 36; "Death of Potter Palmer," *New York Times*, May 5, 1902, http://query.nytimes.com/mem/archivefree/pdf?res= 9F07E0D6103BE733A25756C0A9639C946397D6CF.

8 Ledermann, 17–28.

9 Ledermann, 17–28.

10 Gioia DiLiberto, "A Painter and Her Patron: Two Modern Women," *New York Times*, December 20, 1998, http://www.nytimes.com/1998/12/20/arts/ art-architecture-a-painter-and-her-patron-two-modern-women.html; and Art Institute of Chicago, "Bertha Honoré Palmer and Potter Palmer," *Monet Paintings and Drawings in the Collection of the Art Institute of Chicago*, https:// publications.artic.edu/renoir/reader/monet/section/138187.

11 U.S. House of Representatives, "Women's Rights Movement, 1848–1920"; and Eisenberg and Ruthsdotter, "History of Women's Rights."

12 Miriam Cohen, "Women and the Progressive Movement," *The Gilda Lehrman Institute of American History*, https://www.gilderlehrman.org/history-by -era/essays/women-and-progressive-movement; National Women's History Museum, "Introduction to Club Women," *Reforming Their World: Women in the Progressive Era*, https://www.nwhm.org/online-exhibits/progressiveera/ introclubwomen.html; and National Women's History Museum, "Settlement

House Women," *Reforming Their World: Women in the Progressive Era*, https://www.nwhm.org/online-exhibits/progressiveera/settlementhouse.html.

13 "By 1890, it was clear that the U.S. Congress would have to decide where the fair would be held and that the principal contenders, by virtue of their superior financial resources, would be Chicago and New York. New York's financial titans, including J. P. Morgan, Cornelius Vanderbilt, and William Waldorf Astor, pledged $15 million to underwrite the fair if Congress awarded it to New York City. Not to be outdone, Chicago's leading capitalists and exposition sponsors, including Charles T. Yerkes, Marshall Field, Philip Armour, Gustavus Swift, and Cyrus McCormick, responded in kind. Furthermore, Chicago's promoters presented evidence of significant financial support from the city and state as well as over $5 million in stock subscriptions from people from every walk of life. What finally led Congress to vote in Chicago's favor was banker Lyman Gage's ability to raise several million additional dollars in a 24-hour period to best New York's final offer." *Encyclopedia of Chicago*, "World's Columbian Exposition," http://encyclopedia.chicagohistory.org/pages/1386.html.

14 Jeanne Madeline Weimann, *The Fair Women: The Story of the Women's Building at the World's Columbian Exposition, Chicago 1893* (Chicago: Chicago Review Press, 1981), 33.

15 *American National Biography Online*, "Myra Colby Bradwell," http://www.anb.org/articles/11/11-00095.html.

16 Weimann, *Fair Women*, 30–33.

17 Weimann, 27.

18 Weimann, 28.

19 Weimann, 28.

20 Weimann, 38. Mrs. Palmer's lack of sympathy with the suffrage movement is apparent in her response to the passage of the amendment that established the Board of Lady Managers. She wrote that Mr. Springer had proposed the amendment out of a commitment to social justice, not under pressure from the suffragists. However, some of her disparagement of suffrage may have come more from her desire to control the Board of Lady Managers rather than from her belief in traditional femininity.

21 Weimann, 73–101.

22 Weimann, 103.

23 Weimann, 104.

24 Weimann, 121–124. Also see Amina Gautier, "African American Women's Writing in the Women's Building Library," *Libraries and Culture* 41, no. 1 (2006): 55–82.

25 Weimann 79.

26 Chicago History Museum, Archives and Manuscripts Collections, Board of Lady Managers records, located in the 1893 World's Columbian Exposition archive.

27 Weimann, *Fair Women*, 77.

28 Weimann, 78.

29 Weimann, 79.

30 Enid Yandell, Jean Loughborough, and Laura Hayes, "To the Board of Lady Managers," in *Three Girls in a Flat* (Chicago: Knight, Leonard, 1892), 61, http://digital.library.upenn.edu/women/hayes/flat/chapter-05.html.

31 Weimann, *Fair Women*, 143–145.

32 Weimann, 223.

33 Weimann, 663. Quoted from *Addresses and Reports of Mrs. Potter Palmer, by World's Columbian Exposition, Complete Edition* (Chicago: Rand McNally, 1894), 116. The entire book is reproduced on the website Internet Archive (https://archive.org). It was digitized by the Oesterle Library, North Central College, Napier, Illinois, sponsored by the Consortium of Academic and Research Libraries in Illinois (CARLI). It can be viewed at https://archive.org/details/addressesreports00worl.

34 Hope L. Black, "Mounted on a Pedestal: Bertha Honoré Palmer" (master's thesis, University of South Florida, 2007), http://scholarcommons.usf.edu/cgi/viewcontent.cgi?article=1636&context=etd.

35 Henry Morrison Flagler (1830–1913) founded Standard Oil. He was also a railroad magnate, launching the Florida East Coast Railway, which provided access to the Atlantic Coast of Florida. Along with the railroad, he bought and built properties there, thus playing a major role in the development of the area as a tourist destination and haven from winter weather for the wealthy.

36 Barbara Peters Smith, "From White City to Green Acres: Bertha Palmer and the Gendering of Space in the Gilded Age" (master's thesis, University of South Florida, 2015), http://scholarcommons.usf.edu/cgi/viewcontent.cgi?article=6973&context=etd.

37 Smith, 48–58.

38 Catherine O'Sullivan Shorr, *The Fabulous Bertha Palmer*, Planet Group Entertainment, May 9, 2010, http://planetgroupentertainment.squarespace.com/bertha-palmer/.

39 Shorr.

Bibliography

American National Biography Online. "Myra Colby Bradwell." http://www.anb.org/articles/11/11-00095.html.

Art Institute of Chicago. "Bertha Honoré Palmer and Potter Palmer." *Monet Paintings and Drawings in the Collection of the Art Institute of Chicago*. https://publications.artic.edu/renoir/reader/monet/section/138187.

Black, Hope L. "Mounted on a Pedestal: Bertha Honoré Palmer." Master's thesis, University of South Florida, 2007. http://scholarcommons.usf.edu/cgi/viewcontent.cgi?article=1636&context=etd.

Chicago History Museum. Archives and Manuscripts Collections: "World's Columbian Exposition, Board of Lady Managers Records, 1890–1904."

Cohen, Miriam. "Women and the Progressive Movement." *The Gilda Lehrman Institute of American History*. https://www.gilderlehrman.org/history-by-era/essays/women-and-progressive-movement.

Corn, Wanda, with contributors Charlene Garfinkle and Annelise K Madsen. *Women Building History: Public Art at the 1893 Columbian Exposition*. Berkeley: University of California Press, 2011.

DiLiberto, Gioia. "A Painter and Her Patron: Two Modern Women." *New York Times*, December 20, 1998. http://www.nytimes.com/1998/12/20/arts/art-architecture -a-painter-and-her-patron-two-modern-women.html.

Eisenberg, Bonnie, and Mary Ruthsdotter. "History of the Women's Rights Movement." *National Women's History Project*. http://www.nwhp.org/resources/ womens-rights-movement/history-of-the-womens-rights-movement/.

Gautier, Amina. "African American Women's Writings in the Woman's Building Library." *Libraries and Culture* 41, no. 1 (2006): 55–82.

Ledermann, Robert P. *State Street, One Brick at a Time*. Charleston, S.C.: History Press, 2011.

National Women's History Museum. "Introduction to Club Women." *Reforming Their World: Women in the Progressive Era*. https://www.nwhm.org/online -exhibits/progressiveera/introclubwomen.html.

———. "Settlement House Women." *Reforming Their World: Women in the Progressive Era*. https://www.nwhm.org/online-exhibits/progressiveera/ settlementhouse.html.

New York Times. "Death of Potter Palmer." May 5, 1902. http://query.nytimes.com/ mem/archivefree/pdf?res=9F07E0D6103BE733A25756C0A9639C946397D6CF.

Ross, Ishbel. *Silhouette in Diamonds: The Life of Mrs. Potter Palmer*. New York: Harper, 1960. https://babel.hathitrust.org/cgi/pt?id=mdp.39015006573698 ;view=1up;seq=8.

Shorr, Catherine O'Sullivan. *The Fabulous Bertha Palmer*. Planet Group Entertainment, May 9, 2010. http://planetgroupentertainment.squarespace.com/bertha -palmer/.

Smith, Barbara Peters. "From White City to Green Acres: Bertha Palmer and the Gendering of Space in the Gilded Age." Master's thesis, University of South Florida, 2015. http://scholarcommons.usf.edu/cgi/viewcontent.cgi?article=6973 &context=etd.

Thompson, Margo Hobbs. "Palmer, Bertha Honoré." In *Women Building Chicago 1790–1990*, edited by Rima Lunin Schultz and Adele Hart. Bloomington: Indiana University Press, 2001.

U.S. House of Representatives. "The Women's Rights Movement, 1949–1920." *History, Art, and Archives: U.S. House of Representatives*. http://history.house .gov/Exhibitions-and-Publications/WIC/Historical-Essays/No-Lady/Womens -Rights/.

Weimann, Jeanne Madeline. *The Fair Women: The Story of the Women's Building at the World's Columbian Exposition, Chicago 1893*. Chicago: Chicago Review Press, 1981.

Yandell, Enid, Jean Loughborough, and Laura Hayes. "To the Board of Lady Managers." In *Three Girls in a Flat*. Chicago: Knight, Leonard, 1892. http://digital .library.upenn.edu/women/hayes/flat/chapter-05.html.

FIGURE 3 Photograph portrait of Louise Noun. Photographer unknown. Reproduced by permission of the *Des Moines Register*.

Louise Rosenfield Noun

Feminist, Scholar, Art Collector, Curator, Social Activist, Philanthropist

The life and work of Louise Rosenfield Noun (1908–2002),[1] named by *Art and Antiques* magazine as one of "America's Top 100 Art Collectors" in 1992,[2] were forged by her experiences as a Jewish woman living in Des Moines, Iowa, in the early and mid-twentieth century—a period when living in the midwestern United States put someone who was Jewish and female on the margins of a local culture that was predominantly Christian and patriarchal and, on a national level, outside an art world primarily centered in New York. Hers was a multiplicity of identities—Jew, woman, middle American, scholar, art collector and curator, civil liberties advocate and social activist, feminist, and philanthropist—each identity emerging to the fore individually and collectively, always fluid, and acting in concert to inform her leadership abilities and strategies. Through her vision, as evidenced by her art-collecting strategies and the integration of art collecting with her identity and politics, Noun questioned underlying assumptions that rendered women, women art collectors, and women artists invisible to the mainstream while simultaneously advocating for equal rights for women and everyone. Her career reveals the close intersection of feminism, art, and politics in the modern era.

Louise Rosenfield was born into a family that owned the largest department store in Des Moines. Personal experiences of discrimination led Noun to become an activist. Noun was Jewish, and starting early in her life, she became aware of discrimination despite her

position as a member of a white, wealthy upper-class Des Moines family. She wanted very much to attend Barnard College, but Barnard rejected her because of her religion: in the 1920s, Barnard, like many other prestigious colleges, maintained a quota to limit the number of Jewish students admitted to the school.

Although she did join the Junior League, one of the few groups with a tolerant membership policy,[3] she felt uncomfortable with the group because it often met at country clubs that excluded Jews from their own membership. At the time that Noun joined the Junior League, it was identified as "having an image of being full of WASP-y, soon-to-be or already married 'ladies who lunch;' and having a prevalent presence of pearls & pumps, and tea & twinsets. Yet . . . any exclusions were unwritten and quietly 'understood.'"[4] The mission of the Junior League was philanthropic from the start, but it was not until 1978 that "diversifying the membership became a priority for the Junior League, with the adoption—despite some attempted dissent from a few groups in Southern states—of a statement by AJLA [the American Junior League Association] that they 'reach out to women of all races, religions and national origins.' As a former African-American President of The Junior League of San Francisco, Annette Harris said: 'The Junior League is not the all-American, upper-middle-class organization it was, even 30 years ago. The idea of giving back to the community is not just for a particular class.'"[5]

Noun graduated with a history degree from Grinnell College in 1929.[6] She pursued graduate studies at Harvard University's Museum Studies Program with Paul Sachs, who created the "scholar connoisseur" model to train future museum administrators. For decades, from the 1930s to the 1980s, his legacy to American society could be found in the policies of every major museum in the United States, where many of his protégés achieved prominence as curators and directors. Noun received her master's in art history and museum management in 1933 and tried to find employment in the visual arts.

At Harvard, Noun experienced prejudice for being a woman. When she received her Harvard degree in 1933, she asked Sachs for help in finding suitable employment, assistance he gave to most of

his male students. However, he refused her request and told her to return to Iowa and get married. He said he would not even place her as a volunteer in museums. Sachs's opinion about women's employment, like so many of that era, was captured in a diary entry in 1927 by James Rorimer, a student of Sachs and an influential director of the Metropolitan Museum of Art from 1955 to 1966: "Women are employed in positions of importance with hesitancy, because they are apt to leave anytime. They are particularly adapted to carry on work in special fields: teaching children and lecturing, and they do this with greater skill than men."[7] Noun subsequently remarked that this incident humiliated her and "that it took years—in fact until the arrival of the current feminist movement—before I could even talk about it. At that time his rejection seemed a denigration of my personal worth . . . it was a reflection of his attitude toward women."[8]

Dismayed by her continuing unemployment and the resulting loss of self-confidence, she returned to Des Moines in 1936 and married Maurice Noun, a Russian émigré dermatologist.[9] Noun wrote in her journal, "I was hesitant about marrying Maurie because he did not have any of my intellectual interests but . . . I could adjust my life to the role of a doctor's wife. I would devote myself to promoting his welfare and also to rearing . . . children. . . . At this time I wasn't sure who I really was or what I wanted out of life so the easiest solution seemed to be to merge my identity with someone else's."[10]

Noun followed in her own mother's footsteps as a volunteer committed to the well-being of the community. Her mother had been active in the Garden Club and Junior League, founded the Des Moines Parent-Teacher Association, and led both the Women's Division of the War Bond Drive during World War I and the Women's Division of the Community Chest in Des Moines.[11]

Because of her training as an art historian, on her return to Des Moines, she pursued active involvement with local art groups (note that it was fine for women to be on the philanthropy end of art institutions but not as art professionals). She was elected in 1938 to the board of the Des Moines Association of Fine Arts. In 1943, the association was given a bequest to build and endow a museum in

the city. Noun was invited to serve on a committee to advise trustees planning the new museum building—it was to be designed by Eliel Saarinen, one of the leading architects of the era.[12] Later, in 1956, when the art center had been established and its headquarters constructed, Noun served a term on its board, heading the membership and then acquisitions committees. Over the years, she formed working relationships with various directors of the museum, and they, in turn, encouraged her art collecting and introduced her to modern and contemporary artists.

Noun became an active participant in the civic community as well as in the arts. She concentrated her energies on liberal causes such as civic improvement and free speech. In 1948, she was elected the president of the Des Moines chapter of the League of Women Voters (LWV). When the organization was founded in 1920, its purpose was to train women for their newly gained civic roles resulting from the passage in 1920 of the Nineteenth Amendment, granting women the right to vote. While heading the Des Moines LWV, she mounted a major campaign to reform city government, abolishing the commission form of government in favor of a council-management plan. Her outstanding work led to her election to the National Council of the Municipal League, and in 1956, she was the recipient of their Distinguished Citizen Award as well as national attention that led to her appointment in 1954 as one of a few women on the panel to judge the All-American City Awards. Noun recognized the impact of her LWV experiences: "[It was] a distinct turning point in my life. . . . League activity heightened my interest in economic and social issues and was far more stimulating than any of the service-oriented volunteering . . . [I had been doing]."[13] However, she ceased to be active in the LWV in the 1960s, when they failed to take proactive stances on civil rights and fair housing issues.

Instead, she turned her attention and energies to leading the Iowa Civil Liberties Union (ICLU) from 1964 to 1972. During her presidency, she helped bring a landmark free speech case to the United States Supreme Court, *Tinker v. Des Moines Independent Community School District* (393 U.S. 503 [1969]). In 1965, the Tinker

children wore black armbands to their schools to protest the Vietnam War. Their schools then suspended them. Noun, with the backing of the ICLU and American Civil Liberties Union (ACLU), helped the Tinkers sue the school board in district court; the suit eventually made it, four years later, to the Supreme Court. Louise Noun and her brother, Joseph, paid for all the Tinkers' legal fees. The United States Supreme Court ruled in favor of the Tinkers, defining public school students' constitutional First Amendment rights to protest without a school's disciplinary action. *Tinker* remains, today, a viable and frequently cited court precedent applied to free speech cases such as student newspaper censorship and searches of school lockers.

Noun turned out to be a very effective executive. Under her directorship, the ICLU doubled its membership and quadrupled its treasury from $5,000 in 1965 to $21,000 in 1972. Noun commented that she "found satisfaction with the ICLU association, because they brought me into contact with liberals who took for granted a support of civil rights and civil liberties that I had not found with the League of Women Voters."[14]

As a result of her leadership within Iowa, she was then appointed a board member of the national ACLU. At first, she didn't question the ACLU's lack of initiatives on behalf of women. Perhaps it was because Noun was intimidated by the fact that she was one of a very small group of female board members against an overwhelming group of eighty male board members.

But one of her colleagues in the ACLU was Pauli Murray, a civil rights activist, lawyer, and PhD who refused to sit in the colored section of a bus fifteen years before the Montgomery Bus Boycott, which was one of the founding incidents of the civil rights movement in the 1960s. As early as 1939, Murray wrote to President Roosevelt asking him to name a "qualified Negro" to the Supreme Court. Murray cofounded the National Organization for Women (NOW) and fought to keep the prohibition on sex discrimination in the Civil Rights Act. She was the first African American woman to be ordained an Episcopal priest. Noun and Murray formed a Women's Caucus to set several women's issues on the agenda for

the next ACLU board meeting. To their chagrin, their agenda items were passed without any discussion because "the men didn't feel like talking about it. . . . So I began to feel frustrated."[15]

Having become passionate about women's rights, Noun became a founding member of, and contributed start-up funds for, the Des Moines chapter of the National Organization for Women in 1971, just one year after the first issue of the premier radical feminist newspaper *Ain't I a Woman* was published in Iowa City. She was sixty-three years old.

Noun was now on the watch for gender inequality. She noticed the disparity of funding given by the local United Way. More money went to the Boy Scouts than the Girl Scouts, yet women employees of Blue Cross/Blue Shield, the local telephone company, and other businesses were compelled to donate to the United Way. She wrote to the organization pointing out that this inequity was wrong but got no reply. The situation was problematic for Noun because her mother had previously headed the United Way's women's drives and all the Nouns, including Louise, were generous donors to the organization. However, she thought that these policies and practices gave preferential and unequal treatment. She went to the editor of the *Des Moines Register*, the largest circulating newspaper in the state, to complain. The paper gave the story front-page coverage, and then the local TV stations aired a story on it. Noun reminisced, "I remember standing in front of the YMCA on a TV program pointing to the expensive new hardball courts for men, while poor kids needed help."[16]

In 1978, as an outgrowth of her involvement with NOW, Louise Noun, working with the Iowa Women's Political Caucus (which she also founded), established the Des Moines Young Women's Resource Center, a place where teens and women received free job training and counseling as well as monetary support for their education. Her work with the Young Women's Resource Center was acknowledged in 1995 when she received the Wise Woman Award from the Ms. Foundation. Noun remarked that her concerns for women "had always been . . . trying to improve the status of women on any front that seemed reasonable. I just thought that I was in the right and everybody else was in the wrong."[17]

With her time and energy as well as her money, Noun supported many other city and state organizations that were created to help women achieve equity. She underwrote the Des Moines Area Community College Women's Assistance Fund and established the Chrysalis Foundation in 1989 (with her friends Senator Elaine Szymoniak and attorney Barbara Barrett) to counter the United Way's ongoing imbalance in support of girls and women. The foundation "invests in the safety, security, education, and economic empowerment of girls and women" in the Greater Des Moines area. At her death, Noun bequeathed $1 million to the Young Women's Resource Center and $25,000 each to the ICLU and the ACLU, and the balance of her estate, estimated to be in the millions, was given to the Chrysalis Foundation.[18]

Another aspect of Noun's feminist activism was her series of publications on Iowa women's history, among them biographies of Carrie Chapman Catt and Amelia Bloomer, both important figures in the women's suffrage movement in the United States.[19] It is remarkable that she could generate so much writing simultaneously with her organizational and philanthropic involvement. There were few easily available materials, but her unrelenting research resulted in the 1969 publication *Strong-Minded Women: The Emergence of the Woman Suffrage Movement in Iowa*. It was later followed by the 1992 sequel entitled *More Strong-Minded Women: Iowa Feminists Tell Their Stories* and by a memoir. Her last monographic study, published when Noun was ninety, was a history of the Iowa women involved with the Works Progress Administration, a 1930s Depression-era program established by U.S. president Franklin Delano Roosevelt to provide employment for at least some of the millions who were unemployed as a result of the 1929 stock market crash. Noun also researched and authored several exhibition catalogs for shows she curated, among them one for the Iowa sculptor Abastenia St. Leger Eberle, a suffragist and political activist rediscovered by Noun.

The difficulties of finding the materials for her publications led to Noun's creation of an archive of primary source material relating to women. Noun approached her fellow Iowan Mary Louise Smith to partner in the funding and establishment of the Iowa Women's Archives at the University of Iowa. The two were political

opposites. Noun had cochaired Shirley Chisholm's Democratic presidential campaign in Iowa—the first black woman to seek that office—while Smith replaced George Bush as head of the Republican National Committee and was the first woman to lead the GOP (1974–1977).[20] Despite their disparate party loyalties, they were good friends. Their collaboration resulted in the founding in 1992 of the Louise Noun–Mary Louise Smith Iowa Women's Archives[21] at the University of Iowa, composed of manuscript collections of personal papers and records that document women's history in Iowa and other states. Noun had already built an art collection, and to fund the archives, she sold the most valuable piece in her collection, the Mexican artist Frida Kahlo's 1947 painting *Self-Portrait with Loose Hair* for $1.65 million—then a record for the most expensive work by a Latin American artist ever sold at auction. The painting had entered the Noun Collection in 1983 when she paid "only" $85,000 for it.[22]

When the quality of her life diminished to the point that she no longer had control over it, she was forced to move to a nursing home. Having decided midway through her adulthood to be in control of her own life, she also controlled her death by committing suicide. Even in death, Noun continued to stir controversy by raising difficult topics that garnered the public's attention. She committed the ultimate final act, leaving a suicide note railing against U.S. laws that prohibited the terminally ill from taking their lives. She said this was her "final project." "It has kicked off a debate about the importance of people being able to control their own lives, something that was always important to her," said Gil Cranberg, who served with Noun on the national board of the ACLU in the 1970s.[23] The FBI seized her computer to try to identify who committed a crime by assisting her, and articles and letters to the editor were published for at least two months after her death in the *Register*. Her death instigated a review of Iowa's suicide laws; however, the Iowa legislature has not yet approved a law permitting assisted suicide.

While Noun was a spectacular civil rights advocate and scholar, her unique contribution to the world was building a collection of work by women artists at a time when it was inconceivable to the

mainstream art world. When she attended the annual national NOW Conference, where the issue of volunteerism was on its agenda, the discussions on this topic helped Noun reject the concept of volunteering, which had become traditional for women of the upper class in the United States since the nineteenth century. She learned that volunteering takes paying jobs from other women and enforces sex stereotyping: "The unpaid work in society is usually done by people who have no place in society. . . . The idea was that women were expected to produce free labor and that even when they went to work, that meant they should work for less."[24]

Noun resigned from the Des Moines Art Center Advisory Council, disillusioned by both the misogyny and the antisemitism she found in the Des Moines art world. She determined that the advisory committee's function was to rubber stamp the decisions of the trustees. Instead, she then joined the Des Moines Art Center Association, the support group for the art center, headed by another Des Moines resident, Fleur Cowles, a woman from a distinguished publishing empire.[25] Women donated much of the initial money for the museum's operating expenses.[26] When the association asked to consolidate with the trustees, they were not allowed, in part because of sexism and the perception that the association was partial to modern art. Members of the association, including Noun, resigned and then left the entire responsibility for the museum's operations to the trustees. Noun had always assumed that these experiences derived from gender discrimination. However, in the late 1980s, she discovered a 1942 document written by the head of the museum's governing board describing his concern over the Jewish presence on the board, bringing another discriminatory aspect to the fore: antisemitism. At this point, Noun decided to reveal the document and name the man who discriminated against her in a letter published in the *Des Moines Register*.

Disillusioned by her volunteerism, committed to feminism, and deeply involved in art, Noun's decision around 1971 only to collect women's artwork was made in the context of the sudden outpouring of information about women artists written by feminist art historians like Linda Nochlin, Ann Sutherland Harris, and Eleanor Tufts, who were rediscovering the work of women artists and dismantling

the assumption that the only good artists were men.[27] There is no question that Noun was inspired not only by her own experiences but also by an intellectual concept that challenged the status quo of the art world.

Resolution

In 1971, Noun decided exclusively to collect works of art by American and European women artists whom she felt were making contributions to new ways of seeing. She gave up all her volunteer activities, including her duties as a wife and parent by divorcing her husband. Noun thought that Betty Friedan had articulated the case against volunteerism accurately when she termed it "the problem with no name," in her germinal book *The Feminine Mystique*, though Noun also criticized Friedan because she did not offer any solution to improve women's second-class citizenship.[28]

The Noun Collection predates Wilhelmina Cole Holladay's collection, usually credited with having been the first American collection for women artists. Holladay's collection formed the basis for the National Museum of Women in the Arts.[29] But it was Noun who established cultural and monetary value for women artists who had been ignored by the mainstream art world. The decision to limit her collection to works by women was unique among her peers. The fact that she was a woman collector when the large majority of art collectors at the time were male was an anomaly, and her motivation to make women artists better known was unlike the aim of her male counterparts, who acquired art for investment, power, and prestige.

Noun collected art created by many American artists active in the 1920s, from Marguerite Thompson Zorach[30] to contemporary artists. She also gave Iowa women artists special attention. Noun's choice to collect the work of women artists was a form of activism, confirming the feminist adage that the personal is political and the political is personal.[31]

She had actually purchased her first work by a woman artist, Isabel Bishop,[32] as early as 1964, but that was before she decided to make art collecting her primary activity. During the early 1970s, her

first years of serious collecting, she acquired sixteen objects, among them works by Berthe Morisot, one of the few women who were members of the French Impressionist group, and by a number of early twentieth-century German artists, such as Paula Modersohn-Becker and Käthe Kollwitz.[33] As she began to amass her collection, she made a point of learning about the context in which the artists lived and worked—an approach not included in her Harvard museums studies and art historical training. At the 1990 University of Iowa Museum of Art exhibition *The Louise Noun Collection*,[34] Noun remarked that she had found a pattern of gender discrimination in each of the life histories of the artists represented in her collection—the artists may have been prohibited from attending art school, burdened with family responsibilities, criticized by their communities, and neglected and/or excluded from histories of art.[35] She told the audience that her purpose was "not to prove anything other than that there are women who have painted good pictures, and that by putting them together makes more of a statement than showing them alone."[36]

The Russian avant-garde of the early twentieth century was introduced to her in 1976 by the director of the Des Moines Art Center, who alerted Noun that *Fishers* (1909), an outstanding work by the early twentieth-century Russian avant-garde artist Natalia Goncharova, was there on consignment.[37] Although Noun had never heard of the artist, she took one look at the painting and acquired it. She said that she didn't worry about how she was going to pay for the artwork; rather, her concern was where to hang it.[38] With the addition of the Goncharova painting, Noun began her passionate interest in Russian women artists of the avant-garde and continued to add their works to her collection. Noun recognized their significance well in advance of their later vogue and rediscovery. Only within the last decades of the twentieth century did these artists receive renewed interest from the scholarly community and the art market due to the work of feminist art historians.

On a trip to Germany in the late 1970s, Louise Noun discovered another artist, the German Dadaist[39] Hannah Höch, who had been described by some art historians as a woman generally reduced to a footnote in the history of Berlin's Dada movement[40] despite the fact

that she invented the medium of photomontage. Like her contemporary Käthe Kollwitz, Höch made art that engaged in political dialogues focused on themes around gender, race, class, and war. Once again, Noun recognized artistic significance well in advance of its later acclaim. Her discerning selection predated, by almost twenty years, Höch's reevaluation by art historians.[41]

In the 1980s, well into her eighth decade, Noun continued to enhance her collection by acquiring more than fifty works, among them Gabriele Münter's painting *House with Fir Trees in the Snow* and the previously mentioned *Self-Portrait with Loose Hair* by Kahlo, which she sold to establish the Iowa Women's Archives.[42]

In the 1990s, Noun purchased, on average, four works annually, often including more than one work by the same artist. Many of these women are now recognized as significant to the history of twentieth-century art, among them Louise Bourgeois, Rebecca Horn, Jenny Holzer, Gwen John, Barbara Kruger, Lee Krasner, Agnes Martin, and Eva Hesse.[43]

The works acquired by Noun were often purchased at reasonable, even undervalued, prices because those artists were not in demand or held in high esteem by the mainstream art market at the time of their acquisition.[44] However, as each group or individual became fashionable, the prices of their work increased and, in some cases, became prohibitive for most collectors, Louise Noun included.

During her lifetime, Noun donated about a hundred works of art to the Des Moines Art Center, and with her death, about eighty more were bequeathed. Some pieces of her collection were also given to other art venues in the state. Thus she transformed the public art collections in the state of Iowa by including the work of women artists in their permanent collections.

What general principles of leadership can be derived from her life story? It must be acknowledged that her class status gave her the resources to be independent, and few have that advantage. Noun's experiences with injustices—sexism and antisemitism—coupled with the philanthropic culture of her religious heritage affected her outlook on life and led to her activism. For many years, she complied with the traditional conventions of behavior considered suitable for an upper-class woman at that time, limiting her life to the

domestic sphere, philanthropy, and volunteerism. Even her art collecting was an approved avenue for wealthy women to explore, as evidenced by the fact that many museums have benefited from bequests from women collectors. However, Noun did an about turn in her later life. She renounced her marriage and her volunteerism to concentrate on art collecting with a modern twist, basing her collecting practice on feminist principles—a courageous choice for a wealthy woman who could have chosen to lead a comfortable life adhering to the social conventions of her time and place.

She had some remarkable qualities that can be emulated. One was her never-ending attention to questioning the social and intellectual conventions that discriminated against all women, a quality that can be generalized and applied to various underrepresented populations. Another was her recognition of the need for evidence to combat the invisibility of the achievements and histories of women artists within the cultural mainstream. By forming her collection of work by women artists and making those works accessible to the public through donations to various museums and funding the establishment of archives to document women's achievements, she was one of the first collectors to restore women to the history of art. The accumulation of evidence and bringing it into public view with the goal to deter discrimination can also be applied to other situations.

Another important quality that Noun possessed was her willingness to make her voice heard. If she perceived injustice, she wrote to newspapers, resigned publicly from boards, and sought changes in organizational priorities. In addition, Noun joined with others when she believed acting as a group would bring more results than acting as an individual—the Des Moines Art Center Association; the ICLU, and NOW, just to name a few examples. She "was an icon, a very, very, very big fish in a fairly small pond. And as a woman, she was a giant, because she was such a prominent voice at a time when there weren't a whole lot of female voices."[45] Her life is an inspiration, and her qualities are worthy of emulation.

Notes

1. Louise Noun was interviewed by Ferris Olin in Chicago, February 12, 1992; in Des Moines, April 23–24, 1994, and May 5, 2000; and subsequently numerous times by phone until April 2002. She died on August 23, 2002; See also Ferris Olin, "Consuming Passions: Women Art Collectors and Cultural Politics in the United States, 1945–1995" (PhD diss., Rutgers University, 1998).

2. Each March, the editors of *Art and Antiques* publish their list of the top one hundred collectors in the United States. The 1992 issue included Noun on a list of more well-known collectors. Her collection was described as seventy-five to eighty "'well-loved' pieces. . . . She liked Russian art before it was popular. . . . It's a striking collection." *Art and Antiques*, "America's Top 100 Collectors," 15 (March 1992): 74.

3. Susan Ostrander, *Women of the Upper Class* (Philadelphia: Temple University Press, 1984), 113. The author describes membership in the Junior League as providing a "training ground for young women on their way up to board positions."

4. Zena Martin, "A League of Their Own? A Black History View of The Junior League," LinkedIn, February 18, 2016, https://www.linkedin.com/pulse/league-own-black-history-view-junior-zena-martin.

5. Martin.

6. In 1986, Grinnell established the Louise R. Noun Program in Women's Studies to honor her life's work.

7. Karl E. Meyer, *The Art Museum: Power, Money and Ethics* (New York: William Morrow, 1979), 42.

8. Louise Noun, *Journey to Autonomy: A Memoir* (Ames: Iowa State University Press, 1990), 10.

9. Noun, 58.

10. Noun, 58.

11. Community chests were predecessors of centralized charitable organizations. Businesses and individuals contributed to the community chest, which then distributed the funds. Today in many cities, such organizations are called the United Way. In other cities, they are called community foundations.

12. Eliel Saarinen (1873–1950) was the patriarch of a family of architects. Saarinen was born and trained in Finland. He immigrated to the United States in 1923 and became the head of Cranbrook Academy, designing its campus and also elevating the school into one of the top schools of art and design in the world. His son Eero also became a highly regarded and influential architect and was known also for the furniture he designed for the prestigious Knoll Company. The architecture and furniture created by the Saarinens are considered masterpieces of twentieth-century design. See Famous Architects, "Eliel Saarinen," http://architect.architecture.sk/eliel-saarinen-architect/eliel-saarinen-architect.php.

13. Noun, interview with Olin, February 12, 1992.

14. Noun, *Journey*, 87.

15 Noun, interview with Olin, April 23–24, 1993.

16 Noun, interview with Olin, February 12, 1992.

17 Noun, interview with Olin, February 12, 1992.

18 Noun, interview with Olin, February 12, 1992.

19 Carrie Lane Chapman Catt Girlhood Home, website of the National Nineteenth Amendment Society, Charles City, Iowa, "Carrie Chapman Catt: A Biography," http://catt.org/biography.html; and National Park Service website, "Amelia Bloomer," https://www.nps.gov/wori/learn/historyculture/amelia-bloomer.htm.

20 Throughout her lifetime, Noun financed the Democratic Party in Iowa and other organizations, and her brother had the "distinction" of being named to President Nixon's "enemies list" because he was a lifelong democratic financier. For more information on Smith, see Sidney Blumenthal, "A Doll's House," *New Yorker*, August 19, 1996, 32; and Eric Pace, "Mary L. Smith, Only Woman to Lead G.O.P., Dies at 82," *New York Times*, August 25, 1997, http://www.nytimes.com/1997/08/25/us/mary-l-smith-only-woman-to-lead-gop-dies-at-82.html.

21 University of Iowa Libraries, "History and Mission of the Iowa Women's Archives," http://www.lib.uiowa.edu/iwa/history/.

22 Frida Kahlo (1907–1954) was one of the central figures in the intellectual and artistic community of Mexico in the 1930s and 1940s. Others in the group included her husband, the painter Diego Rivera; the Surrealist artist Remedios Varo; and the Russian revolutionary Leon Trotsky. Kahlo's work consists primarily of self-portraits that portray her suffering. She was in a terrible bus accident when she was a teenager and lived the rest of her life in constant pain. Her most well-known painting shows her in her underclothes, wearing a brace for her spine. Kahlo also painted scenes of her miscarriages. She desperately wanted a child with Rivera, but her accident prevented her from coming to full term when she became pregnant. Kahlo became a cult figure in pop culture around the world and an important influence on feminist artists. See Frida Kahlo Foundation, "Frida Kahlo Biography: Childhood and Family," http://www.frida-kahlo-foundation.org/biography.html.

23 James Jenega, "Louise Rosenfield Noun, 94: Iowa Feminist, Writer, Civic Activist," *Chicago Tribune*, September 1, 2002, http://articles.chicagotribune.com/2002-09-01/news/0209010066_1_des-moines-iowa-civil-liberties-union-women-and-girls.

24 Jenega.

25 Fleur Cowles was married to Gardner Cowles, the publisher of *Look Magazine*, one of the most successful popular magazines of the 1940s–1960s. It was discontinued in 1971. Cowles was heir to a publishing empire that included the *Des Moines Register*, a daily newspaper. Fleur Cowles worked at *Look* and then founded *Flair* in 1950. *Flair* lasted only one year but is remembered for its elegance and sophistication. See Enid Nemy, "Fleur Cowles, 101, Is Dead: Friend of the Elite, and the Editor of a Magazine for Them," *New York Times*, June 8, 2008, http://www.nytimes.com/2009/06/08/business/media/08cowles.html.

26 In the history of many institutions, it is often women who have founded and given money and art in support. The Museum of Modern Art in New York, for instance, was established by Abby Aldrich Rockefeller, Lillie P. Bliss, and Mary Quinn Sullivan.

27 In 1971, Nochlin's essay "Why Are There No Great Women Artists?," arguing the point that women had been excluded from art history, first appeared in *ARTnews*, January 1971, 22–39, 67–71, and was later published in *Women, Art, and Power, and Other Essays*. See preface note 1 for more information. Eleanor Tufts (1927–1991) wrote one of the first books documenting the history of women artists—*Our Hidden Heritage: Five Centuries of Women Artists* (New York: Paddington Press, 1974).

28 Noun, interview with Olin, April 23–24, 1993.

29 The National Museum of Women in the Arts (NMWA), located in Washington, D.C., was established in 1987 through the generosity of Wilhelmina Cole Holladay, who had decided to collect women artists' work and then donated them to form the basis of the collection of NMWA: "NMWA is the only major museum in the world solely dedicated to recognizing women's creative contributions. By bringing to light remarkable women artists of the past while also promoting the best women artists working today, the museum directly addresses the gender imbalance in the presentation of art in the U.S. and abroad, thus assuring great women artists a place of honor now and into the future." See National Museum of Women in the Arts, "About," http://www.nmwa.org.

30 Michael Rosenfeld Gallery, "Marguerite Zorach (1887–1968)," http://www .michaelrosenfeldart.com/artists/marguerite-zorach-1887-1968.

31 Noun, interview with Olin, February 12, 1992.

32 Isabel Bishop (1902–1988) is a twentieth-century American realist artist. See National Museum of Women in the Arts, "Isabel Bishop 1902–1988," https:// nmwa.org/explore/artist-profiles/isabel-bishop.

33 Berthe Morisot (1841–1895) was one of only a few women associated with the French Impressionist group; others include the American artist Mary Cassatt (1844–1926) and the French artist Eva Gonzalès (1849–1893). Paula Modersohn-Becker (1876–1907) and Käthe Kollwitz (1867–1945) were German artists of the early twentieth century. Kollwitz used her art to protest social injustice. Modersohn-Becker was an innovator in Expressionism, using bold brushwork and color to give emotional intensity to her paintings. She is known particularly for a nude self-portrait, highly unusual for the period.

34 Jo-Ann Conklin, ed., *The Louise Noun Collection, Art by Women* (Iowa City: University of Iowa Museum of Art, 1990).

35 Louise Noun, "Collector's Choice," speech given in March 1990 at the University of Iowa Museum of Art.

36 Noun, interview with Olin, February 12, 1992.

37 Museums often ask to look at artists' works to consider acquiring them.

38 Noun, *Journey*, 134.

39 The Dada artists were a group who decided after World War I that since the
world was so absurd, art should reflect that absurdity rather than promote
false beauty.

40 Mary Abbe, "The Photomontages of Hannah Höch," *ARTnews* 96 (1997): 122.

41 Höch was the subject of a major exhibition, *The Photomontages of Hannah Höch*,
organized by the Walker Art Center in 1996–1997. Noun lent several objects
from her collection to this traveling show.

42 National Museum of Women in the Arts, "Gabriele Münter, 1877–1962,"
https://nmwa.org/explore/artist-profiles/gabriele-münter. Münter was
associated with early German Expressionism and was the partner of the Rus-
sian avant-garde artist Wassily Kandinsky, who was in Munich to escape the
excesses of the Bolshevik Revolution. Kandinsky returned to Russia, leaving
Münter in Munich.

43 The women artists Louise Bourgeois, Rebecca Horn, Jenny Holzer, Gwen John,
Barbara Kruger, Lee Krasner, Agnes Martin, and Eva Hesse are documented
extensively in contemporary art history books and on the internet. Bourgeois
(1911–2010) is renowned as one of the leading and highest-priced feminist
sculptors and printmakers (see Cheim and Read, "Louise Bourgeois," http://
www.cheimread.com/artists/louise-bourgeois); Horn is a German artist who is
an innovator in multimedia art; Holzer is an American artist known for her use
of words as art (see JennyHolzer.com, "Biography," http://projects.jennyholzer
.com); John (1876–1939) is now rediscovered as a predecessor of the feminist
view of women's bodies (see Tate Museum, "Gwen John, 1876–1939," http://
www.tate.org.uk/art/artists/gwen-john-1363); Kruger is a pioneer in the use of
advertising techniques in critiquing stereotypes of women (see BarbaraKruger
.com, "Biography," http://www.barbarakruger.com/biography.shtml); Krasner
(1908–1984), the wife of Jackson Pollock, is now credited with the influence
she had on Pollock, who is viewed as one of the primary artists associated with
Abstract Expressionism, and as an innovative artist in her own right (see The
Art Story, "Lee Krasner: American Painter," http://www.theartstory.org/artist
-krasner-lee.html); Martin (1912–2004) is considered one of the leading paint-
ers of Minimalism, a movement of the 1960s–1990s (see Solomon R. Guggen-
heim Foundation, "Agnes Martin," https://www.guggenheim.org/exhibition/
agnes-martin); and Hesse (1936–1970) is one of the innovators of postmodern
art (see Solomon R. Guggenheim Foundation, "Eva Hesse," https://www
.guggenheim.org/artwork/artist/Eva-Hesse).

44 Noun, interview with Olin, April 23–24, 1993.

45 Noun, interview with Olin, April 23–24, 1993. Iowa Civil Liberties Union Execu-
tive Director Ben Stone characterized her impact on Iowa in Noun's obituary.

Bibliography

Abbe, Mary. "The Photomontages of Hannah Höch." *ARTnews* 96 (1997): 122.
Art and Antiques. "America's Top 100 Collectors." 15 (March 1992): 74.

Blumenthal, Sydney. "A Doll's House." *New Yorker*, August 19, 1996.

Carrie Lane Chapman Catt Girlhood Home, website of the National Nineteenth Amendment Society, Charles City, Iowa. "Carrie Chapman Catt: A Biography." http://catt.org/biography.html.

Conklin, Jo-Anne, ed. *The Louise Noun Collection, Art by Women*. Iowa City: University of Iowa Museum of Art, 1990.

Harris, Ann Sutherland, and Linda Nochlin. *Women Artists, 1550–1950*. Los Angeles: Los Angeles County Museum of Art.

Jenega, James. "Louise Rosenfield Noun, 94: Iowa Feminist, Writer, Civic Activist." *Chicago Tribune*, September 1, 2002. http://articles.chicagotribune.com/2002-09-01/news/0209010066_1_des-moines-iowa-civil-liberties-union-women-and-girls.

Martin, Zena. "A League of Their Own? A Black History View of The Junior League." *LinkedIn*, February 18, 2016. https://www.linkedin.com/pulse/league-own-black-history-view-junior-zena-martin.

Meyer, Karl E. *The Art Museum: Power, Money and Ethics*. New York: William Morrow, 1979.

National Park Service website. "Amelia Bloomer." https://www.nps.gov/wori/learn/historyculture/amelia-bloomer.html.

Nochlin, Linda. "Why Have There Been No Great Women Artists?" *ARTnews*, January 1971.

———.*Women, Art, and Power, and Other Essays*. New York: Harper Collins, 1988.

Noun, Louise. "Collector's Choice." Speech given in March 1990 at the University of Iowa Museum of Art.

———. *Journey to Autonomy: A Memoir*. Ames: Iowa State University Press, 1990.

Olin, Ferris. "Consuming Passions: Women Art Collectors and Cultural Politics in the United States, 1945–1995." PhD diss., Rutgers University, 1998.

Ostrander, Susan. *Women of the Upper Class*. Philadelphia: Temple University Press, 1984.

Pace, Eric. "Mary L. Smith, Only Woman to Lead G.O.P., Dies at 82." *New York Times*, August 25, 1997. http://www.nytimes.com/1997/08/25/us/mary-l-smith-only-woman-to-lead-gop-dies-at-82.html.

Tufts, Eleanor. *Our Hidden Heritage: Five Centuries of Women Artists*. New York: Paddington Press, 1974.

University of Iowa Libraries. "History and Mission of the Iowa Women's Archives." http://www.lib.uiowa.edu/iwa/history/.

FIGURE 4 Samella Lewis. Reproduced by permission of Scripps College.

Samella Sanders Lewis

Making Visible the Cultural Legacy of the African Diaspora

Background

When Samella Lewis[1] was asked to think back to her childhood aspirations and describe what she wanted to be when she grew up, she answered that this question was never one she asked herself. Why? Because as an African American child brought up in New Orleans, mostly through the Depression and by a single mother, Lewis wasn't sure she would live to adulthood. During her ninety-plus years, she has been an artist, art historian, art collector, curator, publisher, filmmaker, arts administrator, entrepreneur, activist, and educator. Her pioneering efforts as a visual arts professional to promote art and artists of the African diaspora and to support the survival of her community are driven by her "concern . . . not with art as art, but with art as an instrument to change things."[2]

Samella Sanders Lewis was born in the segregated city of New Orleans in 1923 to Rachel Taylor Sanders and Samuel Sanders and raised in that city and in the neighboring areas of Jeanerette–New Iberia, her mother's place of origin, and Ponchatoula, home of her paternal relatives–both segregated black communities. Her mother was self-taught in adulthood, but her father could read and write, was an African Methodist Episcopal minister, and was self-employed. Lewis's paternal grandfather was believed to have emigrated from Jamaica and was very light skinned, though his wife was nicknamed "the African." He was a landowning strawberry farmer whose property was so extensive that it included one third of the town.

Samella Lewis was the youngest of three daughters, and when her parents divorced, Mrs. Sanders moved to New Orleans. At that time, Louisiana state law considered children to be the property of their father, but because Lewis was in frail health and was not able to contribute as a farm hand, she lived with her mother. Due to her move away from rural Louisiana, Lewis received an education and was primarily raised and influenced by her mother who earned a living as a laundress, seamstress, and domestic. Of her mother, Lewis says, "She always defended herself, not just physically. Nobody insulted her, even if she worked for them. She had dignity and I saw her act the way she did."[3]

Throughout her public school education, teachers recognized Lewis's artistic talents and encouraged her. Because of the lack of art classes in high school, Lewis enrolled in a drafting class where her teacher required his students to read Alain Locke's *Negro Art: Past and Present*. She was also able to receive free art instruction and supplies from a French Quarter gallery owner Alfredo Galli, an Italian immigrant, who befriended her.

Following high school graduation, Lewis attended two historically black colleges (HBCs). She spent her first year (1942–1943) at Dillard College in New Orleans, where historian Benjamin Quarles and artist Elizabeth Catlett[4] were on the art faculty. (Catlett remained a lifelong mentor and friend of Lewis.) It was Catlett who organized Lewis's first visit to a museum—not an easy feat, since the New Orleans Museum of Art is located in a park that was inaccessible to African Americans at that time. The professor outsmarted segregation laws by hiring a bus to transport and drop her students in front of the museum. When Lewis discovered that Dillard only had an art education major, not art-making courses, she transferred to Hampton Institute (now Hampton University), where Catlett had taken her next teaching position with her then husband, the artist Charles White.[5] Hampton was originally founded as a vocational school for blacks and later transformed itself into a liberal arts college. It provided employment for African American artists and scholars who, in turn, taught emerging scholars and practitioners. In addition, the art department curriculum

was transformed by an Austrian émigré professor, Viktor Lowenfeld, who collected African art. He encouraged his students to reference their life experiences when creating art. He also introduced his students to Hampton's well-known African art collection—the only Southern museum open to African American visitors until the late 1920s—so they could come to know their rich and varied cultural heritages as they were forming their own racial identities. In addition, he invited many artists and scholars for campus visits—for example, Zora Neale Hurston, Dinah Washington, and several of the famed contemporary Mexican mural artists. Lowenfeld and Catlett demonstrated to Lewis the healing powers of art, insisted that it is an individual's responsibility to help others, and prepared their students to deal with real-life situations they might encounter. It was Catlett who persuaded Lewis to begin collecting art while an undergraduate and encouraged her students to sell or trade art with their colleagues.

Lowenfeld also arranged for summer jobs for his students, among them Lewis and her classmate, the artist John Biggers. In the mid-1940s. Lewis received a commission to paint two four by eight foot murals to decorate the Negro Chapel at Camp Lee, Virginia. Her plans were to depict Christ as a black man. The African American camp chaplain, educated at Morehouse College, thought that white enlisted men would be insulted and rejected her design, as did the director of the army base and the president of Hampton, each pressuring Lowenfeld to force Lewis to change the figure's skin color. However, Lewis was adamant: "Under no circumstances will I change it . . . and they can't have it because they don't have enough spirituality to accept it, including the negro chaplain."[6] In the end, the two murals were hidden by Lewis's ceramics teacher, where they remained for forty years before they were rediscovered, restored, and installed in the Hampton University Museum.

After Lewis graduated from Hampton, she was hired to teach in the university's art department and also succeeded in selling more than two hundred of her own artworks. The money garnered from the sales funded her graduate studies at Ohio State University, a campus unwelcoming to black students and where she and other

African American students could not live in dormitories. While there, she found another mentor in art professor James W. Grimes, who encouraged her intellectual curiosity and art collecting, though she admitted that there were times when she had to choose between acquiring an artwork or paying her tuition. To this day, she regrets that while in graduate school, she missed out on works by Stuart Davis, Ben Shahn, and Louise Nevelson, all major artists at that time, opting instead to continue her studies. While at Ohio State, she realized that the study of Western art history was of no interest to her, and instead she arranged to take courses taught by faculty at other institutions so that she could study the interrelationships between different societies and their cultural products. In the end, she took courses about Native American, East Indian, Chinese, and African art. She was fortunate to study at Northwestern with scholar Melville J. Herskovits, the author of the landmark book *The Myth of the Negro Past*, who established the field of African and African American studies in academia.

In her dissertation, Lewis investigated the elements of African imagery, religion, and philosophy that were retained in the oral and craft traditions of rural African Americans in the bayous of Louisiana. In 1951, at a time when few women, let alone African American women, received doctorates, at the age of twenty-seven, Samella Sanders Lewis received a PhD in the dual areas of fine art and art history. In 2008, the Ohio State University Black Alumni Society inaugurated its biennial Samella Lewis Professional Achievement Award in recognition of an "African American alumnus [sic] who has achieved notable career accomplishments and made outstanding professional contributions, including professional impact, authorship of significant publications or research, and community service."[7]

By graduation, she also had married Paul Lewis, a returning World War II veteran and fellow Ohio State student (business administration and mathematics), and had given birth to their first son, Alan, who was followed in 1955 by a brother, Claude. The family moved to Baltimore, where Lewis headed the art department at Morgan State University, another HBC, and also voluntarily taught

at a segregated jail. However, the university's administration pro-
hibited her from continuing to perform this community service,
and as a result, she left to chair the art department at Florida A&M
University in Tallahassee, where she developed and headed the larg-
est art department in any Southern HBC.

In the late 1950s, disillusioned by the bigotry in Florida's aca-
demic institutions, Lewis took a position at the State University of
New York–Plattsburgh, where she taught art history and humani-
ties from 1958 to 1968 and used postdoctoral fellowships to expand
her expertise to encompass Asian art in addition to African art and
art of the African diaspora. Through the college administration's
support of its faculty, Lewis received funding to focus on the inter-
disciplinary nature of the humanities and to bring guest lecturers to
campus—among them, poet Robert Frost, folk singer Pete Seeger,
and the philosopher Susanne Langer. In addition, she traveled
internationally—for example, attending in 1967 the First Festival
of Negro People in Dakar, Senegal, where she became involved with
the international planning committee for the second festival held
in 1977 in Lagos, Nigeria; she also traveled extensively in Africa to
meet with her fellow Hampton alumni/ae.

Lewis accepted an appointment as professor of art history
at Scripps College in the Claremont Colleges system in 1969 after
a brief stint teaching in the California State University system at
Long Beach and then the Dominguez Hills campus (1966–1967). She
remained at Scripps until her retirement from academia in 1984;
at Scripps she taught in the humanities program and Black Stud-
ies Center and directed the Clark Humanities Museum, a study
museum that supplemented the curriculum with objects from
Mexico, China, Japan, Africa, the Middle East, and Native American
cultures. At one point, Lewis saved a collection of work by Native
American women that was going to be deaccessioned. Among her
students were the artist Alison Saar and Mary Nooter Roberts, later
a professor in the Department of World Arts and Cultures/Dance
at UCLA and consulting curator for African art at the Los Angeles
County Museum of Art (LACMA). In a 2014 tribute to Lewis entitled
"Vision and Legacy: African Arts at LACMA—a Tribute to Samella

Lewis," Roberts said that Lewis was a pioneer who laid the foundation for the study of African American and Caribbean scholarship and characterized her as a "remarkable trailblazer . . . giving greater visibility amidst challenging circumstances. . . . Her work was prescient [in] connecting Africa to the rest of the world—a new paradigm for African Studies."[8]

Samella Lewis's extraprofessional activities while on the Scripps faculty and afterward were extensive. With her colleague E. J. Montgomery,[9] commissioner of the San Francisco Art Commission, Lewis organized road tours to California college campuses, where they would lecture and introduce the work of artists of color, artists whose work were not part of the curriculum, and discuss racism in the art world.

She served on numerous grant and foundation panels, such as the National Endowment for the Arts (1976–1979), National Endowment for the Humanities (1983), Fulbright Fellowship Awards (1977–1980), and the American Council of Learned Societies (1977–1980), reading proposals and awarding financial support to deserving scholars and projects.

In recognition of her achievements, Lewis has received numerous awards, among them the Ohio State University Citation for Distinguished Alumni (1986), the Women's Caucus for Art Lifetime Achievement Award (1990), and honorary doctorate degrees from Hampton University and University of Cincinnati (1993). She was named one of the "Legends in Our Time" by *Essence* magazine in 1990, awarded the 1999 College Art Association Committee on Women and the Arts Annual Recognition Award, and in 2012 was given the Anyone Can Fly Foundation Award.

Lewis's juncture came at the time of the gathering storm and subsequent upheaval of the civil rights and feminist movements. She had personally experienced the exclusion of African Americans from neighborhoods, schools, and public places, but the immediate instigation was an incident at Florida A&M, which was the last straw. While at Florida A&M, in spite of the very active local Ku Klux Klan, the Lewis family participated in a bus boycott, providing transportation for African American workers to their jobs so they could avoid taking public transportation when they would have had

to sit in the back of the bus. Then Lewis designed a card for the 1956 holiday season as a fundraising tool for the National Association for the Advancement of Colored People (NAACP) with the message "Peace on Earth, Goodwill to All Men."

Her activities incited numerous intimidation actions toward the Lewis family, including KKK marches and shootings at the windows of their car and home. Lewis was subpoenaed by the Florida State Legislative Committee, which was investigating her ties to "subversive" organizations. The president of Florida A&M asked Lewis to a meeting as a pretext to deliver her the subpoena while policemen hid in his office. She was interrogated about her civil rights activities, questioned about the meaning of the wording for the holiday card, and asked why she refused to sign a Feinberg Loyalty Oath.[10] Although Lewis was exonerated, she still encountered repercussions, including denial by the university administration of permission to travel to Ethiopia on a Ford Foundation Fellowship: "When I was going to get my PhD the first thing I wanted to do was to go back and teach at black colleges. Then I found that black colleges were controlled by white bigots. . . . It was colonialist. I found that I was not suited for a black college."[11]

Resolution

Spurred by her own experience, she began to assume leadership in the struggle to extend the democratic privileges accorded to white men to African Americans and women. One of her first efforts was to found the National Conference of Negro Artists (now known as the National Conference of Artists) in 1959 to offset the exclusion of African American artists in art exhibitions across the United States through annual exhibitions and conferences.[12]

The experience at Florida A&M led to her leaving and taking the job at Plattsburgh, where Lewis found a more enlightened university administration and a city in which she would have security for her family. While living in Plattsburgh, the Lewis family continued their activism with the NAACP. However, they were the only African Americans among its one-hundred-plus members.

The Lewises realized that their sons needed to live in a more diverse community, so the family moved to Los Angeles, which was also the scene of Lewis's next intervention. While on a year's sabbatical before joining the faculty at Scripps, Lewis coordinated the LACMA education department. She had already become involved with a community group, the Black Arts Council, formed by museum personnel (guards and installers) and community members who were concerned about the lack of diversity represented on the museum's walls. They often picketed the museum. Lewis says that she chose to work in the education department because she thought she would be more likely to interact with all museum departments and thus encourage the hiring of qualified African American personnel to help change the institution; but also the community group wanted someone inside the museum to help the council transform the environment. The Black Arts Council and Lewis did not succeed. She characterizes her year at LACMA as "horrible." She introduced Jacob Lawrence and other African American artists to the curators but was consistently rebuffed; when she invited Angela Davis to lunch with her at the museum's cafe, they were greeted by stares. After finishing her day job there, Lewis could be found at night picketing her employer. She protested, for example, the museum's handling of a Cubism show that did not include or even mention African art, which was influential to the development of Cubism. The museum administration retaliated by hiring a private investigator to seek information against Lewis. Lewis was fortunate, though, that one of the museum's board members, Joseph Hirshhorn, and his daughter (who joined Lewis on the picket line) offered her a job at the museum he was building to house his art collection in Washington, DC—the Hirshhorn Museum. She turned him down, but Hirshhorn then purchased a number of Lewis's artworks, which were subsequently donated to the Palm Springs Museum, among others.

With her extensive academic credentials, Lewis was sought after by organizations like the National Endowment for the Arts to make their selection committees fulfill requirements for inclusivity. She often got into heated debates with other members of the selection committees. Hers was the "minority" opinion trying to bring the

equitable distribution of resources to projects proposed by women and people of color:

> I remember fighting at the NEA [National Endowment for the Arts] for a grant for the Los Angeles Women's Building. . . . People were simply laughing; even the director was laughing about this whole idea. . . . And there were women on the panel allowing this. I got very irate and said, 'No, you can't do this, you can't act this way, you can't be so chauvinist.' They ended up funding the entire grant, and this was the first government grant they received. I didn't go and sit quietly. . . . NEH [National Endowment for the Humanities] had turned down the Studio Museum's request for *The Turbulent 60s* twice until I got on the panel. I did the political Washington thing and struck a deal with someone else on the panel. I said, 'You know this is a disgrace. They keep turning it down for no reason because they don't know much about it. . . . I know that you guys were involved in the sixties; it was all you guys, no females on there.' I just did what I had to do to get things through.[13]

Lewis was one of a national circle of prominent feminist and African American artists and art historians who often mounted collective efforts to generate change. It would be difficult to say who was the instigator; their protests were the result of mutual planning. The fact that they were working with each other does not diminish their individual leadership but instead enhances it, revealing the success of collaborative working methods. Three incidents, one on the East Coast and two on the West Coast, are examples of their joint leadership. Lewis played a key role in each of these three incidents, which are milestones in the narrative of generating inclusivity in the arts during the 1960s and 1970s. Lewis received the Vesta Award from the Los Angeles Woman's Building for her participation in the actions to end race and gender discrimination in the creative arts in Southern California.

When the Whitney Museum's 1968 exhibition *Painting and Sculpture in America: The 1930s* excluded any reference to or work by African American artists, Lewis and many others joined the Black Emergency Cultural Coalition, spearheaded by artist Benny

Andrews,[14] to address and protest this omission. In response, the Studio Museum in Harlem quickly mounted its own exhibition: *Invisible Americans: Black Artists of the '30s*. The coalition also picketed the Whitney. That institution agreed to organize an exhibit in consultation with African American curators and artists. This action resulted in the Whitney's 1971 show *Black Artists in America*, for which Lewis advised.

Almost simultaneously in Los Angeles, LACMA installed an exhibition that caused a similar firestorm—*Art and Technology* (1970). No women were included in the show, and as a result, a new artists' group was formed to deal with issues of gender equity in museums—the Los Angeles Council of Women Artists (LACWA), founded by Joyce Kozloff, Sheila De Bretteville, Lewis, and others, with a membership at one point of more than 250. LACWA employed similar strategies to those used at the Whitney Museum. Their lobbying efforts resulted in two women's exhibitions, including the pioneering *Women Artists, 1550–1950*, the first international female artists exhibition, which laid the cornerstone of feminist art scholarship.

At the same time, Judy Chicago and Miriam Schapiro developed a new feminist art curriculum at the California Institute of the Arts that resulted in a historical exhibition entitled *Womanhouse*. Chicago and Lewis collaborated on a fundraising event, "Cookies for Dough," in support of the then newly established Los Angeles Woman's Building, on whose board Lewis served (1983–1987).

Lewis was always on the watch for racism and discrimination. Two incidents, one from the 1960s and one from the 1970s, illustrate that vigilance. In 1967, she partnered with artists Charles White and John Outterbridge to counter a critique of an exhibition by African American artists at the Brockman Gallery by the *Los Angeles Times* art critic. They accused him of having no knowledge of African American visual culture. He listened to them, returned to the exhibition, and recanted his negative review. In 1976, while visiting Elizabeth Catlett, who had moved to Mexico, Lewis and her friend caused a media frenzy when they demonstrated against a racist window advertisement for Eastern Airlines flights to Africa. The window depicted a white man sitting inside a cauldron while

pygmies fished for him. Lewis and Catlett asked to meet with the office manager but were refused. Catlett then took action by drawing a big X across the offensive picture with her lipstick. The police were called, and newspaper photographers captured the story. The offending window display was taken down and the office closed. Lewis said of this incident, "One of the things that I learned earlier in working with Elizabeth is that you don't just sit by and criticize; you get out there and try to make a difference and try to do what you can."[15]

What is strikingly in variance to these incidents is that Lewis denies that she is an activist, though all of these incidents contradict her disclaimer. Although Lewis plays down her overt protests against racism and sexism, she does believe that she has been influential and powerful "in a much quieter, more extended way. . . . I don't know that the 'mainstream' is the place for any of us to be. We know the history of the mainstream. We know what has happened; how the mainstream came about. And we know that we don't want to be part of that. We want to create our own time and place, and art. It's not just a woman's art. It's a human kind of art that speaks."[16]

Lewis's career includes another kind of activism different from overt protests against racism and sexism, instead characterized by long-term efforts directed at institutional change. These endeavors fall into two categories.

The first category, reminiscent of her initial activist achievement, the founding of the National Conference of Artists, consists of programs to increase visibility and recognition for African American artists. Recognizing the absence of commercial outlets for African American artists, she established several enterprises that nurtured artists of color by providing exhibitions spaces and markets for their work as well as educational components that introduced their art to African American audiences and the mainstream art community. Lewis and others formed the enterprise she named Contemporary Crafts, Inc., in 1968 to expand beyond the Brockman Gallery.

Funding for the project exemplifies the effectiveness of Lewis's entrepreneurship. First, she contacted the Urban League's Score Program, a service that provides would-be entrepreneurs with help

from retired professional businesspeople. Lewis received advice in capitalizing the venture. She also solicited financial assistance from the numerous friends she had made in the Chinese community through her expertise in Chinese art. In addition, she convened a board of diverse professionals and secured an interest-free loan for the not-for-profit entity.

Contemporary Crafts, Inc., included The Gallery—a storefront "poor people's gallery" where artists such as Betye Saar and Houston Conwill[17] had their first solo shows. In addition, the organization also underwrote publishing projects. With her colleagues E. J. Montgomery and Ruth Waddy,[18] Lewis created a forum for minority artists to discuss their work. The presentations at the forum events became *Black Artists on Art,* a two-volume book containing biographical information, portraits and statements by artists, and illustrations of work comprising 160 African American artists, 35 percent of whom were women. It was a contemporary who's who of black visual culture. Lewis noted that the majority of the artists were considered "unknowns" because the mainstream art world demeaned their aesthetics, labeling their work "primitive, quaint, or suspect."[19] The book was so successful that people wanted postcards with images of the artworks illustrated in the book. Encouraged by the response of the public, Lewis initiated production and distribution of slide sets and films based on the book.

In 1973, with funding from the federal government, Lewis developed community-based art education programs at the newly established cooperative Asanti Gallery and Handcraft Studios located at Scripps, specializing in prints, portfolios, cards, and reproductions of works by black artists. These enterprises worked with junior and senior high school students and offered training programs in black aesthetics and ethnic perspectives as well as arts administration and opportunities to develop careers in the arts.

Lewis came to the realization that her efforts to provide more visibility and recognition for contemporary black artists would be ephemeral unless their work was preserved for posterity through documentation and permanent public institutions such as museums. Being the activist she was (despite her disclaimer), she founded a national scholarly publication and established a museum.

In 1975, Val Spaulding (an English teacher in upstate New York) and Jan Jemison (a student) expressed to Lewis how disappointed they were with the lack of information about black artists in the various American art journals. Lewis reasoned that if they wanted this information, surely there must be others who would also like to learn about artists of color. Without much planning or experience in magazine publishing, the three women each went to their respective banks to borrow $500 and pooled their resources. After locating a printer who would work within their budget, the inaugural issue (Winter 1976) of *Black Art: An International Quarterly* appeared.

They sought additional funding to ensure that high-quality colored reproductions were included. Advertising was kept to a minimum. Claremont Colleges served as the financial administrator. Lewis designed each issue—another outlet for her creative energies. In addition to providing scholars with a forum to publish their work (and advance to academic promotion and tenure), the publications serve as an informal art gallery. Lewis also expected that people who could not afford to own original works of art would cut out the reproductions, frame them, and decorate their homes, and schoolteachers could post the "artworks" in their classrooms. In addition, as Lewis traveled to research for articles and develop curatorial projects, she also collected works from the African diaspora. Many of the shows she organized traveled internationally. Lewis also wanted to ensure that the exhibiting artists knew that they were part of a vibrant community of artists, regardless of their locations—rural, island countries, and so on. In 1992, Hampton University assumed the journal's management and operation and renamed the publication the *International Review of African American Art*.

Lewis's next step was to establish a museum for the work of black artists. Up until the period of the civil rights movement, fewer than thirty American museums focused on black culture, and most were at HBCs. Between 1950 and 1980, more than ninety museums of African American history and culture were founded in U.S. urban centers. Among these was Lewis's Museum of African American Art in Los Angeles. Its inception was catalyzed by Lewis's complaints about discrimination against African American artists to National Endowment for the Arts chairwoman Nancy Hanks during her

service on NEA juries. Hanks challenged Lewis to find a solution and gave her $15,000. In just three months, Lewis established the museum, first with temporary offices at Claremont Colleges and as a "museum without walls." She formed a not-for-profit 501(c)3 corporation (an Internal Revenue Service designation that relieves public cultural and educational institutions from paying income taxes) and appointed a board of advisors that included Maya Angelou, Elizabeth Catlett, people from the music industry, and others. Lewis also successfully sought monies from foundations and corporations such as ARCO Foundation, California Arts Council, and the Times Mirror Foundation as well as additional funding from both the National Endowment for the Arts and the National Endowment for the Humanities. By spring 1984, the museum moved into its permanent home on the third floor of the May Company (now Macy's) in what is now the Baldwin Hills Crenshaw Shopping Center, right in the middle of the Los Angeles African American community. The museum originally rented six thousand square feet for a token $1 annually and is located next to the housewares department. In a May Store publication upon the opening of the museum, Lewis stated, "If anything is going to help us from killing each other, it is art and culture. We have to validate people and culture. This is not a status museum. It is a place where people can experience other cultures (and see the similarities between them)." Lewis's vision (with the help of Mary Jane Hewitt as the director) was that the museum would also be an educational facility, and they arranged a collaboration with UCLA's Visual and Performing Arts Academy; they built a museum archive and library as well as its art collection. As ambitious as their program was, the problem of sustainability—in terms of both financial and staff resources—occurred in the late 1980s with staff turnover and lack of ongoing funding. But the museum has survived with changes in the board and with support from the community. In 2016, it celebrated its fortieth anniversary. Students take field trips to the museum, and families and teachers see it as a resource for both seeing and creating art. The museum's initiatives to learn about science, technology, engineering, art and math (STEAM) have also expanded its educational offerings.[20]

While Samella Lewis spent much of her professional career throughout the second half of the twentieth century in building institutions and developing emerging art professionals, she also tried to find time to make art. Early in her career and following Lowenfeld's advice, she represented, in a variety of media, her own and other African Americans' experiences of life in the South as well as racism. In 1997, Hampton University mounted a retrospective of her work to inaugurate their new museum.

After the 1940s, Lewis continued to collect art, sometimes trading and/or bartering with fellow artists as well as purchasing works. A visitor to the Lewis household would have been immediately struck by the sight of innumerable art objects displayed on walls, shelves, and pedestals as well as in storage in closets and drawers and under beds, with many more in storage elsewhere. Her pursuit of objects by artists of African descent was both an academic and a political one, and she calls collecting her "nourishment."[21] Her collection includes a virtual who's who of African American art history (Elizabeth Catlett, Romare Bearden, Jacob Lawrence, Betye Saar), works by "outsider" artists (Clementine Hunter and David Butler), and artists from Latin and South America. To summarize her career is not easy. Lewis was the first (African) American to receive a dual PhD in art and art history (Ohio State University, 1951). She is a practicing artist whose subject matter has always reflected her experiences as a woman of color. She taught both at historically black colleges and at the Claremont Colleges in California. Her scholarly publications have become the standard texts for survey courses on African American art. She produced slide sets, prints, and films and founded, edited, and published the first scholarly journal of art that documents the artists of the African diaspora. As an art dealer, curator, museum educator, and museum founder, she made visible the cultural legacy of the African diaspora by bringing contemporary artists from the United States and abroad to local, regional, national, and international attention. Works from her art collection, primarily from the African diaspora but also from Native American cultures and China, have been loaned and/ or donated to many museums, and her extensive research archives

are now housed at Hampton University while her personal papers now enhance the African American Collection at Emory University Rose Library. Under her leadership, she employed a range of interventions from which to independently and creatively push for social transformation in the visual arts.

Lewis's successes were derived from her own position as an outsider within the art establishment and American society. Her lifelong struggle against discrimination, her challenge of the mainstream, her concern for others, her collective approach in developing networks, and her self-confidence fueled the many paths she took as a change agent and leader. In an *Essence* magazine interview, she talked about the nurturing that black women give: "We nurture our families by seriously listening to and seriously considering what they tell us. We also have an obligation to see that valuing and collecting our art is a significant aspect of nurturing. We must familiarize ourselves with our historical and contemporary art in order to understand and know ourselves."[22]

Unlike the isolated, genius (white) male artist who has been celebrated throughout Western art history, Samella Lewis provides a positive prototype as a leader reaching out to her communities and beyond the confines of her studio.

Notes

1 Brodsky and Olin interviewed Samella Lewis on August 26, 2015. Previously, Olin had conducted extensive interviews with Lewis in 1993. Lewis was one of the women collectors documented in Olin's PhD dissertation, "Consuming Passions: Women Art Collectors and Cultural Politics in the United States, 1945–1995" (PhD diss., Rutgers University, 1998).
2 Philip E. Bishop, "Samella Lewis Exhibit Confers Status to Hurston Museum," *Orlando Sentinel*, October 28, 1998, http://articles.orlandosentinel.com/1998-10-28/lifestyle/9810270445_1_hurston-zora-neale-samella-lewis.
3 Samella Lewis, in conversation with Ferris Olin, October 3, 1993.
4 Elizabeth Catlett (1915–2012) has long been recognized as a major American sculptor and printmaker, even when African American artists were generally discriminated against. For more information on Catlett, see her website, http://www.elizabethcatlett.net.
5 Charles White (1918–1979) was another important African American painter and printmaker. See Michael Rosenfeld Gallery, http://www.michaelrosenfeldart.com/artists/charles-white-1918-1979.
6 Lewis, in conversation with Olin, October 3, 1993.

7 Ohio State University Black Alumni Society, "Samella Lewis Professional Achievement Award," http://www.osuaaasociety.org/content.aspx?page_id=22&club_id=883426&module_id=155539.

8 See Mary (Polly) Nooter Roberts, "Vision and Legacy: African Arts at LACMA—a Tribute to Samella Lewis," Scripps College Events, http://www.scrippscollege.edu/events/noon-academy/mary-polly-nooter-roberts-81.

9 E. J. Montgomery (Evangeline), artist and administrator, was a remarkable person in her own right. Like Lewis, she often was called on to represent the African American cultural community. Montgomery eventually became a member of the United States State Department staff and concluded her career as a program development officer for the Arts America program, specializing in American exhibitions touring abroad. See the December 13, 2004, interview with Montgomery on the History Makers website: http://www.thehistorymakers.com/biography/evangeline-montgomery-40.

10 The Feinberg Loyalty Oath, initiated under President Truman's administration and during the Red Scare, required loyalty oaths signed by all teachers, especially those suspected of subversive activities. In 1967, the Supreme Court struck down this requirement.

11 Lewis, in conversation with Olin, June 5–6, 1993.

12 The National Conference of Artists (NCA) was established on March 28 and 29 in conjunction with the Atlanta University's Eighteenth Annual Art Exhibition. The records of the NCA are located at the Amistad Research Center. Chapters of the NCA are active in several states including Michigan, Louisiana, and New York.

13 Lewis, in conversation with Olin, June 5–6, 1993.

14 Benny Andrews (1930–2006) became the head of the National Endowment for the Arts, the first and only African American as well as the only visual artist to be appointed to that position. See "Benny Andrews Estate" website, http://www.bennyandrews.com.

15 Lewis, in conversation with Olin, June 5–6, 1993.

16 Lewis, in conversation with Olin, June 5–6 1993.

17 Betye Saar is one of the most important African American artists. In her work, she explores the stereotypes around African American culture. For further information, see her website: http://www.betyesaar.net. Houston Conwill (1947–2016) was a highly regarded sculptor. See Sam Roberts, "Houston Conwill, Whose Sculpture Celebrated Black Culture, Dies at 69," New York Times, November 20, 2016.

18 Ruth Waddy (1909–2003) was another of the founders of the Black Arts movement in California, along with E. J. Montgomery and Lewis. See the Museum of Nebraska Art website for her biography: https://mona.unk.edu/collection/waddy.shtml.

19 Samella S. Lewis and Ruth Waddy, Black Artists on Art (Los Angeles: Contemporary Crafts, 1969), 1:iv.

20 "Museum of African American Art to Celebrate 40 Years of Cultural Excellence in the Community," Los Angeles Sentinel, February 23, 2016, https://lasentinel

.net/museum-of-african-american-art-to-celebrate-40-years-of-cultural
-excellence-in-the-community.html.

21 Lewis, in conversation with Olin, June 5–6, 1993.
22 Elsie B. Washington and Marilyn Milloy, "Listening to Our Elders' Souls,"
 Essence 27 (July 1996): 68.

Bibliography

Bishop, Philip E. "Samella Lewis Exhibit Confers Status to Hurston Museum."
 Orlando Sentinel, October 28, 1998. http://articles.orlandosentinel.com/1998-10
 -28/lifestyle/9810270445_1_hurston-zora-neale-samella-lewis.

Brodsky, Judith K., and Ferris Olin. Interview with Samella Lewis on August 26,
 2015.

Lewis, Samella S., and Ruth Waddy. *Black Artists on Art*. Los Angeles: Contemporary
 Crafts, 1969.

Los Angeles Sentinel. "Museum of African American Art to Celebrate 40 Years of
 Cultural Excellence in the Community." February 23, 2016. https://lasentinel
 .net/museum-of-african-american-art-to-celebrate-40-years-of-cultural
 -excellence-in-the-community.html.

Mendelsohn, Meredith, and Tess Thackara. "How Advocates of African American
 Art Are Advancing Racial Equality of the Art World." *Artsy*, January 12, 2016.
 https://www.artsy.net/article/artsy-editorial-in-black-artists-pursuit-of
 -equality-these-17-art-world-leaders-are-changing-the-game.

Ohio State University Black Alumni Society. "Samella Lewis Professional Achieve-
 ment Award." http://www.osuaaasociety.org/content.aspx?page_id=22&club_id
 =883426&module_id=155539.

Olin, Ferris. "Consuming Passions: Women Art Collectors and Cultural Politics in
 the United States, 1945–1995." PhD diss., Rutgers University, 1998.

Washington, Elsie B., and Marilyn Milloy. "Listening to Our Elders' Souls." *Essence*
 27 (July 1996): 68.

FIGURE 5 Left to right: Gayle Austin, feminist drama critic and playwright; Kathleen Chalfant, actor and activist; and Julia Miles (seated) in the Women's Project office. Photograph by Martha Holmes. Reproduced by permission of Anne Holmes Waxman representing the Estate of Martha Holmes. Photograph courtesy of Women's Project Theater.

Julia Miles

Women's Project Theater: Forty Years of Making the Case for Inclusivity in the Professional Theater World

Background

Julia Miles[1] played a key role in raising the status of women play-wrights, directors, and producers by initiating the effort to bring gender parity to American theater. In 1978, Miles established Women's Project Theater with the mission to present plays written and directed by women. She received $80,000 from the Ford Foundation to open the Women's Project at the American Place Theatre (APT), where she was associate director. Women's Project Theater (WPT), as it later became known,[2] became independent in 1988,[3] and by the middle of the second decade of the twenty-first century,[4] it had produced more than six hundred fully developed plays and experimental projects.

Before the women's movement of the 1960s and 1970s, women in the arts were not taken seriously. Plays by women were not considered critically or economically viable.[5] It's not that there weren't women playwrights. As Miles remarks, "Once we got the word out that there was a place—a home—for women playwrights . . . we began to get five and six hundred scripts."[6]

Julia Miles was born in the tiny town of Pelham, Georgia, the daughter of John Cornelius and Sara Hinson, who were farm-ers. According to her daughter, Marya Cohn, a writer and director known for her film *The Girl in the Book*, which was released in 2015,[7] Miles found Pelham and her life as a child limited in terms of cultural attractions.

Although she had no opportunity to see any live theater, she did see films regularly. In those days, every town had its own movie theater, often with double bills. These ubiquitous entertainment emporiums have disappeared in the face of newer technologies that have made small-town theaters obsolete. But at the time of Miles's childhood, they were the settings for learning about the larger world and dreaming of escape from everyday humdrum life. The movies were Miles's escape. In an interview conducted by her friend Billie Allen, Miles revealed that her first ambition was to be a movie star.[8]

Although the young Miles had no contact with live performances, she did hear stories about the theater. Aunt Grace, her father's sister, had gone to New York to be a showgirl or dancer. Cohn speculates that it might have been Aunt Grace who instigated Miles's desire to become a member of the theater world through telling her niece anecdotes about her own experiences.[9] The first play Miles saw was *Oklahoma*—at the time, a revolutionary production in which the songs and choreography were integrated into a continuous story-line for the first time in a musical. It was the initial collaboration of Oscar Hammerstein and Richard Rogers, who went on to write such critical and popular successes as *Carousel*, *South Pacific*, and *The King and I*. Miles recounted that as a result of the experience, she wanted nothing else but to be involved in the theater.[10]

Miles did escape Pelham when she was sent, at fourteen years old, to the Bernau Academy, the oldest boarding school for girls in Georgia. Her experience at prep school is unknown, but from there she went to Northwestern University in Evanston, just out-side of Chicago, where she majored in theater. She might have become aware of gender issues while at Northwestern because there were few women in the department. In 1949, at age nineteen, she received her undergraduate degree.

She married a fellow Northwestern student, William Miles, in 1950. She and her husband went to New York to become actors. Like all aspiring actors, she and her husband had little money. After they had two children, he took a job in a New York advertising agency to support the family. They lived in Stuyvesant Village, a set of rent-controlled apartment buildings in New York City, and sent the children to Georgia in the summertime.[11]

Miles was a traditional wife and mother during the 1950s, a period when social conventions made it difficult for middle-class white women to take on careers outside the home. Yet she persisted in her theatrical interests. She started taking classes at Lee Strasberg's Actors Studio. Strasberg was a drama coach whose student roster included future stars like Marilyn Monroe, Paul Newman, Robert DeNiro, and Jane Fonda. Strasberg is identified with "method acting," the technique in which actors perform as if they are actually the characters rather than merely portraying them.[12] Throughout the 1950s, Miles auditioned for television roles and played the role of a nurse on a soap opera.

Miles's first marriage ended in 1958. She met her second husband, Sam Cohn, when they were coproducing Arnold Weinstein's play *Red Eye of Love* at St. Ann's Church, Brooklyn, where Miles was one of the founders of the off-off-Broadway theater program that eventually became St. Ann's Warehouse, a major venue for experimental and innovative theater.[13] When Julia Miles met Cohn, he was already an entertainment-world personality, but not yet on the level he reached in the 1970s and 1980s. He is considered the first superagent. In the 1970s and 1980s, he represented the most well-known stars of stage and screen, including Paul Newman, Meryl Streep, Woody Allen, and playwright Arthur Miller, the author of such classic plays as *Death of a Salesman*.[14]

In 1964, Miles joined APT, which had been established the previous year. APT's first venue was St. Clement's Church in Manhattan. Like St. Ann's, APT focused on producing innovative plays by new playwrights. Miles started as an assistant manager and quickly rose to become an associate director. APT became highly respected within a very short time.[15]

Miles began to take notice of how few women there were in writing, directing, and production in New York. She wanted to correct that situation by exposing audiences to productions that were excellent in their own right, written and directed by women. APT had played an important role during the 1960s in introducing African American playwrights into mainstream theater, so Miles found a receptive atmosphere in which to establish the Women's Project to provide visibility for another group of underrepresented artists.[16]

In the first season of the Women's Project, Miles mounted twenty readings and four studio productions, all by women playwrights and directed by women. Readings were followed by lively discussions moderated by Miles with participation between the playwrights and audience. The atmosphere was warmly casual, and coffee was always served. These events exuded a special energy that carried Miles forward to continue her work.

Miles ran WPT within APT for a decade, typically producing three plays each season. WPT began to attract attention and receive critical praise as it mounted plays by such talented women as Penelope Gilliatt, later a famous screenwriter (*Sunday, Bloody Sunday*) and critic, and the play *Signs of Life* by the redoubtable Joan Schenkar, which has had more than five hundred productions worldwide. Paula Cizmar's first off-Broadway play, *Death of a Miner*, was produced in the 1981–1982 season, starring Sarah Jessica Parker and Mary McDonnell, and it earned Cizmar a National Endowment for the Arts grant and a Susan Smith Blackburn Prize Special Commendation.

But the work that helped propel WPT toward broader audiences was the critically acclaimed *A . . . My Name Is Alice*, a musical revue compiled by film director Joan Micklin Silver and theater director Julianne Boyd, an active artistic member of WPT, who became artistic director of the Barrington Stage Company. The revue later ran at Village Gate for more than three hundred performances and has been produced in countless theaters across the United States.

However, the success of WPT resulted in tension between Miles and APT's management. WPT was paying rent to APT, and the two organizations were raising funds separately. When Miles's production of the play *Abingdon Square* received enthusiastic critical attention, APT wanted to claim the glory, but Miles had chosen the play and developed the team, and she felt that WPT should have the credit.[17] She decided it was time to establish WPT as an independent institution.

Resolution

Thanks to a million-dollar grant from the writer and philanthropist Sallie Bingham, two of whose plays Miles had produced,[18] Miles was able to found WPT. Because Miles was so highly respected, WPT continued to be successful in attracting financial support after the split. The Ford Foundation, having helped sustain WPT during its initial phase at APT, assured Miles that funding would continue. Miles's risk was paying off: women were becoming integrated into mainstream theater. The *New York Times* theater critic Mel Gussow wrote a long article about the transformation in the *New York Times Magazine*:

> The increase in the number of women playwrights is part of a larger pattern in which women are assuming roles of authority and creativity in all aspects of the theater. . . .
>
> This year, the John Solomon Guggenheim Memorial Foundation gave three of its five playwriting awards to women: Mary Gallagher, Emily Mann and Wendy Wasserstein [Emily Mann's play *Still Life* was produced by the WPT in the 1980–81 season, and Wendy Wasserstein was honored by WPT in 1989 and served on the WPT board]. . . . Since 1978, for example, the APT has had an ongoing Women's Project under the direction of Julia Miles. According to Miss Miles, when the project began, only about 100 plays by women were submitted annually to the American Place. Now she receives 500 a year.[19]

Despite the backlash against feminism in the 1980s, through her drive and persistence, Miles maintained WPT with offices on Forty-Second Street and productions mounted at the Apple Core Theater in Chelsea (later to become the home of Atlantic Stage Company). While at the Apple Core, Miles produced Marlane Meyer's *Etta Jenks* with the Los Angeles Theatre Center to great success. This was the start of a close and productive relationship with Meyer. Also, in the 1990s, she mounted *Black*, a play by the esteemed writer Joyce Carol Oates, continuing her longtime interest in encouraging women

like Penelope Gilliatt, who usually wrote in nondramatic genres, to try theater.

Part of her economic solution that also reflected her ambition to promote women of color involved sharing production costs by coproducing with theaters such as the well-known African American company New Federal Theatre and the Latino company INTAR. At the Actors Studio, Miles had met the African American actress and director Billie Allen. Allen liked to tell everyone that she and Miles were the only two members of the Actors Studio who were mothers. The fact that Miles had been raised in the South did not prevent her from establishing a friendship with Allen. They became best friends and remained close to each other for the rest of their lives.[20]

Miles was instrumental in opening the theater world to women of color. Cassandra Medley, whose play *Ma Rose* was produced during WPT's 1988–1989 season, has had her plays produced nationwide.[21] Bridget Wimberley's well-known play *Saint Lucy's Eyes* had its world premiere at WPT in 2001; it was directed by Billie Allen herself and starred the iconic African American actress Ruby Dee. *Saint Lucy's Eyes* moved on to the Cherry Lane Theater that same year and has been produced by regional repertory theaters in St. Louis, Atlanta, and Cleveland. Wimberley's later output includes *Charlie Parker's Yardbird*, which was performed at the landmark Apollo Theater in Harlem in 2016.[22] Cheryl C. Davis, an alumna of the WPT Playwrights' Lab, subsequently wrote the book and lyrics for the musical *Bridges*, interweaving stories of blacks marching for voting rights and activists seeking same-sex marriage rights.[23] The celebrated playwright and fiction writer Kathleen Collins, now deceased, also got her start when WPT produced her play *The Brothers* in 1981–1982. A never-before-released collection of her short fiction, *Whatever Happened to Interracial Love?*, was published in 2016 to critical acclaim. In addition, Miles produced plays by Cuban-Argentine-Spanish-Croatian Caridad Svich; Shanghai-born Kitty Chen's first play, *Eating Chicken Feet*; and several plays by Carmen Rivera, whose Obie-winning play *La Gringa* was the longest-running Spanish-language play in off-Broadway history as of 2017.

Plays by the renowned Cuban American playwright Irene Fornés were mounted by WPT starting in 1987–1988. The first of those plays was *Abingdon Square*, described earlier in this case study as an important critical success. Other plays by Fornés were later produced in the 1996–1997 and the 1997–1998 seasons. Emily Mann, who became the esteemed longtime artistic director of McCarter Repertory Theater, Princeton, had early visibility in her career through WPT. *Ladies* by Eve Ensler, who is famous for her later play *The Vagina Monologues* (1996), was produced by WPT in the 1988–1989 season.[24] Broadway and off-Broadway playwright-performer Anna Deavere Smith's first play, *Aye, Aye, Aye I'm Integrated*, was also first produced at WPT in the 1980s.[25]

In the mid-1990s, Miles concluded that it was necessary for WPT to acquire its own venue in order to thrive. Since separating from APT, WPT had been nomadic, with plays mounted in various theaters. Miles felt, as she said, "like a gypsy, ever on the move for a new tent in which to mount a play."[26] The twentieth anniversary of WPT was coming up in 1998. Miles was planning how to celebrate that anniversary, and moving into a permanent location could be a high point of the celebration. For several years, she worked on a collaboration with the Sixty-Third Street YWCA, producing events such as readings and even a satirical revue with the expectation that it would result in a theater space in the YWCA's building that would be dedicated to WPT. She was helped by board president Pat Schoenfeld, but the deal came apart when the national board of the YWCA would not approve it. Finally, she discovered a theater for sale off Ninth Avenue at the edge of the theater district. It was a church that had become a theater. Miles undertook a campaign to buy the building and made a down payment in 1998 with a combination of funds from the city of New York and her previous benefactor Sallie Bingham. Tina Chen, one of the board members, found relatively inexpensive offices in a building where a developer needed a not-for-profit organization to occupy space in order to receive certain benefits from the city.

During the years between the acquisition of WPT's own theater in 1998 and Miles's retirement in 2002 (it was named the Julia

Miles Theater in 2004 in honor of Miles after her retirement), WPT flourished as the first and only theater devoted to mounting the work of women theater professionals. Miles maintained high standards, and WPT's productions at its own theater were often praised by theater critics in the mainstream press, thus fulfilling one of Miles's goals: she insisted that WPT's plays be judged by the same standards applied to professional theater in general. Among some of the important productions during the period between acquiring the theater and Miles's retirement were Julie Hébert's *The Knee Desired the Dirt* in 1998–1999 and Darrah Cloud's *O Pioneers!* in 2000–2001. In addition to her career in live theater, for which she has received many awards, Hébert became a major television writer, director, and producer—the executive producer of the series *American Crime* and a director for episodes of *ER*, *The Good Wife*, and *West Wing*, among many others. Cloud has won numerous awards. She has had more than ten movies-of-the-week produced on CBS and NBC. In the 1998–1999 season, Karen Hartman's *Gum* was produced. Hartman's plays have subsequently been performed in New York at the National Asian American Theatre Company, P73, and Summer Play Festival and at regional theaters, including Cincinnati Playhouse, Dallas Theater Center, the Magic, and elsewhere.

However, the perpetual cycle of fundraising, the work involved in attracting audiences, and the constant need for renovations to the building began to catch up with Miles—she was in her seventies. She decided to retire in 2001–2002, but she did not make any provisions for succession. Many not-for-profit organizations experience difficulties when the founder leaves and the organization is left to plan succession. At the request of a member of the board, her daughter, Marya Cohn, who was a former lab member of WPT, took over briefly in order to maintain the organization while planning took place. Two subsequent directors, Loretta Greco and Julie Crosby, along with the board struggled for a few years to work out sustainability issues, including the management of the theater, which was finally sold in 2011.

Eventually, Lisa McNulty, who had worked at WPT earlier as literary manager under Miles and briefly as an associate artistic director with Loretta Greco and thus knew the organization well, was hired

as artistic director. After leaving WPT, McNulty had spent eight seasons at the Manhattan Theatre Club, where she had worked on more than thirty productions. With an experienced artistic director like McNulty, WPT steadied its course and continues to produce plays by women playwrights and support emerging playwrights and directors through its labs.[27]

What were the strategies that made Miles an effective leader? She created an organization that became a driving force in the theater world by the force of her will, steely intelligence, and commitment to the women she produced. Thanks to Miles and the persistent existence of WPT, discussion of how to pursue parity in the theater world became an issue and continues, reminding everyone of the importance and excellence of women playwrights, directors, and producers.

One of her most effective strategies was to avoid pigeon-holing women to address particular audiences. She believed that women playwrights or productions by women did not have to address gender issues, whereas most of the women's theater companies established in the same period were structured as collectives by women who wanted to produce plays that addressed the issues of specific communities of women—gay women, working-class women, battered women whom theater, and American society, had ignored. In New York City alone there arose It's All Right to Be Woman Theatre, the Women's Experimental Theatre (WET), New Cycle Theater, New Feminist Theatre, Womanrite Theatre, Westbeth Playwrights' Feminist Collective, Spiderwoman, Women's Interart Theatre, and Split Britches, among others. But most did not last very long. The fact that the Women's Project survived despite the fall-off of other organizations that were trying to accomplish the same goal was due to Miles's insistence that women playwrights compete at the same level as men and that productions be determined by the strength of the works themselves rather than by ideology.

Another strategy was her flexibility in meeting challenges at various stages of organizational development. According to Suzanne Bennett, a close colleague of Miles who has directed plays for WPT, managed the Directors Forum for more than a decade, and collaborated as editor on some of the anthologies (to name only a few of

the roles she played in WPT), Miles was successful in conception; in rallying support not just among artists but also, importantly, among funders; and in initially asserting a separate identity from APT. Then Miles had to shift gears to maintain and sustain the organization over a period of time.[28]

One of Miles's great strengths was her persuasiveness. Bennett says that her strong beliefs in what she was doing were very convincing. She remarks that in working with Miles, "you felt that you were working on something important, in an historic sense."[29] Miles was "a tough cookie," says her daughter. "But she could also be collaborative." Cohn says that if Miles would give advice to young women today, it would be to urge them not to let anything stand in their way.[30] That determination and, at the same time, an ability to work with others were strong elements in Miles's success.

What is her legacy? Julia Miles brought attention to discrimination against women in mainstream theater and provided a venue that has created visibility for women playwrights, producers, directors, and actors for decades. Some of the most critically acclaimed writers and directors in the four decades since 1978 have been women. Miles gave them their start. As her daughter states, "There are all the women that she helped . . . hundreds."[31]

It would be too much to list everyone who worked at or was involved in one of WPT's programs, but naming a few more will give a sense of the role WPT has played in promoting gender inclusivity on and off Broadway and throughout the country. Liz Diamond, who directed three plays at WPT in 1985–1986, 1991–1992, and 2007–2008, became a professor at Yale School of Drama, chair of the directing department, and resident director of Yale Repertory Theater. Carey Perloff is the director of the American Conservatory Theater, San Francisco. Lisa Peterson is a two-time Obie Award–winning writer and director who has directed productions all over the country. Liz Duffy Adams's play *Or* premiered at WPT (2009) and has been produced some fifty times since, including at the Magic Theater and Seattle Rep. She has received a Women of Achievement Award, Lillian Hellman Award, and New York Foundation for the Arts Fellowship, among other honors. Melanie Joseph, who headed up the Directors Forum for several years, is the artistic

producer and founder of the Foundry Theatre in New York City. She has collaborated on the creation of eighteen Foundry premieres that have collectively been awarded twelve Obies and seven Drama Desk nominations for Unique Theatrical Experience.[32]

One of the ways in which Miles encouraged and provided training for neophyte women playwrights and directors was to establish a mentoring arm of WPT in 1994. There were two separate programs: the Playwrights' Lab and the Directors Forum. The participants received leadership, entrepreneurial, and networking training. The program culminated in productions open to the public. By creating the lab and the forum, Miles ensured a permanent flow of women professionals into the theater world. Directors Forum alumna Pam MacKinnon went on to become an acclaimed Broadway director who received the Tony Award for best direction in 2013 for the revival of *Who's Afraid of Virginia Woolf*. Dana Leslie Goldstein is an award-winning playwright and lyricist whose musical *Liberty* ran off-Broadway; the original cast recording was released by Broadway records.[33] Other active playwrights from labs and former productions include Cynthia Cooper, Julie Jensen, Carol Mack, Claire Chafee, Heather McDonald, Migdalia Cruz, Andrea Lepcio, and Terry Galloway.

While Miles was primarily interested in promoting women playwrights and directors, as a former actress, she also had a keen casting eye and recognized talent. Thus actresses also benefitted from her efforts. Among them are the very successful Kathleen Chalfant, Mary McDonnell, Deidre O'Connell, and Joan MacIntosh, who have received many awards and have appeared in many stage productions, films, and television series over the decades. There were many other important actors and actresses over the years, such as Linda Hunt, Jimmy Smits, Frances Sternhagan, Kim Hunter, Jayne Atkinson, Mia Katigbak, and Rocco Sisto, to mention just a few of the most distinguished.

It has been proved many times that without documentation, the history of women's contributions becomes invisible. In addition to WPT's productions, Miles's legacy also rests on how she furthered recognition for women playwrights by publishing anthologies of plays by women.[34] Miles published eleven anthologies during her

tenure at WPT. *The Women's Project: Seven New Plays by Women* was published in 1980, only two years after the founding of WPT. Various publishing companies that specialized in publishing play scripts issued subsequent anthologies, such as *The Women's Project 2* (1984); *Playwriting Women* (1993); *Here to Stay: Five Plays from the Women's Project* (2000); *Women's Project and Productions: Rowing to America and Sixteen Other Short Plays* (2002); and *A Theatre for Women's Voices: Plays and History from the Women's Project at 25* (2003). These anthologies enabled regional theaters to have access to plays by women and resulted in many productions across the nation. They also provided texts of plays by women for the theater courses taught throughout the country.

Another innovative program was the education project "Ten Centuries of Women Playwrights," initiated in the mid-1990s and later expanded under the directorship of Fran Tarr. Miles was aware of the importance of providing models of female achievement for young women to aspire to careers and for future theatergoers to be aware of gender parity. This program introduced high school students in New York City public schools to plays by women and the history of women in the theater. Supported by foundations and individuals, the program grew from the participation of two schools in 1995 to eighty schools by 2008. By 2008, Tarr was assisted by a staff of twenty-five teaching artists, thus not only introducing plays by women to teenagers but also providing employment for theater professionals.[35]

Miles's long-term legacy also comes from the fact that her mission has been and continues to be carried out by subsequent generations. Some of the undertakings consist of data collection and analysis. By the 1990s, WPT began making a regular count of the numbers of plays written and directed by women nationally from the *American Theatre Magazine*'s listing of productions. They were the only organization keeping a regular accounting. In 1978, only 7 percent of plays produced in the United States were by women playwrights.[36] In 2002, Miles's colleague Suzanne Bennett (with Susan Jonas) did a data and interpretation study for the New York State Council on the Arts. Their highly respected study, which became a model for subsequent studies, showed that 17 percent

of plays in the 2001–2002 season were written by women. Their analysis explored the various reasons for the lack of recognition for women professionals in the theater world.[37] Cohn declares, "She [Miles] nudged the numbers [upward] and would be horrified at how little [subsequent] progress has been made."

But change is occurring, only slowly. Many individuals and organizations have been updating their information. Gwydion Suilebhan, a playwright in Washington, DC, "discovered that 26 percent of works were by women in the 2013–2014 D.C. season; the Los Angeles Female Playwright Initiative found that 20 percent of productions in L.A. from 2002 to 2010 were authored or co-authored by women; [and] the Chicago Gender Equity Report disclosed that 19 percent of productions in 2009 were solely authored by a woman."

In 2015, the Lilly Awards organization, along with the Dramatists Guild of America, decided to consolidate the regional reports to arrive at a national picture. Approximately twenty regional representatives assisted with the counting.[38] The first report in 2015 sampled 2,508 productions in American theaters from 2011 to 2014.[39] Overall, the number of plays by women had risen to 22 percent. Another study was undertaken by the Theatre Communications Group (TCG): "The TCG surveyed the 2013–2014 and 2014–2015 seasons of its member theaters and corroborated the Lilly Awards/ Dramatists Guild report with its unofficial counting, which also showed that female playwrights accounted for 22 percent of productions in 2013–2014 and 24 percent (including adaptations and coauthorship) in the 2014–2015 season."[40] The League of Professional Theatre Women, an organization that Miles helped found[41] and of which she was the first chair, conducted a study called "Women Hired Off-Broadway 2010–14" to look at women hired in offstage roles at twenty-two off-Broadway theaters over four seasons. For 2013–2014, 28 percent of productions were female authored, according to the study.[42]

In 2009, Jonas (Bennett's coauthor in the study of women in theater), Julie Crosby, and Melody Brooks, artistic director of New Perspectives Theatre Company, founded "50/50 in 2020," a grassroots movement to gain employment parity for women theater professionals by the one hundredth anniversary of American suffrage

in 2020. The organization is allied with the League of Professional Theatre Women and other organizations supporting women theater professionals.[43] Another group, The Kilroys, based in Los Angeles, has declared, "[We] are done talking about gender parity and are taking action. We mobilize others in our field and leverage our own power to support one another."[44]

Julia Miles initiated galas to achieve visibility and recognition for women's achievements. She included women from various fields as well as the theater among the recipients of the awards. Honorees in the 1980s included theater luminaries such as Lucille Lortel, Irene Fornés, Jessica Tandy, and Wendy Wasserstein, as well as such notable women as Betty Friedan, Toni Morrison, Gloria Steinem, and Billie Jean King. Following in Miles's footsteps, in 2010, playwrights Julia Jordan, Marsha Norman, and Theresa Rebeck banded together to create The Lillys, awards recognizing women playwrights. Echoing Miles, they declared that they established the awards in the belief that recognizing plays by women would encourage the production of those plays in regional theaters.

Miles also organized conferences focusing on the issue of gender bias. One example was the Ford Foundation–sponsored *Women in Theater: Mapping the Sources of Power*, a conference celebrating the twentieth anniversary of the Women's Project in 1998, which was cocurated by Bennett. It focused on such topics as "Where Is the Power in the Same Gender/Ethnic Theater?" Five hundred participants attended the conference, held at the New School, and *American Theatre Magazine*, the national publication for nonprofit theaters, published the proceedings of the conference.

Others have picked up on that idea and have continued to hold such conferences. In 2014, a meeting titled *The Summit* was organized by women artistic directors in Washington, DC. The issues that Miles had identified were still the topics of discussion.[45] The first was the necessity of consciously balancing the season's schedule to include women in all aspects of productions—as playwrights, producers, and directors.[46] Presenters talked about the fact that women make up the largest proportion of theater audiences. Sixty-eight percent of the Broadway audience is female, but there was not a single new play by a woman on Broadway in the 2013–2014 season.

In addition, the Pulitzer Prize and all finalist nods went to men.[47] Panelists also echoed Miles's belief that the concentration should be on increasing the number of women professionals in all areas of the theater rather than on ideological content.[48] Another issue revolved around making it easier for women to take up careers in the theater. Again, the continuing discourse echoes Miles's declarations. If aspiring female playwrights don't see plays by women being produced, they are going to be less likely to continue to write.[49]

In the second decade of the twenty-first century, academic institutions have also followed Miles's lead in questioning the lack of women's leadership in the theater: "Wellesley Centers for Women in cooperation with the American Conservatory Theater (ACT) launched the Women's Leadership Project designed to study such questions as: Why are there so few women in leadership positions at resident theatres, and what can be done to address it? Being a decisive leader and being strong and being clear are things that are seen as assets in a male leader, but seen as being bitchy and domineering in a female leader."[50]

Julia Miles had the vision to initiate the struggle to bring gender parity to the theater world. What distinguishes WPT in that endeavor is its longevity and impact. In 2015, thirty-seven years after Miles founded Women's Project Theater, WPT was going strong and continuing to promote the work of women playwrights, directors, and producers. In that year, for instance, WPT's main stage production of a work that had originated in the Playwrights' Lab—*Dear Elizabeth* by Sarah Ruhl, a recipient of a MacArthur Fellowship—received widespread, glowing reviews. The ups and downs of the status of women in theater over the decades since the 1970s show that permanent change does not happen overnight. Miles initiated the fight, and her efforts inspired others to continue the work. Did Julia Miles consider herself a feminist? Suzanne Bennett says that Miles definitely considered herself a feminist, but she didn't want to identify the Women's Project as feminist theater. She wanted women playwrights to compete in the same arena as their male counterparts. She wasn't interested in didactic or issue-oriented plays. She wanted women to write about everything they "experienced and dreamed." She supported women of color at a

time when there was little support for them.[51] What advice would she give young women today? "Dream big and expect to fight for what you want and you'll enjoy the satisfaction."[52]

Notes

1 Brodsky and Olin interviewed Suzanne Bennett, former colleague of Julia Miles, and Marya Cohn, Miles's daughter (and film maker) and were in contact by phone and email with them several times again throughout 2015, 2016, and 2017.

2 The name was changed several times. One of its names was the Women's Project and Productions (WPP). It seems mostly to be referred to as Women's Project Theater. As of the publication of this book, its official name is WP Theater. See BWW news desk, "MTC's Lisa McNulty Named New Producing Artistic Director of Women's Project Theater," Broadway.com, July 23, 2014, http://www.broadwayworld.com/article/MTCs-Lisa-McNulty-Named-New -Producing-Artistic-Director-of.

3 WPT separated from APT in 1986 but continued to hold performances at APT's venue until 1988. It acquired its own theater in 1998. See their website: http:// wptheater.org.

4 "Mission," Women's Project Theater, http://wptheater.org/about/mission/.

5 Susan Jonas and Suzanne Bennett, "Report on the Status of Women: A Limited Engagement?," New York State Council on the Arts, 2002, http://www .womenarts.org/nysca-report-2002/.

6 Alexis Greene, "Introduction," in *Making a Theatre for Women's Voices: Plays and History from the Women's Project at 25*, ed. Julia Miles (Portsmouth, N.H.: Heinemann, 2003), 5.

7 Marya Cohn, interview by Brodsky and Olin, October 6, 2016.

8 Simi Horwitz, "Julia Miles: WPP's Founder Reviews Career," *Backstage*, November 12, 2003, http://www.backstage.com/news/julia-miles-wpps-founder -reviews-career/.

9 Marya Cohn, interview with Brodsky and Olin.

10 Horwitz, "Julia Miles."

11 All biographical information in the previous paragraph is from an interview with Marya Cohn.

12 The most famous method actor was Marlon Brando, who studied with Strasberg's former colleague Stella Adler. "Method acting" was based on the theories of the Russian drama coach Stanislavski.

13 See St. Ann's Warehouse website: http://www.stannswarehouse.org.

14 Bruce Weber, "Sam Cohn, Powerful Talent Broker Dies at 79," *New York Times*, May 6, 2009, http://www.nytimes.com/2009/05/07/arts/07cohn.html.

15 "American Place Theatre Company Records," New York Public Library Archives and Manuscripts, http://archives.nypl.org/the/18636.

16 "American Place Theatre Records."

17 The account throughout this paragraph is based on a conversation with Suzanne Bennett conducted on the telephone by Brodsky and Olin, October 5, 2015.

18 Bingham, in addition to being a playwright and author of other literary forms, was also an heiress, her wealth coming from the Bingham family media empire. As a committed feminist, she established the Kentucky Foundation for Women and engaged in other philanthropy to improve the status of women. See Bingham's website: http://www.salliebingham.com.

19 Mel Gussow, "Women Playwrights: New Voices in the Theatre," *New York Times Magazine*, May 1, 1983, http://www.nytimes.com/1983/05/01/magazine/women-playwrights-new-voices-in-the-theater.html?pagewanted=all.

20 Horwitz, "Julia Miles."

21 See Cassandra Medley website: http://www.cassandramedleyplaywright.com.

22 Chris Hedges, "Public Lives; A Playwright Who Found the Courage to Look," *New York Times*, July 5, 2001, http://www.nytimes.com/2001/07/05/nyregion/public-lives-a-playwright-who-found-the-courage-to-look.html.

23 See Cheryl L. Davis website: http://cldplay.com.

24 Kathleen Chalfant has received many awards, including a Tony and five Drama Desk Awards among them. She appeared in the very first year of WPT (1978–1979) and more recently in APT's 2015–2016 season. She has been in more than fifty plays on and off Broadway and has also been a live stage production coordinator. Her TV roles include starring and supporting roles in many successful series, such as *House of Cards*. Irene Fornés is a Cuban American playwright who won seven Obies for best play, including *Abingdon Square*, which was produced by WPT. Liz Diamond and Joan MacIntosh, with distinguished careers, became members of the faculty at Yale University School of Drama.

25 See Anna Deavere Smith website: http://www.annadeaveresmith.org.

26 Quote from Suzanne Bennett in an email to Brodsky, March 6, 2017.

27 BWW news desk, "MTC's Lisa McNulty."

28 Bennett, interview with Brodsky and Olin, October 5, 2015.

29 Bennett, interview with Brodsky and Olin.

30 Marya Cohn, interview with Brodsky and Olin.

31 Marya Cohn, interview with Brodsky and Olin.

32 For further information, see the Yale University web page for Liz Diamond's biography, http://drama.yale.edu/facstaff/liz-diamond; Charles McNulty, "Out of Carey Perloff's 'Chaos' Comes Theatrical Harmony," *Los Angeles Times* March 27, 2015; http://www.latimes.com/entertainment/arts/la-et-cm-ca-carey-perloff-notebook-20150329-column.html; Playwrights Horizon web page for Lisa Peterson, https://www.playwrightshorizons.org/shows/players/lisa-peterson/; Goodman Theatre web page for Anne Kauffman, http://www.goodmantheatre.org/Artists-Archive/creative-partners/directors/Anne-Kauffman/; Playwrights Horizon web page for Carolyn Cantor, https://www.playwrightshorizons.org/shows/players/carolyn-cantor/; and Celia McGee's article about Melanie Joseph and the Foundry Theater, "City as Stage, Audience as Family," *New York Times*, January 13, 2010, http://www.nytimes.com/2010/01/17/theater/17foundry.html.

33 For a list of some of the well-known alumnae of the Playwrights Lab and the Directors Forum, see the Women's Project Theater website page on the lab and forum: http://wptheater.org/lab/.

34 Bennett, interview with Brodsky and Olin.

35 Fran Tarr Linkedin page: https://www.linkedin.com/in/fran-tarr-b0b6991a.

36 Nancy Rhodes and Carole Rothman started the organization Action for Women in Theatre by surveying productions by women playwrights and female directors in not-for-profit theaters from 1969 to 1975. Their results revealed that only 7 percent of plays being produced were written by women, and only 6 percent were directed by women.

37 Susan Jonas and Suzanne Bennett, *Report on the Status of Women: A Limited Engagement?* New York State Council on the Arts Theatre Program, January 2002 (study comissioned by the New York State Council on the Arts on the status of women in professional theater). See the WomenArts website for the executive summary: https://www.womenarts.org/nysca-report-2002/.

38 Jonas and Bennett.

39 Suzy Evans, "Women Push for Equality On and Off Stage," *American Theatre*, September 17, 2014, http://www.americantheatre.org/2014/09/17/women -push-for-equality-on-and-off-stage/.

40 Evans.

41 See League of Professional Women—History and Background website: http:// theatrewomen.org/about-us/history-background/.

42 See the League of Professional Women website: http://theatrewomen.org/wp -content/uploads/2015/10/Women-Count-2015-Report.pdf.

43 See the 50/50 in 2020 Facebook page: https://www.facebook.com/pg/ 5050in2020/about/?ref=page_internal.

44 See The Kilroys about page: https://thekilroys.org/about/.

45 Evans, "Women Push."

46 Evans.

47 Evans.

48 Evans.

49 Evans.

50 Evans.

51 Bennett, interview with Brodsky and Olin.

52 Interviews with Marya Cohn and Suzanne Bennett by Judith K. Brodsky and Ferris Olin, 2015.

Bibliography

Brodsky, Judith K., and Ferris Olin. Telephone conversations and email exchanges with Suzanne Bennett and Marya Cohn, 2015, 2016, 2017.

BWW news desk. "MTC's Lisa McNulty Named New Producing Artistic Direc-tor of Women's Project Theater." Broadway.com, July 23, 2014. http://www .broadwayworld.com/article/MTCs-Lisa-McNulty-Named-New-Producing -Artistic-Director-of-Womens-Project-Theater-20140723.

Cohen, Patricia. "Rethinking Gender Bias in Theatre." *New York Times*, June 23, 2009. http://www.americantheatre.org/2014/09/17/women-push-for-equality-on-and-off-stage/.

Evans, Suzy. "Women Push for Equality On and Off Stage." *American Theatre*, September 17, 2014. http://www.americantheatre.org/2014/09/17/women-push-for-equality-on-and-off-stage/.

Greene, Alexis. *A Theater for Women's Voices: Plays and History from the Women's Project at 25*. Edited by Julia Miles. Portsmouth, N.H.: Heinemann, 2003.

———. "What Women Want." Theatre Communications Group, February 2008. http://www.tcg.org/publications/at/feb08/women.cfm.

Gussow, Mel. "Women Playwrights: New Voices in the Theatre." *New York Times Magazine*, May 1, 1983. http://www.nytimes.com/1983/05/01/magazine/women-playwrights-new-voices-in-the-theater.html?pagewanted=all.

Horwitz, Simi. "Julia Miles: WPP's Founder Reviews Career." *Backstage*, November 12, 2003. http://www.backstage.com/news/Julia-miles-wpps-founder-reviews-career/.

Jonas, Susan, and Suzanne Bennett. "Report on the Status of Women: A Limited Engagement?" New York State Council on the Arts, 2002. http://www.womenartsorg/nysca-report-2002/.

Miller, Stuart. "An Artistic Director Who's All Business." *New York Times*, May 19, 2010. http://www.nytimes.com/2010/05/23/theater/23project.html.

New York Public Library Archives and Manuscripts. "American Place Theatre Company Records." http://archives.nypl.org/the/18636.

Rampell, Catherine. "Gender Bias in Theater." *New York Times*, June 26, 2009. http://economix.blogs.nytimes.com/2009/06/24/gender-bias-in-theater/?_r=0.

Weber, Bruce. "Sam Cohn, Powerful Talent Broker Dies at 79." *New York Times*, May 6, 2009. http://www.nytimes.com/2009/05/07/arts/07cohn.html.

———. "Judith Malina, Founder of the Living Theater Dies at 88." *New York Times*, April 10, 2015. http://www.nytimes.com/2015/04/11/theater/judith-malina-founder-of-the-living-theater-dies-at-88.html?_r=0.

Women's Project Theater. "Mission." http://wptheater.org/about/mission/.

FIGURE 6 Míriam Colón in "Strange Miracle," an episode of *Alfred Hitchcock Presents*, February 13, 1962.

Míriam Colón

Opening the Theater World
for Diverse Audiences

On September 10, 2015, in a White House ceremony in the East Room, President Barack Obama presented Míriam Colón[1] with the 2015 National Medal of Arts, announcing her award with the following words: "Míriam Colón for her contributions as an actress. Ms. Colón has been a trailblazer in film, television, and theater, and helped open doors for generations of Hispanic actors."[2] Other recipients that day included such noteworthy figures as the actress Sally Field, authors Larry McMurtry and Stephen King, and musician Meredith Monk, among others. These awards were particularly significant in that they were presented in celebration of the fiftieth anniversary of the founding of the National Endowment for the Arts and the National Endowment for the Humanities.

"All the honorees," said Obama, "have one thing in common: They do what they do because of some urgent inner force, some need to express the truth that they experience, that 'rare truth.' And as a result, they help us understand ourselves in ways that we might not otherwise recognize."[3] That statement describes Colón perfectly. Colón was one of the few Latinx to achieve a career in Hollywood on film and in television in the middle of the twentieth century. But Colón played an important role beyond her career as an actress by founding the Puerto Rican Traveling Theater (PRTT), which provided starring roles to Latinx actors and actresses and brought Spanish-language theater to thousands of theatergoers. What imperatives drove a young Spanish-speaking woman from a

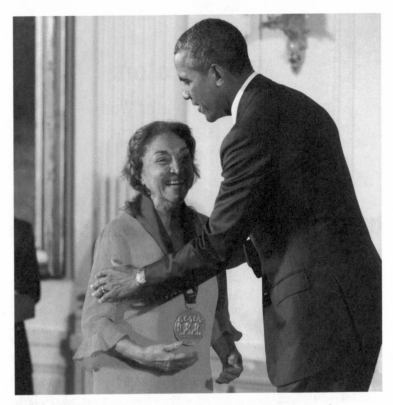

FIGURE 7 Míriam Colón receiving National Arts Medal from President Obama, 2014. Reproduced by permission of Associated Press.

regional city in Puerto Rico to choose a career in Hollywood; to recognize, despite her own success, the lack of representation of Latinx people and narratives in the U.S. theater world; and to establish an organization to combat that absence?

To answer that question fully, one must first consider the history of the Puerto Rican community in New York and the situation in the film industry and the theater world in the second half of the twentieth century. By the 1960s, Puerto Ricans comprised almost 10 percent of the population of New York City. "The Great Migration" began after World War II and is tied to the availability of airborne transport that developed quickly after the war. Thousands were emigrating from Puerto Rico to New York City every year. By

the mid-1960s, the majority of families with children in the public schools of Brooklyn and the Bronx were Puerto Rican, and even in Manhattan they made up 12 percent of the school population.[4] They came to the mainland for jobs. Most of the jobs that were available to them were low paying, partly because they themselves lacked the education and training for higher paying employment but also because of discrimination.[5] Thus most immigrants were poor and suffered from the effects of racism.

During the 1960s, members of the Puerto Rican community, like those in the African American community, became active on behalf of their rights and mounted protests to achieve a better quality of life. New York City government and various welfare agencies responded. So when Míriam Colón began to develop a way to bring Spanish-language theater to Spanish-speaking immigrant neighborhoods, it was in a context of awareness of the need for programs that would enhance the daily routine of people in the Puerto Rican neighborhoods and help erase discrimination because of racism. Also, there was a developing community of poets, novelists, and playwrights who referred to themselves as Nuyoricans. Originally, the term was a derogatory one, used by Puerto Ricans on the island to refer to those who lived in New York. It was transformed in the 1960s into a positive term as a way of describing writers who were born and raised in New York's Puerto Rican working-class barrios and were writing about the experiences of their communities. Colón was to play a role in their recognition. Later in the 1970s, they were associated with the Nuyorican Poets Café, established by Miguel Algarin, one of the members of the group, who became a highly regarded academic and spent much of his career at Rutgers University. Several, like Piri Thomas and Miguel Piñero, had been in prison and wrote about their experiences in jail and about the members of the criminal underclass who were their prison mates. They introduced narratives of crime, drug dealing, and life on the street into American literature, and their influence can be vividly seen in the miniserials and weekly dramas that pervade film, broadcast television, and digital streaming programs. Piñero's prison drama *Short Eyes,* first performed in the Riverside Church, caught the eye of Joseph Papp, who mounted it on Broadway, where it won

an Obie and the New York Drama Critics Best American Play Award for the 1973–1974 season.[6]

Racism affected Puerto Ricans in every aspect of U.S. life, including entertainment. The number of Spanish-speaking professionals in the film and television industry was abysmally small. A study done in 1985 by Jesús Salvador Treviño laid out a dismal picture of the history of Latinx in the industry.[7] In 1969, only 3 percent of the workforce at major Hollywood studios were Latinx (as designated by Spanish surnames). At the three major television networks in Los Angeles (ABC, NBC, and CBS), only approximately 76 employees—representing 2 percent of the total 3,500—had Spanish surnames. At that time in Los Angeles, the Spanish-speaking population was already 20 percent. A study by the United States Commission on Civil Rights found that in forty television broadcast channels, the number of Latinx employees from 1971 to 1975 only increased from 2.0 percent to 3.3 percent, yet the proportion of Latinx in the U.S. population by 1977 was 9 percent.[8] The situation today has improved to some extent; yet a 2014 study by the Annenberg School for Communication and Journalism at the University of Southern California revealed the fact that the statistics continued to be disheartening; Latinx were still the most underrepresented group in Hollywood films. They accounted for only 4.9 percent of all speaking roles, even though they make up 17.1 percent of the national population and 25 percent of film attendees.[9]

Not only were there few Latinx actors and actresses, but they performed in stereotypic roles that denigrated the Latinx population, such as as outlaws, drug dealers, thieves and other criminals, or they were shown working in lowly jobs, such as as fast food employees, car washers, and gas station attendants.[10] Despite the disproportionately small number of Latinx in film and other mass media, including traditional television, the cable channels, and digital streaming, the roles for Latinx have moved away to some extent from the stereotypic characters of the twentieth century. Now Jennifer Lopez can play a lead role in films like *The Wedding Planner*, and Sara Ramirez can play a respected surgeon on *Grey's Anatomy*. But a Columbia University report shows that Latinx continue to be

represented in mass media primarily as "criminals, law enforcers, and cheap labor." The report states that from 2012 to 2013, 17.7 percent of Latinx film characters and 24.2 percent of television characters were linked to crime, a considerable increase from 1994, when it was only 6 percent on television. Furthermore, 69 percent of the housemaids in film and television since 1996 are Latinx.[11]

Colón's childhood and eventual departure from the island of Puerto Rico to take advantage of the opportunities on the mainland fit into the pattern of the Puerto Rican Great Migration. Colón was born in 1936 and spent her early childhood in Ponce, the second-largest city in Puerto Rico after San Juan. It was the capital of Puerto Rico until the Spanish American War, which led to the U.S. invasion of Ponce in 1898. Its history goes back to the sixteenth century, and the name, Ponce, comes from the city's association with the Spanish explorer Ponce de Leon, who was the first governor of Puerto Rico, and his descendants. Ponce has a strong cultural tradition. For instance, the most important art history museum in Puerto Rico is located in Ponce. Assembled through bequests, it has the largest collection of nineteenth-century British Pre-Raphaelite paintings in the Western Hemisphere. The city's economy was based on the sugar industry. Then with the decline of that industry in Puerto Rico, Ponce entered a century of economic decay. Although the economy is now diversified and has improved, the income of approximately 50 percent of Ponce's families falls below the poverty line.[12] Colón's family probably fell into that category or close to it.

Colón's parents went through a divorce. Her father disappeared, and her mother moved the family to San Juan to a complex known as Residencial Las Casas, which had recently been constructed to accommodate middle-class families rather than disadvantaged tenants. Colón described her hardworking mother, who had to be the breadwinner, as having the restricted outlook of those with limited educational and cultural opportunities, mostly caring for her household and the physical needs of her children rather than being involved in activities outside the home. No one mentioned going to college or other preparation for a professional career. She related that her mother didn't understand her enthusiasm about

the theater and expressed her belief that Colón would not keep that interest for very long. Though, as Colón put it, her excitement in the theater lasted a lifetime.[13]

Colón was introduced to the theater while she was in school, but it happened by chance. As they were walking home from school, some of her girlfriends mentioned that they were going to try out for parts in a play. Colón decided to go along. She was entranced. She didn't know anything about the theater beforehand; the concept of learning lines and presenting a narrative to an audience was a revelation. She auditioned for one of the parts and was selected. Colón declared that when the play's run was over, she was devastated. She wanted the play to go on forever. Out of her desperation, she went to the drama teacher who had directed the play, Marcos Colón (no relationship). Believing in her talent and impressed by her powerful desire to act, he suggested that she send a handwritten letter to Leopoldo Santiago Lavandero, the legendary founding head of the drama department at the University of Puerto Rico, where Marcos Colón himself was a student, asking for permission to audit one of the acting classes without academic credit. Lavandero, whom Colón describes as intense and passionate, didn't answer her letter directly but passed along word to her through Marcos Colón, saying that she could sit in on the class three times a week. Colón spoke of that experience with wonder in her voice. Lavandero then invited her to try out for a small role in a university theater troupe that he had organized that traveled to small towns. The role required a young girl, and Colón fit the part. From that time on, she held roles in his various productions on the road. She loved the special bus for actors, performing in public plazas with dogs barking, and the way in which people would run after the bus in order to see the show. She also began to perform more sophisticated roles on the university's main stage, an auditorium with eight hundred seats. Six years later, she began to think of next steps.[14]

Thanks to a scholarship arranged for her by Marcos Colón, she and her mother moved to New York in 1951 so that she could study at the Dramatic Workshop and Technical Institute established originally at the New School by Erwin Piscator, the innovative and influential German theater director. Piscator had had an illustrious

career in Germany in the 1920s and 1930s until Hitler came into power, and he often collaborated with the playwright Bertholt Brecht, one of the major playwrights of the twentieth century. Unfortunately, shortly after Colón began to study at the Dramatic Workshop, Piscator was denied U.S. citizenship and had to return to Germany. Others who studied with Piscator included such acting luminaries as Bea Arthur, Harry Belafonte, Marlon Brando, Tony Curtis, Ben Gazzara, Judith Malina, Walter Matthau, Rod Steiger, Elaine Stritch, Eli Wallach, and Tennessee Williams.[15]

Colón had aunts and uncles already living in New York, and her mother came with her. A friend found them a furnished apartment (living room/dining room/kitchen in one room with a small bedroom attached) on Twenty-Eighth Street, which at that time was a Puerto Rican neighborhood.[16] Colón set about learning English, creating her portfolio, and beginning to make the rounds to agents and producers. When the Theater Workshop closed, Colón auditioned for Elia Kazan at Lee Strasberg's Actors Studio and was accepted immediately, becoming the program's first Puerto Rican member.[17] Shortly after coming to New York, Colón began to meet people involved in Puerto Rican theater, but she was careful not to neglect her connection at the Theater Workshop for fear of losing her scholarship. She quickly became known as an actress not only in Puerto Rico and in the Puerto Rican community in New York but in the mainstream performing world, most likely as a result of her connection to the Theater Workshop and the Actors Studio. In 1953, she performed her first film role as Lolita, the main female character in *Los Pelateros* (The Baseball Players). The film is considered one of the best produced in Puerto Rico.[18] The very next year, she first appeared on the New York stage in *In the Summerhouse* by Jane Bowles, starring Judith Anderson and produced at the Playhouse at 137 West Forty-Eighth Street, a theater that had been in existence since 1911 (later demolished in 1969). Many important plays besides *In the Summerhouse* premiered at the Playhouse, among them *Street Scene*, *The Glass Menagerie*, and *The Miracle Worker*. Colón had more than 250 television credits in ninety-five series, miniseries, and single broadcasts, including soap operas like *The Guiding Light* and guest appearances in two of the most successful prime-time

dramas in U.S. television history, *Gunsmoke* (1955) and *Law & Order* (1990). She appeared as the Cuban American mother of Al Pacino's character Tony Montana in *Scarface* and was in two films with Marlon Brando, *One-Eyed Jacks* (1961)—the only film directed by Brando, in which Mexican American actress Katy Jurado played the female lead—and *Appaloosa* (1966).[19]

In surveying Colón's history as an actress, it is clear that she was constantly working, even though most of her roles were supportive rather than primary. Although she played many characters that fit the stereotypes, Colón also succeeded in moving beyond race and ethnic identification even while leading the PRTT. Her career in New York theater included such roles as Calpurnia, Caesar's wife, in Shakespeare's *Julius Caesar* at the New York Public Theater in 1979.[20]

Her deep involvement in Latinx theater on the U.S. mainland began with her collaboration with Roberto Rodriguez, who came looking for her. Her reputation had preceded her, and he wanted her to star in *La Carreta* (The Oxcart), a play by the Puerto Rican playwright René Marqués that Rodriguez was planning to produce. Marqués was a member of what came to be known as "La generación del 50" in Puerto Rico, a group of artists and writers who were ardent nationalists, critical of Luis Muñoz Marín, the statesman who was the architect of modern Puerto Rico and dominated its public life for much of the mid-twentieth century[21] for not opposing U.S. sovereignty over Puerto Rico. Although Colón initially did not take to Rodriguez—she thought he was very "fragile"—she eventually agreed, and *La Carreta* became associated with Colón for the rest of her career. The play, originally acted in Spanish, is about the trials and tribulations of a Puerto Rican family that emigrates from the island to the United States. Colón tells the story of the audience's emotional reaction. People were so moved they couldn't help themselves from interacting with the actors while they were performing. Men as well as women cried openly. Even non–Spanish speaking people came to see it. *La Carreta* was first performed in the church of San Sebastian in Manhattan on East Twenty-Fourth Street, a church that has been closed since 1971.[22]

Inspired by the success of their first venture, she and Rodriguez founded El Circulo Dramático to mount more plays in Spanish. They wanted to celebrate the Puerto Rican working-class community and also to move Spanish-language theater from the periphery into the mainstream. They mounted their productions at the Teatro Arena, a performance space in Midtown Manhattan. El Círculo Dramático was one of the best known of the Spanish-language theater groups in New York in the mid-1960s.[23]

Along with the misrepresentation and invisibility of Latinx in U.S. entertainment, an equally crucial aspect of the racism experienced by Puerto Rican immigrants was the lack of Spanish-language entertainment in general. Spanish-language theater had functioned in the United States for a long time, but peripheral to the dominant English-speaking theater world. It took place on weekends or only at certain times of the year and was mostly patronized by people interested in the intellectual history of Spanish-language culture. Los Angeles was the center of Spanish-language theater in the first half of the twentieth century, but there were also Spanish-language theater groups and productions before the 1960s in New York. However, they were mostly devoted to classical Spanish theater rather than works about the lives of ordinary Spanish-speaking peoples in the Americas, although they did feature some contemporary playwrights from various Spanish-speaking countries whose work was about subjects such as nationalism.[24]

Through her own life experience, Colón was already aware of the lack of theater in the barrios, the discrimination against Latinx culture, and the stereotypes that prevailed in American entertainment, but she didn't think of herself as the person who could change the situation. She had gained experience as a producer and director as well as an actress. But it didn't occur to her that she had skills she could put to use.

Resolution

Two events in the mid-1960s were catalysts that helped bring Míriam Colón to the point of establishing the PRTT. In 1964, Joseph

Papp, the founder and first executive director of the New York Public Theater, realizing that the members of the African American and Puerto Rican communities were a working-class population that couldn't afford tickets to see live theater, set up the Mobile Theater to bring productions into poor neighborhoods in New York. He mounted two classical Spanish plays in their original language.[25] Then in 1965, Míriam Colón and Raúl Juliá[26] appeared in a very successful off-Broadway English-language production of La Carreta.[27] While performing in the production of La Carreta, Colón, following in Papp's footsteps, decided to bring the production to the neighborhoods and perform in the street, the kind of performance she had experienced in Puerto Rico. Thus after its run in an off-Broadway traditional indoor theater, Colón mounted La Carreta outdoors during the summer. She obtained funds for the production from then New York mayor John Lindsay, resulting in making the tickets free of charge. That production initiated the PRTT.[28]

Colón's concept was to "bring theater to reality, [make it] part of people's lives." She described the origin of the PRTT as follows: "A group of us decided we could have theater, make a project, apply formally to sources of money, to be producers."[29] But it was not easy to establish an innovative theater company, particularly one focused on bringing cultural diversity into the mainstream. Colón did not have in mind a secondary position for the PRTT. From its inception, she operated with confidence that Spanish-language theater focused on contemporary Latinx culture belonged at the center of the dramatic world in the United States.[30]

The capitalization for founding a theater is nothing compared to the funds needed to sustain it. Administrative staff alone, including accountants, public relations professionals, and graphic designers, is a big-budget item requiring not only full-time salaries but also benefits like pensions, health insurance, and federal tax payments. In addition, salaries for actors, directors, scenic and costume designers, stagehands, and other personnel required for production, plus the costs of maintenance, electricity, heat, and materials for scenic and costume design, add up to a sizeable annual commitment. The primary funding for the PRTT annual budget and capital investment has come from city, state, and federal programs that support

the arts, as well as from individual donors. Colón asserted that it was a constant struggle to keep the PRTT functioning. She related, "It was a never ending job to cultivate [donors], write grants. I was investing more time in writing and revising grants, making and changing appointments. You had to do that so you could get dollars. At the same time I was keeping track of [productions]. It was always a struggle, an anxiety. I was afraid to plan for the future. Never mind a three-year plan! I wondered if we would be open even a year from now. This was the reality."[31]

She had to do the paperwork to make the PRTT a not-for-profit organization. But through it all, she declared that it was a matter not of providing a showcase for herself and her acting friends but rather of capturing the life of the Latinx community on stage in order to celebrate that community and educate the American public as to their joys, sorrows, and problems in order to bring about trust and understanding.[32]

Colón mounted plays in school auditoriums, cafeterias, gyms, and other alternative spaces before acquiring a redbrick former firehouse on West Forty-Seventh Street in the center of the Broadway theater area. Then she had to raise the funds to create not only a theater within the building but also all the administrative offices, dressing rooms, and other additional spaces necessary to sustain the PRTT. The theater now has a fully equipped 194-seat proscenium stage that was the result of a $2 million investment several years ago. Following the 1967 summertime production of *La Carreta*, Colón produced more than one hundred plays.[33]

In 2013, the PRTT merged with Pregones, another company focused on Spanish-language theater production. Most of the 60 percent of the merger capital raised by the time of the announcement was provided by Time Warner Inc. and the Ford Foundation. The PRTT and Pregones then had to raise the remaining $1.4 million of their $3.5 million goal. At the reception announcing the merger, Lisa Garcia Quiroz, Time Warner's chief diversity officer and senior vice president of corporate responsibility, declared, "Individually, Pregones and the Puerto Rican Traveling Theater have safeguarded the remarkable story-telling tradition in the Puerto Rican and Hispanic community. Now by coming together, they have the

power to ensure that the cultural richness and vibrancy of New York's Hispanic community is experienced across boroughs, and the voices of Hispanic artists, both new and established, will always be heard."[34]

Pregones Theater was founded as a New York Bronx-based company by Rosalba Rolón and some theater colleagues in 1979. Organized to present ensemble theater, the mission of Pregones was to tour plays in Spanish to underserved communities in the greater New York metropolitan area and the Northeast corridor from Philadelphia to Boston. At the time of the merger, Pregones had presented eighty new plays in English and Spanish, 350 visiting artist presentations, and more than five hundred performances on tour. Like the PRTT, Pregones has attracted mainstream critical attention and approbation. And also like the PRTT, Pregones has a home base, a theater on the border of Manhattan and the Bronx.[35]

Obviously, the merger was intended to save administrative and production costs. The combined organization also gained developmental strength, since Pregones and the PRTT no longer needed to compete for funds. Furthermore, the increased sustainability provided to the two organizations by their union not only benefits them financially; it has implications for maintaining a cultural emphasis on diversity. Pregones/PRTT mounts productions in both sites and continues to alternate Spanish- and English-language productions, introduce new playwrights, and perform the classic Spanish-language repertory. One of the merged entity's plans is titled "The 21 Islands." It includes multidisciplinary and multilingual projects focusing on the creative communities on islands around the world, starting with Hawaii and Puerto Rico. "Extraordinary performances are at the forefront of upcoming seasons, as is a commitment to boost our touring connections and advance our training initiatives," adds Rolón, "so that everything we do is true to the growing interconnectedness among international theatermakers and audiences. Our two stages will also be world stages."[36]

Uniting with Pregones also solved problems of legacy and succession for Colón and Rolón. Most theater companies promoting Spanish-language performance lasted only a few years. The union

of the two theaters addressed the issue of what happens to organizations when founders retire. Studies show that founders give their all to the organizations they have created, but successive leaders are more likely to treat their management as a job rather than a mission.[37] Furthermore, founders often do not think about the sustainability of their organizations after they leave them. As Rolón declared, "Ours is an arts merger, legacy, and leadership succession project all rolled up in one."[38]

The PRTT has showcased and promoted contemporary Spanish-language theater in the United States through several programs in addition to its main stage productions. Despite its name, its outreach is international with a focus on work emerging from Spanish-speaking communities around the world. True to her roots in street theater during her years growing up in Puerto Rico, Colón continued the tradition of free performances in the barrios, plazas, parks, and other public spaces. During the summer months, the PRTT gives more than two dozen performances in New York City and nearby New Jersey neighborhoods. Another PRTT program, called the Raúl Juliá Training Unit, is a tuition-free after-school program offering a performing arts education curriculum consisting of classes in acting, dance, singing, speech, and auditioning technique. Its mission is to introduce the performing arts to low- to moderate-income Latinx and other minority youth in the five New York City boroughs. The PRTT Playwrights Unit promotes playwriting through weekly writer workshops, staged readings, and workshop productions. The unit has originated more than five hundred new plays, with many of them professionally produced at the PRTT and elsewhere.[39]

More than two million Latinx live in New York City. Therefore, it's not surprising that several theater companies have a mission of serving that population. Like the PRTT, some are focused on portraying the problems of immigration, the issues of crime and drugs in the barrios and in their countries of origin, and other gritty aspects of life that are the subject of so many contemporary narratives about Latinx populations. Some are cosmopolitan, mounting productions that are not specific to one country. Others are focused

on the culture and experiences of a single nation. And yet others mount classic Spanish masterpieces.[40] But to a great extent, they owe their mission and focus to Colón's vision.

Colón's leadership accomplished several goals. She raised the status of Latinx culture in the United States through two strategies. The first was to showcase plays by Puerto Rican immigrants to the United States as well as works by playwrights who live in Puerto Rico. Writers like Piri Thomas became celebrated in the theatrical community and known to an American public beyond the Spanish-speaking population, not only as a result of his autobiography *Down These Mean Streets*, but also through productions of his work by the PRTT. The effect has been the inclusion of Latinx playwrights in the canon of contemporary twentieth-century theater. The second strategy was to alternate productions in English and Spanish, thus serving both the Spanish-speaking population of New York and the general theatergoing population. Both strategies have led to a growing recognition of the contribution of Latinx to the mainstream of American culture.

Another achievement has been Colón's contribution to eliminating the stereotype of Puerto Rican immigrants. As an immigrant who shared a background of poverty, she understood that being poor did not mean a lack of interest in or desire to experience the world of the imagination—in her case, theater. By bringing theater to the New York City barrios, she helped reduce the stereotype of Latinx as ignorant and illiterate. In addition, she led the way to establish other theater programs for economically disadvantaged populations.

The continuing lack of recognition and inclusion for Latinx in the mass media and theater sectors makes achievement even more noteworthy. As the Latinx population continues to grow, Colón's career suggests strategies of leadership. First of all, Colón took risks and seized opportunities that came along. Second, she used her own visibility and the connections she made through her career. Third, she reached out to organizations that could help with providing resources—New York City agencies, federal agencies, and private foundations. Fourth, she was always in touch with her community. And fifth, she understood the need for collaboration in order to survive and effected a merger with another organization.

Notes

1 Míriam Colón, interview by Brodsky and Olin, November 19, 2015.
2 Whitehouse.gov, "Remarks by the President at the National Medals of the Arts and Humanities Awards Ceremony," September 10, 2015, https://www .whitehouse.gov/the-press-office/2015/09/11/remarks-president-national -medals-arts-and-humanities-awards-ceremony.
3 "Remarks by President."
4 Virginia Sanchez Korrol, "The Story of U.S. Puerto Ricans, Part Four," Center for Puerto Rican Studies, Hunter College, CUNY, https://centropr.hunter.cuny .edu/research-education/education/story-us-puerto-ricans-part-four.
5 Lorrin Thomas, "Puerto Ricans in the United States," *American History, Oxford Research Encyclopedias*, September 2015, http://americanhistory.oxfordre.com/ view/10.1093/acrefore/9780199329175.001.0001/acrefore-9780199329175-e-32.
6 Thomas.
7 Jesús Salvador Treviño, "Latino Portrayals in Film and Television," *Jump Cut: A Review of Contemporary Media*, March 30, 1985, 14–16.
8 U.S. Commission on Civil Rights, *Window Dressing on the Set: Women and Minorities in Television*, 1977, https://www.law.umaryland.edu/marshall/usccr/ documents/cr12t23.pdf; and U.S. Commission on Civil Rights, *Window Dressing on the Set: An Update*, 1979, https://catalog.hathitrust.org/Record/000258852.
9 Stacy L. Smith, Marc Choueiti, Katherine Pieper, Traci Gillig, Carmen Lee, and Dylan DeLuca, "Inequality in 700 Popular Films: Examining Portrayals of Gender, Race, and LGBT Status from 2007 to 2014," Media, Diversity, and Social Change Initiative at USC Annenberg School for Communication and Journalism, 2014, http://annenberg.usc.edu/pages/~/media/MDSCI/Inequality%20in %20700%20Popular%20Films%2081415.ashx.
10 Treviño "Latino Portrayals," 14–16.
11 Frances Negrón-Muntaner, Chelsea Abbas, Luis Figueroa, and Samuel Robson, "Latino Media Gap: A Report on the State of Latinos in U.S. Media," Center for the Study of Ethnicity and Race at Columbia University, 2014, https:// pmcdeadline2.files.wordpress.com/2014/06/latino_media_gap_report-wm .pdf; and Ed Morales, "The Latino Media Gap: A Conversation with Frances Negrón-Muntaner," EdMorales.net, June 18, 2014, https://edmorales.net/ 2014/06/18/latino-media-gap-a-conversation-with-frances-negron-muntaner/.
12 "Ponce Municipio, Puerto Rico QuickFacts," Census.gov, http://www.census .gov/quickfacts/table/PST045214/72113/embed/accessible#footnotes.
13 Míriam Colón interview by Judith K. Brodsky and Ferris Olin on November 19, 2015.
14 Colón, interview.
15 "Erwin Piscator," Lahr von Leitis Academy and Archive, http://www .lahrvonleitisacademy.eu/en/archive_erwin_piscator.html.
16 Colón, interview.
17 The Actors Studio was built on the foundation of the Group Studio established by Elia Kazan, Cheryl Crawford, and Harold Clurman in 1934 to bring together

a group of actors who would use the Stanislavski method, developed in the
Moscow Art Theater. The basis of the Stanislavski method was training actors
to live the parts rather than to think of them as external. It became the
Actors Studio in 1948, and Lee Strasberg became its director in 1949. Later it
became the Strasberg Studio. The technique, which originated with Stanislav-
ski, became associated with Strasberg and is known as method acting. Stras-
berg died in 1982. Among the famous alumni of the Strasberg Studio are actors
Marlon Brando, Marilyn Monroe, and Al Pacino and directors Elia Kazan,
Cheryl Crawford, and Harold Clurman, who were all important Broadway
theater directors with long careers that lasted for decades. Clurman died in
1980, Crawford in 1986, and Kazan in 2002. See the Lee Strasberg Theatre and
Film Institute "Legacy" page: http://newyork.methodactingstrasberg.com/
legacy/.

18 Serafín Méndez-Méndez and Ronald Fernandez, *Puerto Rico Past and Present:
An Encyclopedia*, 2nd ed. (Santa Barbara, Calif.: Greenwood, 2015), 171.

19 Some biographical detail has been derived from the interview conducted by
Brodsky and Olin. Other sources include the brief biography of Colón on the
New York Public Library (NYPL) website, since the records of the Puerto Rican
Traveling Theater are in the NYPL archives. A guide to the records with the
biography of Colón is available on the NYPL website: http://archives.nypl.org/
uploads/collection/generated_finding_aids/the22690.pdf. A Spanish-language
online source for her biography is on the website of the Fundaciòn National
para la Cultura Popular, http://www.prpop.org. Colón's own words about her
childhood in Puerto Rico are included in Gus Puleo, "Living and Working in the
Border Town, an Interview with Míriam Colón Valle," *Review: Literature and
Arts of the Americas* 30, no. 54 (2012): 11–18. A good summary of Colón's early
theater experiences in Puerto Rico and her move to New York can be found in
Elisa De la Roche, *Teatro Hispano!* (New York: Taylor and Francis, 1995), 60.

20 "Míriam Colón Biography (1945–)," filmreference.com, http://www
.filmreference.com/film/23/Miriam-Colon.html.

21 See the Encyclopedia Britannica web page for the biography of Luis Muñoz
Marin: https://www.britannica.com/biography/Luis-Muñoz-Marin.

22 Interview with Colón by Brodsky and Olin, November 19, 2015. Also see
De la Roche, *Teatro Hispano!*, 61; and Mel Gussow, "Theater: 'The Oxcart,' by
Puerto Rican Troupe," *New York Times*, May 26, 1983, http://www.nytimes
.com/1983/05/26/theater/theater-the-oxcart-by-puerto-rican-troupe.html.

23 John Carlos Rowe, *Literary Culture and U.S. Imperialism* (Oxford: Oxford
University Press, 2000), 694; and Federico Ribes Tovar, *El libro puertorriqueñ*
de Nueva York (New York: Plus Ultra Educational, 1970), 204.

24 Nicolás Kanellos, "Hispanic Theatre in the United States: Post-war to the Pres-
ent," *Latin American Theatre Review* 25, no. 2 (1992): 197–209, https://journals
.ku.edu/index.php/latr/article/download/937/912.

25 Helen Epstein, *Joe Papp: An American Life* (New York: Da Capo Press, 1996),
180.

26 Raúl Juliá (1940–1994) was a charismatic and popular theater, television, and film star who gained international recognition. He appeared in such iconic films as *Kiss of the Spider Woman* and had a long-standing role in *The Addams Family* movie series.

27 "100 Years of Latino Theatre," Latinopia.com, March 6, 2010, http://latinopia .com/latino-theater/100-years-of-chicanolatino-theatre/.

28 Rosa Luisa Marquez, "The Puerto Rican Traveling Theatre Company: The First Ten Years" (PhD diss., Michigan State University, 1977), 71, https://issuu.com/ coleccionpuertorriquena/docs/the_puerto_rican_traveling_theatre_.

29 Interview with Colón by Brodsky and Olin, November 19, 2015.

30 Colón, interview.

31 Colón, interview.

32 Colón, interview.

33 Marquez, "Puerto Rican Traveling Theatre," 115–117.

34 "Artists, Philanthropists, and Community Leaders Celebrate Latino Theater Merger, Call on Peers to Help Raise Remaining $1.4M," Pregones.org, November 5, 2013, http://pregonesprtt.org/ensemble/press-room/.

35 "History and Mission," Pregones Theater Puerto Rican Traveling Theater, http://pregonesprtt.org/ensemble/mission/.

36 "Artists, Philanthropists"; and Felicia R. Lee, "Two Latino Theaters in New York to Merge," *New York Times*, October 30, 2013, http://artsbeat.blogs .nytimes.com/2013/10/30/two-latino-theaters-in-new-york-to-merge/.

37 Elizabeth Schmidt, "Rediagnosing 'Founder's Syndrome': Moving beyond Stereotypes to Improve Nonprofit Performance," Non Profit Quarterly.org, July 1, 2013, https://nonprofitquarterly.org/2013/07/01/rediagnosing-founder-s -syndrome-moving-beyond-stereotypes-to-improve-nonprofit-performance/.

38 "Artists, Philanthropists."

39 "Artists, Philanthropists."

40 Kanellos, "Hispanic Theatre."

Bibliography

Brodsky, Judith K., and Ferris Olin. Interview with Colón, November 19, 2015.

Census.gov. "Ponce Municipio, Puerto Rico QuickFacts." http://www.census.gov/ quickfacts/table/PST045214/72113/embed/accessible#footnotes.

De la Roche, Elise. *Teatro Hispano!* New York: Taylor and Francis, 1995.

Epstein, Helen. *Joe Papp: An American Life.* New York: Da Capo Press, 1996.

Filmreference.com. "Míriam Colón Biography (1945–)." http://www.filmreference .com/film/23/Miriam-Colon.html.

Fundaciòn National para la Cultura Popular. "Míriam Colón." http://prpop.org/ biografias/miriam-colon/.

Gates, Anita. "Míriam Colón, 80, Actress and Founder of Puerto Rican Traveling Theater, Dies." *New York Times*, March 5, 2017. https://www.nytimes.com/2017/ 03/05/movies/miriam-colon-actress-puerto-rico-dies.html?_r=0.

Gussow, Mel. "Theater: 'The Oxcart,' by Puerto Rican Troupe." *New York Times.* May 26, 1983. http://www.nytimes.com/1983/05/26/theater/theater-the-oxcart -by-Puerto-rican-troupe.html.

Kanellos, Nicolás. "Hispanic Theatre in the United States: Post-war to the Present." *Latin American Theatre Review* 25, no. 2 (1992): 197–209. https://journals.ku.edu/ index.php/latr/article/download/937/912.

Korrol, Virginia Sanchez. "The Story of U.S. Puerto Ricans, Part Four." Center for Puerto Rican Studies, Hunter College, CUNY. https://centropr.hunter.cuny.edu/ research-education/education/story-us-puerto-ricans-part-four.

Lahr von Leitis Academy and Archive. "Erwin Piscator." http://www .lahrvonleitisacademy.eu/en/archive_erwin_piscator.html.

Lee, Felicia R. "Two Latino Theaters in New York to Merge." *New York Times,* October 30, 2013. http://artsbeat.blogs.nytimes.com/2013/10/30/two-latino -theaters-in-new-york-to-merge/.

Marquez, Rosa Luisa. "The Puerto Rican Traveling Theatre Company: The First Ten Years." PhD diss., Michigan State University, 1977.

Méndez-Méndez, Serafin, and Ronald Fernandez. *Puerto Rico Past and Present: An Encyclopedia.* 2nd ed. Santa Barbara, Calif.: Greenwood, 2015.

Morales, Ed. "The Latino Media Gap: A Conversation with Frances Negrón-Muntaner." EdMorales.net, June 18, 2014. https://edmorales.net/2014/06/18/ latino-media-gap-a-conversation-with-frances-negron-muntaner/.

Negrón-Muntaner, Frances, Chelsea Abbas, Luis Figueroa, and Samuel Robson. "Latino Media Gap: A Report on the State of Latinos in U.S. Media." Center for the Study of Ethnicity and Race at Columbia University, 2014. https:// pmcdeadline2.files.wordpress.com/2014/06/latino_media_gap_report -wm.pdf.

Pregones.org. "Artists, Philanthropists, and Community Leaders Celebrate Latino Theater Merger, Call on Peers to Help Raise Remaining $1.4M." November 5, 2013. http://pregonesprtt.org/ensemble/press-room/.

Pregones Theater Puerto Rican Traveling Theater. "History and Mission." http:// pregonesprtt.org/ensemble/mission/.

Puerto Rican Traveling Theatre Records, 1960s–1994. New York Public Library, Billy Rose Theater Division. Guide compiled by Valerie Wingate, 2014. http:// archives.nypl.org/uploads/collection/generated_finding_aids/the22690.pdf.

Puleo, Gus. "Living and Working in the Border Town, an Interview with Míriam Colón Valle." *Review: Literature and Arts of the Americas* 30, no. 54 (2012): 11–18.

Rowe, John Carlos. *Literary Culture and U.S. Imperialism.* Oxford: Oxford University Press, 2000.

Smith, Stacy L., Marc Choueiti, Katherine Pieper, Traci Gillig, Carmen Lee, and Dylan DeLuca. "Inequality in 700 Popular Films: Examining Portrayals of Gender, Race, and LGBT Status from 2007 to 2014." Media, Diversity, and Social Change Initiative at USC Annenberg School for Communication and Journalism, 2014. http://annenberg.usc.edu/pages/~/media/MDSCI/Inequality%20in %20700%20Popular%20Films%2081415.ashx.

Thomas, Lorrin. "Puerto Ricans in the United States." *American History, Oxford Research Encyclopedias.* September 2015. http://americanhistory.oxfordre.com/view/10.1093/acrefore/9780199329175.001.0001/acrefore-9780199329175-e-32.

Tovar, Federico Ribes. *El libro puertorriqueñō de Nueva York.* New York: Plus Ultra Educational, 1970.

Treviño, Jesús Salvador. "Latino Portrayals in Film and Television." *Jump Cut: A Review of Contemporary Media* 30 (1985): 14–16.

U.S. Commission on Civil Rights. *Window Dressing on the Set: Women and Minorities in Television.* 1977. University of Maryland, Thurgood Marshall Law School Library. https://www.law.umaryland.edu/marshall/usccr/documents/cr12t23.pdf.

———. *Window Dressing on the Set: An Update.* 1979. Hathi Trust Digital Library. https://babel.hathitrust.org/cgi/pt?id=umn.31951d00301862b;view=1up;seq=3.

Whitehouse.gov. "Remarks by the President at the National Medals of the Arts and Humanities Awards Ceremony." September 10, 2015. https://www.whitehouse.gov/the-press-office/2015/09/11/remarks-president-national-medals-arts-and-humanities-awards-ceremony.

FIGURE 8 Photograph portrait of Jaune Quick-to-See Smith. Photographer unknown. Courtesy of the artist.

Jaune Quick-to-See Smith
A Tireless Political Activist

Jaune Quick-to-See Smith[1] is regarded as a significant American artist. In addition, she is recognized as a determined and effective activist who has worked relentlessly to achieve respect for American Indian cultural accomplishments. Her success as a leader in helping change the perception of American Indian culture is due to several strategies. She was aware of the discrimination against Native Americans and women, and rather than accepting the position that society allotted her, she decided to fight that discrimination. Then, instead of going it alone, she organized her American Indian colleagues, particularly women, so that it was an army rather than a single soldier entering the fray. Very importantly, her own work and the artists she worked with were at a level of excellence that enabled her to connect with mainstream advocates who could help in bringing her messages to a wide audience. She reached out to create partnerships with people in the mainstream cultural community sympathetic to her cause and in a position to help. And by constant lecturing and writing in college and university settings, museums, and other public cultural venues, she reinforced her message and educated the general population to recognize the value of Native American culture.

Smith was born on the reservation of the confederate Salish-Kootenai nations, just north of Missoula, Montana, in 1940. Her generation spans an era that saw the paradigm shift from a prevailing American jingoism to doubts about all American social and philosophic beliefs. We no longer think of war as honorable; the

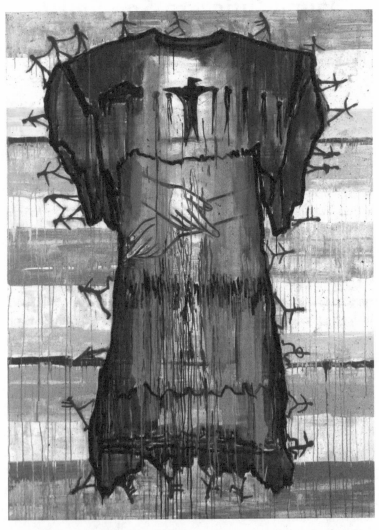

FIGURE 9 Jaune Quick-to-See Smith, *Who Leads, Who Follows?*, 2004, oil on canvas, 80 × 50 inches. Courtesy of the artist.

reasons for going to war are suspect. We have come to the realization that the Declaration of Independence meant equality for white males of European descent rather than for all. And we have come to understand the true meaning of manifest destiny—the vanquishment of the people who originally occupied the land that became the United States of America. The changes in perception came about gradually at first but then accelerated in the 1960s, driven by the horrors of the Vietnam War along with the civil rights and feminist movements.

At the time Smith was growing up, most people looked down on Native Americans. They were considered uneducated, dirty, drunk, and wrapped in blankets. They were isolated from the rest of the American population, having been forced to leave their homes and live on "reservations." The march to the Oklahoma territory by the Cherokees became a metanarrative of colonialism, exploitation, and misuse of power. Nevertheless, when Smith describes her childhood, her memories have pleasant aspects despite the poverty, dislocation, and hard work. Her father, Albert Smith, was a horse trader, as were her forebears. Smith's first name is the French word for *yellow* and was passed down to her by her French-Cree ancestors.[2]

Some sources report that her middle name, Quick-to-See, was given to her by her Shoshone grandmother. However, Smith is quoted by Joni L. Murphy, who has written a dissertation on Smith, as saying that her father gave her the middle name in honor of her great-grandmother:[3] "It doesn't mean eyesight; it means being able to grasp things readily."[4] Smith was introduced to the life of a horse trader very early. She often accompanied her father on extended horse-trading trips to other reservations. Albert Smith was also a rodeo rider and a trainer, although he could neither read nor write English. Smith's mother, according to Murphy, was a fifteen-year-old who abandoned Smith and her sister when Smith was two and a half years old. Smith says that she lived in more than fifty foster homes, not always on the reservation, during periods when her father was away: "The story of my early childhood is typical of a Native American family of fifty years ago and even today, for some Indian families. This is a story of how a child develops resiliency

and coping mechanisms in a difficult and disenfranchised world. It demonstrates the skills and creative capacity of children to find alternative routes in coping with adversity. It is not the typical story of Dick and Jane, or the Brady Bunch. . . . And yet, I think it is an uplifting and hopeful story for any adult and child."[5]

Smith also had to work. She split and nailed shingles, helped build corrals and fix fences, and groomed the horses:

> When [my father] needed help on our farm he called on my sister and me. When he wanted to round up a herd of horses, he asked my sister and me to help him. One year we had 40 head of horses to care for. We had to load wheel barrows full of hay to feed them in the winter. Sometimes, my Dad wanted to round up horses so he would ask us to stand and shoo the horses in a certain direction while he thundered behind them on his horse driving the herd toward us. I still shiver thinking about it. When my father built new corrals, he expected us to help. When he boarded race horses we were expected to exercise them though they were jumpy and skittish. He expected us to chop wood, clean barn stalls, shovel manure, whatever chores needed to be done. He never said "Be a little lady."[6]

Smith always wanted to be an artist. She's not sure where that ambition came from, but her father did draw animals beautifully, she recalls. And he was an art collector. Smith recalls, "Most definitely my father was my favorite artist. He would draw pictures of animals on small pieces of paper for me and I would carry them for weeks in my pocket." Smith fondly recalls many times when she was inspired by the fine split corrals and the tightly braided lariats he made by hand, his collection of Charlie Russell prints that hung in their bunkhouse among the sawhorses and bridles, and his treasured collections of beadwork and Navajo saddle blankets.[7]

When she started school, she was enthralled with the opportunity to paint—the first grade class was equipped with easels and poster paints. Later, with money she had saved working as a farmhand since the age of ten, she sent away for the "Famous Artists School" correspondence course.

Smith's ambition to be an artist was fired up by an experience when she was a young teenager. She was working for a Nisei family who took her to the Hollywood film *Moulin Rouge*, on the life of Toulouse Lautrec. Seeing the film was an epiphany for Smith. In the first place, it was about a world-famous artist who was a revolutionary in his work. Second, it took place mostly in Paris, and the scenes of the city were in spectacular Technicolor. Smith was so taken with Lautrec and so impressed by the fact that one could live a life as an artist that she actually dressed up as Toulouse Lautrec and had herself photographed on her knees so that she would appear as short as her hero.[8]

Smith's desire to make art reflects the fact that artmaking is integral to Native American cultures. Eventually, that centrality was recognized, and the Institute of American Indian Arts (IAIA) was founded with funding from the United States Department of the Interior, Bureau of Indian Affairs (BIA) in 1962.

But the history of the education of Native Americans is a horrifying insight into colonialist practices. On the assumption that the Indians were "savages," a series of schools were set up, starting early in the nineteenth century, to assimilate Indians into European/English culture, the idea being to turn them into "civilized human beings." The worst of these experiments were the boarding schools established thousands of miles away from the reservations in order to prevent the students from returning home and resuming their savage ways.[9] The IAIA was a colonialist institution in that, for many years, it concentrated on instilling awareness of Indian traditions rather than seeing them within the broader context of mainstream culture.[10]

Smith finished high school on the reservation. She was determined to continue her education and initiated her college education in 1958 at Olympic Junior College, Bremerton, Washington, from which she received an associate's degree. Smith later matriculated at Framingham State College in Massachusetts. Framingham State College may have seemed an unusual choice for a young Indian woman from Montana, located as it is on the East Coast in Massachusetts, but the college had ties to the education of Indians. Olivia

Davidson, later the wife of Booker T. Washington, had received her degree in education from Framingham in 1881 and in the same year taught in a program at Hampton Institute to teach reading and writing to Plains tribe members (the Salish and Kootenai are Plains nations) who had been imprisoned at Fort Marion in Florida as potential "troublemakers."[11]

Smith worked part-time to finance her education. She finally received her bachelor's degree from Framingham in 1976. She then applied to the University of New Mexico for the master of fine arts (MFA) program. She states that her interest in New Mexico stemmed from the fact that it was the only institution of higher education that offered Native American studies. Undeterred by the fact that the university rejected her application three times (she says that they didn't want an Indian student in the prestigious MFA program), she continued to paint. When *Art in America* gave her work in an exhibition in New York an enthusiastic review, she was finally admitted to the program, where she finished in 1980. As she says, in the meantime, throughout this long, drawn-out college experience, she was employed while also raising three children: "By the time I started graduate school, I was already a working artist. . . . You know essentially it took me 22 years to get through college, both of my degrees that is." When her first marriage failed, Smith supported her two sons singlehandedly. She "worked in canneries, waitressed, clerked, was a maid, a janitor, a veterinary assistant, a librarian, an Avon lady, a secretary, and taught Head Start to Mexican nationals in Texas."[12]

In 1977, Smith entered a juried exhibition at the University of New Mexico, and her work was accepted. As a result, she was invited to show her work at the Houshour Gallery in Albuquerque. Smith states that it was an honor because the gallery showed distinguished New York artists rather than local or regional ones. She showed again at Houshour in 1979. In 1978, Smith also joined the Clark Benton Gallery in Santa Fe. This gallery was one of the leading galleries in Santa Fe, showing New York artists as well as locals.

The year 1979 was a banner year for Smith. The artist Susan Crile, who was based in New York, saw Smith's work in Albuquerque,

bought one of Smith's paintings, and asked her partner, the cartoonist and author Jules Feiffer, to introduce Smith to the New York gallerist Jill Kornblee. In that year as well, the Native American artist Fritz Scholder, whose work was well known and critically respected in the mainstream art world, introduced Smith to Marilyn Butler, a gallerist in Scottsdale, Arizona, and Smith began to show there as well.[13] It should be pointed out that Santa Fe and Scottsdale have long attracted cosmopolitan wealthy people to establish vacation homes in the two cities. Many of them collected art, so belonging to a gallery in Scottsdale furthered Smith's career.

Smith established another prestigious connection. The print department at the University of New Mexico, located in nearby Albuquerque, had a long-standing reputation for distinction and had become the site for the Tamarind Institute, which invited Smith to be in residence to create new work in lithography. Because the Tamarind Institute was known for introducing well-known artists to the field of lithography, a connection with Tamarind immediately raised the profile and reputation of any artist lucky enough to be invited to make lithographs. Smith entered the company of such artistic personages as Elaine de Kooning, Jim Dine, Philip Pearlstein, Ed Ruscha, and Kiki Smith, all internationally renowned. Fritz Scholder had also been a Tamarind artist.[14]

To give a sense of her importance in the context of American mainstream culture, one has only to look at the fact that Smith has had more than one hundred solo exhibits and has received commissions and executed public projects nationwide, including the floor design in the Great Hall of the Denver Airport and a mile-long sidewalk history trail in Seattle. She has lectured at more than two hundred universities, museums, and conferences internationally, including five appearances in the People's Republic of China.

Smith's contributions to American art have been recognized through such honors as election to the most selective cultural organization in the United States, the Academy of Arts and Letters; a Lifetime Achievement Award from the leading national feminist art organization, the Women's Caucus for Art; the Distinguished Feminist Award from the College Art Association, the definitive scholarly organization of art historians, curators, and artists with

a membership of fifteen thousand; an award for outstanding painting from the Joan Mitchell Foundation; two awards from the governor of the state of New Mexico; recognition through the Visionary Woman Award, given annually by the Moore College of Art and Design, Philadelphia, the only art school for women; the Living Artist of Distinction Award from the Georgia O'Keeffe Museum; and four honorary doctorates from distinguished institutions: Minneapolis College of Art and Design; Pennsylvania Academy of Fine Arts; Massachusetts College of Art, Boston; and University of New Mexico, Albuquerque.

Her paintings and prints are in the collections of the Museum of Modern Art, the Whitney Museum of American Art, and the Metropolitan Museum of Art, all in New York; the Brooklyn Museum; the National American Art Museum, the Smithsonian Institution, Washington, DC; the Walker Art Center, Minneapolis; the Museum of Mankind, Vienna, Austria; and the Victoria and Albert Museum, London, just to give some examples of the illustrious institutions that have acquired her work.[15]

What is the catalyst that led to her ambition to become a leader in the movement to insert Native American culture into the American national mainstream? Her juncture came with her experiences of discrimination as she struggled to attain an education. She was met by resistance even in high school. She had two strikes against her: she was a Native American and she was female. She recalls that at the Puyallup High School, she was told she "was not college material."[16] At Olympic State College in Bremerton, an art teacher told her that although her drawing skills were better than those of her male fellow students, she should not consider a career as an artist, since it was a man's field.[17] Smith says, "From the start, I was bothered by the fact that the only artists I heard about in school were mostly white men. . . . I felt that there had to be more to this, and of course, in time I encountered women artists like O'Keefe and Kollwitz. . . . I am an American Indian and this gives me a particular kind of perspective. I am an advocate of our issues, but I am also a woman. I feel solidarity with African-American, Asian, and Latino artists."[18]

The breaking point came when she was rejected three times by the University of New Mexico, where she wanted to do graduate work in the MFA program. "They kept telling me that Indians didn't belong in fine arts," Smith explains.[19]

> In 1976 I came to Albuquerque to go to graduate school at the University of New Mexico because of their comprehensive Native American studies program. I knew I would have to teach to support myself and my children. I particularly wanted to teach at the Institute of American Indian Arts in Santa Fe. But as they say: "Best-laid plans. . . ." I applied three times to the graduate school of fine arts and was turned down each time. I continued to take classes, kept making art and exhibiting. I was encouraged to enroll in the art education department, where the majority of Indians were sent if they had a hint of Indian imagery in their work. After I had a review in *Art in America* from my exhibit at the Kornblee Gallery in New York, I was finally accepted into the fine arts department. . . .
>
> From the time that I started taking college art classes in 1958 to the time I finished college with a master's degree in 1980, twenty-two years, it wasn't acceptable to show any ethnicity in my work. My professors taught from a perspective that was all white, Euro-centric, and male. I worked many years developing a painting sur-face based on my academic training.[20]

Resolution

These rejections, combined with her earlier experiences with discrimination, led to her leadership in combatting bigotry against Native Americans and building mainstream recognition for the value of their culture. To achieve her goals, she undertook strategies that provide models for future leaders to consider. The first strategy was to create collaboratives. She understood that it would be more effective to gather together a group of artists whose work belonged in the mainstream and establish an alliance rather than only to promote her own work. So she created a collaborative of Native

American artists living in the Albuquerque area who, like Smith herself, were integrating motifs from their Indian heritage with Modernist style.

There is a tradition of Native American artist collaboratives. Generally a collaborative is governed democratically, with the group as a whole deciding on its mission and operation. Everyone in the collaborative works equally to promote the common good. The oldest Native American artists' collaborative is the Qualla Arts and Crafts Mutual of the Cherokee Tribe, which was established in 1946, a few years after the opening of the Great Smokies National Park in 1940.[21]

In addition to the Native American model, Smith also had another model in the feminist art movement of the 1970s, when women artists on the East and West Coasts found that collaboratives helped them gain visibility. The earliest feminist collaborative was the A.I.R. Gallery in New York, which was established in 1972, followed shortly by women's cooperative galleries in Chicago, Rhode Island, and Minneapolis. Seeing their success, Smith had models she could emulate to achieve her goals.[22]

Smith's first collaborative was called the Grey Canyon Artists. The name refers to how the streets of Albuquerque look like gray cement canyons. Smith began to organize exhibitions for the group. Some of the first exhibitions were in Albuquerque, but from the start, Smith had no intention of staying local. Her ambition was larger: she realized that if she were to change the perspective of American society toward Indians, she had to organize exhibitions on the national level. So she set up the exhibitions to travel to locations across the United States—the American Indian Community House in New York City, the Art Gallery of the University of North Dakota, the Upstairs Gallery in Berkeley, and the Heard Museum in Phoenix. At least two of the locations were in areas not associated with Native American populations—Berkeley and New York. Smith was thinking of integrating as well as promoting cultural preservation.[23]

In 1979, Smith organized another collective called Coup Marks on the Salish-Kootenai reservation of her birth. A *coup mark* is a term used to denote success in battle; it is a strike against an

enemy that doesn't physically harm either the recipient or the per-
petrator. It is a sign of humiliation for the enemy. In the case of the
artists in the collective, it meant that through the exhibition of their
artworks, they were delivering "coup marks" on the mainstream art
world. As with Grey Canyon Artists, Smith sought out venues that
were mainstream rather than confined to Native Americans. Coup
Marks had exhibitions at the American Indian Community House
Gallery in New York and the Via Gambara Gallery in Washington,
DC, as well as in Native American venues.[24]

Recognizing that according to contemporary museum practice,
many institutions were more receptive to proposals around topics
rather than artists' names, Smith's second strategy was to organize
thematic exhibitions of the work of Native American artists. These
exhibitions always had political goals. In 1985, with artist Harmony
Hammond, Smith curated the first exhibition of Native American
contemporary women artists. Titled *Women of Sweetgrass, Cedar,
and Sage: Contemporary Art by Native American Women*, it was seen
at the American Indian Community House.[25]

Smith's third strategy was to seek partnerships with influential
mainstream artists and critics who were in tune with her goals. By
making these connections, she could get her message out to the
broader world rather than keeping it only within the circle of Native
American cultural communities. It was a strategy that was crucial to
the success of her efforts.

The first of these relationships was the one with Hammond.
Smith and Hammond met when Hammond was teaching at the
University of New Mexico and Smith took her course.[26] Hammond,
one of several Southwestern women active in the American feminist
art movement of the 1970s, was particularly concerned with dis-
crimination against gay and lesbian artists and ultimately wrote the
first history documenting their work.[27]

Smith also collaborated with Lucy Lippard, one of the most
important contemporary art critics; she was a champion of feminist
artists and artists of color who were making political statements
in their work. Hammond and Lippard were friends, and Smith met
Lippard through Hammond—like Hammond, Lippard also had
a home in the Santa Fe area. Lippard contributed an essay to the

Sweetgrass catalog as well as to the catalog accompanying another major exhibition organized by Smith on Native American landscape painters in 1991, *Our Land/Ourselves: American Indian Contemporary Artists.*[28]

The latter exhibition is an example of Smith's broad-ranging critique of American culture as seen through the lens of her indigenous heritage. She critiques not only discrimination and stereotyping of American Indians but also the destruction of the environment through expansion of cities resulting in the reduction of open spaces central to Indian life; commodification, such as the use of Indian motifs for names of sports teams or to promote cigars (e.g., the wooden Indian); and the narrow parameters of art history, which have privileged Western European art over indigenous art.[29]

Smith's strategies of forming collaboratives and organizing exhibitions were effective in making headway. Her artistic practice also played an important part in the success she had in promoting Native American contemporary art. Although she was using an iconography based on her tradition, she was also painting in a manner that showed she was fully cognizant of the developments in twentieth-century art—a personal style of brush strokes, employing spatial relationships internal to the paintings themselves rather than representational perspectival space, integrating iconic images within an abstract context, and utilizing color symbolically rather than realistically. Smith was probably conscious of contemporary developments before graduate school, but certainly during her years at the University of New Mexico, she would have been immersed in these developments. In many of her paintings, one can clearly see her awareness of Abstract Expressionism.

The author of a monograph on Smith, Carolyn Kastner, a curator at the Georgia O'Keeffe Museum in Santa Fe, compares Smith's compositional devices to those of Willem de Kooning—forms often originating in representation but fragmented and organized in a shallow space. Smith's style also shows her familiarity with the tradition of Western landscape painting, as in the work of John Marin, an American abstract painter of the first half of the twentieth century, or the paintings of O'Keeffe. Like Marin, Smith exploded the connections between elements in the landscape, isolating the

individual components and rearranging them in her own spatial order. While Smith's style is very different from O'Keeffe's, the impact of the earlier artist's deep commitment to landscape permeated the art world of the Southwest. It would have been impossible to live in Santa Fe or Albuquerque and not know O'Keeffe's work. Revealing her devotion to O'Keeffe, after O'Keeffe's death, Smith painted an homage to the artist titled *Georgia on My Mind*. Smith's use of text, fragments of recognizable images incorporated into the abstract framework of the paintings, and on occasion, actual objects attached to the paintings show her awareness of the work of the Pop Art Movement and artists like Robert Rauschenberg, Jim Dine, and Jasper Johns.[30]

At the same time that Smith was a sophisticated painter whose work was based in the Modernist aesthetic, she also intended her work to be political. In daring to be political, she was influenced by the Feminist Art Movement of the 1970s, which took place when Smith was studying for her undergraduate and graduate degrees in the mid- to late 1970s. Empowered by the Feminist Art Movement, Smith and artists of color—Native American, African American, Asian American, and Latinx artists—felt free to incorporate elements into their work that would relate to their cultural heritages and their gender.[31]

One of Smith's early series of political paintings was inspired by the actions of a developer in Albuquerque who was going to destroy a site covered with ancient petroglyphs to build new homes. Smith and other Native Americans in the area fought and won the struggle to prevent the developer's actions. She countered the development in two ways, first through helping fund the legal battle to stop the destruction by putting some of her paintings in a fundraising auction and second by responding through painting a series called *Petroglyph Park*. Her painting *The Courthouse Steps* refers to an action taken by the frustrated developer that infuriated the Native American cultural community. He dumped a huge block of stone with important petroglyphs onto the steps of the courthouse. The fragmented images are derived from Native American traditional patterns, but without knowing the back story, the painting does not necessarily evoke a sense of political action.[32] Another

series painted a few years later is more easily interpreted as political in intent. In the *I See Red* series, Smith uses the color red, paralleling the way African American artists were using black as a signifier for protest against white culture. *I See Red (Snowman)* and *The Red Mean: Self Portrait* satirize popular culture and high art, with the red "snowman" referring to the middle-class childhood winter sport of making snowmen and *Red Mean* referring to the ideal of white beauty as expressed in Leonardo da Vinci's diagram of the perfectly proportioned man, crossed out with a delete sign and a sign across his chest with the text "Made in the USA."[33]

Smith's political messages became very explicit in the work she did in reaction to the quincentenary anniversary of the voyages of Columbus. The quincentenary was first promoted by the U.S. government and also by private institutions as a celebration. The Native American, African American, and Latinx communities protested on the basis that the voyages led to slavery and genocide. Many artists from these populations expressed their protest through their work. Smith joined them with two projects, *Trade (Gifts for Trading Land with White People)* and *Paper Dolls for a Post Columbian World with Ensembles Contributed by the US Government* (1991-1992). In *Trade*, Smith's painting centers on a canoe, a signifier of American Indian culture. Above the canoe is strung a series of tourist items—sports caps promoting teams with names like "The Reds," cheap mass-produced figurines of Indians, lanyards, and other mass-produced beadworks. Collaged over and around the canoe are clippings relating the sad history of American Indians and photographs of the poverty-stricken daily life on the reservations. Smith offers the tourist items to pay for the return of the land. In *Paper Dolls*, Smith utilized the Barbie and Ken phenomenon. In the place of these two idealized white characters, she substituted the Plenty Horses family—Barbie Plenty Horses, Ken Plenty Horses, and their son, Bruce Plenty Horses. Barbie Plenty Horses has a rather plump, shapeless figure, as opposed to the tiny-waisted, big-breasted Mattel Barbie doll. Unlike white Barbie, who has countless costumes, she has only one outfit. Ken Plenty Horses has several outfits, but each refers to a different phase in his life. He starts out with his full

Native American regalia, but then his outfits reveal his degradation. He has a trading suit for receiving whiskey with gunpowder mixed in. He and Bruce have smallpox suits to wear when they contract smallpox from the infected blankets purposefully given to them by the government to kill them. The costumes finish up with a hospital gown that can be worn by the whole family when they contract tuberculosis.[34]

These are very effective political pieces because Smith's iconography is not esoteric. It is based on traditional Indian culture, but it resonates with traditional indigenous cultures worldwide and thus echoes the cultural heritages of viewers who are not Native American—rabbits, horses, wild animals like coyotes, and figurative line drawings reminiscent of ancient petroglyphs. It is also based on popular cultural images like the Barbie and Ken dolls she used in the *Plenty Horses Family* project. In addition, Smith often used text in the images to give clues as to the meaning of the works.

A wonderful example of Smith's use of popular images is her print *Celebrate 40,000 Years of Art*, featuring a parade of rabbits coming closer and closer to the viewer. The print was included in the journal *Frontiers* (published by the University of Nebraska) in a volume on indigenous culture. In the journal, Smith describes her choice of rabbits as her iconography:

> I chose rabbits as an art icon because there is a cultural universality to them throughout the world. Standing rabbits not only appear in petroglyphs in the Americas (these are from the Peterborough Site in Toronto, Canada), but in petrogylphs around the world as well. Japanese wood block prints, children's books (including those about Peter Rabbit), literature (for example, Richard Adam's novel, *Watership Down*, New York: Avon, 1972), the Easter Bunny, movies, pop culture images, and contemporary art such as Jeff Koons's stainless steel balloon rabbit and Barry Flanagan's bronze standing rabbits all give significance to my choice of art iconography. In educational institutions in this country, reference is often made to the age of America as being two hundred years or five hundred years, but because we still live under the aegis of colonial thinking,

it's never taken into consideration that some of the world's greatest cultures and cities were here in the Americas for thousands of years—and are still here. This etching is my succinct comment on colonial thinking.[35]

A fourth strategy that made Smith a successful leader was her emphasis on educating the public. She lectured and wrote ceaselessly to promote the collaboratives and exhibitions she organized. In her presentations, she upheld Native Americans not as preservers of their cultural heritage but rather as important artists who should be respected by the cultural mainstream. They were like Smith herself—artists who merged their traditional Native American heritage with mainstream Modernism. Many of them became well known in their own right.

Thanks to Jaune Quick-to-See Smith and other advocates of American Indian culture, we are all too familiar with the tragic history of American indigenous peoples—the genocide that left only a remnant of Native Americans to survive into the twenty-first century.[36] Another sad aspect of that history is the way in which their rich culture has been denigrated and dismissed as "savage." Through her activism, her paintings and prints, her lecture tours, and her writings, Smith has ceaselessly strived to change that colonialist perception and win admiration and inclusion for Native American culture in the American mainstream. Smith is a model for understanding how an individual working outside institutions can have an impact on the general society.

Notes

1 Brodsky and Olin communicated with Smith several times in 2015 and 2016, both by telephone and through emails.

2 Joni L. Murphy, "Beyond Sweetgrass: The Life and Art of Jaune Quick-to-See Smith" (PhD diss., University of Kansas, 2008), 6, https://kuscholarworks.ke .edu/bitstream/handle/1808/5335/Murphy_ku_0099D_10101-DATA_1.pdf ?sequence=1.

3 Murphy, 2–3.

4 Suzanne Fricke, "Jaune Quick-to-See-Smith, Trade (Gifts for Trading Land with White People)," Khan Academy, https://www.khanacademy.org/ humanities/global-culture/identity-body/identity-body-united-states/a/jaune -quick-to-see-smith-trade-gifts-for-trading-land-with-white-people.

5 Murphy, "Beyond Sweetgrass," 4; Jaune Quick-to-See Smith, "Once upon a Time . . . ," in *The Memories of Childhood . . . So We're Not the Cleavers or the Brady Bunch*, by Bernice Steinbaum (New York: Bernice Steinbaum Gallery, 1994), 43.

6 Lawrence Abbot, *I Stand in the Center of the Good: Interviews with Contemporary Native American Artists* (Lincoln: University of Nebraska Press, 1994).

7 Murphy, "Beyond Sweetgrass," 8. Jaune Quick-to-See Smith, personal communication with the author [Murphy], September 10, 2007.

8 Murphy, 9.

9 The government finally stopped imposing this policy in 1978, the same year that the United States government passed a law permitting Native Americans to practice their own religions, according to the award-winning Native American author Louise Erdrich. See Charles McGrath, "Obsessively Mining a Familial Landscape," *New York Times*, May 7, 2016, C-2. For a general history of the Bureau of Indian Affairs and an interpretation of the complex relationship between the U.S. government and Native Americans, see Christopher Brookerman, "The Native American Peoples of the United States," American Studies Resource Centre, Liverpool John Moores University, http://www.americansc.org.uk/Online/brookman.html.

10 Winona Garmhausen, *History of Indian Arts Education in Santa Fe* (Santa Fe: Sunstone Press, 1988).

11 "Olivia Davidson Washington," Encyclopedia.com, http://www.encyclopedia.com/women/encyclopedias-almanacs-transcripts-and-maps/washington-olivia-davidson-1854-1889.

12 Lucy Lippard, "Jaune Quick-to-See Smith's Public Art," in *Subversions/Affirmations: Jaune Quick-to-See Smith, A Survey*, ed. Alejandro Anreus (Jersey City: Jersey City Museum, 1996), 82.

13 Murphy, "Sweet Grass," 13.

14 Murphy, 13.

15 Jaune Quick-to-See Smith website, http://jaunequick-to-seesmith.com/bio-4/.

16 Lippard, "Jaune Quick-to-See Smith," 63.

17 Alejandro Anreus, "A Conversation with Jaune Quick-to-See Smith," *Subversions/Affirmations: Jaune Quick-to-See Smith* (Jersey City: Jersey City Museum, 1996), 110.

18 Anreus, 111–112.

19 Murphy, "Beyond Sweetgrass," 14; and personal communication with author, November 2, 2005.

20 Abbot, *I Stand*, 216.

21 Qualla Arts and Crafts Mutual, http://www.quallaartsandcrafts.com/history.php.

22 Judith K. Brodsky, "Exhibitions, Galleries, and Alternative Spaces," in *The Power of Feminist Art*, ed. Norma Broude and Mary D. Garrard (New York: Harry N. Abrams, 1994), 104–120.

23 Murphy, "Beyond Sweetgrass," 12.

24 Murphy, 14–16.

25 The American Indian Community House was established in 1969 to serve the Native American community in the New York metropolitan area and Native American reservations.

26 Murphy, "Beyond Sweetgrass," 17.

27 Harmony Hammond, *Lesbian Art in America: A Contemporary History* (New York: Random House, 2000). Also see her website, http://www .harmonyhammond.com.

28 Murphy, "Beyond Sweetgrass," 18, 19. Lippard wrote about Smith in several of her books. See the many references to Smith in *Mixed Blessings: Art in a Multicultural America* (New York: New Press, 2000).

29 *Our Land/Ourselves: American Indian Contemporary Artists*, an exhibition organized by the University Art Gallery, University at Albany, State University of New York; Paul Brach, Richard W. Hill Sr., Lucy R. Lippard, Jaune Quick-to-See Smith, University Art Gallery, University at Albany, SUNY, 1990.

30 Carolyn Kastner, *Jaune Quick-to-See Smith: An American Modernist* (Albuquerque: University of New Mexico Press, 2013), 8–13, 18–35. Also Mary Smyth Basquin, "Words Expand Postmodern Prints: Pat Steir, Jaune Quick-to-See Smith, Lynne Allen, and Lesley Dill" (PhD diss., Union Institute and University, Cincinnati, Ohio), 93–124. Available through UMI Dissertation Services.

31 For a comprehensive history of the feminist art movement, see Norma Broude and Mary Garrard, eds., *The Power of Feminist Art*.

32 Kastner, *Jaune Quick-to-See Smith*, 35.

33 For a more detailed discussion of the "I See Red" series and the relationship of the works in this series to the political work of African American artists of the period, see Kastner, 22–26.

34 Kastner, 51–59.

35 Murphy, "Beyond Sweetgrass," 58. Original source of quote is Jaune Quick-to-See Smith, "Celebrate 40,000 Years of American Art," special issue, "Indigenous Women," *Frontiers* 23, no. 2 (2002): 154–155. See Muse Project, Johns Hopkins University Library, for online viewing: https://muse.jhu.edu/article/12076.

36 In the United States now, there are about 5.2 million Native American, Alaska Natives, and mixed-race individuals compared with 45 million African Americans. See Lydia Millet, "Native Lives Matter, Too," *New York Times*, October 13, 2015, http://www.nytimes.com/2015/10/13/opinion/native-lives-matter-too .html.

Bibliography

Abbot, Lawrence. *I Stand in the Center of the Good: Interviews with Contemporary Native American Artists*. Lincoln: University of Nebraska Press, 1994.

Anreus, Alejandro. *Subversions/Affirmations: Jaune Quick-to-See Smith*. Jersey City: Jersey City Museum, 1996.

Basquin, Mary Smyth. "Words Expand Postmodern Prints: Pat Steir, Jaune Quick-to-See Smith, Lynne Allen, and Lesley Dill." PhD diss., Union Institute and University, Cincinnati, Ohio.

Brach, Paul, Richard W. Hill Sr., Lucy R. Lippard, and Jaune Quick-to-See Smith. *Our Land/Ourselves: American Indian Contemporary Artists: An Exhibition Organized by the University Art Gallery, University at Albany, State University of New York*. Albany: University Art Gallery, University at Albany, SUNY, 1990.

Brodsky, Judith K. "Exhibitions, Galleries, and Alternative Spaces." *The Power of Feminist Art*. Norma Broude and Mary D. Garrard, eds. New York; Harry N. Abrams, 1994.

Brodsky, Judith K., and Ferris Olin. Telephone interview on October 15, 2015. Smith sent supplementary emails following the interview. Notes and emails available.

Brookerman, Christopher. "The Native American Peoples of the United States." American Studies Resource Centre, Liverpool John Moores University. American Studies Resource Centre. http://www.americansc.org.uk/Online/brookman .html.

Broude, Norma, and Mary D. Garrard, eds. *The Power of Feminist Art: The American Movement of the 1970's History and Impact*. New York: Harry N. Abrams, 1994.

Encyclopedia.com. Women in World History: A Biographical Encyclopedia. "Olivia Davidson Washington." http://www.encyclopedia.com/women/encyclopedias -almanacs-transcripts-and-maps/washington-olivia-davidson-1854-1889.

Garmhausen, Winona. *History of Indian Arts Education in Santa Fe*. Santa Fe: Sunstone Press, 1988.

Green, Christopher. "When You Tell Someone You're an Artist That Is Native, They Tell You Who You Should Be." *Hyperallergic*, June 9, 2016. http://hyperallergic .com/304347/when-you-tell-someone-youre-an-artist-that-is-native-they-tell -you-who-you-should-be/.

Kaster, Carolyn. *Jaune Quick-to-See Smith: An American Modernist*. Albuquerque: University of New Mexico Press, 2013.

Lippard, Lucy. *Mixed Blessings: Art in a Multicultural America*. New York: New Press, 2000.

McGrath, Charles. "Obsessively Mining a Familial Landscape." *New York Times*, May 7, 2016. http://www.nytimes.com/2016/05/07/books/louise-erdrich-on-her -new-novel-larose-and-the-psychic-territory-of-native-americans.html.

Meier, Alison. "A Century of Indigenous Printmaking in North America." *Hyperallergic*, June 17, 2015. http://hyperallergic.com/214227/a-century-of-indigenous -printmaking-in-north-america/.

Millet, Lydia. "Native Lives Matter, Too." *New York Times*, October 13, 2015. http:// www.nytimes.com/2015/10/13/opinion/native-lives-matter-too.html.

Murphy, Joni L. "Beyond Sweetgrass: The Life and Art of Jaune Quick-to-See Smith." PhD diss., University of Kansas, 2008. https://kuscholarworks.ku .edu/bitstream/handle/1808/5335/Murphy_ku_0099D_10101_DATA_1.pdf ?sequence=1.

Nochlin. Linda. "Why Have There Been No Great Women Artists?," *ARTnews*, January 1971.

———."Why Have There Been No Great Women Artists?" *Women, Art, and Power, and Other Essays*. New York: Harper Collins, 1988.

Qualla Arts and Crafts Mutual. "History." http://www.quallaartsandcrafts.com/
history.php.

Raphael, Jody. "The History of Violence." *Women's Review of Books* 33, no. 2 (2016).

Regan, Sheila. "In Mainstream Museums, Confronting Colonialism While Curat-
ing Native American Art." *Hyperallergic*, June 26, 2015. http://hyperallergic
.com/217807/in-mainstream-museums-confronting-colonialism-while-curating
-native-american-art/.

Smith, Jaune Quick-to-See. "Celebrate 40,000 Years of American Art." Special
issue, "Indigenous Women," *Frontiers* 23, no. 2 (2002): 154–155. https://muse.jhu
.edu/article/12076.

———. "Once upon a Time . . ." In *The Memories of Childhood . . . So We're Not the
Cleavers or the Brady Bunch*, by Bernice Steinbaum. New York: Bernice Stein-
baum Gallery, 1994.

Tremblay, Gail. "Jaune Quick-to-See Smith: Flathead Contemporary Artist."
http://www.missoulaartmuseum.org/files/documents/collection/Montana
%20Connections_Smith/TremblayEssay.pdf.

FIGURE 10 Photograph portrait of Bernice Steinbaum. Photographer unknown. Reproduced by permission of Associated Press.

Bernice Steinbaum
Advancing Women Artists toward Parity in the Marketplace

Background

Angry over the injustice toward women artists, Bernice Steinbaum[1] abandoned an academic career to become their champion. She was teaching art history and art education at Hofstra University, but she was dismayed by the fact that the art history curriculum included no women artists. She reached a point where she felt that she could no longer promote a view of history that excluded women. But what was she to do now? One of her efforts to keep current with contemporary art trends and to fill her free time brought a solution. When she did her usual tour of the New York galleries to see the exhibitions on view, a light bulb went on in her head. None of the galleries were showing women artists or artists of color. No wonder they were not in the art history books. They were unknown and invisible to the mainstream art world: "As I visited the galleries and museums in New York several times a week, it occurred to me that many of the women and artists of color—Asians, Latinos, African-Americans and Native Americans—who were graduating with MFAs were not being shown at these places. And if dealers weren't exhibiting their works, and critics weren't writing about them, the museum curators were not going to discover them."[2] In response to the situation, Steinbaum decided that she would open a gallery featuring women artists and artists of color, thus helping promote their critical recognition and create a market for their work.

The gallery she established was a mainstream art gallery in New York City from 1977 to 2000. But it was unique among the

prominent galleries[3] because of its roster, which included 50 percent women and 35 percent artists of color.[4] Today, the inclusion of women artists in gallery and museum exhibitions, if not yet on par with men, is taken for granted.[5] Moreover, artists of color are beginning to receive their due.[6] While the 1970s and 1980s saw the rise of the Feminist Art Movement and multiculturalism among activists and academicians, the market for their artwork lagged behind. Steinbaum provided a link between the discourse and the marketplace, building a foundation for the visibility and financial and comparable remuneration of underrepresented artists. Steinbaum was knowledgeable in her field, a passionate feminist and advocate for ideals of equality, a willing risk taker, and a marketing ace. These characteristics led to her success.

Much has been written about the undervaluation of women's contributions in all fields. The gender gap in wages still exists, and although there is progress, it has slowed in recent years, nor is it likely to go away. In 2015, white women were still paid only at 79.6 percent of the salaries commanded by men, and the gap was starker in the salaries of women of color, with African American women at 63.3 percent and Hispanic women at 54.4 percent of white male compensation.[7]

The situation has been worse for women artists in the art market. In 2015, *Spider*, a sculpture by Louise Bourgeois, considered one of the most significant twentieth-century artists, sold for $25 million, 15 percent of the price of Picasso's painting *Les femmes d'Alger (Version 'O')*, which, at $160 million, was the highest price paid that year at auction for a work by a male artist. Nevertheless, despite the shocking gap in value, to reach even the height of 15 percent represents an advance. Before the 1970s, works by women artists were never auctioned off because there was no market for their work; and even today, the works by women artists that come to auction only make up 7 percent of the total.[8]

The 1970s saw the evolution of the Feminist Art Movement. Women artists and art historians became politically active, protesting the absence of women artists in major exhibitions and in museum collections, conducting research that revealed the fact that art faculties were almost entirely male while student bodies were

predominantly female, and undertaking statistical studies that showed women's exhibitions were woefully neglected in review journals.[9] Feminist art historians and curators mounted exhibitions and wrote books documenting historical women artists.[10] Professional organizations promoting recognition and parity for women in the visual arts had an impact on hiring and compensation.[11] And women artists, who were contributing new ideas to the cultural mainstream, began to emerge and become more visible to the art world.[12]

Today, the position of women in the visual arts is considerably improved, although it still has a long way to go. Women artists are critically acclaimed and included in art history survey textbooks and courses. Women artists and art historians now occupy faculty positions as well as curatorial positions in museums. But the monetary gap still persists, and male artists command the high prices collectors are willing to pay.[13]

Art has become a major global source of investment opportunity. Value has always played a role in collecting art. But value has been interpreted differently in various eras. The giants of the American industrial era advanced their social standing by fulfilling their civic duty through supporting the development of cultural institutions. The collections in the great American museums like the Metropolitan Museum in New York are based on gifts from donors like the Havemeyer family; the National Gallery in Washington, DC, was established with a gift from Andrew Mellon. Today, value has shifted from using art to obscure the origin of family fortunes in exploitative industrial development to viewing art as an investment. Buying art is now seen as offering as much, if not even more, of an opportunity to increase one's fortune than if one were to invest in equities.[14]

Galleries and auction houses serve as the conduit between artists and collectors. New York is the center of the art world, having replaced Paris after World War II. It is the location of more galleries than any other city in the world and the location of the most prestigious ones.

When asked how she came to create a gallery that would focus on women artists almost exclusively, Steinbaum said, "[I] was just

doing my job."[15] She relates an anecdote from her childhood. She describes herself as "a latch key kid." Her father, a rabbi, died on her eighth birthday. (She states that she gave up organized religion the same year.) Her mother, who had to go to work after her father's death, died nineteen years later, also on Steinbaum's birthday. She was one of five children. She went to the library every day after school. The library had long tables, and every day she saw the same man at the other end across from her. He always asked her what she was reading. One day he invited her to his studio. Although she said her mother wouldn't have liked it, she trusted him and went along. For a year she went to his studio, which was in a converted garage. He, his mother, and his brother, disabled because of cerebral palsy, lived in the house. He always asked her what she saw and talked about what he was making, describing his work as "making magic." The man was the artist Joseph Cornell (1903–1972). Although working quite differently from other contemporaries of his time, like Jackson Pollock and the abstractionists, whose work dominated the art world during the 1960s, Cornell became recognized. He created collages made from fragments, like the German artist Kurt Schwitters (1877–1948), an early Modernist who preceded Cornell. But unlike Schwitters, whose collages were usually two-dimensional and mostly came from litter, such as discarded theater tickets, Cornell's works of art were three-dimensional. They consisted of shadow boxes, the interiors of which were dreamlike tableaux composed of found fragments or objects he came upon and bought in antique stores. They usually had themes. He often made series such as the *Soap Bubble Series*, the *Pink Palace Series*, and the *Observatory Series*.[16] Steinbaum declares that she became a gallerist because she was excited by the connection to the artist—not so much to Cornell himself as to the visual, creative mind to which he introduced her.

By the time she decided to open a gallery, Steinbaum was already a feminist. She says she was aware as an undergraduate at Queens College (City University of New York) from 1957 to 1961 that she was not reading any books by women authors. Certain classes were not made available to her. She was told that women should not be at college at all, because "they will have babies." She knew that she did not want to be a homemaker; she went on to pursue a

master's degree at Hofstra University (1965) and received a PhD in art education from Columbia University (1977).

During the first half of the 1960s, Steinbaum lived in Iowa while her husband was enrolled in medical school. To help put him through school, she taught both in the Iowa public school system and at Drake University. On their return to New York, she took a job teaching art history at Hofstra University. Living in New York during the 1960s put her in the middle of the second wave of feminism. She had the opportunity to meet both founders of the National Organization for Women (NOW), Bella Abzug and Gloria Steinem. She also met Alice Walker, the author of *The Color Purple*. Walker was one of the women who inspired her to become a feminist. The novel and Walker's own life story gave Steinbaum insights into who she could be. When asked how she became a feminist, she declared, "If feminism has taught us anything, it has taught us that we can change the world."

Her exposure to feminism led to her agitation over the way art history was still being taught and her anger that so little had changed in spite of the second wave of feminism and the availability of books like Simone de Beauvoir's *The Second Sex* and Betty Friedan's *Feminine Mystique*. Most of the students in her class were young women. She also knew that 60 percent of the graduates of master of fine arts programs were women. There was a disconnect between the art history curriculum and real life.[17]

Resolution

Steinbaum's answer to her own anxiety was to quit teaching and do her part to insert women artists into the art history books. When she complained bitterly to her husband about how unhappy she was at Hofstra, he urged her to resign, but she found that staying at home was also unsatisfying. She says she became obsessed with housework simply because it gave her a goal. She describes cleaning the bathroom tiles with a toothbrush. Her husband then declared, "You have to go back to work." And so she did—by establishing her gallery. She announced to her husband that she had rented a space.

When he asked where, she said, "72nd and Madison." That corner was the epicenter of the art world in the mid-1970s. He exclaimed, "So expensive!" And she replied, "That's it."

Steinbaum was not shy. She tells the story of how she got the *New York Times* to cover the opening of her gallery:

> I decided to open a gallery. I found a space on Madison Avenue with a rent of $5000.00 a month. My husband was appalled and reminded me that I didn't even have art to show. "Not to worry," I said, "we'll use what we have in our house." I naively called the *New York Times* and told them that I was having an important art show and that they should be there for the opening with a camera. I think they were so taken with my stupidity, my chutzpah that they actually came! They did a story, giving me a page and a half in the *New York Times* and I was in business![18]

When she opened the gallery, she took works from their personal collection to see what would appeal to collectors. Her husband noticed and delivered a sarcastic remark: "What, our art is lend-lease?" She replied that they would replace them. Steinbaum and her husband were both born collectors. As a child, he had a marble collection. She had seashells. They began to collect art while still in Iowa. The first piece they acquired was by William Kortlander, an artist associated with the Middle West. Eventually, they donated the painting to a museum. They were also very early collectors of work by women artists and artists of color. The Steinbaums were excited by the work these artists were doing. They felt that women artists and artists of color were breaking new ground. They were greater risk takers because they had less to lose. When asked about where and when she first saw work by women artists, Steinbaum mentions the Native American artist Jaune Quick-to-See Smith[19] and prints by the Argentinian artist Liliana Porter. She also was reading books about women artists like the Surrealist artist Leonora Carrington.

Steinbaum describes her first marketing strategy as "Jewish guilt." Because her husband was an established physician, she socialized with well-to-do doctors and their wives. Many of these couples

were collecting art but hadn't thought about what they were collecting. She particularly worked on the women. She describes them as intelligent women who could absorb the message. They were in the process of reevaluating their own situations. Steinbaum says, "They had begun to write their own checks. They had put in their years as mommies and were now reaching out for wider experiences." She would say, "You have daughters, but no women artists in your collection." They were taking art tours, but awakened by Steinbaum, they realized that there were no works by women artists on view in the museums they were visiting. Steinbaum's gallery became the gallery of record on the tours so that they could see work by women artists.

Steinbaum's second marketing strategy was to tell stories about the art her prospective clients were viewing. She would make the narratives compelling. Her motive was not simply to sell the work; she also wanted to educate collectors. She wanted them to understand and appreciate the work for itself. She wanted to broaden their intellectual horizons to recognize that women were capable of making great art and to comprehend art beyond the traditional division by discipline, which characterized museums until only recently. For instance, any artwork based on textile materials was considered "decorative art" or "craft." In a traditional museum, it would not be placed in a painting gallery. And yet African American artist Faith Ringgold's story quilts, which Steinbaum introduced to the art world, are as much pictorial narratives as any oil paintings.[20] To give Ringgold's quilts a historical context, Steinbaum would talk about the quilting bee as a predecessor to an internet chat room. Today it would be called networking. The women quilters could talk about problems that couldn't be talked about elsewhere.

The two marketing strategies above were directed at potential collectors. Her third marketing strategy was, as Steinbaum herself puts it, "to collaborate with the artists." She worked to make her artists superstars. She took an interest in her artists as people. She says that "she gave them permission to be and to do, and that rather than her being in the forefront, she wanted her artists to be there."[21] Unlike most gallery owners, she was starting with a roster of artists who were not very well known, since as women artists or

artists of color, most had little access to the commercial art market. She helped them with various techniques for developing their careers. For instance, she coached them to understand the differences among group exhibitions, teaching them to distinguish a group exhibition that would enhance their standing in the art world from one that would diminish their reputation. So much depended on the institution mounting the exhibition. Was it a recognized museum? A gallery known for exhibiting well-known artists? Or was it a high school in a small town? She also instructed her artists to maintain their prices, not to succumb to selling a work at a lower price in order to make the sale. Even though the client might be a private one, nothing in the art world is secret, and word would spread. Steinbaum may have been the first gallerist to sell work by contemporary women artists in the high five-figure range and perhaps even for six figures.

One of Steinbaum's most successful strategies was organizing traveling exhibitions—hers was the first commercial gallery to do so. She reached out to curators across the country, and they were responsive. *The Definitive American Quilt* traveled for five years, and *Gardens Real and Imaginary* traveled to twenty museums, just to give two examples. Because she circulated exhibitions to galleries and museums, a significant number of curators came to know the work of her artists, and since the venues were often museums on college or university campuses, so did the art historians on the faculties. Thus she helped foster the long-term inclusion of her artists in the timeline of art history.

The names of artists Steinbaum represented now read like a who's who of American women artists. In addition to Faith Ringgold, the list includes Miriam Schapiro, one of the founders of the Feminist Art Movement of the 1970s. Schapiro introduced decoration and materials identified as female, such as lace and beautiful fabrics, as well as heart, house, fan, and kimono shapes, into her painting, thus precipitating a whole art movement called Pattern and Decoration (P&D). Steinbaum also represented the Native American artist Jaune Quick-to-See Smith. To introduce a Native American artist into the New York art world and make it seem normal was an audacious move on Steinbaum's part given the stereotypes held by the

majority of Americans about Native Americans. How could a Native American artist be considered seriously in the elitist realm of high art? Steinbaum points out the irony in the fact that no commercial gallery was representing a Native American on the island of Manhattan.[22] In 2015, the Metropolitan Museum of Art included a signature work by Smith in its exhibition *The Plains Indians: Artists of Earth and Sky* and commissioned her to create a lithograph edition in conjunction with the exhibition.

How Steinbaum helped with Beverly Buchanan's (1940–2015) career is an example of her strategy for creating "superstars." Buchanan was an African American artist whose sculptures are derived from the shacks in which slaves and freed blacks lived. Steinbaum first showed Buchanan's work in 1990. In that same year, Steinbaum arranged for Buchanan's sculptures to be shown in two additional venues. In 1991, Buchanan had another solo show at Steinbaum's gallery and two additional exhibitions. The next year, there were four exhibitions of Buchanan's sculptures at geographically diverse institutions. From 1994 to 1996, Steinbaum circulated a midcareer retrospective of Buchanan's work to ten institutions or galleries.[23] Through the extended visibility that Steinbaum accorded her, Beverly Buchanan became an important figure in modern and contemporary art. In 2016, she received a major retrospective at the world-renowned Brooklyn Museum.

In 2000, Steinbaum closed her New York gallery—not because it wasn't successful but because her three children were living in Miami, Florida, and she wanted to be near them. One was a physician, another an attorney, and the third a landscape architect. Her husband said, "Let's go visit the kids—New Year's Eve, outdoors, balmy weather, no snow!" He asked Steinbaum, "Can you move the gallery business to Miami?" She took risks, as she had always done, and moved to Miami. She refers to Miami in those days as "God's waiting room."

Her gallery was the first in the Wynwood area. Steinbaum wanted a good space. At that time, Wynwood was a warehouse district. When the realtor said it was not a safe space, Steinbaum said, "I'll make it safe." She explains in an interview in the *Miami New Times*, "When I purchased the building, my daughters were furious. . . . The

neighborhood was unsavory, and the lot across the street was dotted with rusting shipping containers. My building was being used as a crack house, and people were sleeping behind the walls. But they forgot that I'm from New York and had a New Yorker's savvy. I felt that this could really grow to become a great arts community." When pressed to reveal the cost of the property, she replies, "That's relative. But I can tell you I invested a small fortune repairing cracked windows and clearing the cokeheads and drug paraphernalia and needles that littered the space to turn it into a respectable cultural institution."[24]

Within two years, Steinbaum had transformed the property into one of Miami's prestigious art galleries and established Wynwood as an arts district.[25] The success of the gallery exceeded expectations, representing "three MacArthur 'genius grant' recipients—Pepón Osorio, Amalia Mesa-Bains, and Deborah Willis—five Guggenheim fellows, multiple National Endowment for the Arts award winners, two Annenberg fellows, and other lauded artists."[26] By the time she closed the Wynwood gallery in 2012, eighty-six galleries had relocated there. According to Rifas, one of the artists she represented, "Bernice was a real mover . . . my gosh, I know she helped people in the community in many ways—from serving on committees judging student shows for the University of Miami arts program to organizing a salon of artists who were left out of Art Basel during its first year. Her gallery is probably the nicest place to show in all Miami."[27]

Before she closed her space, Steinbaum tried to help her artists find alternative gallery representation. She remarked, "Some of my artists I've helped put in other programs, some are still in the process of finding a new place, but not all will remain in Miami. . . . Some of them feel they are not receiving appropriate feedback for their work here. . . . Miami has matured into a thriving arts town with the presence of Art Basel [Miami's international art fair]." In 2017, Steinbaum opened a new gallery in Miami.

Steinbaum influenced a new generation of artists who were making their own mark on the art scene, as former assistant Nina Johnson-Milewski attests: "Bernice Steinbaum was my mentor for many years. I started working with her when I was 15, and she helped

shape who I am, not only as a professional but also a person. . . . Bernice is an educator at heart and always treated her gallery as an educational hub—mentoring artists, interns, and anyone who came through the door."[28]

When asked about her legacy, Steinbaum says, "My grandchildren will know that [I] did more than bake chocolate chip cookies." Indeed, she did. She raised the visibility and the value of the work of women artists and artists of color. She established a floor underneath their prices from which the value of their art has gone steadily up. In 2016, one of Faith Ringgold's important paintings pertaining to the civil rights upheaval during the 1980s was acquired by the Museum of Modern Art in New York for seven figures.

Steinbaum's life crisis led her to a career. She had reached a point in her life where she needed to find a direction to make her life meaningful and was able to develop a plan that grew out of her education and interests. She was well educated in her field so that she could make intelligent judgments about the quality of artists' work. She was passionate in her belief in feminism and the importance of making women's voices heard. Rather than going off in a direction that would have nothing to do with her skills and might have led to failure, she started the gallery. She was undertaking a risky venture but knew the field well enough to limit her risks. In starting the gallery, she was bold—by taking a space that was identified as a prime gallery location, she gave her enterprise instant prestige. Then she became a marketing expert, using emotional appeals to sell the work. Initially, she persuaded her friends and acquaintances, who were fairly well-to-do and could afford to buy art. Knowing that the women among her friends were still traditional housewives and therefore the ones who spent the money in decorating their homes, she approached them as her potential customers. Then she educated them in feminism, bringing them to realize the importance of supporting women artists. She also made them feel like art experts, educating them through visits to the gallery. And then, in the best marketing tradition, she told them stories about the artwork and the artists themselves. These tactics provided her with a financial base of clients from which she could then expand. She also believed in her artists and did everything she could to advance their

careers, educating them to make good career choices and providing them with geographically diverse exhibitions that would help make them household names. At the same time that she was working on their behalf, she was also ensuring the success of the gallery, since its recognition would increase sales.

Steinbaum was resilient. To pick up and move to Florida, open another gallery, and make the new space a success was a challenge. She made the Miami gallery successful through the same leadership skills she had employed in New York. Realizing the potential for promoting the careers of artists from Latin America, she made showing their work and helping their careers the central mission of her new gallery. At the same time, she continued to work on behalf of women artists and artists of color. She herself became a visible person in the Miami art community, working to promote the community as a whole and playing a key role in the development of Miami Art Week. Steinbaum's gallery was one of the few local galleries to be included in the first three editions of Miami Art Basel, but in 2005, when she was declined an invitation, "she gave a legion of supporters her trademark white bedroom slippers, stamped with her gallery logo, to wear at the Miami Beach Convention Center that year."[29] Subsequently, Miami Art Week, which takes place early in December annually, has evolved into an event considered one of the most important venues for seeing contemporary art. There are now twenty-one fairs, including Art Miami, which was the first.

Steinbaum's energy, perseverance, and attention to marketing were hallmarks of her leadership. She has received many honors, ranging from the Woman of the Year Award from NOW in 1988 to the Perez Art Museum gala honoree in 2017. A film about her life, *Bernice*, was released in 2015. The film, by Kristina Sorge, features interviews with artists whom Steinbaum represented, including Faith Ringgold, Hung Liu, Amalia Mesa-Bains, and Magdalena Campos Pons.

She was honored for lifetime achievement by the Women's Caucus for Art in 2012 with a citation that read, "We honor you, Bernice Steinbaum, for your indomitable drive and your trailblazing gallery that showcases women artists and artists of color."[30]

Notes

1 Bernice Steinbaum was interviewed by Judith K. Brodsky and Ferris Olin on September 11, 2016. Direct quotes from that conversation can be found in the body of the text.

2 Carlos Suarez de Jesus, "Bernice Steinbaum, Miami Art Matron, Departs," *Miami New Times*, June 21, 2012, http://www.miaminewtimes.com/arts/ bernice-steinbaum-miami-art-matron-departs-6387181.

3 Lydia Martin, "Miami Gallery Pioneer Bernice Steinbaum Moves On," *Miami Herald*, July 8, 2012, http://www.miamiherald.com/latest-news/article1941031 .html.

4 Women artists had already established alternative galleries, usually co-ops where they ran the galleries themselves, but their success in the wider art marketplace was limited. They helped develop recognition for their artists, but not a market for their work. A.I.R., founded in 1972, was the first to be established; it is the best known and is still operating today. It should also be noted that there were women gallerists among the mainstream galleries, but they followed in the steps of their male colleagues and represented few women, if any. For more information on alternative women's galleries, see Judith K. Brodsky, "Exhibitions, Galleries, and Alternative Spaces," in *The Power of Feminist Art: The American Movement of the 1970s, History and Impact*, ed. Norma Broude and Mary D. Garrard (New York: Harry N. Abrams, 1994), 104–119. For information on women gallerists, see Lizzie Crocker, "Is the Art World Truly Sexist?," *The Daily Beast*, May 30, 2015, http://www.thedailybeast.com/articles/2015/05/30/ is-the-art-world-truly-sexist.html.

5 Maura Reilly, "Taking the Measure of Sexism: Facts, Figures, and Fixes," *ARTnews*, May 2015, http://www.artnews.com/2015/05/26/taking-the-measure-of -sexism-facts-figures-and-fixes/.

6 Randy Kennedy, "Black Artists and the March into Museums," *New York Times*, November 28, 2015, http://www.nytimes.com/2015/11/29/arts/design/black -artists-and-the-march-into-the-museum.html.

7 Ariane Hegewisch and Asha DuMonthier, "The Gender Wage Gap 2015: Annual Earnings Differences by Gender, Race, and Ethnicity," Institute for Women's Policy Research, September 2016, http://www.iwpr.org/publications/pubs/ the-gender-wage-gap-2015-annual-earnings-differences-by-gender-race-and -ethnicity.

8 Hannah Ghorashi, "Inequality Endures: The Price of Being a Female Artists in 2015," *ARTnews*, December 2015, http://www.artnews.com/2015/12/30/women -art-status-in-2015/.

9 Rosalie Braeutigam, Betty Fiske, and June Wayne, *Sex Differentials in Art Exhibition Reviews: A Statistical Study* (Albuquerque, N.M.: Tamarind Lithography Workshop, 1972). Also see Grace Glueck, "No Fair Play for the Fair Sex," *New York Times*, June 11, 1972; and Ferris Olin and Catherine Coleman Brawer, "Career Markers," in *Making Their Mark: Women Artists Move into the*

Mainstream, 1970–1985, ed. Randy Rosen and Catherine Coleman Brawer.

10 Linda Nochlin, "Why Have There Been No Great Women Artists?," first published in *ARTnews*, January 1971, 22–39, 67–71, and then in *Women, Art, and Power, and Other Essays* (New York: Harper Collins, 1988); also see Judith K. Brodsky, "Setting the Stage," in Changing the Equation, Women's Leadership in the Visual Arts, 1980–2005, ed. Barbara Cavaliere. (New York: ArtTable, 2005). See preface note 1 for more information on Linda Nochlin and her impact on the Feminist Art Movement.

11 The Women's Caucus for Art and the College Art Association first carried out the surveys that revealed the discrimination against women art historians and artists in academic institutions. Records of the Women's Caucus for Art, the Miriam Schapiro Archives of the Papers of Women Artists, Rutgers University Libraries.

12 Documentation of the 1970s feminist art movement by women artists and art historians active during the period can be found in Norma Broude and Mary D. Garrard, eds., *The Power of Feminist Art: The American Movement of the 1970's History and Impact* (New York: Harry N. Abrams, 1994).

13 Reilly, "Taking the Measure."

14 Suzanne Muchnic, "American Art Collectors Ripe for Study," *Los Angeles Times*, July 18, 2010; see also the Center for the History of Collecting in America at the Frick Art Reference Library, http://www.frick.org/research/center.

15 Steinbaum's personal history is based on the interview conducted by Brodsky and Olin on September 11, 2015. Steinbaum also recounts her history in the film by Kristina Sorge, dir., *Women in Art: Bernice Steinbaum* (n.p.: Lightbox Media, 2015).

16 Olivia Laing, "Joseph Cornell: How the Reclusive Artist Conquered the Art World from His Mum's Basement," *Guardian*, July 25, 2015, https://www.theguardian.com/artanddesign/2015/jul/25/joseph-cornell-wanderlust-royal-academy-exhibition-london.

17 Reilly, "Taking the Measure."

18 Marilyn Stewart, "Bernice Steinbaum: Life in a SOHO Gallery," *School Arts*, October 1, 1998, https://www.thefreelibrary.com/Bernice+Steinbaum%3a+life+in+a+SOHO+gallery.-a021137644.

19 Smith is also the subject of a case study in this book. See chapter 6.

20 Andrew Russeth, "The Story Teller: At 85, Her Star Still Rising, Faith Ringgold Looks Back on Her Life in Art, Activism, and Education," *ARTnews*, March 1, 2016, http://www.artnews.com/2016/03/01/the-storyteller-faith-ringgold/. See also Ringgold's official website at http://www.faithringgold.com.

21 Telephone conversation with Judith K. Brodsky, December 2016.

22 Telephone conversation with Brodsky, December 2016.

23 See Beverly Buchanan's Solo Exhibitions, http://beverlybuchanan.com/about/solo-exhibitions/.

24 Suarez de Jesus, "Bernice Steinbaum."

25 Jose Fresco, "10 Questions for Bernice Steinbaum," *The Smiley Stone*, September 28, 2011, http://smileystone.com/10-questions-for-bernice-steinbaum/.

26 Fresco.
27 Suarez de Jesus, "Bernice Steinbaum."
28 Suarez de Jesus.
29 Suarez de Jesus.
30 "Women's Caucus for Art 2012 Honor Awards," Women's Caucus for Art, 48, https://www.nationalwca.org/LTA/LTA2012.pdf.

Bibliography

Braeutigam, Rosalie, Betty Fiske, and June Wayne. *Sex Differentials in Art Exhibition Reviews: A Statistical Study*. Albuquerque, N.M.: Tamarind Lithography Workshop, 1972.

Brodsky, Judith K. "Exhibitions, Galleries, and Alternative Spaces." *The Power of Feminist Art: The American Movement of the 1970s, History and Impact*, Norma Broude and Mary D. Garrard, eds. New York: Harry N. Abrams, 1994.

———. "Setting the Stage." *Changing the Equation, Women's Leadership in the Visual Arts, 1980–2005*, Barbara Cavaliere, ed. New York: ArtTable, 2005.

Crocker, Lizzie. "Is the Art World Truly Sexist?" *The Daily Beast*, May 30, 2015. http://www.thedailybeast.com/articles/2015/05/30/is-the-art-world-truly-sexist.html.

Fresco, Jose. "10 Questions for Bernice Steinbaum." *The Smiley Stone*, September 28, 2011. http://smileystone.com/10-questions-for-bernice-steinbaum/.

Ghorashi, Hannah. "Inequality Endures: The Price of Being a Female Artist in 2015." *ARTnews*, December 2015. http://www.artnews.com/2015/12/30/women-art-status-in-2015/.

Glueck, Grace. "No Fair Play for the Fair Sex." *New York Times*, June 11, 1972. http://www.nytimes.com/1972/06/11/archives/no-fair-play-for-the-fair-sex.html?_r=0.

Hegewisch, Ariane, and Asha DuMonthier. "The Gender Wage Gap 2015: Annual Earnings Differences by Gender, Race, and Ethnicity." Institute for Women's Policy Research, September 2016. http://www.iwpr.org/publications/pubs/the-gender-wage-gap-2015-annual-earnings-differences-by-gender-race-and-ethnicity.

Kennedy, Randy. "Black Artists and the March into Museums." *New York Times*, November 29, 2015. http://www.nytimes.com/2015/11/29/arts/design/black-artists-and-the-march-into-the-museum.html.

Laing, Olivia. "Joseph Cornell: How the Reclusive Artist Conquered the Art World from His Mum's Basement." *Guardian*, July 25, 2015. https://www.theguardian.com/artanddesign/2015/jul/25/joseph-cornell-wanderlust-royal-academy-exhibition-london.

Martin, Lydia. "Miami Gallery Pioneer Bernice Steinbaum Moves On." *Miami Herald*, July 8, 2012. http://www.miamiherald.com/latest-news/article1941031.html.

Muchnic, Suzanne. "American Art Collectors Ripe for Study." *Los Angeles Times*, July 18, 2010. http://articles.latimes.com/2010/jul/18/entertainment/la-ca-collectors-20100718.

Nochlin, Linda. "Why Have There Been No Great Women Artists?" *ARTnews*, January 1971.

———. *Women, Art, and Power, and Other Essays*. New York: Harper Collins, 1988.

Olin, Ferris, and Catherine Coleman Brawer. "Career Markers." *Making Their Mark: Women Artists Move into the Mainstream, 1970–1985*, Randy Rosen and Catherine Coleman Brawer, eds. New York: Abbeville Press, 1989.

Reilly, Maura. "Taking the Measure of Sexism: Facts, Figures, and Fixes." *ARTnews*, May 2015. http://www.artnews.com/2015/05/26/taking-the-measure-of-sexism-facts-figures-and-fixes/.

Russeth, Andrew. "The Story Teller: At 85, Her Star Still Rising, Faith Ringgold Looks Back on Her Life in Art, Activism, and Education." *ARTnews*, March 1, 2016. http://www.artnews.com/2016/03/01/the-storyteller-faith-ringgold/.

Sider, Sandra. "Womanhouse: Cradle of Feminist Art." *Art Spaces Archives Project*, August 5, 2010. http://as-ap.org/content/womanhouse-cradle-feminist-art-sandra-sider-0.

Sorge, Kristina, dir. *Women in Art: Bernice Steinbaum*. N.p.: Lightbox Media, 2015.

Stewart, Marilyn. "Bernice Steinbaum: Life in a SOHO Gallery." *School Arts*, October 1, 1998. https://www.thefreelibrary.com/Bernice+Steinbaum%3a+life+in+a+SOHO+gallery.-a021137644.

Suarez de Jesus, Carlos. "Bernice Steinbaum, Miami Art Matron, Departs." *Miami New Times*, June 21, 2012. http://www.miaminewtimes.com/arts/bernice-steinbaum-miami-art-matron-departs-6387181.

Women's Caucus for Art. "Women's Caucus for Art 2012 Honor Awards." https://www.nationalwca.org/LTA/LTA2012.pdf.

FIGURE 11 Portrait of Anne d'Harnoncourt from the *Philadelphia Inquirer*. Photograph by Bonnie Welles. Courtesy of the Philadelphia Museum of Art.

Anne d'Harnoncourt

Showing That Women Can Run
Major Cultural Institutions Successfully

Background

Anne d'Harnoncourt, director of the Philadelphia Museum of Art
from 1982 to 2008, was larger than life.[1] While she wasn't the first
woman to head a major museum in the United States, she broke
the glass ceiling to become an international figure, a symbol for the
effectiveness of women at the helm of large art institutions.[2]
She died suddenly on June 1, 2008, at the age of sixty-five, while
still in office. During her tenure at the Philadelphia Museum of Art,
d'Harnoncourt was the only woman to head a major museum in the
United States, except for the years 2000 to 2005, when Katherine
Lee headed the Cleveland Museum.[3] D'Harnoncourt's reputation
was so impressive that although it was an era when women were
still not generally thought of as leaders of America's most presti-
gious cultural institutions, she was reportedly courted by institu-
tions like the Museum of Modern Art (MoMA) in New York and the
National Gallery in Washington, DC.

Although one might think that once the top ranks had been
breached by d'Harnoncourt, more women might rise to the upper-
most levels, that has only partially happened. An overview con-
ducted by the American Association of Museum Directors, issued
in 2014, shows that women comprise the directorships of almost
half the art museums in the United States, but mostly at smaller
museums. Women still remain few and far between as CEOs of
the largest museums, like the Metropolitan Museum of Art or the
Whitney Museum of American Art in New York, the Art Institute

FIGURE 12 Anne d'Harnoncourt with Hilary Clinton. Photographer and date unknown. Courtesy of the Philadelphia Museum of Art.

of Chicago, the National Gallery of Art in Washington, DC, the Fine Art Museums of San Francisco, the Louvre in Paris, or the Hermitage in St. Petersburg, let alone the museums of countries in Asia, South America, or Africa.[4] An exception is the appointment of Maria Balshaw in January 2017 as director of the Tate galleries in London; Balshaw is the first woman to be the head of one of the largest museums in England.[5] In opening remarks at the American Alliance of Museums meeting in 2016, Kaywin Feldman reported that of the seventeen largest American museums (defined as having annual budgets over $30 million), there are only two women directors.[6] One is Feldman herself, and Anne Pasternak at the Brooklyn Museum is the other. And even more alarming is the fact that women art museum directors are paid less than their male counterparts.[7] The gender gap in pay in museums in the United Kingdom is documented in a 2018 report.[8] Feldman commented, "When professions become mostly female, they become less well respected and more poorly paid. After all, if so many women can do the job, how hard can it really be?"[9] Furthermore, Feldman described the bias against women: "We are worried that she has no gravitas."[10]

What led to d'Harnoncourt's rise in the museum world? Will she continue to be one of only a few women to make it to the summit in the art museum world? Or are there aspects of her career and life that we can look to so that women can emulate her success and occupy more leadership positions?

Why is it important for more women to lead the major museums of the world? Study after study shows that it does make a difference. Museums led by women develop policies that broaden collections to include more work by artists from diverse backgrounds. With the United States and the countries of Western Europe soon to have majority non-Caucasian populations, museums must address cultural diversity if they are going to remain relevant.[11]

The Philadelphia Museum is one of the great art historical museums of the world. It was established after the 1876 Centennial Exhibition celebrating the Declaration of Independence. The exhibition grounds contained a number of buildings, some of which still exist today. The intention was to use the fine arts building, Memorial Hall, for an institution that would house the artifacts from the Centennial Exhibition and also include a school for applied arts. In 1895, the city allocated funds for a new building that would be closer to downtown (called Center City by Philadelphia residents), but construction didn't begin until 1919, and the main central part of the building wasn't completed until 1928. The building sits on a promontory overlooking the Schuylkill River, which bisects Philadelphia, and is the culmination of Benjamin Franklin Boulevard, which runs diagonally from City Hall to the museum. It is an outstanding example of Neoclassical architecture as well as the first polychromed Neoclassical structure. Neoclassicism is a style of American and European architecture used for official buildings evoking Greek or Roman temples. It was a grandiose style intended to signify the connection of Western culture to its heritage in the classical world.[12]

The museum collection grew largely through gifts from prominent Philadelphians. It includes masterpieces of European and American painting and sculpture from all periods; a collection of decorative arts, including furniture, textiles, and ceramics; extensive holdings in

art from Asian cultures, featuring a Chinese temple and a Japanese teahouse; and a comprehensive body of prints, drawings, and photographs. It has the largest holding of work by one of the foremost nineteenth-century American artists, Thomas Eakins, who lived and taught in Philadelphia.[13]

Anne d'Harnoncourt came from a background that prepared her for a position in the art world. She was born in 1943 in Washington, DC, where her father, René d'Harnoncourt, was the manager of the Indian Arts and Crafts Board. He had become well known as an expert in Native American and Latin American arts, and it was, in part, due to her father that Native American art became accepted in the canon of world art. He came to New York in a roundabout way, first going to Mexico to find a job (he had trained as a chemist). In Mexico, he met Dwight Morrow, the American ambassador to Mexico, and his wife, Elizabeth. They collected Mexican folk art and were the ones who introduced d'Harnoncourt to the world of collecting. Through the Morrows, he came to the United States in 1943, the year of Anne d'Harnoncourt's birth, to become vice president of foreign activities and director of the Department of Manual Industries at the MoMA. He eventually became MoMA's director, a position he held for nineteen years, from 1949 to 1968.[14]

In an interview with d'Harnoncourt preserved in the archives of the MoMA, she spoke about the influence of her father—not only his broad esthetic interests but also his curatorial abilities to organize an exhibition and make it accessible and appealing to audiences despite their unfamiliarity with the work. A historical note published by the Philadelphia Museum reports that d'Harnoncourt's earliest memories were the times that she would spend leafing through her parents' books.[15] Also documented are the titles of the artworks that became her first favorites: Henri Matisse's *Blue Window* and the *Piano Lesson*, as well as Picasso's memorial to the Spanish Civil War, *Guernica*, all key Modernist works.[16]

She attended the Brearley School in New York, a private, all-girls school with a reputation for rigorous academic standards and an indepth education in all areas. Brearley would also give d'Harnoncourt friendships that would be useful to her in her career, since the young women who were enrolled came from prestigious families,

and many emerged in later life as cultural, political, academic, and philanthropic figures of importance.

She went on to Radcliffe College, Harvard University's college for women, for her undergraduate degree, which she received in 1965. The only distinction between Radcliffe and Harvard College was the fact that male and female students lived separately. All classes were coeducational.[17] She majored in history and literature, a field restricted to top students and open only upon invitation. Although she had a lifelong habit of drawing, she didn't take courses in art history for most of her college career. It wasn't until her senior year that she took classes in the history of architecture and audited a course in Chinese painting. These experiences led her to enroll in graduate studies at the Courtauld Institute of Art, University of London, to immerse herself in art history. It should be noted that she was an outstanding student at Harvard and graduated with high honors.[18]

During her studies at the Courtauld, she worked at the Tate Gallery in London. The Tate has several branches. The two in London are the original Tate Gallery—restricted to collecting only British art—and Tate Modern, which contains international modern and contemporary art.[19] She was writing her master's thesis on a group of mid-nineteenth-century English painters called the Pre-Raphaelites because they wanted to base their painting style on early Renaissance painting—before Raphael.[20] They were seeking to break out of a worn-out tradition just like the Impressionists, but unlike the Impressionists, they were looking to the past for new ideas rather than to the future.[21] They saw these painters (for instance, Botticelli and Fra Angelico) as expressing a purity that became lost in later art and thought of themselves as sweeping away the influence of Raphael, which they viewed as having become corrupt and decorative in the hands of academicians. While working at the Tate, d'Harnoncourt wrote the catalog entries for thirty Pre-Raphaelite works in the museum's collection.

When she returned to the United States, she looked for a job in a museum. Her father called some colleagues on her behalf, but no positions were available at the museums they directed. In London, however, d'Harnoncourt had met an assistant curator at the

Philadelphia Museum. He suggested that she be interviewed by Evan Turner, then the director, who hired her as a curatorial assistant in the painting and sculpture department.[22]

The Philadelphia Museum has an extraordinary collection of early twentieth-century avant-garde art, a gift from the collectors Walter and Louise Arensberg. It contains early work by the leading artists of the period—Picasso, Braque, Mondrian, Matisse, Brancusi, de Chirico, and Marcel Duchamp. The first five are pioneers in various kinds of abstraction; de Chirico is a predecessor of the Surrealists; and Duchamp is one of the earliest artists to delve into the absurd (his work, a urinal, which he put forward as a sculpture with the title *Fountain*, became a scandal at the Independent Artists Exhibition, an exhibition meant to feature the most advanced contemporary art, in New York in 1917).[23]

Just as d'Harnoncourt had been attracted to the Pre-Raphaelites by their risk taking, so she became interested in the artists of the Arensbergs' collection, all of whom were inventing new artistic visions. She wanted to know more about the Arensbergs and how the collection was formed. Duchamp had been an advisor to the Arensbergs. He was living in New York, so d'Harnoncourt decided to go and interview him, and they subsequently became close friends. Many works by Duchamp were already in the Arensbergs' collection, and in 1954, the *Large Glass*, subtitled *The Bride Stripped Bare by Her Bachelors, Even*, one of his signature works, entered the collection through the bequest of Katherine Dreier, in whose collection it had resided for decades. D'Harnoncourt was responsible for the installation. Duchamp himself worked with d'Harnoncourt to select the location and supervised the installation.[24]

When Duchamp died in 1968, it was believed in the art world that he had stopped his art practice years earlier. Indeed, he himself had declared that he no longer would make art but devote himself to chess. Instead, he did continue to make art and willed his last piece, an installation titled *Etant donnés: 1. La chute d'eau, 2. Le gaz d'éclairage* . . . , to the Philadelphia Museum. D'Harnoncourt helped Paul Matisse, Duchamp's stepson, dismantle the installation in order to ship it to Philadelphia and in the process became friendly with Duchamp's widow, who introduced her to important cultural

figures like the composer and artist John Cage; Jasper Johns, one of the giants in art of the second half of the twentieth century; and Duchamp's daughter, Jacqueline Matisse Monnier, also an artist, who became a lifelong friend.

The installation is in a dark corner. One's first view of it is a rough wall made of vertical wooden planks with holes to look through. The interior installation, seen only through the eye holes, shows a scene with a nude female figure, who looks like a store window mannequin, lying in a bed of foliage with a fake waterfall, which, through lighting, is made to look as if it is flowing. Walter Hopps, a distinguished curator of contemporary art, was invited to write the essay for the catalog, and he invited d'Harnoncourt to write it with him. According to the interview with d'Harnoncourt in the MoMA archives, d'Harnoncourt declared that their collaboration was her "real plunging into the art world."[25]

Shortly after *Etant donnés* was installed, d'Harnoncourt went to work at the Art Institute of Chicago. Accepting a position at another museum validated her expertise and abilities. Her change of job resulted in an invitation from the Philadelphia Museum to rejoin at the higher level of Associate Curator of Twentieth Century Painting. She met her husband, the curator Joseph J. Rishel, at the Art Institute of Chicago. He left Chicago and took a position as curator of European art before 1900 at the Philadelphia Museum at the same time that d'Harnoncourt took her new post. Thus they were able to stay together.[26]

The important exhibitions that d'Harnoncourt organized are too numerous to describe here. She became one of the most respected and influential curators of modern and contemporary art, known not only for the substance of her exhibitions but also for the elegance and effectiveness of their presentation, values she said she learned from her father. After fourteen years as curator, d'Harnoncourt, at the young age of thirty-eight, was named the George D. Widener Director of the Philadelphia Museum of Art in 1982. While she had thoroughly demonstrated her scholarship, her understanding of museum practice, her skills at dealing with people, and her willingness to take the initiative, she was faced with the responsibility of running a major museum.

When she took over, the museum was at its nadir. It was impoverished (having the lowest endowment of any museum its size), many galleries were frequently closed because of a lack of guards, and it had a very low profile in the community. D'Harnoncourt's challenge then was to find the strategies that would rectify the situation.

Resolution

Initially, d'Harnoncourt was only responsible for the exhibitions and programs of the museum, not for the fiscal and administrative areas, which were the responsibility of president and chief executive officer Robert Montgomery Scott. But by the time Robert Montgomery Scott retired, she, in partnership with Scott, her husband, and others, had transformed the museum. The museum's endowment doubled, and the building underwent major renovation as the result of a successful capital campaign titled the Landmark Renewal Fund. The collections were expanded significantly. The infrastructure was modernized, and the museum entered the digital age. Through exciting exhibitions, a reorganization of the education department, and the publishing of informational materials, the museum attracted its best attendance up to that point in its history. It was clear from her success in fund-raising, in building the collection, and in upgrading every aspect of the museum's operation that she was capable of taking over complete responsibility for the museum, and thus she was made chief executive officer as well as director.[27]

D'Harnoncourt's overall accomplishments in directing the museum are massive. In the limited space of this case study, it would be impossible to describe all the actions she undertook to demonstrate the tactics that made her effective as a leader to restore the museum to its rightful place as one of the great museums of the world and make it an institution geared to serving the public.

The overriding principle of d'Harnoncourt's leadership was to make the museum serve its constituencies better. She was particularly concerned about the role of the museum in educating the

general public. There was one huge obstacle to developing effective educational programs—the way the Johnson Collection, one of the most important collections in the museum, was installed in the galleries. The collection contains 1,200 paintings—important historical works by early Renaissance Italian, Flemish, and Dutch paintings but also many works by artists alive during Johnson's lifetime, such as Edouard Manet, Claude Monet, John Singer Sargent, and James Whistler. For years, visitors, both casual and scholarly, wandered back and forth among the galleries, puzzled by the lack of organization. John G. Johnson had stipulated in his will that the museum was obligated to mount the paintings as a group separate from the rest of the museum's collection. While this restriction may not sound very serious, keeping a collection apart from the rest of the museum is an impediment to any rational arrangement that a museum might want to establish—a chronological sequence of galleries or a set of galleries devoted to particular subject matter, for instance. No directors before d'Harnoncourt questioned the arrangement. D'Harnoncourt, with Rishel, developed a reorganization plan to make the collection more accessible to visitors and allocated the funds to implement it. But in order to make the changes, she had to contest Johnson's will in Orphan's Court, a process that took many years.

Just to give a little history of the situation, Johnson was a lawyer for the industrial giants often referred to as the robber barons, including the founders of Standard Oil, the Sugar Trust, the American Tobacco Company, the Pennsylvania Railroad, and the United States Steel Corporation. These companies exploited cheap labor and became the target of strikes. Their callousness and abuses led to the creation of unions. When these men became wealthy (Johnson was the son of a blacksmith), they built art collections and gave them to museums as a way of establishing themselves in high society.[28] Johnson's will stipulated that the collection be donated to the city of Philadelphia (not the museum), kept intact, and shown in his house. Eventually, the house deteriorated to such a degree that the situation was no longer feasible, and the collection was transferred to the museum. It is still owned by the city (although administered by the museum). When the Johnson Collection was

transferred to the museum, the stipulation remained in place. D'Harnoncourt was successful in her effort to break the will, and today the Johnson Collection is integrated into the overall holdings of the museum with educational programs that help the public understand and enjoy its holdings.[29] Edward Sozanski, writing in the *Philadelphia Inquirer*, said of the effort,

> The Philadelphia Museum of Art should be commended for allocating $9.4 million to reorganize its European collections. Regardless of what the galleries will look like three years hence, the project affirms that caring for the permanent collection is really the most important thing an art museum can do, for the collection is its heart and its soul. Permanent collections aren't nearly as glamorous as special exhibitions, and they're difficult to promote. That's why this project represents an extraordinary commitment on the part of an American museum. Through this project, the Art Museum is reminding its constituency what its mission really is. The reinstallation project is not about bricks and mortar, or about creating exciting new appendages to the building. It's about interpretation—how art work is presented, how it's understood—which is more intangible. Every aspect of the project, which will be carried out in four overlapping phases, is directed at enhancing the public's ability to appreciate what the building contains.[30]

Integrating the Johnson Collection into the overall plan of the museum's galleries was only one example of d'Harnoncourt's leadership in improving the museum's educational programs to serve the public better. Museum education has long been an important aspect of museums in the United States, but its effectiveness was debatable. D'Harnoncourt partnered with Danielle Rice, at first Curator of Education and later Senior Curator of Education. In 2001, going even further in emphasizing the central role of education, d'Harnoncourt appointed Rice to a newly created position, the museum's first Associate Director of Programs, thus giving education an important role right from the start in planning exhibitions and publications. The museum's educational methodology evolved into combining expertise with viewer interpretation. Rice wrote,

"We worked hand in hand with the curators on the reinstallation, introducing a layered approach to interpretation that included the first random access audio guides, short videos, interactive games and clear simple labels."[31] Their work has been an important influence on other museums in structuring their education programs.

D'Harnoncourt worked constantly to make sure that the museum's various constituencies understood the museum's actions. She valued the community of artists. Her sense of diplomacy was put to good use when she curated an exhibition of sixty contemporary Philadelphia artists. An artist whose work was not selected for the exhibition criticized her selection publicly. Her response was, "There is always going to be more good work than a show is going to be able to include."[32] Sozanski said of d'Harnoncourt, "If she hadn't become a museum director, she would have made a splendid secretary of state."[33]

Another constituency with which d'Harnoncourt had to cope was the city government, which supplied a major portion of the museum's budget. Her efforts to make the museum seen as a valuable asset to the city combined with her powers of diplomacy paid off over and over again. In 1994, Edward G. Rendell, who later became governor of the state of Pennsylvania and was an influential politician, was mayor. The city was severely in deficit, and Rendell cut the city's contribution to the museum significantly. The guards who had previously been city employees were privatized, and the museum had to absorb the cost. But then d'Harnoncourt proved to Rendell that the arts had economic value. The example was the huge Cézanne exhibition in 1996, which attracted the largest audience ever to the museum and brought tourists and their dollars to the city. Rendell became a huge fan of the museum and of d'Harnoncourt. At her memorial, he declared, "[Anne] . . . was the leader of our cultural community. . . . [She] could have worked in virtually any city in the world."[34]

In 2004, Mayor John Street, faced with a budget gap, proposed cuts in the city budget that included zero funds for the Philadelphia Museum. In an address to the city council, d'Harnoncourt laid out her objections to the cut. She pointed out that Street's proposal to eliminate all the museum's funding would force reduction of days

open, "eliminate programs that serve 75,000 school children annually, and ruin its ability to lure the blockbuster shows that generate millions of dollars and priceless prestige to the city. 'This cut would be devastating,' she told city council members, her voice thick with emotion. 'It would seriously impair our ability to operate.'"[35]

Philadelphians rallied to the cause of the museum. Councilman Michael Nutter, who eventually succeeded John Street as mayor, "compared the zero-funding to 'a mortal sin,' particularly in light of the city's nearly $400 million contribution to its two new sports stadiums."[36] Other legislators declared that they were forming a bipartisan coalition to restore 90 percent of the arts cuts. At the beginning of May 2004, the Greater Philadelphia Cultural Alliance organized a rally to protest the cuts. Approximately two hundred people stood in the rain to support restoration of arts funding.[37] Eventually, a compromise was reached, and the museum received $2 million—only a small reduction from the $2,250,000 allocation of the previous year. This crisis led d'Harnoncourt to undertake the museum's first economic impact study to prove how the museum contributed to the city.[38]

D'Harnoncourt could also think outside of the box. A crisis developed in 2006. The Philadelphia Medical College, Thomas Jefferson University, owned one of the masterpieces by the nineteenth-century artist Thomas Eakins called *The Gross Clinic*, painted in 1875. It is a large painting, approximately eight feet high by six feet wide, and depicts Dr. Thomas Gross, a highly respected professor of medicine, lecturing to students who surround the table on which a young boy is lying. Gross is performing surgery on the boy's leg but has stopped in the middle of the operation to tell the students what he is doing. The painting is significant for a number of reasons. It celebrates surgery as a new medical phenomenon. Until the second half of the nineteenth century, surgery was basically amputation. With the advent of anesthesia, it became possible to perform operations. On the other hand, while the painting celebrates the advance of surgery, the conditions under which the surgery is being performed show that surgical procedures at that time were still far from hygienic. Dr. Gross and his students are all dressed in black frock coats with not a sterile glove in sight.[39]

Eakins is considered one of the greatest painters of the United States. He painted the portraits of the leading figures of Philadelphia society, but he was also a realist who painted the life around him. The wound in the thigh is clearly visible, as is the blood on Dr. Gross's hand; the painting was rejected for the 1876 Centennial Exhibition as being too unpleasant. It has been in the possession of the Jefferson Medical University ever since. Jefferson paid $200 for it. Today, it is considered not only priceless but also one of the iconic images associated with Philadelphia. In November 2006, the board of Jefferson College threatened to sell it for $68 million to two institutions, which planned to share it, each showing it for six months at a time: the National Gallery in Washington, DC, and the new Crystal Bridges Museum, established by Alice Walton, one of the heirs of Walmart founder Sam Walton. The price of $68 million set a record for an American painting created before World War II. An uproar ensued in Philadelphia. The city of Philadelphia was given forty-five days to match the selling price.

It was d'Harnoncourt's idea to form a partnership between the museum and the Pennsylvania Academy of Fine Arts, the other major art institution in the city (restricted to American art), to raise the funds to retain this piece of Philadelphia in its rightful city location. In a flash of brilliance, she suggested that the painting could be shared by the two museums, alternating every six months. She made it an issue for the people of Philadelphia, personally working the phones day and night soliciting contributions from people who had never donated before.[40] Everyone who loved art and was sentimental about the city made a contribution to the museum. In the end, both d'Harnoncourt and the Pennsylvania Academy had to sell other Eakins works in order to raise the funds, but with d'Harnoncourt's leadership, *The Gross Clinic* remained in Philadelphia.[41]

What were the characteristics that led to d'Harnoncourt's success as a leader? Can we learn strategies useful for others from her history? Danielle Rice, now program director of the Museum Leadership Program at Drexel University's Westphal College of Media Arts and Design, who worked alongside d'Harnoncourt for many years, describes d'Harnoncourt as follows:

She was absolutely and completely convinced of the power of art to change lives. This was the passionate belief that motivated her at all times. She was also always optimistic and calm no matter what the situation. She did have great respect and caring for all people as well. . . . She really supported my decision to become Executive Director of the Delaware Art Museum (which she loved because it has the largest collection of Pre-Raphaelite art in the United States). She was a great mentor and I could always turn to her for advice and support. She was extremely generous in that way.[42]

William Valerio emphasizes how meaningful her personal philosophy and style were. She was civic minded and believed that art should relate to people's lives rather than exist in a rarefied vacuum. Good museum education would draw visitors to return. She championed living artists as well as protecting the artistic legacy of the past.[43]

She surrounded herself with strong people and partnered with them in running the museum. Her husband, Joseph Rishel, was her closest partner. Their personal and professional lives converged on all levels, stemming from their mutual passion for art and their shared excitement about what a museum could be. Rishel shared d'Harnoncourt's sensitivity to the role of the museum in the life of the city as well as a clear perception of how to further the preservation of cultural heritage and, at the same time, focus on contemporary artistic concepts.

D'Harnoncourt had the self-confidence to share authority. The partnerships she formed were very much related to her success. First was her professional partnership with her husband, as described above. Second was her partnership with Robert Scott, who was president of the museum at the beginning of her directorship. They ran the museum as a duo. Scott came from the well-to-do suburbs west of Philadelphia, nicknamed the Main Line, based on the fact that trains from the west went into Philadelphia through each of the towns, thus enabling residents of those towns to commute into Center City. Scott was a member of an old, well-established Philadelphia family. Since the d'Harnoncourts happened to be Austrian nobility, d'Harnoncourt and Scott were on equal footing in social

class. That equality helped, and they worked well together to gain and keep the support of the Philadelphia philanthropic community as well as serve the general urban population.

Gail Harrity, who became the chief operating officer of the museum in 1997, overseeing a broad range of functions—including finance, marketing and communications, external relations, facilities management, membership, strategic planning, and development—became d'Harnoncourt's right hand.[44] D'Harnoncourt and Harrity worked together on the implementation of many new initiatives, including the acquisition of the Perelman Building, which allowed the museum to expand; the design and construction of a parking garage; and the development of a master plan that although enacted a decade after d'Harnoncourt's death, was hers to begin with.[45] They also collaborated on the development of a single collections database of the museum's 225,000 objects and a new website enabling better public use of the museum's collections. After d'Harnoncourt's sudden death, Harrity served as interim CEO of the museum and was appointed president as well as chief operating officer in 2009. As described by William Valerio, who worked closely with Harrity as well as with d'Harnoncourt, they were two sides of the same coin—they complemented each other. D'Harnoncourt would present an idea and Harrity would operationalize it, providing the numbers to bring it to realization. At the same time, Harrity had a keen strategic sensibility, and d'Harnoncourt would reformulate her plans for fulfilling the museum's mission in response to Harrity's business ideas.

D'Harnoncourt also partnered with Raymond Perelman and H. F. (Gerry) Lenfest, who each served long terms as chair of the board. Both were self-made successful businessmen, very different in background and personality from Scott, but d'Harnoncourt formed relationships with them that paralleled the effectiveness of her relationship with Scott. Perelman was a museum trustee for thirty years and served as chair of the board from 1997 to 2001. With his wife, Ruth, he made an unrestricted gift of $15 million to the museum, the largest gift in the capital campaign to acquire the Reliance Standard Life Insurance building, which stands across the street at the bottom of the hill on which the museum sits and

now provides space for much needed expansion of galleries and offices. The acquisition was made in 1999 and the building, named in honor of the Perelmans, opened in 2007.

D'Harnoncourt and Lenfest shared the vision of integrating the museum into the Philadelphia community. The closeness Lenfest felt for d'Harnoncourt is evident in a comment about Lenfest: "Lenfest can become emotional—as he does when speaking about Anne d'Harnoncourt, the late Art Museum director."[46] He was the spokesperson for the museum in declaring June 19, 2008, "A Day for Appreciation of Anne d'Harnoncourt," along with Mayor Michael Nutter, the city council, and Ed Rendell, governor of the state.

In addition to her partnerships within the museum and with the board of trustees, d'Harnoncourt surrounded herself with strong women in all areas of her life. Her close friends included the arts philanthropist Marion (Kippy) Stroud (1939–2015). Stroud and d'Harnoncourt roomed together when they were young employees at the Philadelphia Museum and remained friends for the rest of their lives. D'Harnoncourt's husband is quoted in Stroud's obituary as saying, "Anne wrote some of her best stuff sitting at Kippy's kitchen table."[47] Stroud founded the Fabric Workshop and Museum, a laboratory for innovative and cutting-edge contemporary art, which is located in Philadelphia. Literally hundreds of major artists, including but not limited to Laurie Anderson, Louise Bourgeois, Mark Bradford, Ann Hamilton, Louise Nevelson, and William Wegman, created new work in residencies at the workshop. Later in their careers, Stroud contributed both moral and financial support to d'Harnoncourt. The Stroud/Duchamp gallery at the museum commemorates their friendship.

Evident from previous paragraphs, another very important element in d'Harnoncourt's success as a leader was her realization that the way to gain support for a cultural institution was to make it integral to the lives of the residents in the community. As described above, when the city wanted to cut the museum's budget, she was able to persuade the mayor to restore the funds by pointing out the importance of the museum to the city's economy and life. Using her people skills, she built her coalition of supporters by mounting exhibitions that attracted audiences among both the cultural

leadership and the general public. They responded to the situation with a furious outcry on behalf of the museum. D'Harnoncourt valued all members of her staff and treated them as equals. Valerio says she would walk into someone's office and just sit down to discuss the matter at hand:

> Or, we had specially designed voice mail systems so that if d'Harnoncourt had an idea in the middle of the night, she could call your office phone and leave a five-minute message. She fostered a diversity of voices, and this started at the top of the museum: although she would let us know when she was taking a strong position on a matter, it would frequently be the case that d'Harnoncourt might express one point of view, Harrity another, and maybe Rishel or the curator of an exhibition another. It was the job of the senior staff to absorb it all and work to bring the best path forward into focus.[48]

D'Harnoncourt also expected a culture of respect to govern the entirety of the museum. She considered no task as too small and would regularly pick up the odd piece of trash that might have fallen into her path as she walked through the museum. She read every wall label associated with the works of art on view, taking seriously the "voice" of the museum and making edits as she felt necessary. She disliked art-speak and the jargon of art history. In this way, language itself was part of her expectation that every member of the staff would create a welcoming atmosphere for the museum's visitors. All staff members were trained to be hosts: gracious, generous, open, and caring. She would encourage staff to think of the museum as their home, and anyone who walked through the doors of the museum was to be considered an honored guest.[49]

These strategies led to her legacy: she maintained and advanced the museum's reputation; she supported the museum financially through her collaboration with public officials and substantial donors; and most of all, she succeeded in transforming the museum into an institution treasured by the people of Philadelphia as their very own. Indeed, she demonstrated that women could be successful leaders of major art institutions.

Notes

1 Brodsky and Olin had telephone conversations and email exchanges with William Valerio and Danielle Rice, both former colleagues of Anne d'Harnoncourt, in March 2017.
2 Before coming to the PMA, Jean Sutherland Boggs had been the first woman director of the National Gallery of Canada from 1966 to 1976. She left the Philadelphia museum to return to Canada, where she became chair and chief executive officer of the Canada Museums Construction Corporation from 1982 to 1985, directing the construction of a new National Gallery building and the Canadian Museum of Civilization. Her field of art history centered around Degas. See Diane Peters, "Visionary Curator Jean Sutherland Boggs Framed a Legacy," *Globe and Mail*, September 18, 2014, http://www.theglobeandmail .com/arts/visionary-curator-jean-sutherland-boggs-framed-a-legacy/ article20684691/.
3 "Major museum" is defined as an institution with a budget of more than $25 million.
4 Anne Marie Gan, Zannie Giraud Voss, Lisa Phillips, Christine Anagnos, and Alison D. Wade, "The Gender Gap in Art Museum Directorships," Association of Art Museum Directors, 2014, https://aamd.org/sites/default/files/ document/The%20Gender%20Gap%20in%20Art%20Museum%20Directorships _0.pdf.
5 Tammy Hughes, "Tate Gets Its First Female Boss: Yoga-Loving Mother-of-Two Announced as New Director of the Galleries," *Daily Mail*, January 17, 2017, http://www.dailymail.co.uk/news/article-4130438/Tate-gets-female-boss.html.
6 Kaywin Feldman, "Women's Locker Room Talk: Gender and Leadership in Museums," Alliance Labs, https://aamd.org/sites/default/files/document/The %20Gender%20Gap%20in%20Art%20Museum%20Directorships_0.pdf.
7 Feldman.
8 Naomi Rea, "The Gender Pay Gap in the UK's Art Industry Is Even Worse than Other Businesses. See How Each Sector Breaks Down," *Artnet News*, April 6, 2018, https://news.artnet.com/art-world/gender-pay-gap-uk-art -organizations-1260317.
9 Feldman, "Women's Locker Room."
10 Feldman.
11 "We Asked 20 Women 'Is the Art World Biased?' Here's What They Said," *Artnet News*, September 16, 2014, https://news.artnet.com/art-world/we-asked-20 -women-is-the-art-world-biased-heres-what-they-said-81162; and Sarah M. Blatter, "The Role of American Women in Museum Leadership: Late 19th to Mid-20th Century" (master's thesis, Buffalo State College, SUNY, 2014), http:// digitalcommons.buffalostate.edu/cgi/viewcontent.cgi?article=1006&context= museumstudies_theses.
 There are many studies showing how cultural, ethnic, and gender matching are related to hiring. In museums when artists are being selected for exhibition or acquisition, diversity in programming is influenced by

diversity in management. To see one of the studies on hiring, go to Lauren Rivera, "Hiring as Cultural Matching: The Case of Elite Professional Service Firms," *American Sociological Review* 77, no. 6 (2012): 999–1022, http://asr.sagepub.com/content/77/6/999.full.

12 For information on Beaux Arts architecture, see "Beaux Arts," *Architectural Styles of America and Europe*, https://architecturestyles.org/beaux-arts/.

13 To research the collections of the Philadelphia Museum of Art, see http://www.philamuseum.org/collections/search.html.

14 "Anne d'Harnoncourt Papers: Historical Note," Philadelphia Museum of Art, https://www.philamuseum.org/pma_archives/ead.php?c=ADP&p=hn. René d'Harnoncourt himself had been born in Austria, where his family was included in the higher echelon of Viennese society. Anne d'Harnoncourt's mother was raised in Wisconsin and was a Wellesley College graduate.

15 "Anne d'Harnoncourt Papers."

16 Sharon Zane, "Interview with Anne d'Harnoncourt," September 11, 2003, Museum of Modern Art Oral History Program, https://www.moma.org/momaorg/shared/pdfs/docs/learn/archives/transcript_dharnoncourt.pdf.

17 Like other early American institutions of higher education, Harvard College was originally all male. The first wave of feminism in the later nineteenth century led to the establishment of colleges for women, such as Wellesley, Vassar, Smith, and Mount Holyoke. In addition, some Ivy League institutions, including Brown University and Harvard, founded colleges for women. Women took courses taught by the same faculty as the male students, but classes were segregated. During World War II, Harvard integrated Radcliffe students because so many faculty were serving in the armed forces that there weren't enough to teach duplicate sessions.

18 D'Harnoncourt's personal history is documented in the interview by Sharon Zane at MoMA in 2003 and also in "Anne d'Harnoncourt Papers."

19 Tate Museum, http://www.tate.org.uk/visit/tate-britain.

20 Janine Catalano, "Memories of Anne d'Harnoncourt from Sue Compton," Courtauld Institute of Art, December 3, 2008, https://courtauld.site-ym.com/news/20636/Memories-of-Anne-DHarnoncourt-from-Sue-Compton.html.

21 For more information on the Pre-Raphaelites, see the Tate Museum website pages on the Pre-Raphaelite movement: http://www.tate.org.uk/learn/online-resources/glossary/p/pre-raphaelite.

22 "Anne d'Harnoncourt Papers."

23 To learn more about the Arensberg Collection, see the finding aid for the Arensbergs' papers collection: http://www.philamuseum.org/pma_archives/ead.php?c=WLA&p=hn.

24 Duchamp's *Large Glass* is surrounded by many myths and has been the subject of intense interpretation. One of the myths centers on the cracks in the glass. There is controversy about when the cracks appeared and whether Duchamp intended them.

25 Zane, "Interview with d'Harnoncourt."

26 "Anne d'Harnoncourt Papers."

27 "Anne d'Harnoncourt Papers."
28 Johnson gave his collection to the city of Philadelphia in 1917. See "Our Story: 1910–1920," Philadelphia Museum of Art, http://www.philamuseum.org/information/45-226-22.html. For general information on the industrial giants of the late nineteenth and early twentieth centuries and their gifts to museums, see "Center for the History of Collecting in America," Frick Collection, http://research.frick.org/directoryweb/browserecord.php?-action=browse&-recid=6270.
29 Edward J. Sozanski, "They're Moving the Paintings for a More Logical Museum," *Philadelphia Inquirer*, February 14, 1992.
30 Edward J. Sozanski, "A Museum and Its Bottom Line: The Art Museum Seems to Have Taken the High Road in Its Renovation," *Philadelphia Inquirer*, February 23, 1992.
31 Danielle Rice in the email of March 28, 2017, to Brodsky. To learn more about opposing theories of museum education and the philosophy developed at the Philadelphia Museum of Art, read Danielle Rice and Philip Yenawine, "A Conversation on Object-Centered Learning in Art Museums," *Curator* 45, no. 4 (October 2002): 289, http://conversation_object_ctrd.pdf.
32 "Anne d'Harnoncourt Papers."
33 "Anne d'Harnoncourt Papers."
34 "Museum Joins with City to Declare June 19, 2008, a Day of Appreciation for Anne d'Harnoncourt," Philadelphia Museum of Art, https://philamuseum.org/press/releases/2008/680.html.
35 Joann Loviglio, "Philly Arts Groups Protest Cuts," *Associated Press*, April 23, 2004, http://www.beatking.com/forums/topic/4688-philly-arts-groups-protest-cuts/.
36 Loviglio.
37 Michael Currie Schaffer and Vernon Clark, "Culture Supporters Protest Funding Cuts 'What Is the Importance of the Arts?,'" Philly.com, May 8, 2004, http://articles.philly.com/2004-05-08/news/25382868_1_arts-funding-greater-philadelphia-cultural-alliance-arts-and-cultural-organizations.
38 Information on the 1994 budget crisis is contained in an email from Danielle Rice to Brodsky, March 18, 2017. A reference to the privatization of the guards and more information about the budget crisis Rendell faced in the city at the time can be found in an article by Fred Siegel and Kay S. Hymowitz, "Why Did Ed Rendell Fizzle Out?," *City Journal*, Autumn 1999, https://www.city-journal.org/html/why-did-ed-rendell-fizzle-out-11907.html.
39 Hygienic conditions did become common very shortly afterward. A later painting by Eakins is often compared with *The Gross Clinic*. In *The Agnew Clinic*, painted only fourteen years later in 1889, the operating theater is cleaner and the doctors and students are wearing white coats.
40 Danielle Rice, in the email of March 18, 2017, to Brodsky, relates this incident, adding that she herself observed d'Harnoncourt on the phones.
41 Edward J. Sozanski, "Museum Seals Eakins Deal," *Philadelphia Inquirer*, April 24, 2008.

42 Email from Danielle Rice to Brodsky.
43 Email from Danielle Rice to Brodsky and telephone conversation between Brodsky and Olin with William Valerio, director of the Woodmere Art Museum, former assistant director for administration, Philadelphia Museum of Art, February 2017.
44 Telephone conversations by Judith Brodsky and Ferris Olin with William Valerio, March 2017.
45 Email from Danielle Rice to Brodsky.
46 Peter Dobrin, "Beyond Philanthropy: Lenfests' Show Personal Commitment," Philly.com, http://www.philly.com/philly/news/special_packages/inquirer/20090510_Beyond_philanthropy__Lenfests_show_personal_commitment.html.
47 Stephen Salisbury, "Marion 'Kippy' Stroud, Fabric Workshop Founder, Dies at 76," *Philadelphia Inquirer*, August 25, 2015, http://www.philly.com/philly/obituaries/20150825_Marion__Kippy__Stroud__Fabric_Workshop_founder__dies_at_76.html.
48 Telephone conversation with William Valerio.
49 Last paragraphs based on the telephone conversation held by Brodsky and Olin with William Valerio.

Bibliography

Artnet News. "We Asked 20 Women 'Is the Art World Biased?' Here's What They Said." September 16, 2014. https://news.artnet.com/art-world/we-asked-20-women-is-the-art-world-biased-heres-what-they-said-81162.

Blatter, Sarah M. "The Role of American Women in Museum Leadership: Late 19th to Mid-20th Century." Master's thesis, Buffalo State College, SUNY, 2014. http://digitalcommons.buffalostate.edu/cgi/viewcontent.cgi?article=1006&context=museumstudies_theses.

Brodsky, Judith K., and Ferris Olin. Telephone conversations and email exchanges with William Valerio and Danielle Rice. March 2017.

Catalano, Janine. "Memories of Anne d'Harnoncourt from Sue Compton." Courtauld Institute of Art, December 3, 2008. https://courtauld.site-ym.com/news/20636/Memories-of-Anne-DHarnoncourt-from-Sue-Compton.html.

Gan, Anne Marie, Zannie Giraud Voss, Lisa Phillips, Christine Anagnos, and Alison D. Wade. "The Gender Gap in Art Museum Directorships." Association of Art Museum Directors, 2014. https://aamd.org/sites/default/files/document/The%20Gender%20Gap%20in%20Art%20Museum%20Directorships_0.pdf.

Grimes, William. "Anne d'Harnoncourt, Who Led Philadelphia Museum, Dies at 64." *New York Times*, June 3, 2008. http://www.nytimes.com/2008/06/03/arts/design/03dharnoncourt.html?_r=0.

Loviglio, Joann. "Philly Arts Groups Protest Cuts." *Associated Press*, April 23, 2004. http://www.beatking.com/forums/topic/4688-philly-arts-groups-protest-cuts/.

Peters, Diane. "Visionary Curator Jean Sutherland Boggs Framed a Legacy." *Globe and Mail*, September 18, 2014. http://www.theglobeandmail.com/arts/visionary-curator-jean-sutherland-boggs-framed-a-legacy/article20684691/.

Philadelphia Museum of Art. "Anne d'Harnoncourt Papers: Historical Note."
https://www.philamuseum.org/pma_archives/ead.php?c=ADP&p=hn.

Rice, Danielle, and Philip Yenawine. "A Conversation on Object-Centered Learning
in Art Museums." *Curator* 45, no. 4 (October 2002): 289.

Rivera, Lauren. "Hiring as Cultural Matching: The Case of Elite Professional Service
Firms." *American Sociological Review* 77, no. 6 (2012): 999–1022. http://asr
.sagepub.com/content/77/6/999.full.

Schaffer, Michael Currie, and Vernon Clark. "Culture Supporters Protest Funding
Cuts 'What Is the Importance of the Arts?'" Philly.com, May 8, 2004. http://
articles.philly.com/2004-05-08/news/25382868_1_arts-funding-greater
-philadelphia-cultural-alliance-arts-and-cultural-organizations.

Sozanski, Edward J. "A Museum and Its Bottom Line: The Art Museum Seems to
Have Taken the High Road in Its Renovation." *Philadelphia Inquirer*, February 23,
1992.

———. "Museum Seals Eakins Deal." *Philadelphia Inquirer*, April 24, 2008.

———. "They're Moving the Paintings for a More Logical Museum." *Philadelphia
Inquirer*, February 14, 1992.

Tate Museum. "Pre-Raphaelite." http://www.tate.org.uk/learn/online-resources/
glossary/p/pre-raphaelite.

Zane, Sharon. "Interview with Anne d'Harnoncourt." Museum of Modern Art
Oral History Program, September 11, 2003. https://www.moma.org/momaorg/
shared/pdfs/docs/learn/archives/transcript_dharnoncourt.pdf.

Mona/Marcel/Marge

FIGURE 13 Martha Wilson, *Mona/Marcel/ Marge*. Photograph by Vincent Bruns; composition by Kathy Grove. Courtesy of the artist.

Martha Wilson

Courageous Leadership in Innovation and Activism

Background

This case study shows how Martha Wilson came to be a leader, an entrepreneur, and an influential cultural figure through her business enterprise, her political activity, and her own art practice. During the late 1980s and 1990s, she was prominent in the struggle to allow artists free creativity at a time when artists were attacked by conservative forces in the United States. Her courage and persistence in maintaining ideals of free speech in creative practice inspire artists today. Wilson was also a leader in establishing the fields of artists' books and performance art as accepted areas of artistic practice. Coming out of a background of conceptual artmaking and feminism, she was conscious of the fact that artists were working in many visual formats and artistic vocabularies beyond traditional painting and sculpture—using words, publishing books, and performing. She established a gallery in 1976 called Franklin Furnace Archive, Inc. (originally called Franklin Furnace), that quickly became a center of the New York avant-garde art world in the 1970s and 1980s. Recognizing the issue of preserving these more ephemeral forms of artmaking, she collected artists' books, documentation of performances, and other nontraditional works. In 1993, the Franklin Furnace Archive, which by this time consisted of 13,500 artists' books, magazines, and tapes by more than 500 artists internationally, was acquired by the Museum of Modern Art, New York. Franklin Furnace continues to collect and has expanded to become an online archive.

Wilson believes her compulsion to collect stems from her personal experience. She had a friend who was bleeding in the brain, losing her memory, and had only a short time left to live. The shock of her friend's loss of recollection and her imminent death recently led Wilson to a need to record her own family's stories, background, characters, and personalities before they became lost to memory. But she says that this compulsion, which led to establishing Franklin Furnace Archive, also derives from her personal background. Wilson's mother was raised as a tenth-generation Quaker. When she was younger, Wilson discounted the influence of her Quaker heritage but says that she has come to understand in recent years that Quakerism had a big impact on her art practice. She believes she became an archivist because Quakers never throw anything out.

She also believes that her activism is a result of her Quaker background. While Quakers are pacifists, they also have a long history of engagement. In talking recently to an artist who fantasizes about overthrowing the United States government, Wilson told the artist to make art that critiques the government rather than to continue daydreaming about actual overthrow; "physical action will land you in prison, or worse," whereas through art, you can have an impact that not only will reach more people but doesn't threaten bodily harm. Wilson considers that Quakerism also accounts for the way in which she has cast her career in the tradition of the artist as outsider: "Quakers were thrown out of England, so being an outcast is a normal place for someone who is a Quaker."[1]

Wilson grew up in Newtown, Pennsylvania, a municipality that was decidedly marginal at that time: it felt remote from Philadelphia, its closest major city; it was modest economically; and although historical, it had no famous landmarks or noteworthy residents to attract tourists. Her parents met during World War II. After the war, they started a little design firm. Her father loved sailing, so they lived in a houseboat for the first six years of their marriage on the New Jersey side of the Delaware River, which separates New Jersey and Pennsylvania. The houseboat looked across at the water company of Philadelphia. Wilson remembers seeing chunks of ice in the Delaware.

Wilson says that her mother decided that there were too many immigrants living along the river, so because her mother wanted her daughter to grow up in a middle-class community, they moved to Newtown to her grandparents' home. In those days, middle class meant white people living in residential communities with mostly freestanding houses and neatly manicured lawns. They lived in a barn behind the house. Her grandparents already had developed the property as apartments, and Wilson's mother ran the apartments.

The marriage wasn't working, but divorce was not comfortable. Her father went to live on a houseboat again. Eventually, her mother moved back onto the houseboat just before Wilson took up residency in New York City in 1974.

In addition to living with estranged parents whose lives bounced back and forth between a desire for traditional white, middle-class values versus an eccentric lifestyle, Wilson was subjected to sexual abuse. Wilson says the shadow of incest hung over her for many years until her father's death in 1980, when "she felt the surveillance camera was turned off." Wilson went through ten years of psychoanalysis as a result of the molestation. She refers to a book called *Trauma and Recovery* by Judith Herman as an explanation of the impact of sexual trauma. Herman writes that the severity of sexual trauma is as bad as the trauma of war. It creates as much posttraumatic stress.[2] Despite the effect of his abuse, Wilson believes that her father helped her become an artist "by showing her you could break the rules." She says that her work "came from looking at things you're not supposed to look at." She describes a new piece that she feels expresses how the incidents in life leave their mark. It's a photographic self-portrait with the wrinkles in her face filled in with black eyebrow pencil so that they stand out.

Wilson's college experience led to her activism. She attended Wilmington College[3] in Ohio and received her BA degree with honors in 1969 after majoring in English literature. It was what was called "an aggie school," meaning that it concentrated on programs to help students become successful farmers. Most of the students came from farming communities and small towns. Wilson says its claim to fame was developing a pig that, when butchered,

gave up sixteen pork chops. This period was the 1960s, and the Vietnam War that started in the mid-1960s continued for almost a decade and resulted in the defeat of the U.S.-led forces. The defeat resulted in the downfall of the temporarily democratic South Vietnam government and the take-over by Communist North Vietnam. It also created considerable political turmoil within the United States. Aggies were pro–Vietnam War, and the hippies (of which Wilson was one), were anti–Vietnam War. There was lots of violence. The townies shot at one of the professors because he was against the war.

The United States still was drafting men into the armed forces during the Vietnam War. Many young men didn't want to fight in this war over which there was so much ambiguity about the role of the United States. Wilson's boyfriend was one of these young men. Like a significant number of young people, she and her boyfriend went to Canada. He enrolled in the Nova Scotia College of Art and Design, which was in its heyday, with influential artist/faculty members who played a very important role in the development of conceptual art. She went across the street to Dalhousie College, where she earned an MA in English literature.[4]

Wilson lived in Canada for five years. She was not planning to be an artist at that point but did hang out at the art college. After receiving her MA, Wilson started on her PhD, but her dissertation plan was rejected. The faculty said it was related to visual art rather than to literature. Her proposal for the thesis was to develop the theory that the nineteenth-century novelist Henry James had visual diagrams in mind when writing his novels. For instance, in *The Golden Bowl*, the actual structure of the novel is wobbly like a carriage with one wheel missing. When her dissertation concept was rejected, she went across the street to the art college. An English professor had just resigned, so she got a job teaching English literature. As a perquisite, she could go to all the classes and use all the equipment.

Wilson quickly moved into the visual arts world through meeting the artists who came to the school for residencies. The influential art critic Lucy Lippard came to Halifax in 1973.[5] When Lippard saw Wilson's work, she said, "Yes, you are an artist." Lippard's approval

was particularly important to Wilson because the mostly male faculty had derided her work. They were working mostly with text, whereas Wilson was becoming involved in performance-related art, in which she combined photography with other media. Calling herself an artist was terrifying, but Lippard also acquainted her with the information that other women artists were doing similar work. Lippard put her *Breast Forms Permutated* in *c.7,500*, an important conceptual art exhibition at the California Institute for the Arts (Cal Arts) in 1973–1974.

It was the Watergate incident that brought Wilson to New York. That episode, in which the national Democratic Party headquarters in the Watergate Hotel complex was invaded by Republican agents, brought about the resignation of Richard Nixon, the only United States president ever to step down. She wanted to be witness to the extraordinary events happening in America. Simone Forti[6] invited Wilson to come to New York and offered to put her up.

Wilson had met the artist Jacki Apple through the California exhibition curated by Lippard. When she moved to New York, she went to live in Billy and Jacki Apple's loft. They were key figures in New York conceptual art circles. Their loft was not only a living space; it was also a meeting place for conceptual artists and an exhibition/performance space.[7] She and Jacki Apple invented a character they named Claudia. They took "Claudia" to lunch and in a limo to see galleries. They hired two photographers to take photos of themselves at lunch at the Plaza Hotel, where they replied as if they were celebrities to the questions people asked, such as "Are you from Vogue?" It was Wilson's first performance in front of an audience.

Judy Siegel, a writer and editor for one of the important feminist art publications of the 1970s, the *Women Artists Newsletter*, founded by Cynthia Navaretta, took Wilson under her wing. Although not in Wilson's consciousness-raising group, Siegel's feminist ideas were very influential on Wilson's development as an artist.

In asking her about how she made a living in New York in those early days, Wilson described reading an employment agency ad in the *New York Times* listing an editorial job available for an art history major at the important art book publisher Harry N. Abrams. She

didn't respond to the agency but instead just showed up at Abrams at 8:30 in the morning. Margaret Kaplan, one of the executives at Abrams, was interviewing someone in front of her. Wilson could hear that Kaplan reacted negatively when the person she was interviewing said she was an artist. So Wilson said she was an English MA, never mentioning that she was an artist. She spent only one year at Abrams, but that job trained her for running a business.

While at Abrams, she was learning about the art world. Wilson saw American avant-garde downtown at Billy and Jacki Apple's loft while becoming familiar with the more established art scene in her uptown job at Abrams. From her time in Nova Scotia, her own art practice had focused on the ephemeral forms of art, such as performance, temporary installations, and artists' books.

She developed a circle of artist friends who were making the same kind of art, and she became even more conscious of the problems inherent in recording and preserving these ephemeral art forms and was concerned for their lack of documentation.

She began teaching art at Brooklyn College in 1975, but shortly afterward, the city, to save money in a bad budgetary year, fired all the studio teachers in the City University of New York (CUNY) schools, including Brooklyn College. Losing her job spurred Wilson into action.

Resolution

Her job crisis led Wilson to rethink her life. The fact that she was now being supported by unemployment income gave her freedom from working to survive and enabled her to concentrate on how she might find a way to preserve and promote the art forms in which she was so passionately involved. The result was the founding of Franklin Furnace. She used some of her unemployment money for expenses related to setting it up. She rented the street floor in a building that had been bought by Willoughby Sharp, who was a significant figure in the art world of the 1970s through his vanguard publication *AVALANCHE* magazine, videos, films, friendships, and collaborative working arrangements with other artists. The building

was in Tribeca, which was then being transformed into a neighborhood for artists to live and work. Sharp was a pioneer in developing the area, having purchased it with the intention of creating an art center by renting out the floors to artists.[8]

At first she thought primarily of operating a store for artists' books, and if she were going to do so, she had to start developing the inventory. A friend of hers helped by stealing the mailing list from the Clocktower, which had become one of the first important alternative art spaces in New York, opened in 1972 by Alanna Heiss. The Clocktower was legendary for mounting exhibitions by leading-edge artists of the early 1970s, including the performance artist Laurie Anderson.[9] The mailing list was a comprehensive collection of avant-garde New York–based artists, many of whom, it turned out, were creating artists' books with nowhere to show them. By the time Wilson opened her bookstore, she had an inventory of more than two hundred books.

Wilson named the store Franklin Furnace. She says that she was going to call it Franklin Stove, but Sharp suggested the more alliterative Franklin Furnace. Wilson had no financial resources with which to open the store, but she and her boyfriend at the time had bought a house together, and as Wilson puts it, he paid her "sweat equity," meaning that she put in many hours and days restoring the house and making it livable. With $1,500 of sweat equity, she was able to buy such necessities as a hot water heater and had funds to send out the letters announcing the store and asking for books to sell.

Another bookstore, Printed Matter, which became as important as Franklin Furnace, was being established at the same time by a group of artists and critics, including Lucy Lippard, whom Wilson already knew from her time in Nova Scotia. Knowing that Wilson was setting up Franklin Furnace, Lippard and some other founding members of Printed Matter, Inc., met with Wilson. They decided to divide the pie: Printed Matter would be a for-profit store, and Franklin Furnace would be a nonprofit venue more focused on collecting, performance, and exhibitions.[10] Here is how Wilson defined the mission of Franklin Furnace: "Franklin Furnace was founded in 1976 to serve artists who chose publishing as a primary, democratic

artistic medium, and were not being supported by existing artistic organizations. From its inception, Franklin Furnace's energies have been focused on three aspects of time-based programming: A collection of artists' books; a performance art program for emerging artists; and exhibitions of time-based arts, both site-specific works by contemporary artists, and historical and contemporary exhibitions of artists' books and other time-based, ephemeral arts."[11]

One of the reasons for Wilson's success in opening Franklin Furnace was the fact that she was an integral member of a circle of artists, art critics, and curators who were all beginning to make their mark in New York. The list of artists who got their start through performing or exhibiting at Franklin Furnace is extraordinary. It includes Jenny Holzer, Barbara Kruger, Laurie Anderson, and Eric Bogosian, to name only a few who became icons of contemporary art. According to art writer Edward M. Gómez, "Performance in the late 1970s was totally focused on the artists' community. It was a way of talking to one another, of trading ideas. The emphasis was on originality. Franklin Furnace was the venue where an important facet of my work began. Martha and curator Jacki Apple encouraged experimentation."[12]

Looking at how Wilson funded Franklin Furnace in the early days reveals her flexibility, her willingness to take risks, her openness to collaboration, and her ability to find alternative solutions, all characteristics of her leadership style. She financed Franklin Furnace through grants from public and private sources and ticket sales to performances; in addition, she relied on the artists who were mounting performances and installations to help with costs. Starting immediately, both the New York State Council on the Arts (NYSCA) and the National Endowment for the Arts (NEA) provided funding. As presented in the brief history of the organization on its website,

> At that time the state and federal agencies were all actually seeking out worthy projects and saying you can apply to us for money. So the lady from the New York State Council on the Arts . . . looked us over, checked out what we were doing and said, the deadline is

March 1st and you can apply for money. And Brian O'Doherty . . . said you know I'm the head of the Visual Arts Program of the National Endowment for the Arts, we want to support budding young arts organizations and you can apply to us for money. I got $5,000 from the New York State Council on the Arts. The budget for the first year was $12,000, so it must have been five from the National Endowment for the Arts (NEA). And then the rest of the money that I had to work with was $2,000 left over from this check from Richards, and Unemployment Insurance. . . . Rent was $500 a month which I was already splitting with my roommate. My year at Abrams was extremely valuable because I learned how a business works. Barbara Quinn, a painter, came in to Franklin Furnace and said, "Look I have raised money in order to keep bread on my table—that's what I've done in my professional life. I'm an artist but I also do this fundraising and you need to hire me because you obviously don't have a flying fuck of an idea what you're doing here." I thought, well, I'm getting $75 a week from Unemployment and she wants $40 a day that leaves me with $35 a week left over for myself. If I don't hire her I die but if I do hire her I'll die also, so, I'm going to hire her to work for me one day a week and help me to raise money. She taught me completely invaluable things: for example, if you write to a foundation and they reject your application, wait six months and you write back. . . . The other thing she figured out . . . visual artists are making this stuff and they understand it and they will help us. So she organized our first art sale. She got big time artists, her colleagues. At first she asked them to donate work then later we figured out that if we offer to split 50–50 with the artists we could get much better work. For our fifth birthday party, we commissioned birthday cakes and then sold them to the public. [She worked] ten years, I think. Jacki Apple, Barbara Quinn, and I ran the joint for some years. Then Jacki and I had a falling out and she moved to California. Jacki programmed the performances and split the gate with the artists, and that's how she made money. She wasn't really making any money from her gate at Franklin Furnace and she was splitting the gate with the artists. . . . Later we started to raise grant money and pay fees.[13]

But in the mid-1980s, approximately a decade after its founding, Wilson and Franklin Furnace ran into problems because of the onset of what has come to be known as the culture wars. Conservatives in the United States government believed that artists should not be using tax dollars to present pornographic and scatological material and desecrate religious symbols. Franklin Furnace was one of the institutions that first came under attack.

The change was abrupt. In 1983, Franklin Furnace had the approval and support of the National Endowment for the Arts, as shown by a $100,000 Advancement grant to promote institutional stability through development and publicity plans.[14] But in February 1985, Franklin Furnace was reprimanded by the NEA for mounting the performance *Carnival Knowledge*, "an exhibition and performance extravaganza that questioned if there can be such a thing as 'feminist pornography.' Annie Sprinkle [made] her debut as an artist during the performance of *Deep Inside Porn Stars*."[15]

Carnival Knowledge's *The Second Coming* [was] a pioneering show that brought feminists and sex workers together to ask: Could there be feminist porn? A porn that doesn't denigrate women or children? These questions were posed in a manifesto painted in red on the Furnace wall. The feminist artists in Carnival Knowledge had first encountered Candida Royalle, Veronica Vera, and Annie Sprinkle at a porn trade show. They all met together for a year, wrote a proposal, and Wilson said, "Yes." Hundreds of artist books and videos with sexual themes went on display on the main floor. Gossamer fabric breasts hung in the stairway leading to the basement, and there Carnival Knowledge featured "domestic" pieces dealing with everything from eating to masturbation. Performances included mud-wrestling done by artists and monologues done by sex workers, most notoriously *Deep Inside Porn Stars,* in which they talked about their lives. . . . The Morality Action Committee picketed for an afternoon and soon had church groups all over the country writing to Wilson's funders. Two of them, Exxon and Woolworth's, pulled their money out. Another vanguard moment. And just the prelude to real trouble.[16]

Carnival Knowledge brought Franklin Furnace to the attention of the conservatives, and Wilson became identified as a radical individual who was a troublemaker. But Wilson was not fazed and continued to promote artists who were challenging gender and race discrimination. With funding from the Jerome and Joyce Mertz-Gilmore Foundations and NYSCA, she founded the Franklin Furnace Fund for Performance Art, the mission of which was to provide awards to emerging artists, enabling them to produce major new work in New York City. She formed a selection panel, which gave awards to a number of artists, including Karen Finley, Holly Hughes, and John Fleck.[17] In 1990, these artists had their NEA awards overturned by the National Arts and Humanities Council because they were "indecent." Their case provoked the restrictions that Congress imposed on the NEA, resulting in the abolishment of the artist fellowship program. With Tim Miller, the artists who came to be known as the "NEA Four" were making art that was judged sexually transgressive. Finley's performance consisted of coating her nude breasts in chocolate frosting to create a performance about the intersection of desire, sexuality, and second-class citizenship as a woman. Because it became known that Franklin Furnace had supported these artists, Wilson and Franklin Furnace again became targets of the establishment.

The question remains as to how Franklin Furnace first came under the scrutiny of the conservative regime in Washington. Wilson believes that it had much to do with her activities as a performance artist rather than with the exhibitions and performances at Franklin Furnace. She, along with the conceptual artist Barbara Kruger, known for her use of advertising style to critique consumer culture, and other artists, including Donna Henes, a sculptor, formed an all-girl band called Disband, which was in existence from 1978 to 1982.[18] From the beginning of Disband, Wilson satirized U.S. politics. For example, the members of Disband took on the roles of President Ronald Reagan's cabinet. Wilson was Alexander Plague—a play on the name of Alexander Haig, who was a major political figure in the 1970s and during the early Reagan administration days in the 1980s.[19] He exemplified the conservative power

elite that held sway in American politics during that period. Wilson made fun of him from her position as a liberal feminist artist.[20]

The actions against Franklin Furnace in the mid-1980s were the first shots fired in the culture wars. To understand the situation in which Franklin Furnace and Wilson found themselves, it's necessary to look at the subsequent battles. The wars continued in the late 1980s with the inclusion of Andres Serrano's photograph *Piss Christ* in an exhibition sponsored by the Southeastern Council of the Arts. *Piss Christ* is a photograph showing a crucifix sitting in a container of urine. It's a critique of how organized religion has often been a powerful force in covering up poverty and subjugation of minorities. However, the Moral Majority, other religious conservative groups, and conservatives like Alphonse D'Amato, senator from New York, took it as casting aspersions on the existence of God. D'Amato brought Serrano's work to the floor of the Senate, questioning the appropriateness of the National Endowment for the Arts' grant to the Southeastern College Arts Conference for the exhibition, including a $15,000 grant to Serrano. While the Senate didn't act to censure the NEA at that time, Congress was alerted and subsequently was on the lookout for further egregious actions that might be taken by the agency.

Conservative religious organizations didn't stop there. They continued to pressure Congress into attacks on the arts. An exhibition of the work of the photographer Robert Mapplethorpe was the next event to undergo congressional wrath. It had been organized by the Institute of Contemporary Art at the University of Pennsylvania and opened in Philadelphia to critical acclaim. The show was partially funded by the NEA and thus became the second object of Congress's focus because of Mapplethorpe's homoeroticism, which was seen as a threat to the traditional heteronormative values of American culture.[21]

Then came Franklin Furnace's next foray into the wars. Karen Finley made the case to Franklin Furnace's peer review panel that while she had a reputation as a performance artist, she was still emerging as an installation artist. In 1990, Franklin Furnace presented Finley's installation *A Woman's Life Isn't Worth Much*, causing Wilson and Franklin Furnace to be subjected to an investigation

and audit by the Internal Revenue Service, the New York State Comptroller, and at the request of Senator Jesse Helms, the NEA Accounting Office.

In May 1990, the New York City Fire Department closed Franklin Furnace's performance space in response to a call claiming Franklin Furnace was an "illegal social club." Also during the spring of 1990, Governor Mario Cuomo cut the NYSCA budget in half, and as a result, Franklin Furnace's NYSCA funding was reduced from $144,000 to $40,000. It's important to note that the cut did not have to do with restricting freedom of expression. Kitty Carlisle Hart, the renowned singer, actress, and performing arts patron, then the chair of NYSCA, told Wilson, "I don't understand what you do but I support your right to do it."[22]

Wilson didn't waver despite the financial setback and political attacks. She carried on Franklin Furnace's activities in spaces belonging to other organizations. Friends and colleagues rallied to her cause, among them the late Joseph Papp, the legendary founding director of the New York Public Theater. Papp, like Wilson, also spoke out on behalf of artistic freedom during this period. Wilson mounted a performance at the Joseph Papp Public Theater called Franklin Furnace Fights for First Amendment Rights, with an all-star cast of artists and performers who were advocates of freedom of expression, among them Finley; Allen Ginsburg, the most famous poet of the Beat generation; the visual artists Leon Golub and Nancy Spero, both of whom were very visible protestors against forms of oppression around the world; the Guerrilla Girls, an organization of women artists who wore gorilla masks and kept their identities secret as they protested discrimination against women artists by posting statistics about the low number of women in exhibitions and in galleries; Annie Sprinkle, the feminist porn star who continued to be a strong voice for freedom of expression; and Jawole Willa Jo Zollar, the founder of Urban Bush Women Dance Company.[23] The event attracted a huge audience.

Franklin Furnace was in a tenuous position after the expiration of its ten-year lease, and Wilson needed funds to buy its loft space. She was helped to raise the down payment by the art dealer Marian Goodman, who mounted a fundraiser in her gallery. With the funds

raised, Wilson was able to purchase the TriBeCa space in which Franklin Furnace had lived during its first decade.

In 1992, Franklin Furnace's NEA application for $25,000 to support Franklin Furnace's programs was denied. The $25,000 Wilson would have received from NEA was replaced instead by Peter Norton, the billionaire who invented Norton Antivirus; Norton is an art collector and patron who thought the government's censorship efforts were stupid. When Wilson was denied NEA funding for Franklin Furnace, she asked for a copy of the transcript of the National Council meeting and was told that her proposal "lacked artistic merit." Congress had put in place restrictions on the NEA, directing the agency only to fund projects that abided by "community standards of decency." During the 1990s, artist groups sued the United States in various courts, with the result that rulings were issued supporting artists in their assertion that the term was being used to limit freedom of expression. Ultimately, the case reached the Supreme Court, which found on behalf of the NEA. But community standards of decency are still one of the criteria used to fund proposals to this day.

Conservative members of Congress were not satisfied yet, and they threatened the NEA with closure. The well-known actress Jane Alexander was appointed by President Clinton as chair of the endowment in 1995. As a mainstream figure, she was able to build trust among the conservatives and worked out a compromise with Congress, which allowed the NEA to exist, but issued a regulation prohibiting the NEA from awarding grants to individual artists (HR 1977, 1995–1996, Appropriations to the Department of the Interior, section 328). This regulation remains in place until this day. According to Wilson, "Although the NEA Four finally won their grants . . . in the end, sadly, the arts agency stopped funding individual visual artists. . . . In a way, avant-garde artists both won and lost the culture wars. Certainly they often took the lead, through their art, in examining topics they felt were urgent but were not embraced right away by the general society. Eventually, though, those subjects became the ones everyone was talking and concerned about."[24]

The struggle to maintain freedom of expression for avant-garde art, along with the financial turmoil that the struggle placed Wilson

in, lasted for about fifteen years. By the late 1990s, the conserva-
tives were focusing elsewhere, and Franklin Furnace entered a
period of legacy development. In 1993, the Museum of Modern Art
acquired the Franklin Furnace book collection for $350,000. Clive
Philpot, the innovative director of the Museum of Modern Art
Library, made it the basis for establishing MoMA as a center for art-
ists' books. By this time, Wilson had decided that the way to ensure
the legacy of Franklin Furnace was to found a digital as well as con-
ventional archive. The payment from MoMA helped make her vision
a reality, and in 2009, the National Endowment for the Humanities
provided more funds for the digitization of Franklin Furnace's first
decade of event records.

It would be difficult to overestimate the impact of Wilson and
Franklin Furnace on the visual arts today. Wilson was largely
responsible for the acceptance of new forms of artmaking—artists'
books, performance art, and temporary installations. As an artist
who was courageous in making work against sexism and as a gal-
lerist who supported other artists in that critique despite all retri-
bution, she became a model for subsequent artists and dealers to
do the same. What were the leadership qualities that enabled her
success? First, she was a courageous risk taker. She started a gal-
lery with no previous experience and no money. She fostered excit-
ing leading-edge art rather than playing it safe and continued to
do so despite the penalties. Second, she recognized her own igno-
rance and sought the help of others to assist in fundraising. Third,
she took the time and made the effort to discover various sources
of funds, both public and private. Fourth, if confronted by obsta-
cles, she was imaginative and found ways to overcome them or go
around them. And finally, she was foresighted and realized that
she had to deal with issues of legacy if Franklin Furnace were to
continue as an ongoing resource.

She says that many of her decisions came from a need to sur-
vive rather than from conscious and rational leadership. As some-
one who was confrontational in acting on her feminist principles,
she says that rather than being confrontational today, she believes
that it's more effective at present to invade the system "melliflu-
ously." Sometimes she feels depressed about whether art has any

impact on other parts of the society. She points out that the Guerrilla Girls have made it impossible to show all white men in major art institutions, but does that mean that the broader society will act on the same principle? Her advice to young artists is to think beyond the traditional. She suggests that they make art that relates to the world—art out of physics or the commodities market. When she sums up her career and reflects on what she wants to tell young people, she says one "should turn lemons into lemonade. If you're abused by your father, then use your lack of understanding of boundaries as an advantage."

Notes

1 The personal details of Martha Wilson's life and direct quotes are from an interview conducted by Judith K. Brodsky and Ferris Olin, September 9, 2015. A very useful online source for Wilson's biography is Toni Sant, interview with Martha Wilson, Parts I, II, III, and IV, originally published in *TDR Magazine*, Spring 2005, T185, containing articles that discuss the history of Franklin Furnace and give much information on Wilson's life and career, available on the Franklin Furnace website: http://franklinfurnace .org/research/texts_about_ff/docs/wilson01.pdf. A full curriculum vitae is available on Wilson's website (http://marthawilson.com/mwresume.pdf) and the website of PPOW Gallery, which represents her (http://www.ppowgallery .com/artist/martha-wilson/biography). See also Alexis Clements, "The Radical Art of Archiving Performance as Practiced by Martha Wilson," *Hyperallergic*, April 8, 2015, http://hyperallergic.com/195681/the-radical-art-of -archiving-performance-as-practiced-by-martha-wilson/; Edward M. Gomez, "In Martha Wilson's New Photo Works, Feminism Meets the Absurd," *Hyperallergic*, October 24, 2015, http://hyperallergic.com/247053/in-martha -wilsons-new-photo-works-feminism-meets-the-absurd/; and Lucy Lippard, "Martha Wilson: The Fire in the Furnace," in *Women's Caucus for Art Honor Awards for Lifetime Achievement in the Visual Arts 2015*, Women's Caucus for Art (2015): 14–16, https://www.nationalwca.org/LTAcat-pics/LTA/ LTA2015.pdf.

2 Judith Lewis Herman, *Trauma and Recovery: The Aftermath of Violence—from Domestic Abuse to Political Terror* (New York: Basic Books, 1997).

3 Wilmington College is a small liberal arts college founded by Quakers. See "History and Tradition," Wilmington College, https://www.wilmington.edu/ about/history-and-tradition/.

4 During the period when Wilson was connected to the Nova Scotia College of Art and Design, it was considered a leading-edge institution. According to its website, in 1973, the prestigious journal *Art in America* named it the best art school in North America. Les Levine, "The Best Art School in North America?,"

NSCAD.edu, http://nscad.ca/en/home/abouttheuniversity/past-present/new
-era.aspx. Dalhousie University was founded in 1818 and is one of Canada's
oldest universities. A research and teaching institution, its present student
population is 18,500. "About Dalhousie University," Dalhousie University,
https://www.dal.ca/about-dal.html.

5 Lucy Lippard is one of the most influential art critics of the second half of
the twentieth century. For more information, see "Lucy R. Lippard Papers,
1930s–2010, Bulk, 1960s–1990," Archives of American Art, http://www.aaa.si
.edu/collections/lucy-r-lippard-papers-7895/more.

6 For a brief biography, see "Simone Forti," UCLA Department of World Arts
and Cultures/Dance, http://www.wacd.ucla.edu/lecturers-visiting-and-adjunct
-professors/40-faculty/lecturers-visiting-and-adjunct-professors/63-simone
-forti.

7 Jacki Apple is a performance artist who combines art, writing, and music in
her work. For her biography and brief descriptions of her major performances,
see "Jacki Apple: One Word at a Time, 1994," *New American Radio*, http://www
.somewhere.org/work_excerpts/apple/main.htm.

 Billy Apple played an influential role in the formation of Pop art
and Conceptual art. In an announcement of his retrospective, Rhana
Devenport, the director of the Auckland (New Zealand) Museum said of
him: "An active player in key art movements from the 1960s to the pres-
ent, Apple has contributed significantly to the histories of Pop art, Light
art, Conceptual art, Performance art, Installation art and more." "Billy
Apple®: The Artist Has to Live Like Everybody Else," *e-flux*, March 2, 2015,
http://www.e-flux.com/announcements/29913/billy-apple/.

8 Willoughby Sharp was a conceptual artist and curator. He died in 2008. "Wil-
loughby Sharp, 72, Versatile Avant-Gardist, Is Dead," *New York Times*, Decem-
ber 31, 2008, http://www.nytimes.com/2008/12/31/arts/design/31sharp.html.
Tribeca became, for a time, the center of the avant garde art world in New
York. Major galleries opened in Tribeca. But with its success as a destination
neighborhood, gradually Tribeca was taken over by fashion boutiques, and the
Chelsea warehouse district near the Hudson River supplanted Tribeca as an
area for galleries.

9 On Alanna Heiss's impact on the New York contemporary art scene, see M. H.
Miller, "The Anti-museum Director: Alanna Heiss on the 40th Anniversary of
PS1 Contemporary Art Center," *ARTnews*, July 14, 2016, http://www.artnews
.com/2016/07/14/the-anti-museum-director-alanna-heiss-on-the-40th
-anniversary-of-ps1-contemporary-art-center/.

10 For the history of Printed Matter, see "History," Printed Matter, Inc., https://
www.printedmatter.org/what-we-do/history.

11 "A Brief History of FF," Franklin Furnace, http://franklinfurnace.org/research/
texts_about_ff/a_brief_history_of_ff.php.

12 Edward M. Gómez, "Franklin Furnace at 40: Still Radical after All These Years,"
Hyperallergic, April 16, 2017, https://hyperallergic.com/372514/franklin-furnace
-at-40-still-radical-after-all-these-years/.

13 Toni Sant and Martha Wilson, "Interview with Martha Wilson, Part II," *Drama Review* 49, no. 1, T185 (2005): 55–59, http://franklinfurnace.org/research/texts _about_ff/docs/wilson02.pdf.

14 "Timeline," Franklin Furnace, http://franklinfurnace.org/research/ organizational_timeline/timeline.php.

15 "Timeline."

16 C. Carr, "The Fiery Furnace," *Drama Review* 49, no. 1, T185 (2005): 19–28, http://franklinfurnace.org/research/texts_about_ff/docs/carr.pdf.

17 The fourth was Tim Miller.

18 The members of Disband came together again in 2008 to perform at the opening of *WACK! Art and the Feminist Revolution*, an exhibition documenting the artists of the 1970s feminist art movement, at PS1. "DISBAND Press Release," *DISBAND blog*, https://disbandny.files.wordpress.com/2011/11/pr_disband .pdf; and M. H. Miller, "Getting the Band Back Together: Martha Wilson's Punk Group Is Still Gigging after All These Years," *ARTnews*, November 19, 2015, http://www.artnews.com/2015/11/19/getting-the-band-back-together-martha -wilsons-punk-group-is-still-gigging-after-all-these-years/.

19 Haig was a war hero, a top military officer who headed the U.S. forces in NATO, and an accomplished administrator. He became President Richard Nixon's chief of staff in the early 1970s and guided the presidency through the Watergate days, easing the transition after Nixon's resignation and the ascension of Gerald Ford to the presidency.

20 After performing as Alexander Haig, she then took on performances as presidents' wives—Nancy Reagan, Barbara Bush, and most recently Michelle Obama, whom she performed in half blackface. They provided her with the opportunity to puncture the surface smoothness of American leaders as well as to promote feminist ideals.

21 Carr, "Fiery Furnace."

22 Quote from Kitty Carlisle Hart, recounted to Brodsky and Olin during their interview with Martha Wilson.

23 Zollar is also the subject of a case study in this volume. See chapter 10.

24 Wilson, quoted in Gómez, "Franklin Furnace at 40."

Bibliography

Brodsky, Judith K., and Ferris Olin. Telephone interview with Martha Wilson, September 9, 2015.

Carr, C. "The Fiery Furnace." *Drama Review* 49, no. 1, T185 (2005): 19–28. http:// franklinfurnace.org/research/texts_about_ff/docs/carr.pdf.

Clements, Alexis. "The Radical Art of Archiving Performance as Practiced by Martha Wilson." *Hyperallergic*, April 8, 2015. http://hyperallergic.com/195681/the -radical-art-of-archiving-performance-as-practiced-by-martha-wilson/.

Franklin Furnace. "Timeline." http://franklinfurnace.org/research/organizational _timeline/timeline.php.

Gómez, Edward M. "Franklin Furnace at 40: Still Radical after All These Years." *Hyperallergic*, April 16, 2017. https://hyperallergic.com/372514/franklin-furnace-at-40-still-radical-after-all-these-years/.

———. "In Martha Wilson's New Photo Works, Feminism Meets the Absurd." *Hyperallergic*, October 24, 2015. http://hyperallergic.com/247053/in-martha-wilsons-new-photo-works-feminism-meets-the-absurd/.

Lippard, Lucy. "Martha Wilson: The Fire in the Furnace." In *Women's Caucus for Art Honor Awards for Lifetime Achievement in the Visual Arts 2015*, ed. Women's Caucus for Art, 14–16. Philadelphia: Women's Caucus for Art, 2015. https://www.nationalwca.org/LTAcat-pics/LTA/LTA2015.pdf.

Sant, Toni, and Martha Wilson. "Interview with Martha Wilson, Part II." *Drama Review* 49, no. 1 (2005): 55–59. http://franklinfurnace.org/research/texts_about_ff/docs/wilson02.pdf.

FIGURE 14 Photograph portrait of Jawole Willa Jo Zollar. Photograph by Crush Boone. Courtesy of Urban Bush Women Dance Company.

Jawole Willa Jo Zollar

Urban Bush Women: The Power of Dance to Promote Cultural Inclusivity and Community Engagement

Jawole Willa Jo Zollar[1] founded Urban Bush Women (UBW) in 1984 with the radical objective to establish a feminist modern dance company based on the cultural heritage of the African diaspora that would perform in mainstream spaces. She also envisioned utilizing the power of dance to generate social justice through community outreach. Under her leadership, UBW has been a driving force in the transformation of modern dance into a more inclusive art form attracting diverse audiences and high critical praise nationally and internationally.

When Zollar was growing up, she and her family lived in an African American section of Kansas City, Missouri. Zollar says that at first, she thought everyone in the world was black; the issue of race simply did not come up. She remembers, "We never said we were of African descent. . . . Our idea of how people moved in Africa came from Tarzan movies: I honestly grew up imagining that everyone there swung from trees."[2]

Her father was an independent realtor who tried very hard to find good housing for African Americans only to see loans canceled when he started selling houses to blacks. Her mother was an accountant after her five children were born (Zollar was the middle child) but had been a dancer and cabaret singer specializing in jazz and blues. According to Zollar, her parents stressed education. As

FIGURE 15 *Hairstories*. Photograph by Jennifer Lester. Courtesy of Urban Bush Women Dance Company.

an adolescent, her father had worked all night in a pharmacy and then walked to school without having had any opportunity to sleep.[3]

Zollar's mother introduced the children to cultural activities early in their childhood. She played the piano, had an extensive jazz collection, and also took them to museums and symphony orchestra concerts. It was still the period when the art in museums and the

music played by the orchestras were created by whites of European descent. Thus Zollar experienced a dual approach to culture—African diaspora and mainstream white American culture.[4]

When Zollar first started taking dance lessons, she and a sister studied classical ballet, but Zollar relates that the two of them were uncomfortable as the only African American students in the class. Consequently, their mother enrolled them in a dance class taught by Joseph Stevenson, an African American dancer who had been a student of Katherine Dunham, the founder of the African/Caribbean dance movement in the United States.[5]

One might assume that since Zollar was taking dance lessons from a teacher with modern dance credentials, she would grow up aware of contemporary dance innovation. However, Zollar says that Stevenson's approach was anything but classical or modern. He taught a little bit of everything—the routines they learned were more related to popular culture. She and her sister learned the steps and began performing: "Anything to do with dance, my sister and I did it. We made up dances for people. . . . Anytime we'd hear of an event, 'Oh your parents are having a birthday? We'll make up a birthday dance, and you can pay us and we'll come over and do it.'" And so Zollar and her sister began their own small business. Zollar says they were only about eight years old, and they received $25 for a performance.[6]

Zollar's values came out of her home environment. She became aware of faith and spirituality through her family—an awareness that continued to permeate her life (in adulthood, she gravitated toward Eastern religions). She believes her faith contributed to the inspiration for UBW. She says of her parents, "What I appreciate is that it was an environment of spiritual seeking, and my parents nurtured that. . . . That was what I grew up in, and that is all in Urban Bush Women in some way."[7]

Her awareness of gender issues also came from the family. She relates that when she was seven or eight years old, she asked her mother why women had to change their names when they married. There were many strong independent women in her extended family, and her mother would say, "What's good for the goose is good for the gander." She also saw the contrast between the attitude

toward women in her family household and the way in which women were depicted in popular culture through such television series as *Leave It to Beaver*. In high school, the lack of literature by black authors led her to begin questioning race relations and the impact of racism on education and cultural institutions.[8]

During her high school years, Zollar danced in talent shows. When she went to college, she was amazed that she could major in dance and earn a degree in something she truly loved. Zollar observed, "I was making dances. . . . I was part of a black theater group, but I was always engaged in dance and politics and experimentalization."[9] This, she recalled, was a period when things were congealing inside her head. When she arrived at college in 1968, she was exposed to the feminist movement, which was well under way, but she also became aware that white women and black women had different interests in feminism.[10] She received her undergraduate degree in dance at the University of Missouri, Kansas City, and her MFA in dance from Florida State University.

Zollar had always been interested in researching the cultural roots of the African diaspora. In Florida, she studied ballet and modern dance, but she says, "Something was absent. What was lacking was who I was." Zollar told *People Magazine*, "It was someone else's vision."[11] In 1980, she moved to New York City to study with Dianne McIntyre at Sounds in Motion, the only dance company in Harlem during the 1970s and 1980s. She had seen McIntyre perform at Florida State and had been inspired by the experience. McIntyre, who trained in mainstream modern dance at Ohio State University, became interested in infusing modern dance with music from the African diaspora under the influence of the Black Arts movement of the late 1960s and the first half of the 1970s. The Sounds in Motion venue was a center for dialogue in Harlem among the activist artists, writers, and dancers involved in inserting black consciousness into mainstream culture.[12] McIntyre's choreography, particularly her partnership with the playwright Ntozake Shange, was very influential on subsequent developments in modern dance.[13]

In founding Urban Bush Women in 1984, Zollar considered herself an inheritor of McIntyre's mission and values. She has remarked that she felt part of a "continuum of sisters." There was no need to

do something different from what McIntyre was doing—just to put her own imprint on black choreography.[14] Like the methodology of McIntyre and Dunham, the compositions that Zollar created for UBW were based on contemporary dance, music, and text fused with the history, culture, and spiritual traditions of the African diaspora, but with a difference. From her experiences in McIntyre's company, Zollar concluded that there was a strong disparity in the commitment between male and female dancers. She observed that the women were deeply involved in the meaning and importance of dance, whereas the men were more superficial and not interested in the social and political implications and possibilities in choreography. Disappointed by the lack of idealism in male dancers, she decided to create an all-women dance company. She heard the name "Urban Bush Men," the title of the Art Ensemble of Chicago's jazz album, and decided to adapt the name; thus Urban Bush Women was designated. To sum up, her leadership initiative in establishing UBW came from her allegiance to several principles: a desire to continue Dunham's and McIntyre's efforts to bring the African diaspora heritage into American modern dance; a commitment to feminism; a devotion to the moral and ethical principles of spirituality; and an intent to generate social change. In the spirit of UBW, Zollar changed her first name to the African name Jawole.

She created the company in reaction to the impediments she experienced as an African American woman: as "a non-traditional dancer she had the wrong shape, wrong technique or wrong body type" for contemporary dance companies.[15] She recalled, "I broke every rule they taught me about composition. I did everything they said you don't do, in terms of making a piece. I was trying to find out, what was my voice? What did I have to say? How could I merge all the things I was interested in into one area? I know I was really looking strongly at my culture as a sense of focus."[16]

The novelty of UBW's approach to dance resulted in initial success, but the company gradually fell apart to the point where it was hundreds of thousands of dollars in debt. In addition to financial difficulties, six dancers walked out. The company was threatened with dissolution.

Resolution

Zollar realized she had to stop focusing on performance quality while simultaneously handling all the management and financial issues associated with running a dance company. She also realized that she had to change her authoritarian style. She says that she had been operating on the principle of toughening up her dancers, humiliating them if they made mistakes and treating them like recruits in a boot camp.[17] Zollar reflects on her early mode of leadership: "When I first began, for me the value was about just getting the work done by any means necessary. What I've learned is that positive reinforcement goes further than negative reinforcement."[18]

Zollar sees building a sustainable UBW company and reinventing her leadership style as having three components: gaining education in management techniques; utilizing experts in areas in which she had little experience; and developing a collaborative rather than hierarchical style. She began to read books on corporate leadership in crisis and to learn about organizational models of development.

Next, she sought advisors. Fortunately for Zollar, she didn't have to look very far. While she had a number of consultants, her chief mentor was her brother, who was an executive at IBM. He helped run the UBW company for two and a half years. They formulated a mission, which captured Zollar's idealistic goal of generating social justice through dance. Zollar says, "The values have to be front and center."[19]

Next, they developed a strategic plan to implement the mission by building a support structure with multiple branches. In seeking funding from foundations and individual donors, they negotiated with potential donors honestly, saying that they would "do their best to return the money, but made no promises."[20] In order to increase performance revenues, Zollar reports that "they made bookings and toured like crazy."[21] They also appointed new board members with "specific expertise and commitment to the values of the organization,"[22] made a plan for audience development, and created an infrastructure headed by an executive director and with a staff of people who had the knowledge and experience to

work collaboratively with Zollar on both the managerial and artistic tasks that she had been handling by herself.

Zollar credits one of her mentors, Karen Pryor, author of the book *Don't Shoot the Dog! The New Art of Teaching and Training*, with helping her develop an ensemble approach where everyone works together rather than the hierarchical method of management that she had previously found harmful.[23] According to Zollar, "The group is stronger when not dependent on one singular leader."[24] Zollar considers this collaborative style as matriarchal as opposed to the patriarchal model of a single powerful leader at the top who directs everyone else. She likens it to a "praisehouse," where there is leadershipless worship.[25]

In addition to using this model for UBW itself, Zollar has employed the matriarchal concept of leadership for social justice projects. Her objective is to help people gain empowerment—she looks for the "communities in which people feel disempowered."[26] A trip by the company to South America illustrates how UBW operates in community engagement. The dancers went into districts with large populations of people of African descent living in poverty in Venezuela, Brazil, and Colombia with the goal of having the residents and dancers learn from each other about their commonalities and misperceptions: "When Americans think about Colombia, they think about drug cartels and kidnapping. . . . The ideas that other countries have about our culture [in the United States] are mass-produced by television."[27] Rather than delivering lectures, the dancers listened to the people in the community as equals, sharing their respective experiences and investigating their attitudes toward each other in a nonconfrontational style. Zollar remarks that this mode of community engagement "shifts the power, giving those at the bottom a place at the table and the ability to shape the table."[28]

Zollar views the period of transforming the dance company into a viable organization as "an opportunity to reshape UBW; every challenge is a gift."[29] She says it was a struggle, and she underwent tremendous physical stress; at one point she took the risk of a sabbatical, even though it may have seemed irresponsible to the outside world, understanding that it was necessary in order to regroup and

maintain progress.[30] But out of this difficult period came a model that brought UBW to sustainability. UBW emerged with "wonderful support from funders"[31]: revenue became evenly divided between earned monies and gifts.

The company has had tremendous success. Based in New York, it mounts performances regularly in the city at prestigious venues, including the Joyce Theatre, the Brooklyn Academy of Music (BAM), and Lincoln Center. It tours nationally to such locations as the Kennedy Center in Washington, DC, and has performed internationally on five continents. UBW has been commissioned to create new works by national presenters. It has received many honors, including a New York Dance and Performance Award ("Bessie") for *Walking with Pearl . . . Southern Diaries*, choreographed by Zollar; the Capezio Award for Outstanding Achievement in Dance; and two Doris Duke Artist Awards for New Work from the American Dance Festival. UBW was selected as one of three U.S. dance companies to inaugurate a touring program to South America as part of Dance-Motion USA, a cultural diplomacy initiative organized jointly by the Bureau of Educational and Cultural Affairs, the United States Department of State, and the Brooklyn Academy of Music.

Zollar has created thirty-four works for UBW; she has also been commissioned to create choreography for the Alvin Ailey American Dance Theater, Philadanco, University of Maryland, and Virginia Commonwealth University, among others, and has worked with collaborators including Compagnie Jant-Bi from Senegal, and Nora Chipaumire, with whom she created *visible*, a dance performance that focuses on immigration and migration.

She has received the *Dance Magazine* Award and the Dance/USA Honor Award and was designated a master of choreography by the John F. Kennedy Performing Arts Center. She also received recognition for her efforts to build equity and diversity in the performing arts from Sphinx Music at its inaugural conference on diversity in the arts. Zollar was one of the subjects of the PBS documentary *Free to Dance*, which chronicled the African American influence on modern dance, and was a featured artist in the film *Restaging Shelter*, produced and directed by Bruce Berryhill and Martha Curtis, available to PBS stations.[32] In 2017, the Bessies recognized her with their

New York Dance and Performance Award for Lifetime Achievement in Dance.

Academic recognition has also come to Zollar. She is the Nancy Smith Fichter Professor in Dance at Florida State University (FSU), and in 2011–2012, she was named FSU's Robert O. Lawton Distinguished Professor, the highest award granted to FSU faculty. Tufts and Rutgers Universities have awarded her honorary degrees.[33] She says she likes the academic world because she has colleagues, whereas "the world of an artistic director is lonely."[34]

Zollar's choreography is a historical and contemporary mix. Her early work at UBW was about new ways of "reading the bodies of women of color."[35] Two of Zollar's signature pieces performed in the early days of UBW were presented again at UBW's twenty-fifth-anniversary program, *Zollar Uncensored*. They are good examples of her initial style. Many of these pieces are erotic. In the program notes, Zollar describes the evening as "a collage of excerpts that connect to this area of my work that I eventually abandoned or that was diminished when the full brunt of the 'Helms era' of censorship frightened presenters and funders." Worse, she adds, "I began to censor myself." In it, she performs a ritual, stripping off her green stilettos and wrap dress and smearing her naked, writhing torso with raw egg. She then pulls a knife from a hidden holster and makes threatening gestures toward an invisible foe. She is joined by a group of female dancers, perhaps worshippers, who are guarding her against sexual attack. The dancers form a processional, carrying baskets of apples and white flowers. Zollar originally danced this piece, but during the anniversary performance, she draws a snake-like figure on the floor in chalk. Zollar herself dances in another selection, *Womb Wars*. She hunches over a naked dancer, pressed against her back, and moves slowly across the stage with her arms outstretched. In a strident voice, she recites a short, brutal story of rape and other physical violence at the hands of strangers and relatives. The other dancer left alone in the center of the stage performs a series of leaps. She then drops to her knees and beats her breast. The other dancers crowd around to comfort her and dress her in a duplicate of their costumes—short tank tops and a stream of pale blue fabric tied loosely around the waist. The piece concludes with

all the dancers moving in rhythmic unison accompanied by three vocalists who sing about aspiration and sorrow.[36]

After her period of concentration on female sexuality and the black body, Zollar began to draw inspiration from everyday popular culture and social themes. *I Don't Know, but I've Been Told, If You Keep on Dancin' You'll Never Grow Old* is humorous. Instead of the symbolic, emotional approach of the two pieces described above, the choreography is based on movements drawn from street dancing, double Dutch rope jumping, cheerleading, and rap. *Shelter* is a piece about homelessness and disregard of the environment. As in her earlier work, Zollar continued to include spoken or sung text along with the dance steps.[37]

The cultural significance of black women's hair is the subject of *Hairstories*. It also combines choreography with text and even includes projected video interviews about hair, conducted with mostly African American women and one man. Most of the talk is about the African American woman's age-old attempts to control "nappiness," which is usually a derogatory term, but in Zollar's choreography, it becomes a positive feature. It opens with Zollar washing and attempting to comb through thick and nappy hair in a black-and-white video. Zollar reappears live throughout the piece as herself as well as several satirical characters, including Dr. Professor, the teacher of a course called "Naphology 101." As Dr. Professor, she talks about "the construct of whiteness" and "reappropriating the tools of the oppressor." In the videos, Zollar refers to Madame C. J. Walker, an African American entrepreneur who built a hugely profitable cosmetics empire on, as Zollar puts it, "black self-hatred." But Zollar also expresses admiration for Madame Walker as the first African American woman millionaire. At one point, a woman in the video projection says, "We are a people who has been taught that everything about us is ugly, especially our hair."[38]

In addition to using choreography to stimulate awareness of African diaspora culture as a positive attribute and racism and sexism as negatives, UBW has directly engaged with communities over several decades. The company's website captures the spirit and intent of these empowerment efforts: "UBW leverage[s] dance as a catalyst for social change . . . at the forefront of activating the

intersections of professional and community art-making, civic engagement, leadership, and group dynamics."³⁹ The company originally developed UBW's community engagement program to help rebuild New Orleans after Hurricane Katrina and has also been in residencies in Tallahassee, focused on HIV/AIDS prevention; in Flint, Michigan, in response to General Motors plant closings; and even on college campuses such as the University of California, San Diego to find solutions when a 2005 student survey revealed negative feeling on campus. UBW works with local artists and activists and the core constituencies to set content and goals with and for the community.⁴⁰

Zollar's interest in provoking social change through the arts has led to the establishment of several ongoing community engagement programs. These initiatives illustrate UBW's collaborative, multidisciplinary, and community-centered creative approach. Builders, Organizers, and Leaders through Dance (BOLD) has more than twenty-nine facilitators who travel nationally and internationally to conduct workshops enabling communities to create performances focused on local histories. The Summer Leadership Institute (SLI), established in 1997, conducts a ten-day intensive training program to educate dance professionals and community-based artists/activists in how to use the arts as a vehicle for civic engagement and to develop leadership skills. In 2016, UBW instituted the Urban Bush Women Choreographic Center to support the development of more women choreographers of color and other underrepresented sectors of the population.

Zollar has not rested. Continuing to develop internal as well as external strength and looking toward succession after she retires, she has divided the top administration into two positions, each a director with different skills: one artistic and the other managerial. She says that her concept is to create partnerships. Zollar remarks, "When people start to ask about succession, there shouldn't be a crisis. Growth is stronger [if there is a partnership] rather than one leader."⁴¹

To summarize, several aspects of Zollar's life shaped her leadership, UBW's sustainability, and its artistic success. She grew up in a circle of family and friends who inculcated their children with

the ideals of the civil rights and feminist movements that had such an impact during her formative years. Zollar's resulting commitment to social justice can be found in her own words: "I work to listen and help uncover the under-told perspectives of people who have often been told they have limited power and potential."[42] Dianne McIntyre provided a model for Zollar to follow not only because she was promoting black culture through dance but also because she was an entrepreneur who had established her own company.[43] When she was confronted by the potential failure of UBW, Zollar developed the necessary management skills to save the company. She stresses how important it was "to turn to people who knew what she didn't know—a learning community."[44] It took her several years to cope with UBW's problems, but she never neglected choreography. Despite her entrepreneurial responsibilities, Zollar always maintained her artistic practice. She pioneered many new choreographic concepts, one of which is the use of multimedia in choreography, now widely accepted, and she has been critically acclaimed.

Zollar rescued the organization she had founded by engaging in expert strategic planning and reinventing her leadership style. Her goal, however, went beyond creating a viable institution for its own sake. Her ultimate ambition was to further social justice through a twofold vision: to create dance performances based on her African diaspora heritage and her feminist principles and to use dance to uplift communities. By educating herself in business practices that were appropriate to establishing a not-for-profit arts organization, she succeeded. She considers learning management techniques so important that UBW organizes educational programs on management for other not-for-profit organizations:[45] "We have changed perceptions about body types and approaches to performance in both form and content. Driven by our passion for dance, we have shown how choreographers can address socio-political issues in their work and involve whole communities in art making."[46]

Her advice to others is to "[consider] the mandates of the time, be innovative, and approach community. . . . Be true and grow. Do not say this is the way I am, but grow and be around people who will facilitate your growth."[47]

Notes

1 Brodsky and Olin interviewed Zollar by telephone, September 28, 2016.

2 Alastair Macaulay, "So You Think It's African Dance?," *New York Times*, May 23, 2010, http://www.nytimes.com/2010/05/23/arts/dance/23african.html?_r=0.

3 Zollar, interview.

4 Zollar, interview.

5 From a speech made by Zollar at Minnesota State University, Mankato, where she served as Worlds of Thought Resident Scholar, 1993–1994, reported in Alison Carb Sussman, "Zollar Jo, Jawole Willa 1950–," in *Contemporary Black Biography. Volume 28: Profiles from the International Black Community* (Detroit: Gale Research, 2001), http://www.encyclopedia.com/doc/1G2-2873000072.html.

6 Sussman.

7 *Faith and Leadership*, "Zollar, Jawole Willa Jo: Coming Together to Create," February 10, 2014, https://www.faithandleadership.com/qa/jawole-willa-jo-zollar-coming-together-create.

8 Interview with Brodsky and Olin.

9 From Zollar's speech at Minnesota State University, Mankato.

10 Interview with Brodsky and Olin.

11 Quoted in Sussman, "Zollar."

12 Harlem in the 1970s had a vibrant cultural scene. The Black Arts movement of the late 1960s and early 1970s, which involved visual artists, playwrights, poets, and musicians, ushered in a new phase of African American culture. By the 1980s, when Zollar came to New York to study with McIntyre, many Harlem-based cultural figures, such as poets Nikki Giovanni and Maya Angelou and the artists Romare Bearden and Faith Ringgold, had received recognition from the mainstream cultural establishment. For more information, see the Black Past website: http://www.blackpast.org.

13 Ntozake Shange is a black feminist American playwright and poet who writes about issues relating to race and women. She is best known for the Obie Award–winning play *For Colored Girls Who Have Considered Suicide / When the Rainbow Is Enuf.*

14 Interview with Brodsky and Olin.

15 Daryl Foster, "Coming to the Rialto: Urban Bush Women Founder Jawole Willa Jo Zollar Refuses to Stay Put," *ArtsCriticATL*, January 8, 2011, https://www.urbanbushwomen.org/images/Jawole%20Interview%20-%20ArtsCriticATL%2001_08_2011.pdf.

16 Mankato State University speech.

17 Interview with Brodsky and Olin.

18 Victoria Looseleaf, "A Female Force," *Dance Magazine*, March 2011, 30–31.

19 Interview with Brodsky and Olin.

20 Zollar, interview.

21 Zollar, interview.

22 Zollar, interview.

23 Zollar, interview.

24 Zollar, interview.

25 Ananya Chatterjea, "Zollar Uncensored: Jawole Willa Jo Zollar and Ananya Chatterjea, Oct. 2010," Institute for Advanced Study, October 21, 2010, http://ias.umn.edu/2010/10/21/zollar-chatterjea/. See also Nadine George-Graves, *Urban Bush Women: Twenty Years of African American Dance Theater, Community Engagement, and Working It Out* (Madison: University of Wisconsin Press, 2010), where she characterizes Zollar's choreography as "new rituals creativity" in the "womanist theology spirit" (135–139).

26 Zollar, interview with Brodsky and Olin.

27 Rosalyn Sulcas, "The Soft Steps of Diplomacy," *New York Times*, March 19, 2010, http://urbanbushwomen.org/images/NYT%2003%2019%2010.pdf.

28 Zollar, interview with Brodsky and Olin.

29 Zollar, interview.

30 Zollar, interview.

31 Zollar, interview.

32 George-Graves, *Urban Bush Women*.

33 "Jawole Willa Jo Zollar," Florida State University, http://dance.fsu.edu/jawole-willa-jo-zollar/.

34 Zollar, interview with Brodsky and Olin.

35 Ananya Chatterjea, *Butting Out: Reading Resistive Choreographies through Works by Jawole Willa Jo Zollar and Chandralekha* (Middletown, Conn.: Wesleyan University Press, 2004).

36 Claudia La Rocco, "Urban Bush Women, Moving through a Defiant Past," *New York Times*, January 22, 2010, http://www.nytimes.com/2010/01/22/arts/dance/22urban.html. Senator Jesse Helms led a successful battle in the 1980s and early 1990s to censor artists, choreographers, and other creative professionals who were using explicit sexual material. He forced the National Endowment for the Arts, a federal agency that supports creative professionals, to abandon monetary awards to individual visual artists on the basis that artists were undermining American values.

37 Jennifer Dunning, "Urban Bush Women Impart Their Visions of Culture," *New York Times*, December 20, 1990, http://www.nytimes.com/1990/12/20/arts/reviews-dance-urban-bush-women-impart-their-visions-of-cultures.html.

38 Jennifer Dunning, "Teasing in More Ways than One: Seeking Universal Truths in Hairstyles," *New York Times*, August 28, 2001, http://www.nytimes.com/2001/08/28/arts/dance-review-teasing-more-ways-than-one-seeking-universal-truths-hairstyles.html.

39 "Community Engagement," Urban Bush Women, http://www.urbanbushwomen.org/bold/community_engagement.

40 Michelle Vellucci, "Phenomenal Women," *Dance Teacher Magazine*, March 2009, http://www.dance-teacher.com/2009/03/phenomenal-women/.

41 Vellucci.

42 Jawole Willa Jo Zollar, "My Vision of Collaboration and Community," California State University Summer Arts, 2010, newsletter, http://urbanbushwomen.org/images/CSU%20newsletter%20Spring%202010_UBW%20p4.pdf.

43 In 2016, the Dance Theatre of Harlem announced an initiative to address the paucity of female choreographers and lack of diversity in ballet. McIntyre was commissioned by them to create her first ballet. This new dance focused on "black, brown, beige" women, and McIntyre insisted that the dancers research black women in American history. See Gia Kourlas, "Pirouetting into a Different Take on History," *New York Times*, March 27, 2016.

44 Zollar, interview with Brodsky and Olin.

45 Zollar, interview.

46 "Jawole Reflects," Urban Bush Women, http://www.urbanbushwomen.org/our _legacy/jawole_reflects.

47 Zollar, interview with Brodsky and Olin.

Bibliography

Brodsky, Judith K., and Ferris Olin. Telephone interview with Jawole Willa Jo Zollar, September 28, 2016.

Chatterjea, Ananya. *Butting Out: Reading Resistive Choreographies through Works by Jawole Willa Jo Zollar and Chandralekha*. Middletown, Conn.: Wesleyan University Press, 2004.

———. "Zollar Uncensored: Jawole Willa Jo Zollar and Ananya Chatterjea, Oct. 2010." Institute for Advanced Study, October 21, 2010. http://ias.umn.edu/ 2010/10/21/zollar-chatterjea/.

Dunning, Jennifer. "Teasing in More Ways than One: Seeking Universal Truths in Hairstyles." *New York Times*, August 28, 2001. http://www.nytimes.com/ 2001/08/28/arts/dance-review-teasing-more-ways-than-one-seeking-universal -truths-hairstyles.html.

———. "Urban Bush Women Impart Their Visions of Culture." *New York Times*, December 20, 1990. http://www.nytimes.com/1990/12/20/arts/reviews-dance -urban-bush-women-impart-their-visions-of-cultures.html.

Faith and Leadership. "Zollar, Jawole Willa Jo: Coming Together to Create." February 10, 2014. https://www.faithandleadership.com/qa/jawole-willa-jo-zollar -coming-together-create.

Florida State University. "Jawole Willa Jo Zollar." http://dance.fsu.edu/jawole-willa -jo-zollar/.

Foster, Daryl. "Coming to the Rialto: Urban Bush Women Founder Jawole Willa Jo Zollar Refuses to Stay Put." *ArtsCriticATL*, January 8, 2011. https://www .urbanbushwomen.org/images/Jawole%20Interview%20-%20ArtsCriticATL %2001_08_2011.pdf.

George-Graves, Nadine. *Urban Bush Women: Twenty Years of African American Dance Theater, Community Engagement, and Working It Out*. Madison: University of Wisconsin Press, 2010.

Kourlas, Gia. "Pirouetting into a Different Take on History." *New York Times*, March 27, 2016. https://www.nytimes.com/2016/03/27/arts/ dance/steps-arranged-by-women-with-history-at-dance-theater-of-harlem .html.

La Rocco, Claudia. "Urban Bush Women, Moving through a Defiant Past." *New York Times*, January 22, 2010. http://www.nytimes.com/2010/01/22/arts/dance/22urban.html.

Looseleaf, Victoria. "A Female Force." *Dance Magazine*, March 2011, 30–31.

Macaulay, Alastair. "So, You Think It's African Dance?" *New York Times*, May 18, 2010. http://www.nytimes.com/2010/05/23/arts/dance/23african.html?_r=0.

Sulcas, Rosalyn. "The Soft Steps of Diplomacy." *New York Times*, March 19, 2010. http://urbanbushwomen.org/images/NYT%2003%2019%2010.pdf.

Sussman, Alison Carb. "Zollar Jo, Jawole Willa 1950–." In *Contemporary Black Biography. Volume 28: Profiles from the International Black Community*, ed. Ashyia N. Henderson. Detroit: Gale Research, 2001. http://www.encyclopedia.com/doc/1G2-2873000072.html.

Urban Bush Women. "Community Engagement." http://www.urbanbushwomen.org/bold/community_engagement.

———. "Jawole Reflects." http://www.urbanbushwomen.org/our_legacy/jawole_reflects.

Velluci, Michelle. "Phenomenal Women." *Dance Teacher Magazine*, March 2009. http://www.dance-teacher.com/2009/03/phenomenal-women.

Zollar, Jawole Willa Jo. "My Vision of Collaboration and Community." California State University Summer Arts, 2010. http://urbanbushwomen.org/images/CSU%20newsletter%20Spring%202010_UBW%20p4.pdf.

FIGURE 16 Kim Berman conducting Paper Prayers Workshop at Artist Proof Studio, December 7, 2009. Courtesy of the artist.

Kim Berman

Art as a Tool for Social Transformation

How does one combine idealism with the pragmatism required to implement one's ideals? The artist Kim Berman[1] provides a case study that reveals how one leader was able to work successfully for social justice, carrying out her feminist and inclusive ideals through strategies that ranged from community empowerment to business acumen. In keeping with Nelson Mandela's concepts of growth and reconciliation through recognition of common humanity, Berman founded Artist Proof Studio (APS) in Johannesburg, South Africa, as a multiracial, community-based arts studio with a mission not only to provide professional art training but also to emphasize the potential of art to effect social transformation. Her cofounder, the late Nhlanhla Xaba, brought his strong connections to local artists into the mix. Printmaking was seen as a counterforce to the suspicion and division left from the apartheid years, and as a democratic medium, it was considered to be appropriate to building a truly egalitarian society. Berman considered it an ideal art form for a country in transition from a repressive society to one in which all people were citizens with full rights. The APS programs involve arts education, community-based projects, and fine art. There is a formal three-year program for aspiring artists who have talent but lack formal education or money. In addition to launching the careers of artists, APS has also produced educators and activists who have contributed to the development of a democracy in South Africa.[2]

The situation in South Africa at the time that Kim Berman grew up is important to examine because it shaped her career. The problems

FIGURE 17 Kim Berman printing at Artist Proof Studio. Courtesy of the artist.

she chose to address included racial apartheid, economic distress among local South African people, and the spread of HIV/AIDS.

South Africa is the location of some of the earliest human remains, and ironically, considering the history of the denigration and exploitation of African peoples by Europeans, the continent was probably the source of Western civilization. Southern Africa, including the nation of South Africa, has a very complex early history. Somewhere around the first millennium CE, the Khoisan people from whom the Bushmen are descended were overwhelmed by the Nguni, a Bantu-speaking people, and the Tswana-Sotho-speaking people, who came into the area from farther north, resulting in the establishment of various kingdoms, such as the Bantu kingdoms of Zulu, Swazi, Ndebele, and Xhosa and the Sotho kingdoms of Sotho/Basuto, Tswana, and Pedi. These were the peoples encountered by the Portuguese, the first Europeans to enter the geographic region of South Africa. However, the Portuguese never established permanent settlements. In the seventeenth century, the Dutch founded an outpost of the Dutch East India Company at the Cape of Good Hope, ultimately wresting the Cape area from

the population through exile and disease. Exploitation and denial of rights for the South African population were features of European domination right from the start. When the British took over the colony in the early nineteenth century, paying six million pounds to the Dutch, they signed the Cape Articles of Capitulation, which allowed the colony to maintain its own regulations, laws, and customs, thus internalizing the denial of rights to the black people and making the domination by the minority white population a given.

The gold- and diamond-mining ventures undertaken by European nations in the nineteenth century set off the struggle among the Boers (the descendants of the Dutch settlers), the British, and black kingdoms, particularly the Zulu, and resulted in the Boer Wars. The Boers were victors in the first war, but the British triumphed in the second and created a federated nation out of the various territories held by different groups. Despite the fact that the British had abolished slavery in England, whites continued to be privileged, while blacks continued to be denied voting rights, land ownership, civil liberties, and entitlements throughout not only the nineteenth century but also most of the twentieth century.

While exploitation and oppression of the black population by the Europeans started with the voyages of the European explorers in the sixteenth and seventeenth centuries, it was not a systematized subjugation until 1946, when apartheid was established by the Afrikaner-dominated National Party. The Afrikaners were descended from the original Dutch settlers. Afrikaans, derived from a combination of Dutch, English, and African indigenous languages, became the official language. The Nationalist Party won control of the government and proceeded to enact a series of laws, starting in 1948, restricting blacks in every aspect of life and culminating in the forced relocation of 3.5 million blacks into segregated neighborhoods, forbidding them to live in the areas designated for white people. In 1970, blacks were finally deprived of their citizenship in South Africa and became citizens of ten tribal units. The government then segregated schools, hospitals, recreational facilities, and even drinking water fountains, providing only inferior services for blacks.

But the world was moving beyond colonialism and its legacy. By the 1990s, it was almost impossible for South Africa to maintain

apartheid. The international community was boycotting South African goods and services. The UN had issued a resolution condemning South Africa for its apartheid policies, and as a result, South Africa was increasingly isolated and suffering economically. Recognizing the situation, President Frederik Willem de Klerk began negotiations to end apartheid beginning with the release of Nelson Mandela, who had been the leader in the effort to achieve that goal. Mandela had been tried, convicted, and sentenced to life imprisonment for revolutionary activities in the infamous 1963 Rivonia Trial (named after the section of Johannesburg called Rivonia). In 1990, he was released from prison. It was the start of the abolishment of apartheid that reached a climax in the free elections of 1994, when Mandela won the presidency. Mandela became a revered figure throughout the world as an advocate for human rights. He was awarded the Nobel Peace Prize in 1993, shared with Frederik Willem de Klerk.

For several ensuing decades, South Africa has been redefining itself. Now ruled by a black majority, the country has had to deal with an overturn of centuries of white domination and black oppression. Its economy has been rocky, and the question has been how to empower vast numbers of people coming out of the horrors of apartheid, and integrate them into a civil and economic system that allows them the same opportunities and benefits as the white minority. In addition, South Africa has faced a health crisis for the last two decades. Its population, particularly its black working-class population, has been devastated by the AIDS epidemic that has left a significant population of AIDS orphans and child-headed households. South Africa's AIDS epidemic was among the worst in the world. According to the United Nations, at its height, nearly one thousand South Africans died from the disease each day.

Kim Berman, who was born in 1960 in South Africa, grew up in the last years of apartheid. She was one of four children, all girls. Her family was prosperous, and she lived in a large house with a thatched roof in Sandhurst, one of the well-to-do suburbs of Johannesburg. It was a family interested in the arts, and Berman's mother ran an art gallery. The family was Jewish. Jews had been involved in the development of the diamond and gold mines during the

nineteenth century, but by 1960, most of the Jewish community was antiapartheid, and many Jews were activists, involved in demonstrations against the repressive regime. Of the eleven convicted along with Mandela, six were Jews. Berman says of her upbringing, "We as children learnt to use the Holocaust experience to try and understand the horrors of extreme evil, hatred and racism and to learn how we can contribute towards a just, moral and humane society. Holocaust gave me the strength to speak out, abhor the consequences of racism and be aware that an ideology of supremacy, power and hate can and did lead to the extermination of a people."[3]

Berman's youngest sister, Hayley Berman, an art therapist, recounts attending a Jewish institution, King David School, for her childhood education, where she encountered the liberal, antiapartheid thinking that she had experienced within her own family—Berman's maternal grandfather, Richard Feldman, was the founding member of the Labour Party in South Africa.[4] Hayley and another sister, Cindy, were deeply involved in activism against apartheid. Hayley went on to establish the Lefika Art Therapy Center in Johannesburg, and Cindy had to flee South Africa for London in the late 1980s because of her political involvement.

Berman became an activist while still in her teens. She describes one of her early experiences using art as a tool to achieve social justice:

I have always believed that printmaking and papermaking are artistic strategies or interventions that could make a difference to the lives of people in oppressed or impoverished communities. During the height of repression in South Africa, when the African National Congress (ANC) and antiapartheid political activity was banned, I travelled to the rural Northern Province (now Limpopo) with Elleck Nchabeleng, a long-time ANC activist who was part of the underground movement of the MK (Umkontho We Sizwe; translated "Spear of the Nation"), the active military wing of the African National Congress to give "art workshops" to youth. At the time cultural and art activities were not banned, so these were seen by the ANC activists (known as "comrades") as a tool for motivating and organizing youth for political resistance. I provided a

suitable cover when we were followed and questioned by the apartheid police: I was going to teach art to young people. The power and intensity of those days, when "the young lions" embraced printmaking through making their own screens from nylon stockings and wooden frames, making their own ink from dye or food colouring, or shoe polish, remain a model for me. The youth printed slogans and posters, carved images and symbols–they toyi-toyied (toyi-toyi is a South African militant dance step that became famous for its use in political protests during the apartheid era) and sang and felt incredibly empowered.[5]

Having received her undergraduate degree from Witwatersrand University, Berman came to the United States for a summer holiday in 1983 when she was twenty-three, partly to flee life under apartheid and also to live openly with her lesbian partner, since at the time, homosexuality/same-sex relationships were a crime in South Africa. Shortly after her arrival in the United States, South Africa declared a state of emergency, and Berman decided to remain in the United States, obtain a student visa, and enter the master of fine arts (MFA) program at the School of the Museum of Fine Arts, Boston, which offered the MFA under the auspices of Tufts University. She became an accomplished printmaker.[6] In addition to working toward her MFA degree at the Boston Museum School, she was exposed to the collaborative print shop concept through an internship arranged by her teacher Mary Sherwood at Artist's Proof studio, where she worked as a printing assistant throughout her time in Boston. APS was a cooperative print atelier. Artists Catherine Kernan, Jane Goldman, and Ilana Manolson, along with Sherwood, were the members of the cooperative. It was the first studio in the Boston area to concentrate on monoprints.[7] Sherwood opened the studio in 1980 and closed it when she moved to Los Angeles in the early 1990s. Despite its short lifetime, the studio had an enormous impact on the artists who worked there, including Berman. It spawned two print studios in the Boston area and gave birth to Artist Proof Studio, the printmaking center named after the Boston studio Berman established on her return to South Africa.

Berman was thrilled when Mandela walked out of prison, and she decided to respond to Mandela's appeal to all South Africans who were in self-exile to return and help establish the new South Africa, in which all citizens—whether white, black, or what South Africa termed "colored" (mixed race)—could live and work free of apartheid. On her return to South Africa in 1990, Berman set about founding APS: "In February 1990, on a television screen in Boston, I watched Nelson Mandela walk out of prison; a new era for South Africa had begun. I wanted to be part of building a post-apartheid South Africa, so I sold my car and possessions, bought a French Tool etching press—the Rolls-Royce of studio presses—and took home my vision to start a studio in South Africa based on the professional model of the Artist Proof Studio in Cambridge, Massachusetts, where I had been an apprentice for six years."[8]

She conceived of her effort as helping with the transition from an apartheid state to one in which blacks had full rights by establishing an atelier dedicated to serving the community of black artists shut out of such opportunities under apartheid. She partnered with a black artist named Nhlanhla Xaba, whom she met when he showed his work at her mother's gallery, and who had ties to many of the black artists living in Johannesburg. One of the early supporters of APS was Johnson & Johnson (J&J), which has a large presence in the industrial world of Johannesburg. J&J funded the Brodsky Center for Innovative Editions at Rutgers University to help Berman and Xaba develop the workshop on a professional level.

The concept of collaboration between artists and master printers is a well-established one. Print shops have long existed in Europe. The artist and entrepreneur June Wayne introduced the concept into the United States in the early 1960s, funded by a Ford Foundation grant. Wayne's shop, Tamarind Lithography Workshop, was a center to train master printers. Graduates of Wayne's program then initiated their own shops. The movement spread across the United States, spawning both for-profit shops and shops under the umbrella of universities and art schools. Berman experienced an American shop dedicated to professional collaboration at the Rutgers Center for Innovative Print and Paper (RCIPP), now the

Brodsky Center for Innovative Editions. Thanks to annual grants from J&J, master printers from the RCIPP went to Johannesburg to train APS printers in how to collaborate with artists, and APS artists, including Nhlanhla Xaba, came to the RCIPP. Berman herself created an edition at the Brodsky Center.[9] Collaborations with William Kentridge and other well-known South African artists both white, like Kentridge, and black have been key to APS's ongoing survival.[10]

APS underwent a major crisis when the studio burned down in March 2003. Xaba, who had received the 1998 Standard Bank Young Artist of the Year Award, was killed in the fire. He was only forty-three. The fire was traced to an electrical fault in an appliance in the studio. It spread to the storage of chemicals, causing an explosion that destroyed the studio within hours. Xaba was asleep on the couch. The fumes from the flames caused his asphyxiation, and he never woke up. The works of more than 120 artists were lost in the fire.[11]

In the days immediately following the fire, APS students and teachers sifted through the rubble.[12] When they found items that had belonged to Nhlanhla Xaba, they created a little shrine on the spot where he had died. It was a community activity. They reminisced, mourned together, sang, and began to put together a series of collages made from the fragments of prints they found in the debris. The studio was given temporary space by the Johannesburg City Council. They borrowed etching presses in order to continue the student program and to mount a print marathon, in which a group of well-known as well as emerging artists created prints from the fragments rescued from the ruins, which were then sold to raise funds. The owner of a prominent gallery donated 120 portfolios, printing paper, sets of etching tools, and drawing materials, which were given to all APS members to start work again, and extra instructors came in to help with classes. Therapy sessions were held in which APS members could express their shock, sorrow, and despair. Berman describes the atmosphere as one in which people recognized the loss, realized that the studio as it had existed could not be resurrected, and saw that it was time to look ahead.[13]

Three weeks after the fire, Berman came to the United States to speak at a printmaking conference in Boston. One of the APS artists, Daniel Stompie Selibe, was already in the United States as an artist-in-residence at Brandeis University and, like Berman, was a speaker at the conference. Knowing about the terrible tragedy of the fire, the conference organizers held an auction and event to raise funds to help with building a new studio and invited Berman and Selibe to apply for the Brandeis International Fellowship program.

On Berman's return from Brandeis, she was disheartened to see that the artists had not moved forward toward renewal. She mentions specifically, for instance, that "none of the staff members had taken the initiative to order chairs and tables for their classes or try to improve a very depressing basement workshop into an environment more conducive for learning. A depressed 'victim of circumstance' mentality had emerged. Survival was the most anyone could manage, coming daily into work and undermining each other to the extent that conflict spilled into the classroom, where teachers gossiped to students, pitting one against the other. We were very concerned about the demoralization that seemed to pervade the studio."[14]

Resolution

The situation pushed Berman to a level of leadership she hadn't experienced before. How was she going to revive the spirit of new beginnings and forward movement that had inspired the shop to begin with? The year of her return was 2004, the tenth anniversary of the South African democracy. Berman took the opportunity to tie the rebirth of the APS to the national moment of renewal and reflection by putting to use what she and Selibe had developed during their time at Brandeis. The theme of the fellowship program had been *Recasting Reconciliation through Culture and the Arts*. Berman reformulated the theme in South African terms as the principles of *ubuntu*.[15]

Nelson Mandela had made *ubuntu* the basis of his political philosophy in rebuilding South Africa as a democratic state. Berman defines the principle as follows:

> At Artist Proof Studio, we have introduced the concept of *ubuntu* as an embodiment of the ethos and values of our common humanity. The meaning of *ubuntu* is best captured through the expression, "A person is only a person because of other people." . . . The term *ubuntu* was introduced within the context of the Truth and Reconciliation Commission and has become a common frame of reference for the reestablishment of our common humanity as the core for building a new South Africa. This concept has become the engine for indigenous strategies to explore reconciliation and transformation. The heritage of the philosophy of *ubuntu* from traditional African roots is one of sharing and hospitality, of honesty and humility, and is the ethic and interaction that occurs in the extended family.[16]

As successful a community project as the old APS had been, Berman felt that there were aspects of it that were left over from the era of apartheid that were contrary to the creation of a democratic society. She determined to build the new APS on principles of collaboration and democracy, empowering the black artists and bringing the white members of APS together on mutual grounds of respect and shared leadership. Berman credits her experience at Brandeis as a key element in shaping her subsequent philosophy of leadership:

> During the fellowship at Brandeis University, the question of gender and power dynamics surfaced in one of the discussions. Stompie Selibe, who was my collaborator on the fellowship, voiced a question that he presented as representative of the black artists at APS: "How can a white woman be a director of a black collective?" The Brandeis fellowship had given me the opportunity to explore relations between class, race and power—a painful but necessary process. I had always seen myself as a member of the liberation movement for South Africa and believed to my core in the struggle for non-racism and democracy. That I was perceived as oppressive,

authoritarian, powerful and critical was difficult for me to reconcile with my own self-image.

Thus a key aspect of the reconciliation process was facing my own role as a middle class white woman leader of a black collective. Because I was the founding director of both Artist Proof Studio and Phumani Paper, the organizations were often referred to as "Kim's projects" rather than as collectives. I realized that I had failed to interrogate my own power and position within APS, because the skills and vision I had brought were necessary to the organization. As a result, I continued to deny the issues of power underlying my role, and this had fueled resentment. Part of the "reconciliation process" required me to further cede control of the organization I had co-founded.[17]

Berman established a new organizational structure with a new board in which decision-making was shared. The studio's temporary quarters in the Bus Factory were renovated with a grant from the Ford Foundation. The Bus Factory is in the center of Newtown, the arts and culture district of Johannesburg. It also houses the offices of the Johannesburg Development Agency, which facilitates inner-city development and renewal, as well as a number of other cultural nongovernmental organizations (NGOs) in addition to Artist Proof Studio. In an article celebrating Artist Proof Studio's twentieth anniversary, Berman wrote about how she restructured the organization after the fire:

[It] gave us the opportunity to imagine a new model—an NGO built on the lessons of ten years of democracy. The struggle for positive change is ongoing, evolving and transforming. We continually revisit our organisational structure and strategy for sustainability. We have discovered and experimented with multiple ways to survive a dry funding climate for the arts. Our Board of Directors leads by example, using their own businesses and professional practices to engage partnerships with artists. APS is not the recipient of services bestowed by the corporates, but engages in partnerships of collaboration and mutual exchange, for example, the patron programmes where corporates provide bursaries for artists in exchange

for artworks and interactive projects. In an exchange with a local law firm, ten artists led ninety staff members, including top litigators, in a team-building project that presented their strategic plans through images painted on the basement walls. The inversion of the hierarchy of skills and power was humbling and inspiring to all. Through these collaborations, artists learn not only technical proficiency, but also diplomacy, organisation, and partnership skills. They also see the value of qualities such as leadership, patience, optimism, a sense of humour and a love for the unpredictable and complex nature of community arts work.

We have had successful artists in residence, international artists and educators coming to teach, and have promoted exchanges with printmaking and papermaking studios around the world. We have hosted tourist groups, guest workshops, seminars, overseas internships, research projects and social advocacy campaigns.[18]

While the going was smooth for a few years, a crisis occurred in 2009, when the national government eliminated a training program that funded approximately 70 percent of APS's budget. To have so much withdrawn all at once was a blow. Berman solved the problem by launching a program to provide professional printing services to artists beyond the APS group. The sale of works by emerging and established artists published by the APS now replaces that 70 percent of the income needed to sustain the APS and also provides income for the artists themselves.

It should be noted that the APS holds "section 21" status, the equivalent of 501(c)3 companies in the United States; the designation is given to officially recognized not-for-profit organizations, making them eligible for charitable donations. Berman and her staff have actively applied for and received support from private corporations and government agencies, including, at various times, Bell Dewar law firm (now Fasken Martineau); the Ford Foundation; Johnson & Johnson International; the National Arts Council; the National Lotteries Foundation; Business and Arts South Africa; the Arts and Culture Trust; the Gauteng Department of Sport, Arts, Culture, and Recreation; and the South African Development Fund in Boston.[19]

Since the restructuring, APS has been stable, with a permanent staff of instructors, printers, a hand-papermaking shop with professional papermakers, and administrative staff. In addition to the professional print shop and the gallery, APS has two other units. The educational program consists of a three-year professional printmaking training course for approximately sixty talented students from South Africa and other African countries. The program trains students in a full range of printmaking skills, drawing, visual literacy, and business practices. Acceptance is based on individual talent and potential for professional achievement. Students from financially disadvantaged backgrounds are eligible to receive subsidies or bursary funding. At APS, the capacity of the students is built through the development of positive habits and the life skills necessary for becoming well-rounded artists-as-citizens: professional practitioners, community leaders, and empowered and self-sustaining individuals. Additionally, students are given the opportunity to consult with experienced guest artists regarding both their own work and the artists' perspectives on visual arts in general.

Special Projects provides community outreach and awareness programs, particularly focusing on the enormous impact that the creative industries can have in addressing issues surrounding HIV/AIDS, especially in raising awareness of the disease and facilitating a culture of healing and positive living through the processes of art and craft. The unit has many outreach programs, including mural and other public art projects. The Special Projects unit has developed a holistic approach to promoting social change through art and craft aimed at growing committed, skilled, and professional artists who make meaningful contributions to society through outreach. Income for the Special Projects unit comes primarily from public art commissions, donations, and grants.

In addition to founding APS, Berman initiated other programs that integrate art and social justice. Like APS, they also have undergone periods of smooth operation and crises that Berman has had to resolve. In her studies in Boston, Berman had been exposed to handmade paper processes. That background led her to develop a papermaking facility at the Technikon Witwatersrand, now merged

218 | Junctures in the Arts

into the University of Johannesburg, where she was a senior lecturer in printmaking, to give her students papermaking experience and to make archival paper for printmaking. Before Berman's program, no archival paper was being manufactured in South Africa, thus requiring all printmaking papers to be expensively imported from Europe or the United States. Her facility was called the Papermaking and Research Development Unit (PRDU). Because there was no papermaking equipment manufactured in South Africa, she and the students had to design and build their own. She received funding support for the PRDU from the National Research Foundation and University Research Committee. Her vision was to involve postgraduate students in research on best practices in papermaking, to explore products that would be viable both in fabrication and in the market, and to teach them how to be educators. Several of the areas the students explored became very successful: one of them being research on using invasive plants for papermaking; the second was to use a mix of cotton and sisal for archival paper production; and the third to develop paper-based technologies such as paper-clay and cast paper pulp for three-dimensional craft production.

Berman also initiated a community outreach project centered around paper that would provide some income for the poor population in a rural section of South Africa.[20] Phumani Paper, as she named it, was funded from 1999 to 2005 by the South Africa Departments of Arts and Culture and Science and Technology under a program established in 1997 directing universities and other institutions of higher education to participate in the Reconstruction and Development Program of the new national government through the transfer of knowledge and technology to create jobs. Her students trained workers in papermaking techniques, and the student themselves felt empowered by using their art skills for community engagement.

Papermaking is an ideal craft for community engagement in that it can be done with very little equipment. It is a way of using waste fiber agricultural products, and it is free of chemical hazards. Berman writes, "In nine months, Phumani Paper (isiZulu for 'reach out'), established 21 papermaking projects in seven of South Africa's nine provinces. Each province would make paper from the natural

resources of the region: for example, maize in the Free State, banana stem in Limpopo Province, milkweed . . . in Gauteng, Port-Jackson willow, an invader plant in the Western Cape."[21]

Berman's plan to jump-start craft enterprises that would then become independent entities was successful. By 2005, there were twenty Phumani Paper units operating in nine provinces, one thousand people had been trained in papermaking, and 460 jobs had been created against an unemployment rate of over 25–35 percent in the country. Products included archival paper that was sold to government units for documents, bowls made from paper pulp, and all kinds of decorative stationery, boxes, and boards.

Once again, though, Berman faced the challenge of how to sustain an enterprise when funding was withdrawn. She traces the loss of funding for Phumani Paper to two causes: the first was the creation of the University of Johannesburg by integrating the Technikon Witwatersrand with the Randse Afrikanse Universiteit (Rand Afrikaans University). Berman says that the new University of Johannesburg narrowed its outlook and moved toward a more traditional mode of higher education, no longer supporting community engagement as economic empowerment. The second was the South African government's move away from the principles of reconstruction and development that typified Nelson Mandela's policy for the new South Africa when apartheid was abolished. Thabo Mbeki's government established an economic policy called GEAR that favored an entrepreneurial business model.

Phumani Paper was educational on many levels besides teaching the process of papermaking, business practices, and marketing. One of its major goals was AIDS education. Berman tells a wonderful story about one of her initial experiences in AIDS education in a rural village. The women would not talk about it at all while the men were in the room. They made the men leave. Later, they embroidered pictures of condoms and body parts in pink and purple thread, using the pictures to educate the men. Berman says she was inspired by "the power of the visual image . . . to break the silence around HIV/AIDS."[22]

Needless to say, there was a drop-off in participation when stipends were discontinued. However, Phumani Paper survived.

Berman transformed it from a university project into a not-for-profit independent entity. Its headquarters were still in the university, but Berman had to raise independent funds to pay rent on the organization's behalf. A staff was still available to help form the administrative structure for new units and teach them business practices as well as advise on production. Financial success varied. No units provided enough personal income to make major changes in people's lives like buying a house or property, but the income from sales of merchandise made daily life more comfortable, since many impoverished households receive a social welfare grant of the equivalent of only $50 monthly as the sole family income. With the additional income, a cell phone might be purchased, a helper paid to take care of the children while mothers went to work, transportation to a clinic provided, or medicine and supplementary food purchased. The following quote sums up the success of the program in alleviating poverty:

> Craft-based group interventions work well in alleviating poverty. . . . The impact of the programme—in terms of financial performance and its ability to alleviate poverty—depended significantly on the specific implementation strategy or project model. . . . A key variable was the consistent presence of strong leadership. Coordinators/project managers who were present on a regular basis and remained with the projects for a significant period of their development were able to guide the participants through the processes of project administration and day-to-day functioning. In addition, they were able to reinforce aspects of marketing, quality control and effective group dynamics. They were also present to address unexpected problems with relative efficiency. . . . Another factor that contributed to the successful impact of some projects, was the partnership with organisations that offered secure and well-developed infrastructure. . . . All projects had a human development impact, especially in the area of skills capacitation. This indicates that a craft-based intervention, such as Phumani Paper, is effective in addressing human development poverties. . . . [Being part of a] work group provides a secure environment where people can act out roles and responsibilities, make mistakes or test ideas,

all of which will have a spillover effect on their personal lives [giving] participants the feeling that they had gained some power or control of their own lives. . . . The opportunity to create something that is original and provides room for personal expression fostered a sense of self-esteem on the part of many participants. . . .
Financially unviable units will neither be able to alleviate poverty in material terms, nor provide the sustainable opportunity for human development.[23]

In addition to Berman's endeavors to empower the black community and help alleviate poverty, she also has addressed the AIDS epidemic through art. Using the APS and the network of Phumani Paper, Berman has published work by professional artists on AIDS-related themes and mounted public art projects such as the Paper Prayers campaign, in which South African women are taught to make prints and take photographs; they then use the pictures to discuss the role AIDS has played in their lives.[24]

It should also be noted that Berman has maintained her own individual studio practice during all these years. Her prints address economic, social, and health issues in South Africa. She uses the image of fire frequently, even before the fiery destruction of the first Artist Proof Studio. Her images of the veld fires that burn to make way for new growth refer to the *Flame of Democracy*, an eternal flame in the Constitutional Court building.

Kim Berman has devoted her career to using art in the cause of social justice, utilizing the cultural sector to help black artists and community members in the goal of achieving economic independence and sustainability and to promote health practices by such efforts as combatting the resistance to undergo HIV testing, thus in some cases saving lives. While Berman's entrepreneurial leadership was inspired by the principle of social justice and her strategies are based on the feminist principles of empowering the community, working collaboratively, and insisting on inclusivity, her strategies also included practical ones. She made use of opportunities offered by government and the business community, such as registering her enterprises as not-for-profit entities, thus giving them tax advantages; going to corporations and government agencies for funding;

instituting earned-income programs; and establishing a board with business contacts. Her career demonstrates how moral principles can be implemented through leadership that also includes pragmatic action.

Notes

1 Since Brodsky and Olin could not interview Berman in person, they sent her the draft of the case study, and she responded with corrections and suggestions, which were then incorporated into the text.

2 Steven Dubin, "The Proof Is on the Walls: Johannesburg's Artist Proof Studio Celebrates 21 Years," *Art in America*, July 1, 2012, http://www .artinamericamagazine.com/news-features/news/south-africa-print-studio/.

3 Kim Berman, "Agency, Imagination, and Resilience, Facilitating Social Change through the Arts in South Africa" (PhD diss., University of the Witwatersrand, Johannesburg, 2009), xxxi, https://www.researchgate.net/publication/ 268031466_AGENCY_IMAGINATION_AND_RESILIENCE_FACILITATING _SOCIAL_CHANGE_THROUGH_THE_VISUAL_ARTS_IN_SOUTH_AFRICA.

4 Naomi Safran, "The Art Therapy Center: A Portrait," in *Alone with Five Others: Dispatches from a Changing World* (Waltham, Mass.: International Center for Ethics, Justice and Public Life, Brandeis University, 2006), 52, https://www .brandeis.edu/ethics/pdfs/ecsf/ecsf2006.pdf.

5 Berman, "Agency, Imagination, and Resilience," 32.

6 The origin of printmaking in Western countries is tied to the invention of movable type by Johannes Gutenberg in 1436. Until his invention, books were laboriously produced by hand, each letter formed by writing in pen and ink. Gutenberg had the paradigm-changing idea that if he were to make individual letters from wood or metal, they could be combined and recombined. Thus books as we know them were formed. The printed word is fine by itself, but images could help convey the meaning of the words. The next step was for an artist to use a knife to cut a picture into the surface of a block of wood or, with a sharp point, scratch an image into a piece of copper. Like type, these matrices could be inked by rolling an ink-coated brayer that looked rather like a rolling pin across the surface of the block or by rubbing ink into the scratched lines and wiping the excess off the surface. Paper could be placed over the inked block or plate, pressure could be applied to transfer the ink to the paper, and when the paper would be lifted off the block, the image would be on the paper. With the invention of movable type came the invention of the printing press, which could apply pressure to transfer the ink from the matrix to the paper mechanically. Because more than one copy of a text could be produced easily (one had only to ink the block or plate again), an image could be distributed to many people rather than one person. Due to its potential for widespread distribution, printmaking came to be associated with democratic ideas.

7 In 2002, The Boston Public Library published a book titled *Proof in Print: A Community of Printmaking Studios* documenting Art's Proof Cooperative's

history as the model for three other print shops, including Artist Proof Studio, Johannesburg. The book was published in conjunction with an exhibition of prints from the four workshops held at the Boston Public Library.

8 Berman, "Agency, Imagination, and Resilience," 33.

9 An edition is the set of impressions made from inking the same plate or block many times and transferring each inking to paper by using a press. Editions can range from as few as five to one hundred or more.

10 For further information on the Brodsky Center at Rutgers University, see http://www.brodskycenter.org.

11 Kim Berman and Daniel Stompie Selibe, "Artist Proof Studio: A Journey of Reconciliation" (Waltham, Mass.: International Center for Ethics, Justice, and Public Life at Brandeis University, 2003–2004), 4, https://www.brandeis.edu/ethics/peacebuildingarts/pdfs/peacebuildingarts/kim%20artist_proof_studio-1.pdf.

12 Berman and Selibe, 3.

13 Berman and Selibe, 1.

14 Berman and Selibe, 8.

15 Berman and Selibe, 11–15.

16 Berman and Selibe, 12.

17 Berman, "Agency, Imagination, and Resilience," 53.

18 Kim Berman, "Artist Proof Studio Turns Twenty," Art South Africa, http://artistproofstudio.co.za/wp-content/uploads/2015/03/Art_SA_-_APS_Turns_Twenty.pdf.

19 Berman and Selibe, "Artist Proof Studio," 9.

20 Berman, "Agency, Imagination, and Resilience," 112.

21 Kim Berman, "A Case Study of Phumani Paper as a Community Engagement Initiative at the University of Johannesburg," Education as Change 11, no. 3 (2007): 39, https://innerweb.ukzn.ac.za/scer/Journal%20articles/Berman.pdf.

22 Robin Nixon, "Out of Africa, a Positive Ripple on AIDS, a Film at the MFA Details Artist's Healing Campaign," Boston Globe, November 25, 2007, http://archive.boston.com/news/education/higher/articles/2007/11/25/out_of_africa_a_positive_ripple_on_aids/?page=full.

23 Taryn Claire Cohn, "Craft and Poverty Alleviation in South Africa: An Impact Assessment of Phumani Paper: A Multi-site Craft-based Poverty Alleviation Programme" (master's thesis, University of Stellenbosch, 2004), 137–140, http://scholar.sun.ac.za/handle/10019.1/16269.

24 Eileen Foti, Ripple in the Water: Healing through Art, a video about the life and work of Kim Berman, narrated by Charlene Hunter Gault, http://www.rippleinthewater.com.

Bibliography

Artist Proof Studio. http://www.artistproofstudio.co.za.

The Artist's Press. "Kim Berman." http://www.artprintsa.com/kim-berman.html.

Berman, Kim. "Agency, Imagination and Resilience: Facilitating Social Change through the Visual Arts in South Africa." PhD diss., University of the

Witwatersrand, Johannesburg, 2009. http://wiredspace.wits.ac.za/bitstream/
handle/10539/7366/Thesis%20FINAL%20July%202009.pdf?sequence=2&
isAllowed=y.

———. "Artist as Change Agent: A Pedagogy of Practice in Artist Proof Studio."
Teaching Artist Journal 10, no. 3 (2012): 145–156.

———. "A Case Study of Phumani Paper as a Community Engagement Initiative
at the University of Johannesburg." *Education as Change* 11, no. 3 (2007): 37–45.
https://innerweb.ukzn.ac.za/scer/Journal%20articles/Berman.pdf.

———. "Imagination and Agency: Facilitating Social Change through the Visual
Arts." *Matatu* 44, no. 1 (2013): 1–14.

Berman, Kim, and Lara Allen. "Deepening Students' Understanding of Democratic
Citizenship through Arts-Based Approaches to Experiential Service Learning."
South African Review of Sociology 43, no. 2 (2012): 76–88.

Berman, Kim, and Daniel Stompie Selibe. "Artist Proof Studio: A Journey of Recon-
ciliation." Waltham, Mass.: International Center for Ethics, Justice, and Public
Life at Brandeis University, 2003–2004. https://www.brandeis.edu/ethics/
peacebuildingarts/pdfs/peacebuildingarts/kim%20artist_proof_studio-1.pdf.

Dubin, Steven. "The Proof Is on the Walls: Johannesburg's Artist Proof Studio Cele-
brates 21 Years." *Art in America*, July 1, 2012. http://www.artinamericamagazine
.com/news-features/news/south-africa-print-studio/.

Foti, Eileen, and Patricia Piroh, producers. *Ripple in the Water: Healing through Art*.
Narrated by Charlene Hunter Gault. Montclair, N.J.: OK/Alright Productions,
2007.

Nixon, Robin. "Out of Africa, a Positive Ripple on AIDS, a Film at the MFA Details
Artist's Healing Campaign." *Boston Globe*, November 25, 2007. http://archive
.boston.com/news/education/higher/articles/2007/11/25/out_of_africa_a
_positive_ripple_on_aids/?page=full.

Safran, Naomi. "The Art Therapy Center: A Portrait." In *Alone with Five Others: Dis-
patches from a Changing World*. Waltham, Mass.: International Center for Ethics,
Justice and Public Life, Brandeis University, 2006. https://www.brandeis.edu/
ethics/pdfs/ecsf/ecsf2006.pdf.

FIGURE 18 Photograph portrait of Gilane Tawadros. Courtesy of Tawadros.

Gilane Tawadros
Breaking the Hegemony of Western Culture

Gilane Tawadros[1] is a leader in shaping a more diverse visual culture in the United Kingdom. She became the founding director of the Institute of International Visual Arts (InIVA), the first multicultural arts center in London. With much fanfare, InIVA cut the ribbon and moved into its new home, called Rivington Place, on October 3, 2007. InIVA and its partner organization Autograph ABP had commissioned the design and raised the funds for its construction. It was the first new museum building in London in two decades—since the Hayward Gallery was built in 1968. And David Adjaye, the first well-known African British architect, was selected to do the design.

InIVA, formally established in 1993,[2] was founded to oppose the supremacy of white European culture through exhibitions and related programs featuring artists of the African and Asian diasporas. Like all the other European countries and the United States, white male artists dominated the British art scene. By the 1980s, the many artists from the African and Asian diasporas who were living in London were making tentative efforts to establish an arts center to provide a venue for showing their work. The appointment of Tawadros as director in 1994 provided a leader who was able to build on their efforts and create a highly visible institution that had an enormous impact on establishing diversity in British culture.[3]

The United Kingdom underwent an identity crisis in the mid-twentieth century when it lost most of its empire, and England itself became more diverse due to immigration from its former colonies. Before World War II, the indigenous peoples of its colonies

were guaranteed the right of immigration to the United Kingdom, but only a small number left their own countries. That privilege existed even after World War II until the 1960s. An increasing number of nationals from former Commonwealth countries immigrated to England during the 1950s and early 1960s. The British Nationality Act of 1948 affirmed this right. But three laws were enacted in 1962, 1968, and 1971 with the goal of "zero net immigration." People from former British colonies like India, Pakistan, and the Caribbean were now subject to immigration controls. Yet emigration from nonwhite countries increased substantially from 1961 to 1971, rising from about two hundred thousand during the previous decade to one million. At the same time, with the American civil rights movement as a model, antidiscrimination Race Relations Acts were enacted in 1965, 1968, and 1976.[4]

The first generation of post–World War II artists were those who had come to maturity before the war, like sculptor Henry Moore and painter Francis Bacon. They were all white and all male except for the sculptor Barbara Hepworth. Furthermore, the contemporary art world at that time was small, and they all knew each other. It was truly an old boys club. The major museums had few exhibitions, if any, of the art of the twentieth century post-1950. The Tate Modern was only created in the year 2000, although the original Tate did show exhibitions of European modern masters like Marcel Duchamp. As was the case in the United States, the 1960s were a time of change, as personified in the emergence and popularity of the Beatles. It is often said that Richard Hamilton, a British artist, was the inventor of Pop art. The world-renowned artist David Hockney, who, like Andy Warhol in the United States, is an icon of the Pop art movement, emerged on the scene during the 1960s as well. Yet white artists continued to dominate.

There were some exceptions. Frank Bowling, from Guyana, immigrated to London at the age of fifteen. After doing his national service in the armed forces, he studied at the Chelsea School of Art and won a scholarship to the Royal Academy, where one of his classmates was Hockney. Graduating from the Royal Academy, particularly as an outstanding student like Bowling, was a ticket to potential success in the British art world at that time. And Bowling

became fairly successful, but nowhere near the level of Hockney, his white classmate. Anish Kapoor, an artist with roots in India, was also successful in gaining attention. A few galleries and institutions were known for showing nonwhite international artists. But in the 1980s, a homegrown group of black artists emerged from the art schools and, taking their careers into their own hands, organized group exhibitions featuring their own work. By the mid-1980s, institutions that focused on leading-edge art, such as the Institute for Contemporary Art and Whitechapel Art Gallery, began to recognize their presence, pushed sometimes by outside forces. For instance, the Greater London Arts Council threatened to withdraw funding from the Institute of Contemporary Art if it didn't mount an annual exhibition of black artists. However, when one of these institutions did mount an exhibition, it was usually in a peripheral space rather than the main gallery. While these exhibitions may have fulfilled the goal of including black artists in institutional spaces, thus validating black artists, they also worked against the inclusion of these artists in the major galleries, the attitudes of which were that black artists had their own venues. Black artists were seen as ethnic practitioners rather than as contributors to mainstream art concepts. But black artists and critics continued to push the establishment to recognize that they were adding new ideas to the mainstream that stemmed from their fusion of aesthetics, history, and present-day identities.

The trajectory of Gilane Tawadros's life has a bearing on her leadership. She was born in Egypt and immigrated with her family to London when she was five years old. To understand the complicated relationship of Egypt and England, it's necessary to consider the fact that Egyptian history is made up of a number of cultural strands. Egyptian civilization has existed for thousands of years, and Egypt has survived as a nation despite conquest by the Greeks, the Romans, the French, the Ottoman Turks, and the British. After the defeat of the Ottoman Empire in World War I, the British and the French, who were the victors in that war, allowed Egypt to resume political life as an independent country, but as Tawadros herself has written, Egypt's civilization is one of the prime examples of a culture appropriated by the West: "The French invasion of

Egypt in 1798 was consolidated and reinforced by an army of Oriental scholars and artists who were charged with the massive task of tabulating, illustrating, and documenting every aspect of 18th century Egypt in what became Napoleon's epic publication *Description de l'Égypte*. At the heart of Napoleon's project was the visual mapping of the Orient, its detailed tabulation by visual artists with the object of making it 'totally accessible to European scrutiny.'"[5]

Her life in Egypt in the 1960s sounds very much like the stereotype of a comfortable middle-class way of life, an aspiration all over the world. According to the obituary for Tawadros's mother, the family went on picnics at the foot of the pyramids and the Cairo zoo with outings to the Red Sea Coast.[6] Tawadros remembers her childhood in Egypt as generally a happy one. However, she became aware of the issue of race early in her life. When asked about whether she experienced any discrimination, she related a story about her head teacher who refused to recognize Tawadros's achievements because she could not believe that an Egyptian student could achieve excellence in English ahead of her English classmates.[7]

But the sojourn of the Tawadros family in Egypt was to come to an end because of politics in the Middle East. Except for Egypt and Iran (known as Persia before the conquest by the Ottoman Turks), after World War I, the countries of the Middle East were created as artificial entities. They were carved out of the vanquished Ottoman Empire without regard to tribal unities, traditional allegiances, or cultural differences to satisfy the economic and political ambitions of England and France, the two major European powers that led the Allied forces to victory in the war. Those arbitrary borders have given rise to many of the conflicts in the years since World War II.

One of those conflicts, the 1967 War, led the Tawadros family to immigrate to London. The war was initiated by Gamal Abdel Nasser, president of Egypt. In six days, Israel took territory from Egypt (the Sinai Peninsula and the Gaza Strip), Syria (the Golan Heights), and Jordan (the part of Jerusalem that didn't belong to Israel and the West Bank), in the process destroying the Egyptian air force on the ground. Kamal Tawadros, Gilane Tawadros's father, had been an officer in the Egyptian air force. The defeat led Nasser to expel, imprison, and in some cases, torture many members of the military.

Increasingly, it became difficult for the Tawadros family to continue living in Egypt.[8]

Tawadros studied art history at the University of Sussex, where she received a bachelor's and a master's degree (1984–1989). She also studied film at the Université de Paris IV (Sorbonne Nouvelle) and received an LLM from Birkbeck College, University of London in human rights in 2008–2009.[9] After her studies at Sussex, she took jobs in the visual arts in the city of London at the Photographers Gallery (the first gallery in the world dedicated to photographs, founded in 1971) and the Hayward Gallery (a public institution that shows modern and contemporary art, established in 1968).[10]

Tawadros's mentor was Stuart Hall, the British sociologist whose books provided the intellectual foundation for a generation of artists, writers, and academics who have been at the forefront of probing issues of racism in British culture. Like Tawadros, Hall came from a culture that differed from the traditional European model—in his case, Jamaica. However, one cannot truly call Jamaica a non-Western culture any more than Egypt can be labeled as such, since it was colonized by Europeans (first by Spain) and ruled by England for centuries. The island finally became independent from England in 1962 but remained in the British Commonwealth. Under British rule, the sugar industry was developed, and Jamaica became one of the leading exporters of sugar. The plantation economy was supported by slaves imported from Africa, freed in 1838. Jamaica's population is mostly of African descent, and its character was formed through centuries-long intermingling of its African heritage, the remnants of indigenous practices, the contributions of the indentured laborers from China and India who were brought along with the African slaves, and the absorption of European ideas and ways of life. Like the countries of the Middle East, Africa, and Asia, Jamaica has had a high rate of emigration, and there is a large Jamaican diaspora.

Hall developed the field of British cultural studies based on the supposition that culture is the battleground of social action and intervention in which power relationships flourish or are overthrown. He believed that constructions of race, gender, and identity were defined through cultural production and that the dominant

culture determined those constructions to its own advantage. Hall wrote that cultural production was coded in various ways to reinforce the dominant culture, including permission for certain oppositions. While on the surface these oppositions may have seemed to threaten the dominant culture, their true impact was quite the opposite. They served to reinforce that domination. Tawadros was particularly influenced by this aspect of Hall's theory, and it inspired her conception of her role as director of InIVA.

According to Eddie Chambers, an artist involved in this effort, the concept gradually emerged of an institute dedicated to the international arts. The effort to set up such an organization was helped by the emergence of sympathetic voices in the London cultural halls of power. Gavin Jantjes, originally from South Africa, one of the most prominent English spokespersons for artists of color during the 1980s and early 1990s (he was classified in South Africa as "colored"), was a member of the Arts Council of Great Britain from 1986 to 1994. At the same time, Sarah Wason, who was a champion of diversity, was hired in the art department of the Arts Council. Together, they conceived the Institute of New International Visual Arts (shortly thereafter, the word "new" was dropped).

While working at the Hayward Gallery on London's South Bank, Tawadros applied for the position as director of the new organization. She thought it extremely unlikely that she would be offered the job but decided to go for the interview anyway and was offered the directorship. She faced the juncture of establishing a new entity with a radical mission.

Resolution

Gilane Tawadros's vision guided the development of InIVA. The original conception for InIVA was to establish a permanent gallery space. When Tawadros took up her role as director, she set aside the idea of a permanent building. Instead, she established partnerships with mainstream institutions to put on exhibitions of work by artists of color and mount innovative programming to add diversity to the art scene. Her concept was that it would create more real

diversity to embed artists of color across familiar traditional institutions rather than to segregate them. When Tawadros was hired in 1994, InIVA took on office premises and established a library (but not an exhibition space) in central London.

A few months later, Tawadros approached Stuart Hall to become chair of InIVA. Hall agreed to accept the role on a temporary basis but ended up chairing InIVA for more than a decade, working closely with Tawadros for most of that time.

As director of InIVA from 1994 to 2005, Tawadros was in a leadership position from which she could work to disrupt the white European cultural hegemony of the art world. In line with the philosophy she developed through her contact with Hall, she seized the opportunity, developing programs and exhibitions not just superficially featuring artists of color from London, the Commonwealth nations, and other countries in Africa and Asia but also featuring ones that would address unconscious, deeply embedded racial and cultural attitudes.

For instance, in 1994, Tawadros's first year at InIVA, she established a series of lectures by international curators for a course in visual arts administration at the Royal College of Art. Her goal in this program was to change the perceptions of the students so that when they took administrative positions, they would be more open to issues of diversity and inclusion. *Time Machine: Ancient Egypt and Contemporary Art*, an exhibition of works by twelve contemporary artists whose art practice relates to Egyptian culture and history, took place in the Egyptian sculpture gallery at the British Museum in 1995. The concept behind the exhibition was to show how ancient Egyptian civilization is relevant to the present as another source of European civilization along with Greece and Rome. *Veil*, an exhibition exploring the symbolism of the veil in contemporary visual culture, toured several cities in England in 2003. *Veil* was one of the first exhibitions to focus on contemporary artists in the Middle East diaspora and the Middle East countries themselves. With Tawadros as director and Hall as chair of the organization's board, InIVA quickly became an important player in the London art world.

Tawadros's strategies were so successful that InIVA and Tawadros herself became well known internationally. She was invited to

become a member of the Forum for African Arts, founded in 1999 by the Ford Foundation with the goal of establishing and sustaining an African presence in the Venice Biennale.[11]

The forum put on two successful exhibitions highlighting African artists. The first took place at the 2001 Venice Biennale. Called *Authentic/Ex-centric*, it was curated by Salah Hassan and Olu Oguibe. The second took place at the 2003 Biennale. Called *Faultlines*, it was curated by Tawadros. She described her theme as follows: "*Faultlines* may be a sign of significant shifts, or even of impending disaster, but they also create new landscapes." She further stated that she wanted to show artists "whose works trace the fault lines that are shaping contemporary experience locally and globally. These fault lines have been etched into the physical fabric of our world through the effects of colonialism and postcolonialism, of migration and globalisation."[12]

As described, InIVA at first was an institution without walls. As such, it had flexibility in programming and also the advantage of working from within mainstream institutions to bring about change. But the next step in advancing InIVA's presence in London would be a permanent bricks-and-mortar home for the organization. Tawadros collaborated with Mark Sealy, the founding director of Autograph ABP (Association of Black Photographers), to begin planning and seek funding.

The two organizations, InIVA and Autograph, applied for an award from National Lottery funds, managed by the Arts Council of England. Based on the preliminary plans, they were allotted £5.9 million (approximately $7.5 million based on the exchange rate in the mid-1990s) from the Arts Council England Lottery Capital 2 program funds.[13] Barclays Bank, as a founding corporate sponsor, contributed another £1.1 million. But problems emerged that they had to deal with. As the plans were developed further, the costs emerged as £8 million rather than the original £7 million. They successfully convinced the Arts Council to add to its initial amount, and it filled the gap by awarding the project an additional £500,000. In response, Barclays added £100,000 to its original gift. Negotiations with the contractors led to a reduction of some £400,000 through changes in construction. The organizations raised an

additional £100,000, and they did so through a variety of activities. They called on their boards and also established international ambassadors who were asked to help with additional funding—well-known figures outside of the United Kingdom, including Henry Louis Gates of Harvard. The Brodsky Center at Rutgers University published a print portfolio containing work by the most highly regarded black British and American artists as a fundraising project.

The building itself was carefully designed to fulfill the needs of both InIVA and Autograph ABP. It has a glass-fronted ground-floor gallery opening out into Rivington Street in the Shoreditch section of London, an area in the East End that was originally working class but has undergone gentrification with the establishment of galleries, coffee shops, bars, and boutiques. It includes an exhibition space with flexible seating to show film and video and conduct seminars; the Stuart Hall Library, a research collection that focuses on international visual arts; an education space for outreach programs to the local community and schools; Autograph ABP's photography archive and print collection of important historical and contemporary black photographers; a café/bar; rental workspaces for two to three creative businesses; and the offices of InIVA and Autograph ABP.

The press release celebrating the opening of Rivington Place quoted Hall as saying, "Difference is complex—it alters and evolves, but does not go away. Difference matters and will continue to matter, it provides an incredible source of richness, new ways of seeing and creativity. Rivington Place is a landmark building which celebrates diversity and the exciting and essential contribution it makes to the visual arts."[14]

It also quoted Sarah Weir, executive director of the Arts Council, as declaring, "The opening of Rivington Place this autumn will be a true celebration of the richness and diversity of the arts in England today. With innovation and internationalism at its heart, it is set to really make its mark on the cultural landscape. It will challenge perspectives, champion new visions and give artists and visitors different opportunities to explore what it means to live in a city as vibrant and diverse as 21st century London."[15]

Funding and building Rivington Place was an extraordinary achievement of leadership. InIVa and Autograph were remarkably successful in breaking through the hegemony of white European culture to persuade the Arts Council of England Lottery and a leading British bank to award such large sums to construct a building devoted to showcasing the work of artists from the Asian and African diasporas. While the activity of black artists, critics, and curators and the growth of the immigrant population in England, with the attendant pressure for cultural recognition and power sharing that eventually comes from a substantial increase in the size of a population group, provided a context for bringing Rivington Place into existence, they were able to take that background and develop it. The fact that Stuart Hall was involved was another element in the successful push to create a home for InIVA. Hall's involvement gave the project credibility. Tawadros's strategy of collaborations with mainstream, established institutions and the timeliness and appeal of her exhibitions and programs also gave strength that helped support the concept of Rivington Place.

However, the law of unintended consequences kicked in, and ultimately InIVA faced controversy and difficulties, providing lessons on the economic and conceptual sustainability of new not-for-profit cultural institutions and the importance of appropriate leadership to their successful continuance. Tawadros left InIVA in 2005 before Rivington Place was completed. The first two directors who succeeded Tawadros each left after two years—scholar and curator Augustus Casely-Hayford was the director from 2005 to 2007, and Sebastian Lopez was the director in place when the building opened. The opening in October 2007 attracted much attention. But InIVA's and Autograph ABP's resources were strained. According to Mark Sealy, Autograph ABP's director, "Developing a building and running a day-to-day programme was the biggest mistake we made. It would have been better to scale down the operation and focus fully on the building."[16] The daily responsibilities for the construction were very intensive, and although the organizations were awarded funds for capacity building and technical assistance, they felt those funds were not adequate. They also concluded afterward that they would have done better if they had had training in how to

manage a construction project. Furthermore, they were obliged to follow reporting procedures, which were onerous and often interfered with their ability to run their programs.

InIVA and Autograph remained separate organizations. A team called Sense of Place (SOP), which was composed of representatives from both organizations, was responsible for the management of the building. They received funds from the Arts Council for continued operations. In 2008–2009, the Arts Council set up an annual fund that was in place through 2010–2011. InIVA was to receive £988,323 and Autograph £359,251, with a 2.7 percent inflation raise each year. Stuart Hall resigned from the board in 2008.

From Tawadros's departure forward, InIVA entered an unsettled period. After Lopez left in 2009, the former director of the Scottish Arts Council, Tessa Jackson, was selected. When InIVA's support from the Arts Council underwent a second substantial cut, Jackson resigned under pressure from artists and curators who were concerned that InIVA had long lost its initial thrust and had become ordinary and somnolent.[17] Thus InIVA was rebuked both by its financial mainstream support and by the constituency it served. InIVA's allocation was cut by the Arts Council in 2013 by 43 percent. Then, in 2014, it was cut again for the years 2015 to 2018 by 62 percent. InIVA was removed from SOP, the management committee for Rivington Place, and Autograph ABP's allocation was doubled to allow it to continue the management of Rivington Place alone.

The question remains: Why did InIVA, after such an exciting start, lose steam? While it is true that InIVA was underfunded and dependent on government grants, subsequent directors did not have the vision that Tawadros possessed, nor did they mount programs and exhibitions that created a stir. The importance of Hall's participation in InIVA and his loss to the institution also cannot be underestimated.

Was it a mistake to build a physical structure to house InIVA? Some critics believe that it was. In particular, Morgan Quaintance has written that organizations like InIVA that are radical in their philosophy and dependent on grants for their existence pay a price when they become more like the institutions they are questioning, with such features as a permanent headquarters and an expanded

administrative staff. He believes that was part of InIVA's decline. Before Rivington Place, Tawadros worked through partnerships with other institutions. This strategy gave her flexibility to keep up with social and intellectual shifts. With a permanent home, InIVA lost a great deal of that flexibility.[18]

But changing times also had much to do with its decline. British Arts Council policy changed, and the council switched away from supporting alternative diversity efforts when the major English museums began to exhibit more artists of color. It seemed as if the diversity struggle had borne results, and organizations like InIVA were no longer necessary.[19] The situation came to a head in 2014 and 2015 when some of the artists who had been supporters of InIVA voted no confidence in the current director. They blamed her and her policies for the sharp drop in Arts Council support.[20] The same group of artists then fought for InIVA's survival. In a letter to the editor of *Art Monthly*, Tawadros herself articulated the case for InIVA's continued existence:

> InIVA was a brand new visual arts organization whose existence had been nurtured for at least a quarter of a century before it actually emerged by a host of black British artists, thinkers and intellectuals who were profoundly critical of the absence from the cultural mainstream not only of black artists but also of a way of seeing and thinking about the world which was not predicated on homogeneous, monosyllabic and monochrome cultural experience. In this context, "black" has to be understood not as a determination of an epidermal schema but as a political position which articulated a challenge to the balance of power in the relations of culture in the UK and beyond. I can't recall a single period of time at which InIVA's right to exist (and its right to be funded) wasn't challenged, its unconventional approach to programming questioned and its contestation of the status quo rebutted as a provocation. As long as InIVA asked difficult questions about the key configurations of the contemporary art world, it was inevitable that it would have to contend with resistance to the challenge it posed. InIVA was not afraid to take on the behemoths of contemporary art and culture . . . questions about modernity, Britishness, identity, globalization,

universality, religion and nationhood . . . the artistic and political agenda which InIVA established early on, something which is becoming increasingly rare in our current cultural landscape, that is: an appetite for taking risks, for being permeable and open to new and diverse participants, for challenging the status quo, for addressing issues of identity and difference, for engaging with a radical global agenda (which is not the same as the increasingly prevalent neoliberal agenda of globalized culture), for opening up dialogues in the thorny terrain of race and colonialism (which is not the same as tokenistic black representation which may itself prove unpalatable further down the line).[21]

Despite the difficulties faced by InIVA since Tawadros's departure, it has survived, although with less visibility and impact in the British art world.

The achievement of establishing InIVA placed Tawadros as an important voice in the interrogation of the hegemony of European culture, and her voice has continued to be heard through her public roles and her publications. She has also broadened her interests to include concern for artists' legacies. She became the executive director of DACS, a not-for-profit visual artists' rights management organization. DACS, founded in 1984, acts on behalf of artists worldwide to ensure that their copyright and financial rights are observed. One of DACS's major activities is collecting royalties on behalf of artists and artists' estates from the resale of works. Since its founding, DACS has secured more than £75 million for living artists and artists' estates. In 2014 alone, it paid out £14 million in royalties.[22] One of Tawadros's innovations at DACS has been to establish the DACS Foundation, a charity whose principal focus is an archive-management and legacy-planning project called Art360. Over a period of three years, Art360 is committed to developing and sustaining the archives of one hundred leading modern and contemporary British artists and artists' estates of diverse generations, nationalities, profiles, interests, and practices.

Tawadros has also continued to curate important international exhibitions and to publish books and articles on issues and artists significant in the diversity and inclusion effort.[23] One measure of

her continued impact is her consultancy at the Tate, one of England's premier art institutions, during which she advised the Tate on how to increase the diversity and inclusivity of its international holdings. Tawadros has also been instrumental in the push to ensure Stuart Hall's legacy. She is vice-chair of the Stuart Hall Foundation.[24]

Several strands came together that led to Tawadros becoming a leader in the British cultural world. First of all, her own background as an immigrant gave her a perspective on the acceptance and integration of a diverse population. Through her education, she was exposed to ideas that provided her with a theoretical structure for her own experience. Then an opportunity presented itself, and she was willing to take the risk of accepting a role for which she had little if any training—developing a new organization. Her strategy of working with established institutions to mount joint programs and her collaborations with the community of artists and intellectuals of color were also key to her success as a leader. Furthermore, her own activities as a curator and a writer gave her the credibility to attract major funding to InIVA. Finally, when she moved on, her continued presence in and impact on the English cultural world was based on the same principles and beliefs that had resulted in the success of InIVA.

Notes

1 Brodsky interviewed Tawadros in 2015 and 2016.
2 Three franchises for exhibitions and publications over three years were awarded by the Arts Council and the London Arts Board: "In setting up InIVA, the intention was to move away from the mainstream and take a new look at society and the interplay of different cultures. Artists of all colours, including white, would be shown together. Anthony Everitt, secretary-general of the Arts Council, said: 'This global approach to the visual arts is unique and we are calling it the New Internationalism.' Two consultants, David Powell, former manager of arts, leisure and tourism for the London Docklands Development Corporation, and Richard Francis, who oversaw the development of the Tate Gallery in Liverpool, have been appointed to lead the building development. Potential London sites are being investigated. InIVA has come about after extensive research by Gavin Jantjes, the artist, and Sarah Wason. Initially, pounds 277,500 has been allocated, to employ a development consultant and offer three exhibition franchises; eventually, InIVA will be funded at the same level as other revenue clients—pounds 400,000 to pounds 450,000 a year."

Dalyla Alberge, "'Artist of Colouyr' Gallery Redraws the Cultural Map," *Independent*, August 24, 1992, http://www.independent.co.uk/news/uk/artists-of-colour-gallery-redraws-the-cultural-map-1542292.html.

3 "Our History: An Introduction to InIVA," InIVA.org, http://www.inIVA.org/about_us/about_inIVA/our_history.

4 Will Somerville, Dhananjayan Sriskandarajah, and Maria Latorre, "United Kingdom: A Reluctant Country of Immigration," *Migration Information Source*, July 21, 2009, http://www.migrationpolicy.org/article/united-kingdom-reluctant-country-immigration; and "A Summary History of Immigration to Britain," MigrationWatchUK.org, http://www.migrationwatchuk.org/briefingPaper/document/48.

5 Gilane Tawadros, "Curating the Middle East: From Napoleon to the Present Day. Critical Remarks on an Historical Background," *Nafas Art Magazine*, February 2004, http://www.universes-in-universe.org/eng/nafas/articles/2004/tawadros.

6 Gilane Tawadros and Tammy Tawadros, "Victoria Tawadros Obituary," *Guardian*, February 2, 2011, https://www.theguardian.com/theguardian/2011/feb/02/victoria-tawadros-obituary.

7 Gilane Tawadros in conversation with Judith K. Brodsky, London, November 2015.

8 Gilane Tawadros in conversation with Judith K. Brodsky, March 2016.

9 Birkbeck College specializes in a law curriculum that emphasizes the intersection of the law with social, political, and cultural factors.

10 The Hayward Gallery is located in the South Bank Centre, consisting of the Royal Festival Hall, Queen Elizabeth Hall, the Purcel Rooms, and the Poetry Library, next to the National Theatre complex. The Hayward Gallery also houses the Arts Council Collection of 7,500 works. The collection was founded in 1946 and includes works by major twentieth-century British artists and continues to collect significant work by contemporary artists.

11 Forum members included artists, curators, and critics already identified as advocates of African art, among them Salah Hassan, professor of art history at Cornell University; Okwui Enwezor, a Nigerian curator based in New York, who was the first non-European artistic director of Documenta, one of the most prestigious art fairs in the world, held every five years in Kassel, Germany; and Marylin Martin, director of the South African National Gallery in Cape Town. The Venice Biennale was established in 1895. Although initially, sales of art could take place, for decades, it has focused on promoting artists considered critically important to the world of art ideas and has no direct connection to sales. To have work exhibited in Documenta, the Venice Biennale, or the other noncommercial art fairs that have sprung up worldwide raises the market value of the artist significantly. The Venice Biennale was to be held every two years in order to showcase artists from countries around the world. The European countries and the United States have long had permanent buildings in Venice in a site at the end of the main island. In recent decades, the Biennale has expanded to include the Arsenale, a huge structure that was

originally used to build ships, as another site for countries to mount their exhibitions. An artistic director is selected for each iteration and is responsible for a central group show. Countries choose their own artist or artists for their individual exhibitions. Until the twenty-first century, the Venice Biennale was a cultural manifestation of the white European colonialist hegemony. As one might suspect, the Biennale traditionally was limited to European countries, although Japan and Argentina were included early in the twentieth century. The United States had its first exhibition in the Biennale in 1934. Until the Forum mounted its exhibitions in 2001 and 2003, except for Egypt and South Africa, African countries had never been invited to participate. Robert Storr, the American critic, curator, and arts educator, was the artistic director of the 2001 Biennale, and has to be given credit for his awareness of the Eurocentrism of the Biennale up to that point. Hassan described *Authentic/Ex-centric* as follows: "These are not stereotypical African artworks but works that involve cutting edge technology, multimedia installations, film, video and completely new areas of production. A large part of this effort is to write the history of contemporary African art and establish a global presence of African and African diaspora artists—to show Africa, not just as a geographical entity, but as a historical presence." Franklin Crawford, "$195,000 Ford Foundation Grant to Cornell's Africana Center to Support Pan-African Presence in Venice Biennale Art Exhibit in 2003," *Cornell Chronicle*, April 18, 2002, http://news.cornell.edu/stories/2002/04/ford-grant-african-presence-venice-biennale-exhibit.

12 Gilane Tawadros, "Fault Lines: Contemporary African Art and Shifting Landscapes," *Universes in Universe*, http://universes-in-universe.de/car/venezia/bien50/fault-lines/e-press.htm.

13 The British lottery program was established in 1992 as a means to provide funding for the arts.

14 "Rivington Place—Celebrating Difference," InIVA.org, July 25, 2007, http://www.inIVA.org/press/2007/rivington_place_launch.

15 "Rivington Place."

16 Chambers, "InIVA: Everything Crash," *Afterall: A Journal of Art, Context and Enquiry* 39 (2015): 50–59.

17 Morgan Quaintance, "InIVA: Fit for Purpose?," *Art Monthly* 380 (2014).

18 Quaintance.

19 Quaintance.

20 "Dear Supporters, What Does InIVA Mean to You?," Supporters of InIVA, April 10, 2015, http://www.supportersofinIVA.wordpress.com.

21 "Letters," *Art Monthly* 385 (2015): 11.

22 "What Is DACS?," The Design and Artists Copyright Society, https://www.dacs.org.uk/about-us/what-is-dacs.

23 Gilane Tawadros, "Curriculum Vitae," Rutgers Center for Women in the Arts and Humanities, https://cwah.rutgers.edu/media/uploads/CV_Gilane_Tawadros_04_12.pdf. In addition to the Venice Biennale, Tawadros was a curator of the important Brighton Photo Biennial and a contributing curator to the Guangzhou Triennial. Her exhibitions include *Veil* (New Art Gallery,

Walsall; Bluecoat Gallery and Open Eye Gallery, Liverpool; and Modern Art, Oxford, UK), 2003; *The Real Me* (ICA, London), 2005; *Alien Nation* (ICA, London and Manchester City Art Galleries), 2006; and *Transmission Interrupted* (Modern Art, Oxford), 2009, just to name a few. She has worked with and commissioned many artists nationally and internationally, including Louise Bourgeois (American feminist artist), Frank Bowling (British black artist), Jimmie Durham (Native American artist), Mona Hatoum (Palestinian/English artist), Glenn Ligon (African American artist), Chris Ofili (British black artist), Doris Salcedo (Brazilian artist), and Yinka Shonibare (British black artist). Tawadros has edited several books on contemporary art, including *Changing States: Contemporary Art and Ideas in an Era of Globalisation* (2004) and *Life Is More Important than Art* (2007), which investigates the conditions of being an artist in the twenty-first century. As commissioning editor of InIVA's publications, she published more than forty exhibition catalogs, monographs, artists' books, anthologies on contemporary visual arts, and print and online resources for teachers. These include *Cosmopolitan Modernisms* (2005); *Veil: Veiling, Representation and Contemporary Art* (2003); *Fault Lines: Contemporary African Art and Shifting Landscapes* (2003); *Modernity and Difference: Sarat Maharaj and Stuart Hall in Conversation* (2001); *Reading the Contemporary: African Art from Theory to the Marketplace* (1999); *Rhapsodies in Black: Art of the Harlem Renaissance* (1997); and *Beyond the Fantastic: Contemporary Art*. She has been a board member and chair of the board of contemporary arts organizations, including *Manifesta, 2009*, a foundation that mounts an important international biennial art exhibition. Between 2007 and 2009, she acted as a consultant to Tate Gallery, London, developing their international strategy across all their activities. Tawadros has taught and lectured widely, including at the Academy of Fine Art (Trondheim), International Centre of Culture and Management (Salzburg), American University (Cairo), Duke University (North Carolina), University of the West Indies (Kingston, Jamaica), Museum of Modern Art (Vienna), International Curators Forum (Venice), Institut National d'Histoire de l'Art (Paris), Museum of Islamic Art (Qatar), Basel Art Fair (Basel), Royal Society of Arts (London), and the Rutgers University Institute for Women's Leadership. She is also the vice chair of the Stuart Hall Foundation (Stuart Hall died in 2014).

24 "About Us," Stuart Hall Foundation, http://stuarthallfoundation.org/who-we -are/.

Bibliography

Art Monthly. "Letters." 385 (2015): 11.
Chambers, Eddie. "InIVA: Everything Crash." *Afterall: A Journal of Art, Context and Enquiry* 39 (2015): 50–59.
Design and Artists Copyright Society. "What Is DACS?" https://www.dacs.org.uk/ about-us/what-is-dacs.
InIVA.org. "Our History: An introduction to InIVA." http://www.inIVA.org/about _us/about_inIVA/our_history.

———. "Rivington Place—Celebrating Difference." July 25, 2007. http://www
.inIVA.org/press/2007/rivington_place_launch.
MigrationWatchUK.org. "A Summary History of Immigration to Britain."
www.migrationwatchuk.org/briefingPaper/document/48.
Quaintance, Morgan. "InIVA: Fit for Purpose?" Art Monthly 380 (2014). https://
morganquaintance.com/2014/12/22/inIVA-fit-for-purpose/.
Somerville, Will, Dhananjayan Sriskandarajah, and Maria Latorre. "United King-
dom: A Reluctant Country of Immigration." Migration Information Source,
July 21, 2009. http://www.migrationpolicy.org/article/united-kingdom
-reluctant-country-immigration.
Stuart Hall Foundation. "About Us." http://stuarthallfoundation.org/who-we-are/.
Supporters of InIVA. "Dear Supporters, What Does InIVA Mean to You?" April 10,
2015. http://www.supportersofinIVA.wordpress.com.
Tawadros, Gilane. "Curating the Middle East: From Napoleon to the Present Day.
Critical Remarks on an Historical Background." Nafas Art Magazine, Febru-
ary 2004. http://www.universes-in-universe.org/eng/nafas/articles/2004/
tawadros.
———. "Curriculum Vitae." Rutgers Center for Women in the Arts and Humani-
ties. https://cwah.rutgers.edu/media/uploads/CV_Gilane_Tawadros_04_12
.pdf.
———. "Fault Lines: Contemporary African Art and Shifting Landscapes." Uni-
verses in Universe. http://universes-in-universe.de/car/venezia/bien50/fault
-lines/e-press.htm.
Tawadros, Gilane, and Tammy Tawadros. "Victoria Tawadros Obituary." The Guard-
ian, February 2, 2011. https://www.theguardian.com/theguardian/2011/feb/02/
victoria-tawadros-obituary.

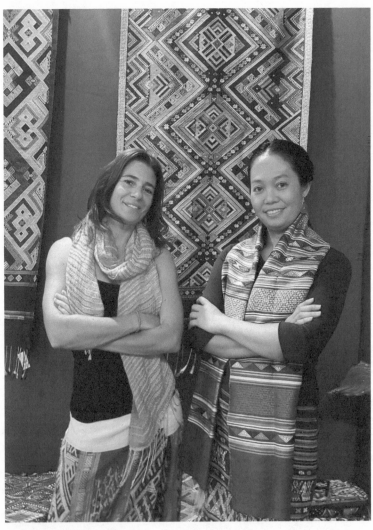

FIGURE 19 Photograph portrait of Ock Pop Tok founders Douangdala and Smith. Courtesy of Douangdala and Smith.

Veomanee Douangdala and Joanne Smith

Ock Pop Tok: Social Entrepreneurship in the Lao People's Democratic Republic

The work of Veomanee Douangdala and Joanne Smith[1] embodies all the characteristics of social entrepreneurship: ambitious, innovative, mission driven, resourceful, and results oriented.[2] Their enterprise, Ock Pop Tok[3] (OPT—East Meets West) was founded in 2000, when they were each twenty-five years old. According to Douangdala, "The mission of our work at Ock Pop Tok is continuing traditional culture in a way that can improve the economic opportunities for artisans and facilitate creative and educational collaborations in Laos."[4] In the ensuing years, they have expanded beyond their initial commercial weaving venture to a multilayered organization recognized by the Laotian government, regionally in Southeast Asia, and across the world as a thriving model for preserving cultural heritage, employing and empowering women, protecting the environment and as a boon for the tourist industry.

Ock Pop Tok's headquarters are located in the picturesque city of Luang Prabang, Laos. The city is situated on a peninsula formed by the Mekong and Nam Khan Rivers in mountainous Northern Laos. It is an ancient city where nineteenth- and twentieth-century European colonial style buildings coexist with Lao traditional and contemporary urban architecture. It is one of only two Laotian sites (and one of thirty-seven Southeast Asian sites) designated

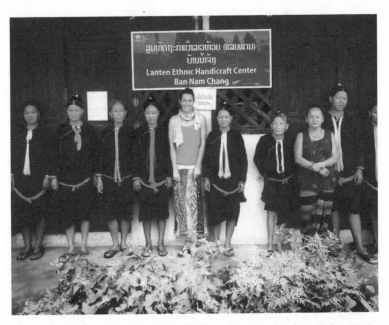

FIGURE 20 Ock Pop Tok cofounder Smith in the center of a group of Laotian women weavers at the Lanten Ethnic Handicraft Center, Ban Nam Chang, Laos. Courtesy of Douangdala and Smith.

as a United Nations Education, Scientific, Cultural Organization (UNESCO) World Heritage Site. This distinction was bestowed on it in 1995.

Laos is a landlocked country bordered by Myanmar, China, Vietnam, Cambodia, and Thailand. The country's population of approximately seven million people is composed of about forty-nine officially recognized ethnic groups, many of which are represented in Luang Prabang's population of fifty thousand people. Most were uprooted during the late twentieth-century wars between political left and right factions (after the French Colonial and civil wars). The Lao People's Democratic Republic was founded in 1975 and is a Marxist-Communist government in the thrall of Vietnam.

Luang Prabang's charms attract visitors from all over the world. The Ministry of Tourism reported that the number of international visitors to the country rose by 22 percent in just one year from 2011 to 2012.[5] In fact, the European Council on Trade and Tourism

recognized Laos in 2013 with an award as the "World's Best Tourist Destination."

Luang Prabang is the center of Buddhism for the region. Buddhist ceremonies and rites are preserved and continue to be observed in the thirty-three gilded wats (temples) that dot the city. Early each morning, saffron-clad monks of all ages proceed through the town's streets collecting alms and food. Douangdala's mother is the leader of her Buddhist temple.[6] Douangdala herself is a practicing Buddhist, and the family's proximity to the religious and cultural center of Laos has always had a strong impact on her life and work.

Fleeing the area ravaged by the Southeast Asian wars, the Douangdala family, like others, immigrated to the region around 1975. Their only daughter, Veomanee (Veo) was born in the village of Ban Xang Khong, near Luang Prabang. The community in the region of Luang Prabang was very conservative and not welcoming to new arrivals uprooted by the wars. Despite the nomadic nature of the family's life and their difficulties, Douangdala's mother, a well-respected weaver known for her knowledge of natural dyes, would always weave to provide income for the family; and from the time she was eight, Veo Douangdala also learned to weave and dye in the Lao tradition of using natural colors—earning enough money to help pay for her own education and books.[7] Her parents were also antique traders and introduced her to many native crafts. She developed a lifelong interest in arts and crafts from all over her country and then subsequently began collecting textiles herself.

Her parents encouraged her to get an education even though she was the youngest and the only girl. Douangdala says, "When I was in high school, I had a better understanding that many women/girls from the village didn't get the same opportunities as men/boys."[8] She absorbed history from listening to the village elders and reading the limited books available to her. Douangdala was a top student who learned both French and English, and after high school, she went to work in her uncle's hotel, where her language skills were extensively used (and honed). She continued to work in her family's weaving business while employed at the hotel. Her parents

had instilled in each child the responsibility to support other members of their family. Her industriousness paid off for other family members—she helped support two brothers while securing their university education, and one went on to become a pediatrician.

After several years of hotel work, Douangdala was given the opportunity to take a business management course. The course brought her to the realization that although she liked working with people, her hotel job wasn't satisfying. During this same period, in the early 1990s, her mother began a small textile business that quickly grew with demand from local customers as well as requests from abroad to export her wares. Douangdala learned about selling and making money from her mother as well as from her business management studies. Other village families began weaving textiles for sale and partnered with her mother. Soon the village became famous for its textiles and mulberry paper products and began to appear on many visitors' itineraries. The Lao government designated it a "cultural village," and the Douangdala family's reputation was cemented; all this recognition came at the same time as UNESCO designated Luang Prabang as a World Heritage site.

In that same year, Douangdala met Joanne Smith, a British photographer, also born in 1976, who came to Luang Prabang with the express purpose of meeting Veo Douangdala. Smith, who as an art major had ironically least liked weaving as an artistic medium, had nevertheless tried working in the textile arts in England but, not unexpectedly, did not find it fulfilling. After graduating from art school, she was hired by a European Union development project to do documentary photography in Southeast Asia. While in Bangkok, she met an architect (called "Uncle" by all who knew him) who suggested that she go to Laos and look up Douangdala, whom he had met while staying at the hotel where she worked. Smith went to the hotel in Luang Prabang only to miss her. Smith figured she had done her "duty." But at a subsequent party in town, the two serendipitously met, and it was then that Smith realized that this new friend named Veo Douangdala was one and the same person Uncle had wanted her to meet.

Although raised and educated in the U.K., Smith's upbringing somewhat paralleled that of Douangdala's. She too grew up in a

very caring family environment. Through her mother, she also came to love the creative process. Smith's grandfather collected African and Oriental art and had a library with books describing foreign lands and a globe—all things that stimulated Smith's imagination and longing for adventure. In school, Smith excelled at athletics but experienced gender bias when she tried to play sports with the boys. Smith admits to not fulfilling her potential as a student and describes herself as challenging the authority of her teachers. While in art school, Smith had the idea that if she and other students pooled their talents, their collective would be quite successful. However, though her peers expressed interest in the idea, everyone went off individually, and her concept didn't materialize until she encountered Douangdala.

When Douangdala and Smith met that fateful night in Luang Prabang, they were twenty-four years old. Douangdala started to teach Smith how to weave and then noticed that Smith was very creative and used colors different from those found in traditional Lao textiles. After many conversations, the two women decided to form the weaving collective Ock Pop Tok in 2000 and formulated several missions. They wanted to preserve the rich and ethnically diverse Laotian craft traditions so that subsequent generations would not lose their heritage; they recognized that through their weaving enterprise, women weavers could have gainful employment and, as a result, improved recognition and status within their families and society; they wanted to create an organization with the potential for cultural impact beyond the local area; and they wanted to establish an organization that would also satisfy their own personal passions.[9] The two women divided the administration of OPT along their individual strengths. Douangdala heads the OPT weaving team, oversees management of the Living Crafts Centre, and is responsible for the Heritage Textile Collection while Smith manages OPT's financial and strategic development.

The initial capital outlay for OPT came from each of the founders, and the first textiles they sold were given to them on consignment by the weavers associated with Douangdala's mother's village at Ban Nong Wat. They sold their goods in a rented storefront downtown, though not on the main thoroughfare. The space was given

free to OPT, since it was in the same building where Smith rented her lodgings.

Because of the city's heritage designation, they were prohibited from placing signs directing people to their location. Tourists and customers asked why their business was not on the more convenient main street of the town. Their location was constricting them from any growth. They were at a juncture not only in their business but in their personal lives as well. Did they want to grow the business? It would mean making a commitment not only to themselves but also to more people. They were young and inexperienced. Could they be successful if they tried to go further?

Resolution

They reached the personal decision to expand OPT. Then the question became how to do it. Their first strategy was the development of a clear mission and goals. Although Smith and Douangdala came from different cultural backgrounds, they agreed on many good management principles, one being to develop a carefully defined mission. Besides the personal satisfaction they derived from the business, they wanted to continue to do their part in preserving the cultural heritage of the Laotian textile tradition, raising the status of Laotian women, helping rural areas achieve economic sustainability, and protecting the environment.

Initially, they perceived their partnership as a fun project, but their youth and inexperience and concern about disappointing those with whom they worked presented challenges. Expanding their small but successful shop into a big business meant that they had to become more knowledgeable about business practices, and they realized they needed to seek expert advice. They consulted with retired Dutch professionals who helped them develop a business plan, accounting procedures, and even landscape design for their garden. They learned that it was very important to understand both their own motivations and the motivations of other people. They also learned to look at a new project from various angles to determine the potential obstacles as well as opportunities.

Their next step was to think about the management of their staff. They developed a team approach in which they asked the members of the team for input in the planning process and created a system to provide rewards and incentives and, most importantly, show respect for their employees.

They found another space on the main road in town, which they named the Ock Pop Tok Heritage Shop, and filled it with displays of fabrics woven by onsite weavers as well as classic Lao textiles. As the town increasingly became a tourist destination, media from abroad, in print, and on the internet, as well as word-of-mouth, contributed to OPT's reputation. The larger shop became a success, and they opened a pop-up store in the country's capital, Vientiane, in response to requests from customers in that city.

Increasing interest in their products led to customers' desire to learn about the dyeing and weaving techniques used in Laotian textiles. People wanted to come and stay for periods of time to practice the techniques OPT weavers employed but couldn't find accommodations. In response to these inquiries as well as recognizing the popularity of Luang Prabang as a tourist destination, they built a hotel, the Mekong Villa. The rooms are appointed with textiles created by OPT weavers and are named for the regions or cultural groups associated with textiles, including the Hmong, Katu, Tai, and Hill Tribe rooms. The duo then established the Silk Road Restaurant adjacent to the hotel, which serves meals for all visitors. It began as a canteen to feed the cooperative's weavers who enjoyed homemade food cooked by one of their own. The hotel and restaurant are in the same location as the Living Crafts Centre, where visitors can enjoy such learning experiences as a half-day natural dyeing class, a full-day natural dye and weaving class, a Hmong batik class, bamboo weaving class, classes for entire families, and classes of longer durations. The center has become not only an opportunity to learn about Laotian weaving but also a way for weavers and visitors alike to share and appreciate Lao culture and heritage. On the second floor, they established the *Fibre2Fabric: The Lao Heritage Textile Collection* to document and showcase their collection of historic textiles. They and the weavers also use the collection to research new designs. Exhibition presentations are bilingual—in Lao and English.

By combining accommodations and programs in a tourist destination, they provide sustainable employment to hundreds of women throughout Laos who are expert in traditional skills, thus fulfilling one of their social goals.[10] The social entrepreneurs work as a team with their weavers, who, along with other team members, provide input in decision-making.[11] Every weaver receives a salary three times the minimum wage, participates in profit sharing, and has benefits—health care, day care, and transportation. All the weavers are individually introduced on the firm's website through their photos and biographies, and some are featured with fuller stories. This system allows visitors (virtual and onsite) to learn the histories of the weavers they meet and personalizes the OPT experience. Douangdala and Smith made the decision that everyone in the company must have a passport paid for by the business, and many of the weavers travel with Smith and/or Douangdala to international fairs and conferences in the United States, Japan, and Vietnam.

What they have contributed in the way of employment, income, and status to Laotians is evident in the profiles of their staff. At the Weaving Studio, the weaving team is led by Davon Lunyalath, who learned weaving from her mother and now, forty years later, teaches other weavers. In 2010, Lunyalath won the Best Textile Award in Laos with a piece that combined silk, cotton, and hemp with weaving and batik techniques. In addition, Mrs. Lunyalath's two daughters are weavers.

As well as providing weavers with income and status, OPT also provides opportunities in administrative work for Laotians. When she was fifteen, Lear Philliminda began work in sales (a position now called "cultural ambassador"). She has risen through the ranks to become head of production and has also visited in the United States as a participant in the Santa Fe International Folk Art Market. Duoa Thao moved to Luang Prabang to be a monk, changed his mind, and then earned a diploma in English. He went on to gain work experience in the hospitality industry. He now manages all bookings for classes and activities at the Living Crafts Centre. As a Hmong, he is among the many representatives of the diverse

ethnicities employed by OPT.[12] In addition, he has also assisted with research for a Hmong Culture exhibition there.

Another center employee, Sengchan Chantyayong, is head of guest experience and also leads classes. She interned in 2006 at the Jim Thompson Foundation in Bangkok and then applied the knowledge she acquired to cataloging the OPT Heritage Collection.

Viengkhone Kodpathome is the shop supervisor for a new boutique opened in 2014 with a line of clothing and home collections showcasing OPT's blending of modern and heritage designs. She has a background in marketing and communications with dual degrees in education and business from Vientiane College; in addition, she has newspaper experience. As well as managing the boutique, Kodpathome represents OPT in Tokyo. One of their master weavers, Mrs. Ting, has taken up residency in the River Resort in Champasak, a premier eco-friendly vacation spot, where she demonstrates weaving to guests, who can also find OPT textiles in the resort's boutique. Douangdala says, "'We're part textiles, part tourism, and part promoters of Lao. . . . Our responsibility has grown bigger than weaving.'"[13]

The Village Weaver Project was conceived in 2006 as a series of initiatives to provide design and marketing assistance to rural communities in eleven provinces with the goal of generating sustainable income. The OPT team is composed of weavers, dyers, designers, and tailors who share their organizational skills as well as their artistic expertise with artisans in the countryside. One of the aims of the teams is to assist villagers in creating enterprises featuring value-added products based on handcrafts. In most cases, OPT works with an NGO[14] partner or with Laotian governmental agencies (e.g., the Department of Trade and Industry, Lao National Tourism Administration, Lao Women's Union) in projects across the country with many ethnic groups.

The United Nations Office of Drugs and Crime (UNODC) collaborated with Ock Pop Tok to reverse the long-term effects of opium farming in a northern Lao province by assisting some villages to replace opium farming with traditional handicrafts as their primary source of income. An OPT team traveled to Ban Chabeu, a Tai Dan

village of 302 people. The Tai Dan are known for growing cotton, weaving textiles on backstrap looms, and wearing distinctive clothing. The remoteness of the village and their own perilous journey in traveling there indicated to the members of the team that the logistics of conveying goods to the nearest market town would be a challenge in transforming the economy. There is no consistent transportation between the villages, the weather often impedes travel, and the journey can take as much as six hours. After a stay of several days in the village chief's house, with conversations to determine the new economic approach, representatives of the village, along with members of the UNODC and OPT teams, drafted a memorandum of agreement that would protect the rights of all involved. They then presented their memorandum to the district governor of Muang Mai, and all parties signed the agreement. OPT continues to oversee the supply chain to ensure that the implementation of the plan is successful; Douangdala and Smith also hosted some village artists in residencies at their headquarters in Luang Prabang and created networks among villages.

OPT consulting effectively helps reduce poverty, provides incentives for people to remain within their communities rather than move away for employment opportunities, and protects the traditional heritage from dying out. Often it is a village woman who coordinates a team of other local women to implement the weaving project. According to Douangdala, "Once they see that one person is earning something, they all want to participate. The women feel proud, especially as they support their families and then get to travel to other villages."[15] In another instance, a joint venture with a Southern rural village resulted in helping "the women there change a particular technique that reduced weaving time from two months to two weeks. Small changes like that can make a huge difference," says Smith.[16]

At each juncture in OPT's business history, Douangdala says she and Smith take a conservative approach, wanting to wait, see, and weigh their options. They want to determine if it is right to grow the business, and when the opportunity comes, they assess whether it is time to act: "If we have the demand, then we can open a new business."

One opportunity that presented itself to them was their first invitation to participate in the Santa Fe International Folk Art Market, which was founded in 2004 by a group of forward-thinking New Mexicans in Santa Fe, a city also with a UNESCO World Heritage Site designation, "to foster economic and cultural sustainability for folk artists and folk art worldwide and to create intercultural exchange opportunities that unite the peoples of the world."[17] The Santa Fe International Folk Art Market has grown exponentially and is now recognized as "one of the top 20 must-see events in the world."[18] Selection is highly competitive. In 2015, for example, more than 173 folk artists from fifty-seven countries were selected from more than six hundred applications by a panel of folk art professionals to bring their art for sale and demonstrate their craft.

OPT has received multiple subsequent invitations. Douangdala and Smith rotate representatives from among their team of Lao weavers to attend and meet with the approximately twenty thousand visitors at the market. Their successes in Santa Fe—where in 2005, for example, each folk artist (or entity) sold more than $20,000 in goods and was designated an "artist" in a worldwide venue—satisfied Smith and Douangdala that they could expand their operations.[19] Douangdala says, "I was blown away the first year we attended by all the interest and support and that we weavers were called artists—a big word in Lao—an appreciation that gave us the confidence to continue to come to New Mexico and share the experiences with our team members."[20]

Douangdala and Smith promote OPT and their creations through many other local and international markets in addition to the Santa Fe International Folk Art Market. OPT participates in festivals and fashion shows as well as markets. They feel that participation in these venues demonstrates that they are "a young, dynamic company embodying East meets West."[21]

In addition to raising the status of women, helping rural regions develop their economies, and preserving cultural heritage, Douangdala and Smith are also investing in education and the environment. In response to queries from customers and visitors asking how they can help the Lao people, they established the East Meets West Fund to facilitate educational opportunities for young people

who otherwise would not be able to continue their education. The fund is set up so that payments are made directly to schools and colleges, and reports on students' progress are required, thus ensuring accountability. In addition to establishing a program to further education in general, Douangdala and Smith also are investing in programs to advance design innovation. They organized a design competition in which weavers are asked to create new designs based on the OPT collection of hundreds of antique textiles, thereby encouraging their weavers to experiment with new colors and patterns.

As an adjunct to their sustainable development policy, Douangdala and Smith are also committed to good environmental practices. The weavers filter their wastewater through sand and charcoal pits and recycle it into their gardens. They also compost and take energy saving measures. Fibers and dyes are locally produced as much as possible, and when using chemical dyes, only European Union–approved dyes are permitted. Display furniture is almost always constructed from bamboo.[22] Their efforts on behalf of sustainable culture were rewarded in 2014, when they received the Wild Asia Award for Responsible Tourism in Cultural Preservation—the first Lao entity to be so recognized. Wild Asia, based in Kuala Lumpur, is "a leader in providing bottom-up solutions and trainings for sustainable development" and inaugurated this award in 2006 to recognize excellence and innovation, where businesses, producers, consumers, communities, and the environment interact and have an impact.[23] According to OPT's website, "Culture is always evolving and changing, and we want to be part of change that is positive. And we want to encourage travelers and tour operators and communities to work together to evolve and grow responsibly and positively."[24]

Douangdala and Smith have been recognized widely for their innovative social entrepreneurship. Lao Airlines published a photo spread on some of the weavers, and the international media, such as the *New York Times*, the *BBC*, and the *Guardian*, have also featured OPT. Museum shops stock its wares. Many guidebooks and travel websites have put OPT on their recommended activities lists, among them *Rough Guide*, *Lonely Planet*, *Frommers*, and *TripAdvisor*.

As the text reads on the OPT website, [the business] "demonstrates that textiles are a platform for creativity. . . . and now local culture is seen as cool."[25]

OPT's accomplishments have also resulted in recognition by the Lao government, which has accorded it the status of a "heritage" business for preserving the nation's textile traditions and promoting handicrafts. The government promotes Douangdala's and Smith's work in various ways (although not financially)—for instance, by assisting them with participation in trade shows abroad in Japan, China, and Vietnam.[26]

What is the takeaway from Ock Pop Tok? Is it Douangdala's and Smith's boundless energy? Their chance international collaboration would be difficult to emulate. Luck also entered into their success—they found each other and they are conscious of being in the right place at the right time. However, their social entrepreneurship practices offer many useful strategies for others to follow. The first is their partnership. It helps to work in partnership so that tasks can be shared. There is also an advantage to bringing different perspectives to bear in solving problems, but two divergent points of view can also present difficulties. Smith and Douangdala discovered that there was an upside to the struggle to find consensus, because often, combining their two approaches resulted in a position of greater strength.

Douangdala believes that their flexibility was crucial. It helped them in adapting to changing government rules, shifts in the economy, and other unexpected situations. In the view of both women, two other features contributed to their success: their willingness to engage in hard work and their passion for what they were doing.

What do Smith and Douangdala say about themselves and their legacies? Smith considers herself "an opportunity provider—economically and creatively" driven by her desire for recognition for women and her own concepts of justice. She also finds great pleasure in collaboration and the sharing of ideas.[27] Douangdala says that her legacy is to have assisted other Lao women in realizing that it is all right to try new things and think differently.[28] She said when learning of the Wild Asia Award, "Since 2000, our passion

for textiles and cultural exchange has motivated my team and me to create a holistic experience for our guests. We only hope we can inspire others to participate in their own cultural preservation."[29]

In mid-2016, they were at a crossroads, as each woman was turning a milestone age—forty years old. Smith admits, "It was not about business first, it was about friendship. . . . The idea was to start something different, something we loved."[30] The time had come when they felt a need to assess what they had created, evaluate how the team was working, and recharge themselves. They hired a CEO of operations on a trial basis and planned to review the position to see if the complexity of the business might require dividing up the supervisory responsibilities. Douangdala found that she needed to focus more on family obligations as well as her own creative production, and she might need to take a leave from the business. Smith also was thinking about changing gears.[31]

Carmen Padilla, in *The Work of Art: Folk Artists in the 21st Century*, assesses Ock Pop Tok as follows: "Within less than a decade, Douangdala and Smith had not only met their goals, they had grown Ock Pop Tok to an internationally known destination about Lao culture and textile traditions."[32] Their success is an inspiration.

Notes

1 Brodsky and Olin corresponded with Douangdala and Smith throughout 2015 and 2016 via email and telephone. In 2016, friends of Olin's, Maureen Strazdon and Vic Barry, were traveling to Luang Prabang, and they were kind enough to interview Douangdala and Smith and record the interviews on videotape.
2 Email message from the Folk Art Alliance described "what a social entrepreneur looked like" with these words, September 1, 2016.
3 For more information, see Ock Pop Tok's website: http://ockpoptok.com/.
4 Veomanee Douangdala, Ock Pop Tok founder, quoted in International Folk Art Market online website: http://ifamonline.org/ock-pop-tok.
5 Caroline Eden, "Weaving a New Future in Laos," BBC.com, August 29, 2013, http://www.bbc.com/travel/story/20130825-weaving-a-new-future-in-laos.
6 Veomanee Douangdala, in conversation with Maureen Strazdon and Vic Barry, January 5, 2016, Luang Prabang, Laos DRP: "Men are more respected than women, though women have bigger roles in the family to raise the kids."
7 Veomanee Douangdala, in an email to Judith K. Brodsky and Ferris Olin: "All along, there were clear roles of what women and should do or act. For example,

one of my male friends was a master weaver and everyone would tease him and call him lady boy, even though he was very talented."

8 Veomanee Douangdala, email correspondence with Judith K. Brodsky and Ferris Olin, December 19, 2015.

9 Smith and Douangdala, email correspondence with Brodsky and Olin, December 19, 2015.

10 OPT succeeds in Goal 3, "promote gender equity and empower women," of the 2015 United Nations Commission on the Status of Women Millennium Development Goals. *Millennium Development Goals Report 2015*, http://www.un .org/millenniumgoals/2015_MDG_Report/pdf/MDG%202015%20rev%20(July %201).pdf.

11 Douangdala, in conversation with Olin, July 28, 2016.

12 It is particularly noteworthy that a Hmong man is one of OPT's higher-level employees. The Hmong belong to an ethnic group that has had low status in Laos. The Hmong live in the mountains and have no written language of their own. Their situation in Laos is complicated further by the fact that they were recruited by the United States CIA to fight the communists in the late twentieth-century Southeast Asian wars. When the Marxist government was established in Laos, thousands of Hmong who had fled Laos refused repatriation for fear of imprisonment and death. The United States eventually agreed to establish a refugee program to allow a number of Hmong to emigrate to the United States.

13 Douangdala, as quoted in Carmen Padilla, *The Work of Art: Folk Artists in the 21st Century* (Santa Fe: IFM Media, 2015), 149.

14 NGOs (nongovernmental organizations) are not-for-profit independent entities, usually associated with the United Nations, established by philanthropic groups for various purposes, such as helping countries develop economic sustainability or expand literacy.

15 Veomanee Douangdala, in telephone conversation with Ferris Olin, July 28, 2016.

16 Helen Anderson, "Calm and Karma," *Sydney Morning Herald*, March 26, 2011, http://www.traveller.com.au/calm-and-karma-1c6ht.

17 International Folk Art Alliance, *The Work of Art: International Folk Art Market Santa Fe 10th Anniversary Impact Report*, 2014, https://www.folkartalliance.org/ wp-content/uploads/2014/03/SFF161_MarketFactsLO-RESm2bh.pdf.

18 American Express Essentials, "20 Must-See Events in July," https://www .amexessentials.com/20-must-see-events-in-july/.

19 All exhibiting artists earned a total of $2.9 million in sales at the 2015 Folk Art Market. International Folk Art Alliance, *Impact Report 2015*, 2, https://issuu .com/internationalfolkartalliance/docs/impact_report_16_issuu?e=23122427/ 32799133.

20 Douangdala, in conversation with Olin, July 28, 2016.

21 Smith, in conversation with Strazdon and Barry, January 5, 2016.

22 Ock Pop Tok, "Ethical Policy," http://ockpoptock.com/about/ethical-policy/.

23 See "Wild Asia," Explained. Today: The Information and Knowledge Portal, http://everything.explained.today/Wild_Asia/.
24 Ock Pop Tok, "Winner of the 2014 Wild Asia Awards," http://ockpoptok.com/wildasiaawards.
25 Ock Pop Tok.
26 Douangdala, in conversation with Olin, July 28, 2016.
27 Smith, email correspondence with Brodsky and Olin, December 19, 2015.
28 Douangdala, email correspondence with Brodsky and Olin, December 19, 2015.
29 Ock Pop Tok, "Winner."
30 Padilla, *Work of Art*, 148.
31 Douangdala, in conversation with Olin, July 28, 2016.
32 Padilla, *Work of Art*, 148.

Bibliography

American Express Essentials. "20 Must-See Events in July." https://www.amexessentials.com/20-must-see-events-in-july/.

Anderson, Helen. "Calm and Karma." *Sydney Morning Herald*, March 26, 2011. http://www.traveller.com.au/calm-and-karma-1c6ht.

Brodsky, Judith K., and Ferris Olin. Emails from Smith and Douangdala, December 19, 2015.

Eden, Caroline. "Weaving a New Future in Laos." BBC.com, August 29, 2013. http://www.bbc.com/travel/story/20130825-weaving-a-new-future-in-laos.

International Folk Art Alliance. *Impact Report 2015.* https://issuu.com/internationalfolkartalliance/docs/impact_report_16_issuu?e=23122427/32799133.

———. *The Work of Art: International Folk Art Market Santa Fe 10th Anniversary Impact Report 2014.* https://www.folkartalliance.org/wp-content/uploads/2014/03/SFF161_MarketFactsLO-RESm2bh.pdf.

International Folk Art Market online, http://ifamonline.org/collections/ock-pop-tok.

Ock Pop Tok. "Ethical Policy." http://ockpoptock.com/about/ethical-policy/.

———. "The Ock Pop Tok Experience." n.d.

———. "Winner of the 2014 Wild Asia Awards." http://ockpoptok.com/wildasiaawards.

Olin, Ferris. Conversation with Veomanee Douangdala, July 28, 2016.

Padilla, Carmen. *The Work of Art: Folk Artists in the 21st Century.* Santa Fe: IFM Media, 2015.

Rosenfield, Cynthia. "Hill-Tribe Style with Urban Panache." *How to Spend It*, April 11, 2013. http://howtospendit.ft.com/style/24633-hill-tribe-style-with-urban-panache.

Strazdon, Maureen, and Vic Barry. Videotape of conversation with Veomanee Douangdala and Joanne Smith in Luang Prabang, January 5, 2016.

Acknowledgments

Having worked on issues of women's leadership in the arts through-out our careers, we were delighted to undertake this book when the Rutgers University Institute for Women's Leadership (IWL) and the Rutgers University Press decided to collaborate in publishing a book series of case studies on women's leadership. We are grateful to the late Alison R. Bernstein, director of IWL; Lisa Hetfield, at the time associate and now interim director of IWL; Mary K. Trigg, IWL director of leadership programs and research and chair of the Women's and Gender Studies Department, Rutgers University; and Marlie Wasserman, at the time director of Rutgers University Press, for their visionary leadership in initiating the project. We appreciate the encouragement and efforts of Kimberly Guinta at Rutgers University Press, who took over as our editor during the final phases of the book's publication. We are also grateful to Mary S. Hartman, Edwin M. Hartman, Donna Griffin, and Bernice Venable, whose early confidence and generous financial support made this book and the rest of the series possible.

We so much appreciate the courage, persistence, imagination, and innovation of the women we have included in the book. Working on their stories has inspired us. We particularly want to thank the women whom we interviewed in person, on the telephone, and through email exchanges: Míriam Colón (whom we were able to interview before her death in February 2017), Samella Lewis, Louise Noun (whom Olin interviewed before she died in 2002), Jaune Quick-to-See Smith, Bernice Steinbaum, Martha Wilson, Jawole Willa Jo Zollar, Gilane Tawadros, Veomanee Douangdala, and Joanne Smith. We are also very grateful for the information provided by Marya Cohn, Julia Miles's daughter, and Suzanne Bennett, her longtime friend and colleague. We appreciate as well the time and effort Maureen Strazdon and Vic Barry made while traveling

in Southeast Asia to meet, interview, and document, on our behalf, a conversation with Joanne Smith and Veomanee Douangdala in Luang Probang. William Valerio, director of the Woodmere Museum, and Danielle Rice, director of the Museum Leadership Program at Drexel University, were invaluable resources of information pertaining to Anne d'Harnoncourt, with whom they worked closely. In addition, Ferris Olin wishes to acknowledge Marcia Tucker and the staff at the Institute for Advanced Study Library, who welcomed her and provided a serene space and access to research materials—all of which was conducive to writing. Judith K. Brodsky, as always, thanks her husband, Michael Curtis, retired Rutgers professor and himself an author of more than thirty books, for his wise counsel and support.

While we did our own research and writing, we could not have wrapped up the case studies so elegantly without the expert editing help of Kim Lemoon, whom we first met when she was a student in an online course we initiated on feminist art. At the time, we were impressed by her thoughtfulness, her ability to synthesize ideas, and her writing skills. She continues to have all those characteristics and more. We also want to thank Elizabeth Napier, who was kind enough to formulate the index. Our own partnership as coauthors is one more rewarding and enjoyable collaboration in the long series of collaborations we have had since the 1970s.

We want to dedicate this book to the late Alison Bernstein. If only she could still be here for us to tell her how much she has inspired us and how much we admire her.

Index

Page numbers in *italics* refer to figures.

About the Authors

JUDITH K. BRODSKY, chair of the board of the New York Foundation for the Arts (2015–), is Distinguished Professor Emerita, Department of Visual Arts, Rutgers University; founder of the Rutgers Center for Innovative Print and Paper, renamed the Brodsky Center in her honor; founder with Ferris Olin of the Rutgers Center for Women in the Art and Humanities and The Feminist Art Project, an international program to promote recognition of women artists; organizer and curator, again with Ferris Olin, of *The Fertile Crescent: Gender, Art, and Society* (2012); founder and chair of the international citywide print festival Philagrafika (2010); past national president of ArtTable, the College Art Association, and the Women's Caucus for Art; and former dean, associate provost, and chair of the art department, Rutgers campus at Newark.

Brodsky has organized and curated many exhibitions and written the essays for many catalogs. She has raised millions to support arts projects at Rutgers University and elsewhere. The Brodsky Center had published more than seven hundred printmaking and handmade paper projects by its thirtieth anniversary in 2017, and work published at the center has entered the collections of major museums worldwide, including the Metropolitan Museum of Art, the Museum of Modern Art, and the Whitney Museum of American Art (all in New York City) and museums both nationally and worldwide, ranging from the Victoria and Albert Museum in London to the Australian National Gallery in Canberra.

As a participant herself in the Feminist Art Movement of the 1970s, Brodsky was a contributor to the first comprehensive history of that period, *The Power of Feminist Art* (Harry N. Abrams, 1993). A printmaker/artist, Brodsky's work is in more than one hundred permanent collections, including the New Jersey State Museum,

the Harvard University Museums, the Library of Congress, the Victoria and Albert Museum in London, the Bibliothèque nationale in Paris, and the Stadtsmuseum in Berlin. Brodsky works in series addressed to social, political, scientific, and philosophical issues, including *One Hundred Million Women Are Missing*, a set of etchings about the status of women; *Memoir of an Assimilated Family*, using old family photographs and accompanying texts to contemplate memory and death in a set of one hundred etchings; and two series on science and the environment, *The Meadowlands Strike Back* and *The 20 Most Important Scientific Questions of the 21st Century*.

She is the recipient of numerous awards, among them a Lindback Award for Distinguished Teaching, the Printmaker Emeritus Award from the Southern Graphics Council International, the Women's Caucus for Art Lifetime Achievement Award, and the College Art Association Committee on Women's Annual Recognition Award (now known as Distinguished Feminist Award), as well as three honorary degrees from Moore College of Art and Design, Monmouth University, and Rider University.

FERRIS OLIN is Distinguished Professor Emerita, Rutgers University, where she was an art historian, curator, women's studies scholar, librarian, and archivist and was the cofounder and codirector (with Judith K. Brodsky) of Rutgers Institute for Women and Art (now known as the Center for Women in the Arts and Humanities) and The Feminist Art Project, an international effort to make visible the aesthetic and intellectual impact of women on the cultural landscape. She was the founding head of the Margery Somers Foster Center, a resource center focused on documenting women's leadership in the public arena, and served as executive officer of the Institute for Research on Women and the Laurie New Jersey Chair in Women's Studies and, earlier, director of the Art Library. She was the curator of the Mary H. Dana Women Artists Series at Rutgers from 1995 to 2006 and later (with Judith K. Brodsky) from 2006 to 2013, the oldest exhibition space in the United States showing work by emerging and established contemporary women artists, founded in 1971. With Brodsky, she also established the Miriam Schapiro Archives on Women Artists.

Olin has curated more than fifty exhibitions and headed many research projects funded by the more than $4 million she raised while on the Rutgers faculty. She is the author of numerous articles on topics as diverse as women's material culture to art librarianship, as well as many exhibition catalogs for the extensive art shows she curated, the most recent of which was *Fertile Crescent: Gender, Art, and Society* (in partnership with Judith K. Brodsky)—a festival of seven exhibitions and more than fifty-five events that took place in fall 2012 focused on women artists, writers, scholars, and performers from the Middle East and all happening at Rutgers and Princeton Universities, Institute for Advanced Study, Arts Councils of Princeton and West Windsor, and public libraries in East Brunswick, New Brunswick, and Princeton. With Brodsky, Olin created the Women Artists Archive National Directory (WAAND), a digital directory of archives where the papers of women artists active in the United States since 1945 are located.

Olin has served on the boards of numerous nonprofit organizations and was vice-president of the College Art Association. She is the recipient of numerous awards, among them the Women's Caucus for Art Lifetime Achievement Award and the College Art Association Committee on Women's Annual Recognition Award (now known as Distinguished Feminist Award).